Λευκός παράδεισος

ΕΚΔΟΣΕΙΣ ΚΑΠΟΝ

Στον εγγονό μου Jules

FRANCIS LATREILLE

Λευκός παράδεισος

Ταξίδι στο Βόρειο Πόλο

Πρόλογος
Claude Lorius

Τα κείμενα γράφτηκαν σε συνεργασία με την
Catherine Guigon

Μετάφραση
Κώστας Μ. Σταματόπουλος

Περιεχόμενα

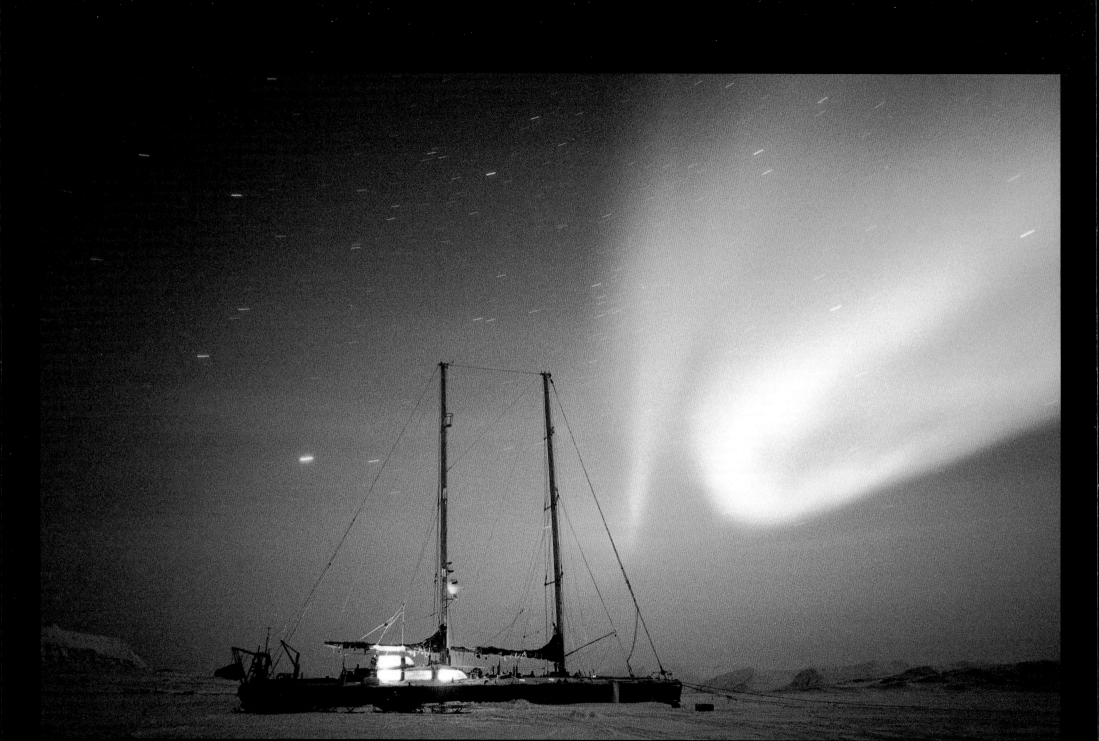

Πρόλογος

Aτέλειωτοι μήνες σκοτάδι, ακτίνες του ήλιου που πέφτουν λοξά, έχοντας διασχίσει ένα πυκνότερο στρώμα ατμόσφαιρας, η ασπράδα του χιονιού και των πάγων που αναπέμπουν το 90% της ενέργειας που έχουν λάβει ... τα ακρότατα γεωγραφικά πλάτη είναι οι πόλοι του ψύχους στον πλανήτη μας. Εκεί, η βροχή γίνεται χιόνι, το νερό μεταμορφώνεται σε πάγο, η κρούστα πάγου καλύπτει τους ωκεανούς, το έδαφος είναι μόνιμα παγωμένο, και το παγωμένο κάλυμμα των *inlandsis* μπορεί να φτάσει το πάχος πολλών χιλιομέτρων. Σ' αυτά τα εξαίσια τοπία ζει μια άγρια πανίδα, ορισμένα είδη της οποίας δεν υπάρχουν παρά μόνον εκεί: η λευκή άρκτος στον βορρά, ο «μονόχειρ αυτοκράτορας» στον νότο. Εάν στην Ανταρκτική δεν πηγαίνουν παρά μόνον ερευνητές και τουρίστες, στην Αρκτική, πληθυσμοί γηγενείς είναι παρόντες εδώ και χιλιετίες. Οι θαυμάσιες φωτογραφίες του Francis Latreille βουτούν μέσα στο κρυσταλλωμένο από το ψύχος σύμπαν της Αρκτικής. Εικόνες που δίνουν την εντύπωση ενός «παραδείσου». Ενός παραδείσου όμως εξαιρετικά εύθραυστου.

Τα πάντα ξεκίνησαν με την κατάκτηση του Βόρειου Πόλου. Πρόκειται για εποποιία χιλιετή, στην καρδιά των πάγων, κατάστικτη από ανθρώπινα κατορθώματα, που υποκινήθηκαν από το πάθος για περιπέτεια, την έλξη που ασκεί η απόκτηση φήμης, την ανάγκη για περισσότερη γνώση, και καμιά φορά από λόγους οικονομικού συμφέροντος. Μια ολόκληρη ιστορία που τιμά τον άνθρωπο και που περατώθηκε πριν από περίπου έναν αιώνα και την οποία προεκτείνουν μέσα στον χρόνο, με τον τρόπο τους, οι σημερινοί ταξιδιώτες των πόλων.

Το βιβλίο αυτό είναι πλούσιο σε εικόνες υπερβόρειων λαών. Συμμέτοχοι στη ζωή και στις συνήθειες των ανθρώπων, τάρανδοι και καριμπού, φώκιες και φάλαινες, αρκούδες και σκυλιά που σέρνουν τα έλκυθρα, έκαμαν δυνατή την επιβίωση αυτών των νομάδων κυνηγών σε έναν τελείως αφιλόξενο κόσμο. Αυτοί οι πατροπαράδοτοι πολιτισμοί πλήττονται σήμερα από τον πολιτισμό και τις οικονομίες των «ανεπτυγμένων» κρατών. Έτσι πια, στην καρδιά των τοπίων, οι καπνοί από τις εγκαταστάσεις για την εκμετάλλευση ορυχείων, φυσικού αερίου, πετρελαίου, θαμπώνουν την εξαίσια λαμπρότητα της υπερβόρειας αυγής. Πρόκειται για μια «βίαιη εισβολή» που καθιστά πασίδηλο το πρόβλημα της προστασίας του περιβάλλοντος. Άλλες, πάλι, απειλές είναι λιγότερο φανερές, όπως η απειλή από τα πυρηνικά απόβλητα που κρύβουν μέσα στο κύτος τους τα υποβρύχια που βυθίστηκαν κοντά στις ακτές.

Αλλά η ρύπανση έρχεται επίσης κι από τις βιομηχανικές χώρες. Η τρύπα του όζοντος πλήττει τα ανώτερα στρώματα της ατμόσφαιρας, και τα κατάλοιπα των πυρηνικών εκρήξεων, ο μόλυβδος που χρησιμοποιείται στη βενζίνη, τα νιτρικά και θειικά άλατα που περιέχουν τα λιπάσματα, είναι πάντα παρόντα στα χιόνια της Γροιλανδίας. Κι εδώ επίσης, η συνειδητοποίηση του προβλήματος οδήγησε σε χειροπιαστές ενέργειες, ώστε να προστατευτεί το περιβάλλον όσο το δυνατό πιο καλά.

Μέσα από τις σελίδες αυτού του βιβλίου έρχονται και μας συναντούν οι ερευνητές, ο κυβερνήτης Charcot και ο Paul-Émile Victor, εκτυλίσσονται μπροστά μας τα επεισόδια των πρόσφατων αποστολών με το πλοίο «Τάρα», με σκοπό να μελετηθούν τα είδη των ζώων και των φυτών. Κι αυτό το επί χιλιετίες κατεψυγμένο μαμούθ που ανακάλυψαν! Οι φωτογραφίες του, ταξίδι αληθινό πίσω στον χρόνο...

Κύμα θερμότητας πλήττει την Αρκτική... Εδώ, βρισκόμαστε μπροστά στις επιπτώσεις της κλιματικής υπερθέρμανσης που παρατηρείται τις τελευταίες δεκαετίες και που πλήττει ιδιαίτερα την Αρκτική. Επηρεάζει πλέον θαλάσσια και χερσαία στρώματα πάγου, παγωμένα εδάφη και ανθρώπινες υποδομές, πανίδα και συνθήκες ζωής των γηγενών πληθυσμών και προαγγέλλει ζοφερές εξελίξεις για τον παρόντα αιώνα. Η Αρκτική, αυτός ο λευκός παράδεισος, διατρέχει πράγματι θανάσιμο κίνδυνο; Ιδού το ερώτημα που ανακύπτει κάθε τόσο στις σελίδες αυτού του βιβλίου.

Οι ίδιοι οι πάγοι προσφέρουν κάποια στοιχεία απάντησης. Σε σχέση με το κλίμα, συνιστούν, ταυτόχρονα, ένα αρχείο του παρελθόντος, έναν δρώντα παράγοντα σε πλήρη ανέλιξη, και έναν μάρτυρα των συνεπειών από τις αλλαγές που συντελούνται.

Σε ό, τι αφορά την ιστορία του κλίματος, μεγάλες πρόοδοι έγιναν χάρη στη μνήμη που διαφυλάσσουν οι πάγοι της Γροιλανδίας και της Ανταρκτικής, έτσι όπως διαμορφώθηκαν στο πέρασμα του χρόνου, καθώς κατέγραψαν περιόδους ζέστης και περιόδους ψύχους που εναλλάσσονται τις τελευταίες εκατοντάδες χιλιάδες χρόνια που διαρκεί η Τεταρτογενής γεωλογική περίοδος. Οι ενεργειακές εναλλαγές, που συναρτώνται με τις κινήσεις της γης γύρω από τον ήλιο, αφήνουν τα ίχνη τους στον πάγο. Τα σημάδια αυτά μεγεθύνονται εξαιρετικά, λόγω της βαθιάς, σχεδόν «σκεπτόμενης», ισορροπίας που χαρακτηρίζει τον πλανήτη μας, και πιο συγκεκριμένα λόγω της μεταβλητής επιφάνειας των πάγων, που αναπέμπει στο διάστημα την ηλιακή ακτινοβολία που δέχτηκε. Αρχεία μοναδικά ως προς τη συγκρότηση της ατμόσφαιρας, οι φυσαλίδες αέρος που περιέχονται στα inlandsis των πόλων, καταδεικνύουν επίσης τη σχέση ανάμεσα στις κλιματικές εναλλαγές –που κάποτε ήταν φυσικές– και την περιεκτικότητα της ατμόσφαιρας σε αέρια, όπως είναι το διοξείδιο του άνθρακα και το μεθάνιο, ικανά να προκαλέσουν συμπτώματα θερμοκηπίου: η σχέση αυτή μας εξηγεί το παρατηρούμενο σήμερα φαινόμενο της υπερθέρμανσης.

Μετεωρολογικές παρατηρήσεις, καθώς και δεδομένα που λαμβάνουμε από δορυφόρους, βεβαιώνουν με τρόπο απόλυτο την αύξηση της θερμοκρασίας τού πλανήτη μας κατά τη διάρκεια του περασμένου αιώνα. Καίτοι προς το παρόν δεν πρόκειται παρά για μία μέση άνοδο, μικρότερη του ενός βαθμού Κελσίου, οι συνέπειες είναι ήδη μεγάλες: είναι η αργή άνοδος της στάθμης των θαλασσών, που σήμερα φτάνει τα είκοσι εκατοστά, και η οποία, όπως ορθά μπορούμε να εικάσουμε, είναι δύο με τρεις φορές μεγαλύτερη στην Αρκτική. Εκεί, οι επιπτώσεις που περιγράφονται σε διάφορα κείμενα είναι εμφανείς, με συνέπειες, τόσο σε βάρος της τοπικής χλωρίδας και πανίδας –η πολική άρκτος αποτελεί το σύμβολο αυτής της κατάστασης – όσο και των πληθυσμών των Εσκιμώων.

Ακόμη και αν η κόνις, ηφαιστιογενούς ή βιομηχανικής προέλευσης, καθώς και η φωτεινότητα του ηλίου έχουν το μερίδιο ευθύνης τους στη διαμόρφωση της ακτινοβολίας της γης, και επομένως επιδρούν στο κλίμα, οι ερευνητές αποδίδουν τη σημερινή αύξηση της θερμοκρασίας στη συνεχώς αυξανόμενη συγκέντρωση στην ατμόσφαιρα των αερίων εκείνων που προκαλούν το σύμπτωμα του θερμοκηπίου. Το φαινόμενο, παρατηρήσιμο σε ολόκληρο τον πλανήτη, είναι μετρήσιμο στον αέρα που βρίσκεται εγκλωβισμένος στους πάγους: η περιεκτικότητα σε διοξείδιο του άνθρακος έχει αυξηθεί πάνω από 20% τον τελευταίο αιώνα, και εκείνη του μεθανίου υπερδιπλασιάστηκε. Η αύξηση αυτή των ρύπων οφείλεται, σε ό, τι αφορά το διοξείδιο του άνθρακα, στη χρήση των ορυκτών καυσίμων – του πετρελαίου δηλαδή και του κάρβουνου – που είναι αναγκαία για την παραγωγή ενέργειας. Η γεωργία και η κτηνοτροφία είναι από την πλευρά τους εκείνες που καίρια ευθύνονται για τη μεταβολή των ποσοστών του μεθανίου. Το συμπέρασμα είναι πως τα χιόνια και οι πάγοι των πόλων αποτελούν αξιόπιστους μάρτυρες που αφενός πιστοποιούν το φαινόμενο της υπερθέρμανσης και αφετέρου αποκαλύπτουν τα αίτια που το προκαλούν.

Απέραντες χιονισμένες εκτάσεις, η παγωμένη κρούστα της θάλασσας, πάχους αρκετών μέτρων, που διαρρηγνύεται και παρασύρεται από τα ρεύματα των ωκεανών, παγετώνες, ακόμη πιο ογκώδεις, που σχηματίστηκαν στα ηπειρωτικά εδάφη ή στα inlandsis της Γροιλανδίας, όπου σωρεύτηκε πάγος βάθους πολλών χιλιομέτρων, αυτοί οι ποικίλου βάθους τεράστιοι όγκοι πάγου, διαβαθμίζουν την ικανότητα αντίδρασης της κρυόσφαιρας, σε συσχετισμό με την κλιματική εξέλιξη, σε ορίζοντα χρόνου που εκτείνεται από μια εποχή του έτους έως μία δεκαετία, και από έναν ή περισσότερους αιώνες έως και χιλιετίες. Τόσο οι παρατηρήσεις στο έδαφος όσο και οι εικόνες οι σταλμένες μέσω δορυφόρου, δείχνουν τη συρρίκνωση – στη διάρκεια των

τελευταίων ετών– των επιφανειών που είναι καλυμμένες είτε με χιόνια είτε με στρώμα πάγου. Η σημειούμενη αυτή μείωση, συνεχώς επιδεινούμενη, επιφέρει μία όλο και πιο μεγάλη απορρόφηση της ηλιακής ακτινοβολίας, φαινόμενο που με τη σειρά του αυξάνει ακόμη περισσότερο τις ήδη υψηλές θερμοκρασίες. Έτσι, όπως σχεδόν παντού στον πλανήτη, το φαινόμενο της υποχώρησης των χερσαίων παγετώνων παρατηρείται και στην Αρκτική, ενώ τελευταία αγγίζει και τη Γροιλανδία. Σε αντίθεση με το στρώμα πάγου που καλύπτει τις αρκτικές θάλασσες, και του οποίου οι συνέπειες στην άνοδο της στάθμης των υδάτων είναι μηδαμινές – καθώς οι πάγοι αυτοί απλώς επιπλέουν στην επιφάνεια της θάλασσας– αυτό που εν μέρει ευθύνεται για την ύψωση της στάθμης των ωκεανών είναι η τήξη των χερσαίων πάγων.

Με βάση τα μέχρι σήμερα δεδομένα, καθώς και τις προβολές που πραγματοποιήθηκαν με αφετηρία κλιματικά πρότυπα, η επιτάχυνση του φαινομένου της υπερθέρμανσης μοιάζει αναπόφευκτη στα επόμενα χρόνια, καθώς δεν διαθέτομε προς το παρόν «καθαρές» πηγές ενέργειας, ικανές να καλύπτουν σε παγκόσμια κλίμακα τις ανθρώπινες ανάγκες. Τα υφιστάμενα πρότυπα, σε συνάρτηση με τα υπάρχοντα σενάρια παραγωγής ενέργειας, καθώς και με την αβεβαιότητα που υπάρχει σχετικά με την πολύπλοκη λειτουργία του κλιματικού μας συστήματος, προμηνύουν ένα ιδιαίτερα θερμό τέλος του αιώνα για την Αρκτική: η συρρίκνωση του στρώματος πάγου στις θάλασσες θα οδηγήσει σε μεγαλύτερη αύξηση της θερμοκρασίας, ενώ παράλληλα, η τήξη των πάγων στη στεριά θα προκαλέσει αισθητή άνοδο της στάθμης των θαλασσών. Πρόκειται, δίχως άλλο, για μία «δυνάμει» οικολογική συμφορά τόσο για την Αρκτική, όσο και για ολόκληρο τον πλανήτη, έστω και αν ορισμένες περιοχές ενδέχεται να ωφεληθούν από την άνοδο της θερμοκρασίας.

Κι αυτό εξηγεί το γιατί το φαινόμενο της υπερθέρμανσης θεωρείται συχνά ως η «πρόκληση του αιώνα». Στη διάρκεια της ιστορίας του, ο άνθρωπος αναγκάστηκε να παλέψει ενάντια σε ακραίες κλιματικές καταστάσεις και να προσαρμοστεί στις φυσικές κλιματικές διακυμάνσεις. Όμως εδώ και έναν περίπου αιώνα έχουμε μπει μέσα σε μια νέα περίοδο, που ο Νομπελίστας Paul Crutzen εύστοχα αποκαλεί «ανθρωποσύνη» (με την έννοια της τεχνητής διατάραξης των φυσικών ισορροπιών του πλανήτη μας). Μέσα δηλαδή από τις ενέργειές του, ο άνθρωπος επηρεάζει την εξελικτική πορεία του κλίματος ειδικότερα, γενικότερα όμως επηρεάζει τις συνθήκες ζωής σε ολόκληρο τον πλανήτη μας.

Η πρόκληση με την οποία βρισκόμαστε αντιμέτωποι δεν είναι αμελητέα, καθώς η λύση της απαιτεί την εύρεση απαντήσεων που να συμφιλιώνουν μεταξύ τους οικολογικές, πολιτικές, οικονομικές και κοινωνικές παραμέτρους, καθώς και την αντίδραση των συνειδητοποιημένων ως προς τα δικαιώματα και τις υποχρεώσεις τους έναντι του κοινωνικού συνόλου, πολιτών, προσεγγίσεις, οι οποίες συχνά αλληλοσυγκρούονται. Ωστόσο, ας εμπιστευθούμε τις ανθρώπινες ικανότητες. Προς το παρόν, τίποτε δεν είναι μη αναστρέψιμο, αν και πρέπει για όλα να βιαστούμε, σύμφωνα με τη ρήση «κάλλιον Προμηθεύς, παρά Επιμηθεύς».

Για την ώρα, οι φωτογραφίες του Francis Latreille αποτελούν μαρτυρίες γι' αυτό που δεν είναι ακόμη ένας χαμένος παράδεισος.

Claude LORIUS
Πρόεδρος της Επιτροπής της Ακαδημίας των
Επιστημών για το Διεθνές Πολικό Έτος

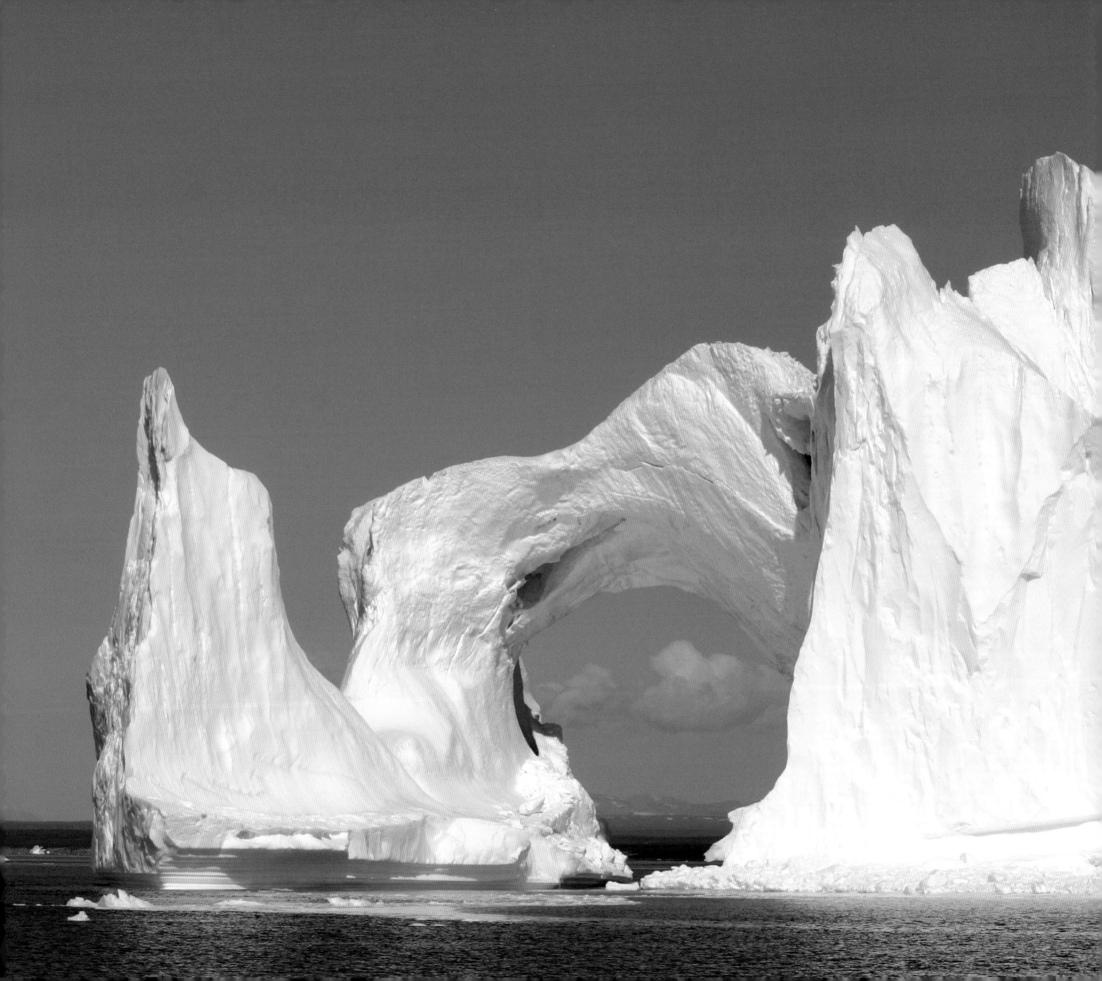

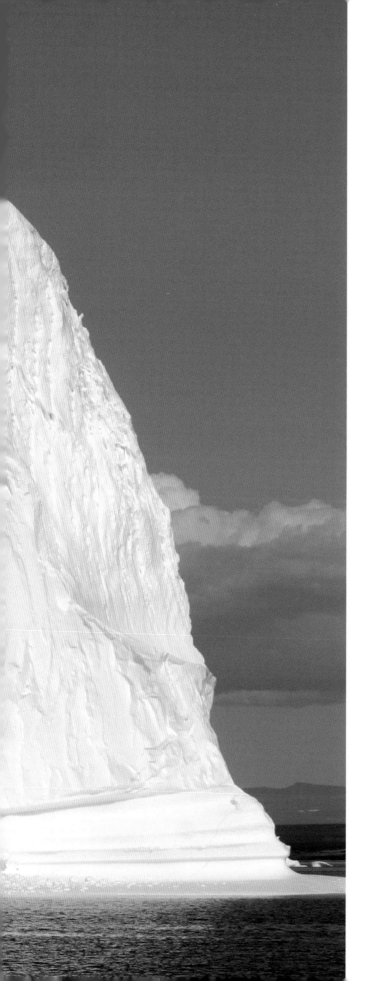

◁ Στη Γροιλανδία, μεγάλοι όγκοι πάγου αποκόβονται καθημερινά από τα παγόβουνα και, καθώς παρασύρονται από τα θαλάσσια ρεύματα, σχηματίζουν εφήμερα γλυπτά.

▷ Η πλώρη της πολικής γολέτας «Τάρα» ανοίγει δρόμο μέσα από τους πάγους του Αρκτικού ωκεανού.

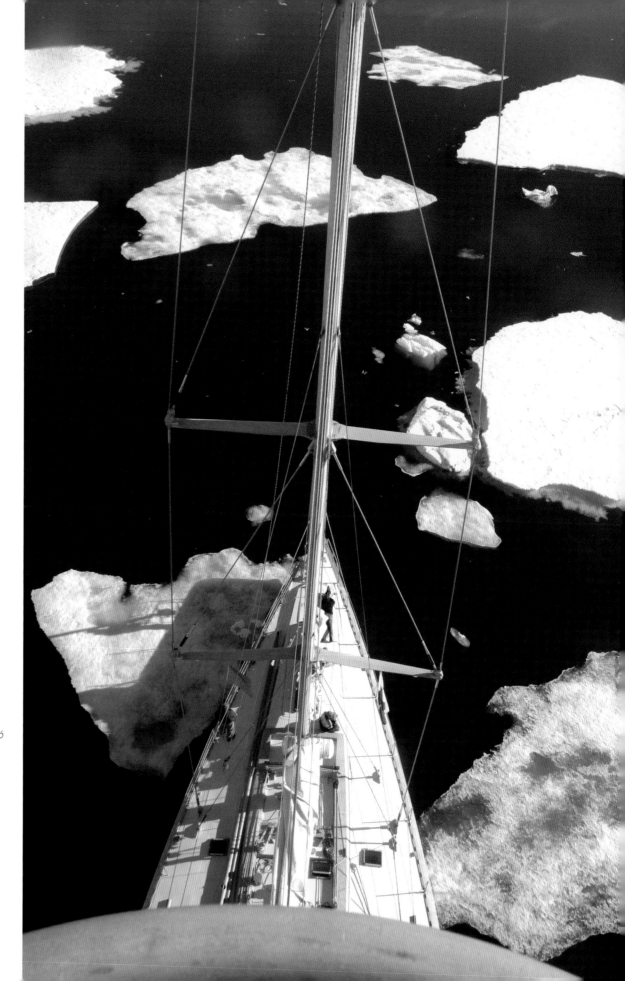

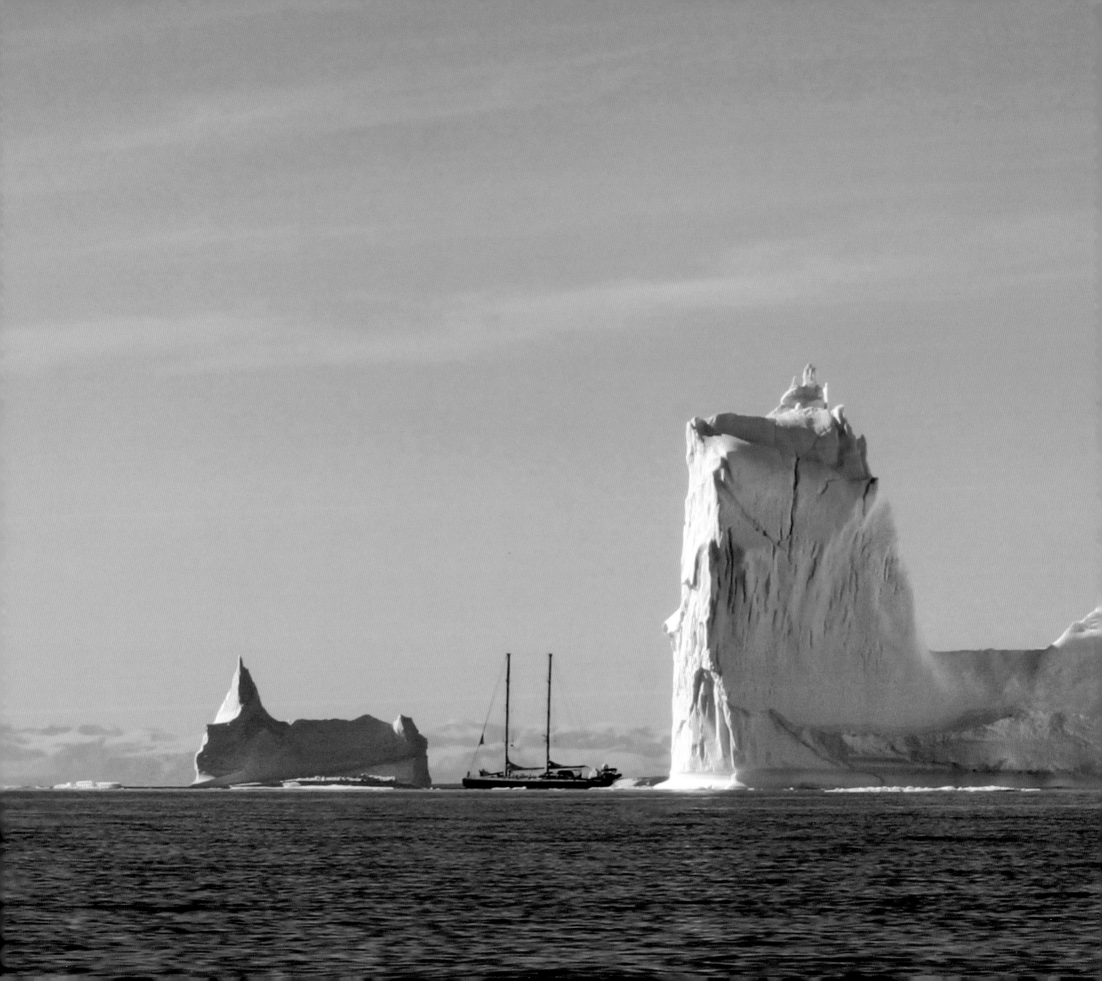

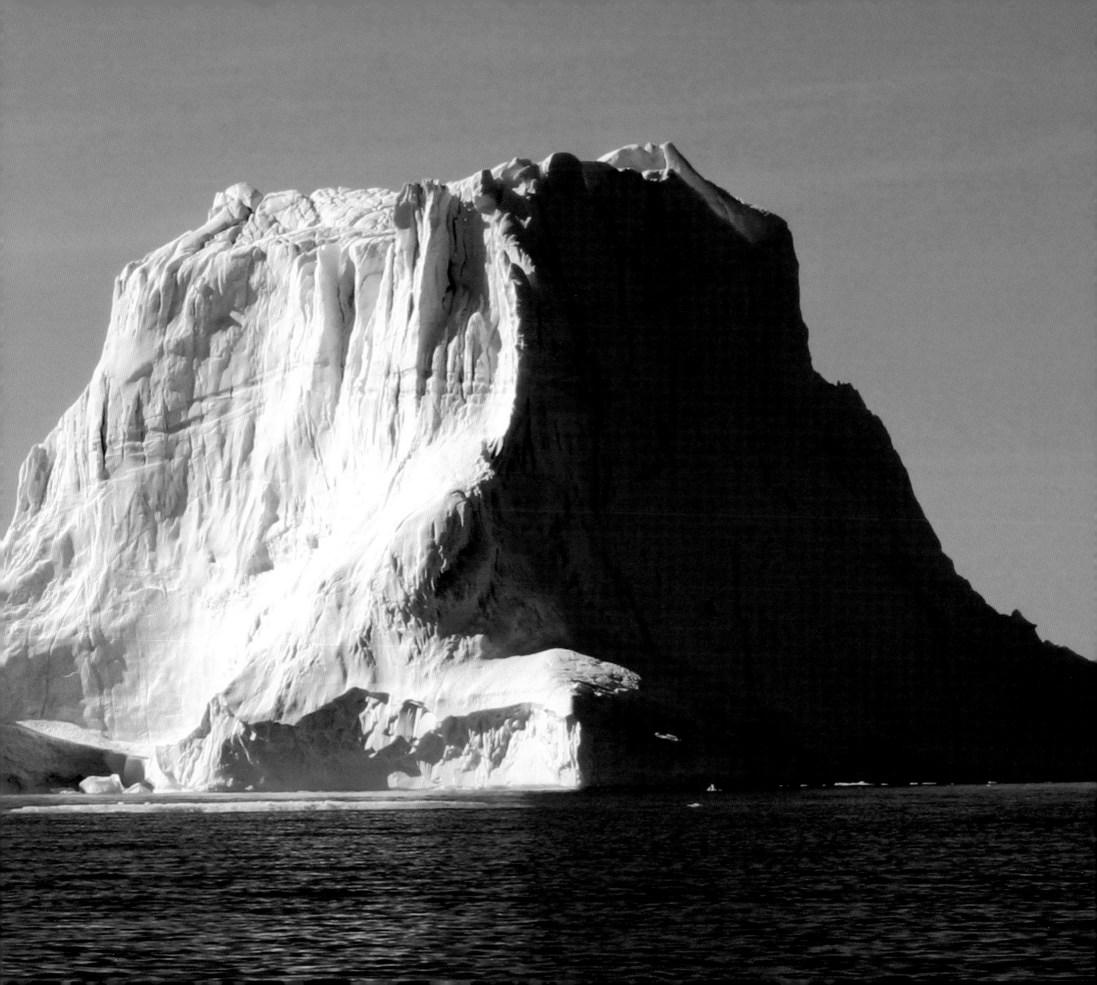

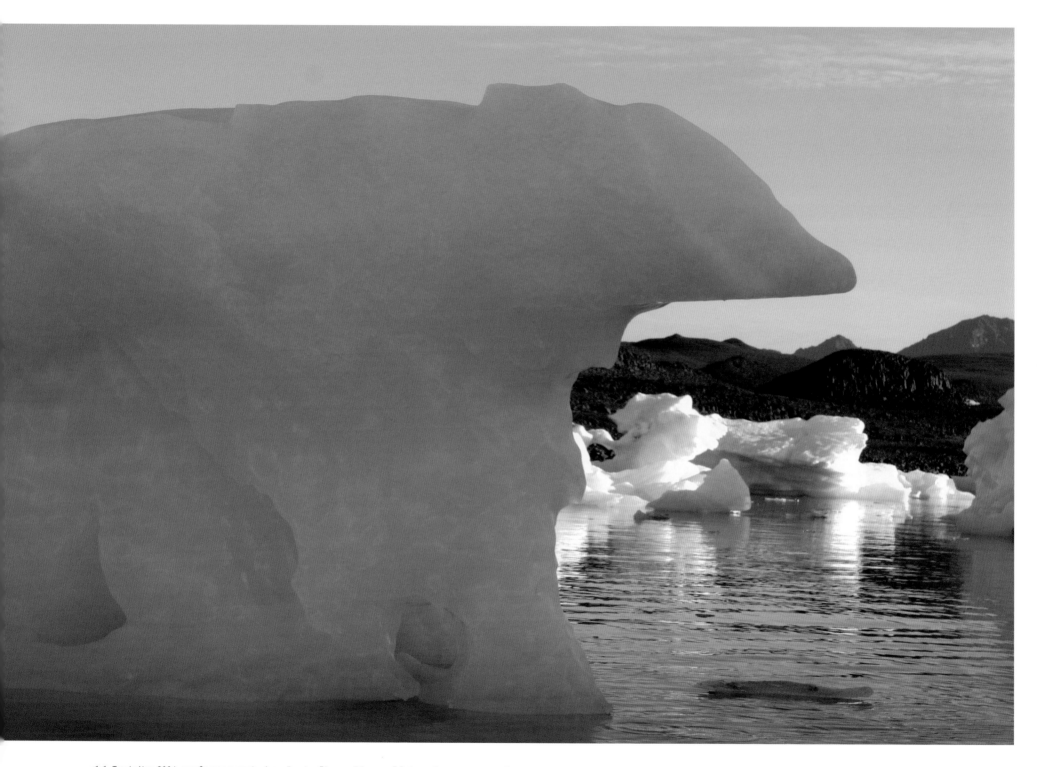

◁◁ Τον Ιούλιο 2004, στα βορειοανατολικά της Γροιλανδίας, η «Τάρα» ταξιδεύει ανάμεσα σε γιγαντιαία παγόβουνα, στην πορεία που χάραξε το «Pourquoi-Pas?» («Γιατί όχι;») του καπετάνιου Charcot.

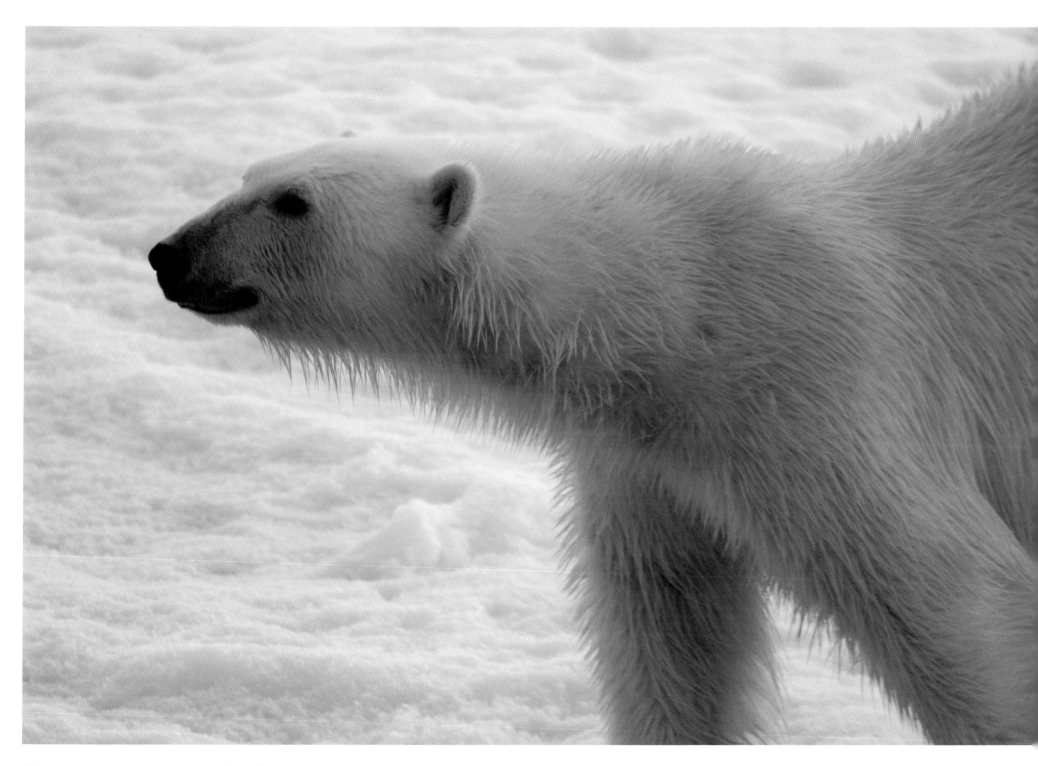

◁◁ Απέναντι στη φιγούρα της από πάγο, η πολική αρκούδα, άρχοντας της Αρκτικής, είναι το έμβλημα του Βόρειου Πόλου και όλης της γύρω περιοχής του.

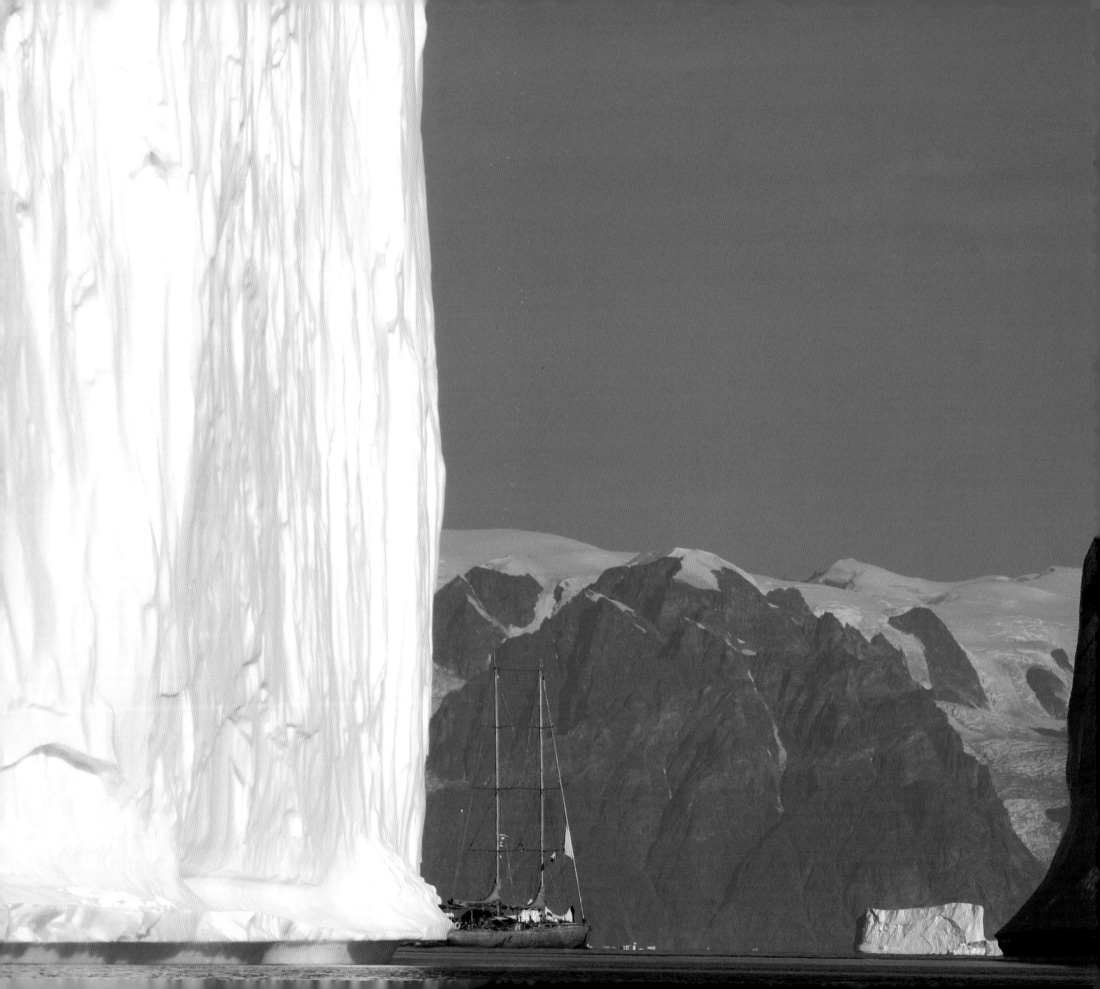

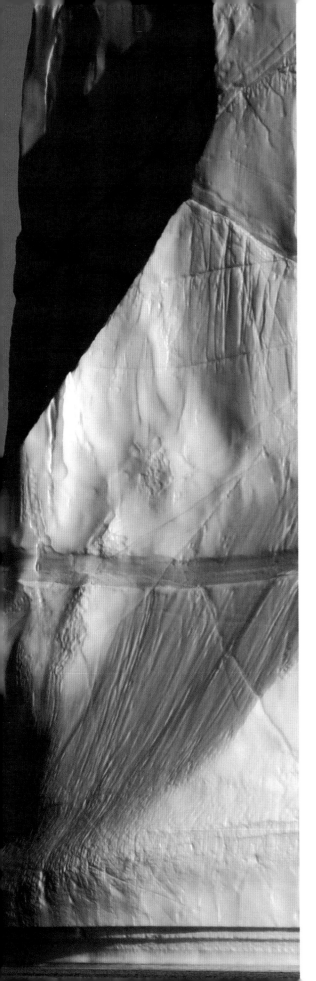

◁ Κάτω από τεράστια
τοιχώματα από πάγο,
τα κατάρτια της «Τάρα»,
ύψους 30 μέτρων, δίνουν
την κλίμακα, σε σχέση με
τα παγόβουνα που η γολέτα
πρέπει να αποφύγει.

▷ Οι παγετώνες καλύπτουν
ολόκληρη τη Γροιλανδία με
ένα κάλυμμα πάγου, που
το πάχος του ξεπερνάει
τα 3000 μέτρα. Πέφτουν στη
θάλασσα και στη συνέχεια
δημιουργούνται παγόβουνα.

▷▷ Μέσα στην ομίχλη της
θάλασσας της Ισλανδίας,
η εγρήγορση είναι το
βασικότερο μέλημα κάθε
καπετάνιου, για να ταξιδεύει
χωρίς πρόβλημα μέσα
στους πάγους.

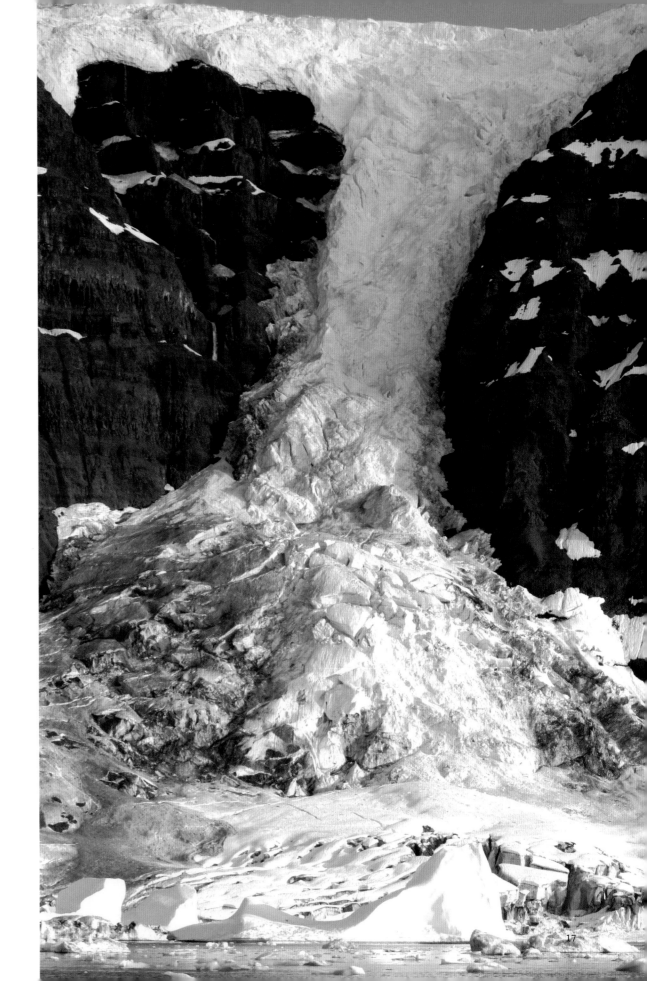

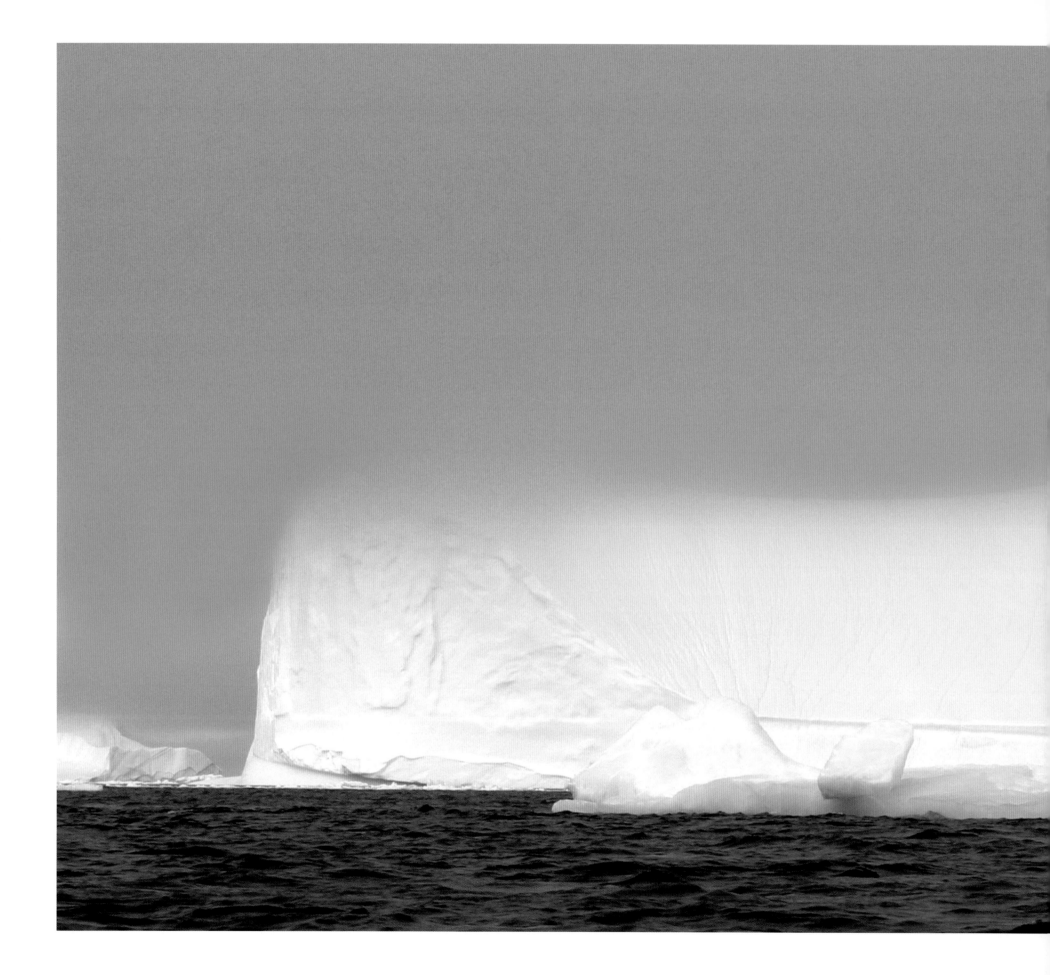

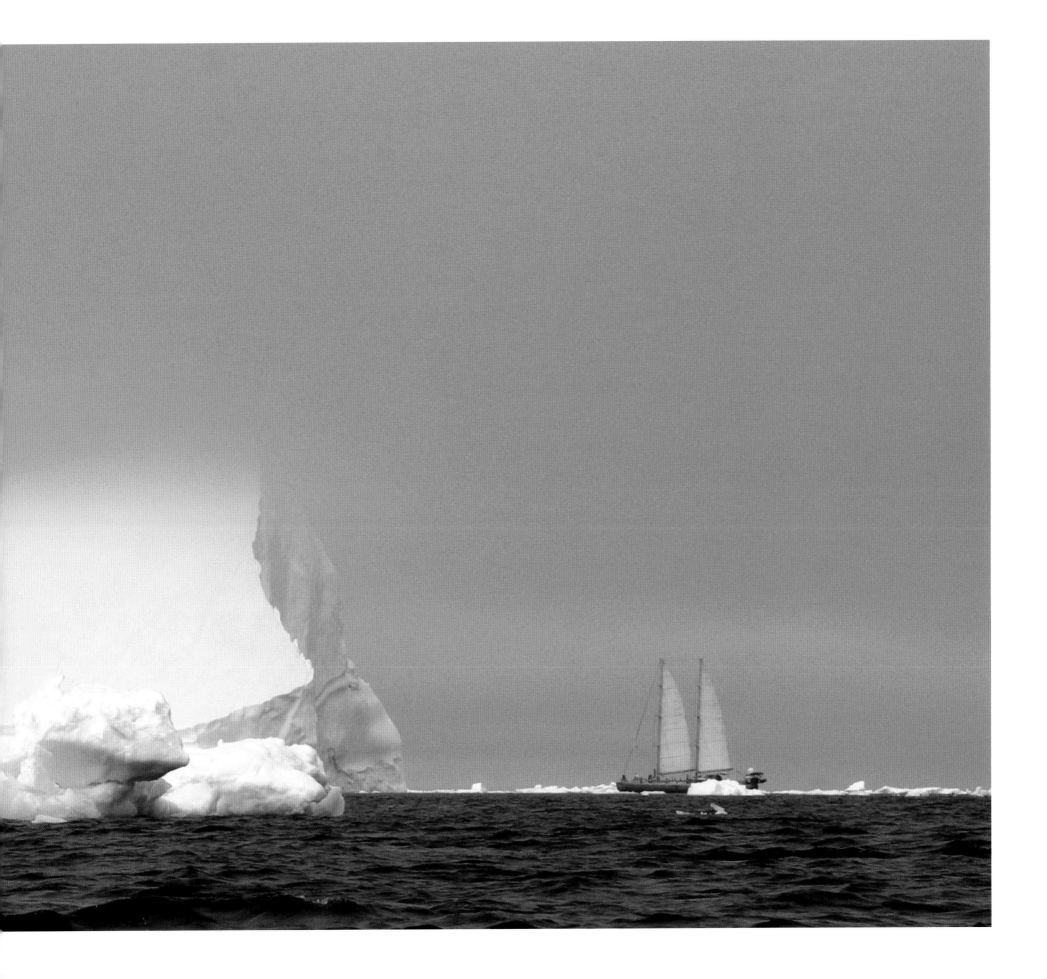

Με τους πρωτοπόρους,
για την κατάκτηση του Βόρειου Πόλου

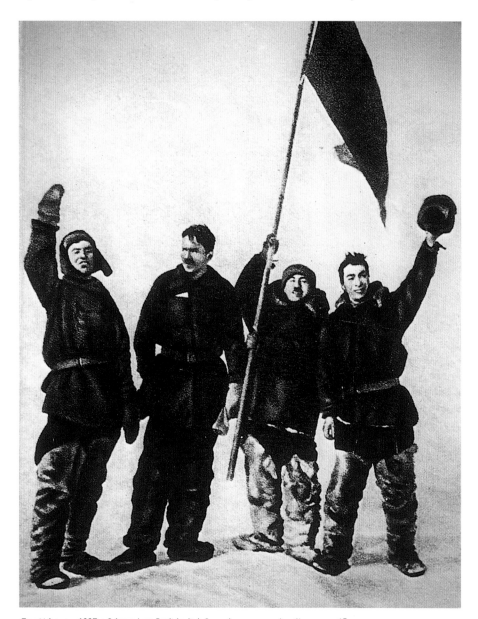

Τον Μάιο του 1937 ο Ρώσος Ivan Dmitrievitch Papanine και τα τρία μέλη της ομάδας του κατασκευάζουν την πρώτη πλωτή επιστημονική βάση πάνω στην παγονησίδα του Βόρειου Πόλου και αφήνονται να παρασυρθούν από τα ρεύματα για εννέα μήνες. Θα καταφέρουν να σωθούν μόλις τον Φεβρουάριο του επόμενου χρόνου, ενώ η σχεδία τους, κατασκευασμένη από πάγο, μήκους 30 και πλάτους 10 μέτρων, λίγο έλειψε να βουλιάξει.

Τα ακρότατα σημεία της γης ανέκαθεν κέντριζαν τη φαντασία των ανθρώπων. Οι Αρχαίοι προαισθάνοντο ήδη την ύπαρξη των πόλων, τους οποίους γεωγραφικά τοποθετούσαν στους «αντίποδες». Από πολύ νωρίς, τολμηροί θαλασσοπόροι ρίχτηκαν στην αναζήτησή τους, πλέοντας στις παγωμένες θάλασσες. Ωστόσο, οι δρόμοι των πολικών εξερευνήσεων προς το περιβόητο βόρειο γεωγραφικό πλάτος των 90 μοιρών είναι από τους χρονικά τελευταίους που ανοίχτηκαν, και η εξερεύνηση των αρκτικών περιοχών διαρκεί μέχρι τις ημέρες μας, έχοντας πίσω της αιώνες αφάνταστου κόπου και πόνου.

Ένας Έλληνας ποντοπόρος, ο Πυθέας από τη Μασσαλία, είναι αυτός που πρώτος θα χαράξει τον θαλάσσιο δρόμο προς τον Βορρά. Κινώντας με μία γαλέρα από τη Μασσαλία, θεωρείται πως γύρω στο 330 π. Χ. έφτασε στη *χώρα της Θούλης*, που ήταν τότε το απώτατο προσιτό όριο του Βορρά, και που ορισμένοι ταυτίζουν με τα νησιά Σέτλαντ, άλλοι με τις Ορκάδες ή με τα νησιά Φερόε ή ακόμη και με την Ισλανδία. Κανείς δεν μπορεί να είναι βέβαιος για το πού πράγματι έφτασαν, αλλά πάντως το πλήρωμα, όταν επέστρεψε, διηγόταν πως αντίκρισε τον «ήλιο του μεσονυκτίου» και πως είδε τα νερά να στερεοποιούνται ξαφνικά και να μεταμορφώνονται σε ένα μεγάλο «θαλάσσιο πνευμόνι». Ο Πυθέας δεν απέφυγε βέβαια εκ μέρους των μεταγενεστέρων τον χαρακτηρισμό του ψεύτη, καθώς και την κατηγορία ότι δεν έκανε τίποτε άλλο από το να πλάσει ιστορίες, με βάση τον ελληνικό μύθο των Υπερβορείων, η χώρα των οποίων πίστευαν πως βρισκόταν πέρα από το σημείο που γεννά τον βόρειο άνεμο... Ο Δανός Έρικ ο Ερυθρός, κι αυτός κατηγορούμενος, αλλά για άλλους λόγους, και καταδικασμένος για φόνο, οφείλει τόσο στην εξορία του, όσο και στη φορά των ανέμων που τον παρέσυραν έως εκεί, την ανακάλυψη, το 982, της Γροιλανδίας, μιας χώρας «καταπράσινης» –ήταν καλοκαίρι όταν έφτασε– , στην οποία ίδρυσε μία αποικία Βίκινγκ.

Παρ' όλα αυτά τα πρώτα κατορθώματα, η κατάκτηση των ψυχρών θαλασσών δεν κινητοποίησε τους εξερευνητές παρά στην περίοδο των Μεγάλων Εξερευνήσεων, έτσι που ο χάρτης του Mercator που εκδόθηκε στα 1569, να απεικονίζει τον Βόρειο Πόλο με τη μορφή ενός μαύρου βράχου περιτριγυρισμένου από νησιά. Τα κράτη της γηραιάς ηπείρου, ωστόσο, άρχισαν να ατενίζουν προς τις παγωμένες απεραντοσύνες. Βασικός λόγος: οι επιταγές του εμπορίου, κυρίως των μπαχαρικών και του μεταξιού. Το 1585, ο Άγγλος John Davis συνέλαβε το σχέδιο ενός περάσματος στα βορειοδυτικά, ανάμεσα στη Γροιλανδία και τη νήσο Μπάφιν, που θα οδηγούσε στον δρόμο των Ινδιών. Την ώρα που η Ισπανία και η Πορτογαλία έστελναν τα πλοία τους στην Άπω Ανατολή, περνώντας από την Αφρική και το ακρωτήρι της Καλής Ελπίδος, οι Ηνωμένες Επαρχίες, ανάμεσα στις οποίες ήταν η Ολλανδία, χρηματοδότησαν ένα ανταγωνιστικό σχέδιο. Τον Ιούνιο του 1594, ο πλοηγός

Willelm Barents έβαλε πλώρη για τη Σιβηρία, τραβώντας προς τα βορειοανατολικά, προκειμένου να φέρει σε πέρας την αποστολή και να βρει κι αυτός επίσης έναν ακόμη δρόμο προς τις Ανατολικές Ινδίες. Τρεις άκαρπες απόπειρες τού επέτρεψαν ωστόσο να ανακαλύψει το Spitzberg, το 1596, προτού αποκλείσουν το καράβι του οι πάγοι στη Νέα Ζέμπλε. Αναγκασμένοι να ξεχειμωνιάσουν –έναν χειμώνα διαρκείας εννέα μηνών– σε βόρειο γεωγραφικό πλάτος 76 μοιρών, οι άνδρες του πληρώματος κυνηγούν αλεπούδες για να επιβιώσουν και αντιστέκονται στις αρκούδες και την παγωνιά. Και με το λιώσιμο των πάγων, τον Μάιο, σπεύδουν να καταφύγουν στις βάρκες, πλέοντας στο έλεος του Θεού. Ο Willem Barents, μέσα σε όλη αυτήν την ταλαιπωρία της περιπέτειας, πεθαίνει, αφήνοντας στον Gerrit de Veer, έναν από τους δώδεκα επιζήσαντες, τη φροντίδα να διηγηθεί την εποποιία, κάτι που εκείνος έκανε, δημοσιεύοντας το *Φυλακισμένοι στους πάγους*, έργο που γνώρισε πραγματική επιτυχία.

Η εύρεση, ωστόσο, περάσματος στα βορειοδυτικά εξακολουθεί να αποτελεί πρόκληση. Αποφασισμένος να εκβιάσει την τύχη, ο Άγγλος θαλασσοπόρος Henry Hudson, το 1607, ακολουθεί στην αρχή μια πορεία όλο στα βόρεια, για να φτάσει σε μια απόσταση 1.065 χιλιομέτρων από τον Πόλο –όπου και θα εξοκείλει. Το ρεκόρ αυτό δεν θα ξεπεραστεί επί 159 χρόνια. Ο ίδιος, αργότερα, το 1610, θα βρει τον θάνατο, καθώς το πλοίο του «Discovery» βυθίστηκε στον τεράστιο κόλπο που στο εξής φέρει το όνομά του. Και οι αποτυχίες διαδέχονται η μία την άλλη, όπως η καταστροφική εκστρατεία του Sir John Franklin, κυβερνήτη των πλοίων «Erebus» και «Terror, που χάθηκαν αύτανδρα το 1845. Τελικώς, ο πρώτος που θα κατορθώσει να διασχίσει το βορειοδυτικό πέρασμα είναι ο Νορβηγός Roald Admunsen, το 1903-1906.

Η έμμονη ιδέα της πλεύσης ανατολικά, προκειμένου να διευκρινιστεί «πού αρχίζει η αμερικανική ήπειρος», παρέμεινε ωστόσο στην επικαιρότητα. Αυτή πάντως η ιδέα παρακινεί τον τσάρο Μεγάλο Πέτρο, επηρεασμένο από το πνεύμα του Διαφωτισμού και την παρισινή Ακαδημία των Επιστημών, να χρηματοδοτήσει το 1724 μία αποστολή, με σκοπό την εξερεύνηση των εσχατιών της αυτοκρατορίας του. Την αποστολή την ανέθεσε στον δανικής καταγωγής ναυτικό Vitus Bering. Ξεκινώντας από την Αγία Πετρούπολη και διασχίζοντας τα 8.000 χιλιόμετρα της Σιβηρίας, ο εξερευνητής έφτασε ύστερα από τρία χρόνια στη χερσόνησο Καμτσιάκα, όπου ναυπήγησε το πλοίο «Άγιος Γαβριήλ», με το οποίο, στις 13 Αυγούστου 1728, διαπίστωσε ότι ένα στενό θαλάσσιο πέρασμα – που στο εξής θα φέρει το όνομά του – χωρίζει την Ασία από την Αμερική. Η πυκνή ομίχλη όμως που κάλυπτε τον πορθμό, τον υποχρέωσε δυστυχώς να επιστρέψει στη βάση του... Το επόμενο στάδιο εξερεύνησης πραγματοποιήθηκε από τη λεγόμενη Μεγάλη Εκστρατεία του Βορρά (1733- 1743),

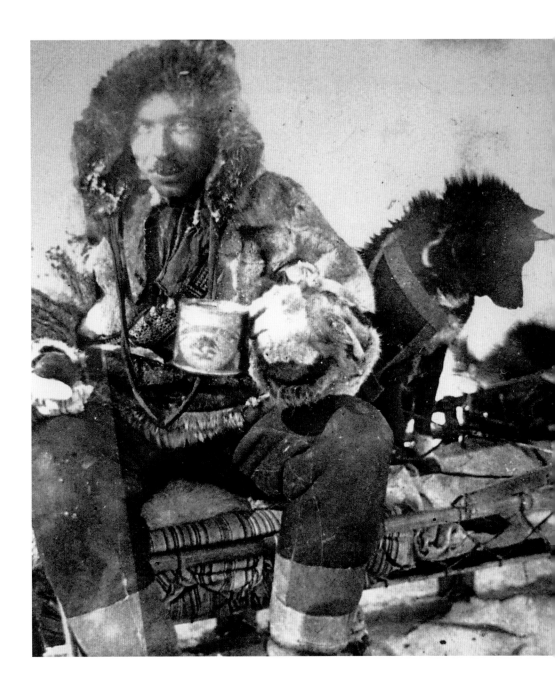

Το 1931, ο Ρώσος G.A. Ushakov χαρτογραφεί τα νησιά του Βορρά στον Αρκτικό ωκεανό.

στη διάρκεια της οποίας ο Bering χαρτογράφησε τις Αλεούτιες νήσους, καθώς και τη νότια ακτή της Αλάσκας. Πέθανε σε ένα έρημο νησί, όπου μία θύελλα είχε ρίξει το καράβι του. Όσο για το βορειοανατολικό πέρασμα, αυτό τελικώς θα το διαβεί, χωρίς ιδιαίτερη δυσκολία, ο Σουηδός Adolf Erik Nordenskjöld, με το πλοίο «Vega», το 1878-1879.

Στο εξής, περιέργεια και επιστημονικό πνεύμα πρυτανεύουν στις πιο τρελές πολικές αποστολές. Με αυτά τα δεδομένα, ο Βρετανός Sir John Ross, μαζί με τον ανιψιό του James Clark Ross, αναλαμβάνουν την προσπάθεια επαλήθευσης των θεωριών του Γερμανού φυσικού Karl Friedrich Gauss σχετικά με τα γήινα μαγνητικά πεδία. Αυτό είχε ως αποτέλεσμα τον εντοπισμό από πλευράς τους του μαγνητικού Βόρειου Πόλου, το 1831. Αλλά η πιο τολμηρή από τις επιστημονικές περιπέτειες του 19ου αιώνα αφορά την εκπληκτική ανακάλυψη, το 1893-1896, του Αρκτικού παγωμένου ωκεανού, από τον Νορβηγό Fridtjof Nansen.

Όλα είχαν ξεκινήσει καμιά δεκαριά χρόνια νωρίτερα, με το ναυάγιο της «Jeannette», ιδιοκτησίας ενός μεγιστάνα του αμερικανικού Τύπου, με κυβερνήτη τον πλοίαρχο Georges Washington De Long. Το πλοίο συντρίφτηκε από τους πάγους, το 1881, στα βορειοδυτικά των στενών του Bering, σε μικρή απόσταση από τα νησιά της Νέας Σιβηρίας. Εξού και η κατάπληξη του επιστημονικού κόσμου, όταν δύο χρόνια αργότερα, Εσκιμώοι εντόπισαν συντρίμμια του σκάφους στη νοτιοδυτική ακτή της Γροιλανδίας, δηλαδή σε απόσταση μεγαλύτερη από 5.000 χιλιόμετρα από το σημείο του ναυαγίου! Τότε, ο Nansen, συντηρητής στο Μουσείο Φυσικής Ιστορίας του Μπέργκεν, έκανε μια μεγαλοφυή σκέψη: «Ο Βόρειος Πόλος είναι στεριά ή θάλασσα;», αναρωτήθηκε. Δεν μπορούσε να ησυχάσει εάν δεν έβρισκε την απάντηση σε αυτήν την απορία. Κατάφερε, λοιπόν, και εξασφάλισε την επιχορήγηση της κατασκευής του «Fram», ενός σκάφους, μήκους 40 μέτρων και πλάτους 11, του οποίου το στρογγυλευμένο σκαρί θα μπορούσε να αντέξει στην πίεση των πάγων. Η αποστολή περιλάμβανε 12 άτομα ως πλήρωμα –ανάμεσα στα οποία, έναν μετεωρολόγο και έναν βοτανολόγο– καθώς και 34 σκυλιά για να σύρουν τα έλκηθρα. Το σχέδιό του ήταν να αφήσουν τους πάγους να τους παγιδέψουν και να

△ Ο Αμερικανός εξερευνητής Robert Peary διεκδικεί την πρωτιά στην κατάκτηση αυτού του μυθικού σημείου της υδρογείου, του Βόρειου Πόλου, που κατάφερε να προσεγγίσει στις 6 Απριλίου 1909.

▷ Στο Spitzberg, σ' ένα ελεύθερο πέρασμα νερού, οι πύργοι από πάγο πέφτουν στο ρεύμα, που τους παρασύρει στην πορεία του προς τον Αρκτικό ωκεανό.

τους παρασύρουν στη δική τους πορεία, ελπίζοντας ότι τα ρεύματα θα τους οδηγούσαν, σύμφωνα με τους υπολογισμούς τού Nansen, στην περιοχή του Βόρειου Πόλου σε λιγότερο από δύο χρόνια! Εγκλωβισμένο μέσα στον πάγο, το «Fram», παρασύρεται από ρεύμα για μεγάλη απόσταση, καταφέρνει όμως να αντέξει. Στις 14 Μαρτίου 1895, ακινητοποιείται στις 84 μοίρες βόρειου γεωγραφικού πλάτους, απέχοντας λιγότερο από 700 χιλιόμετρα από τον Πόλο, με θερμοκρασία 40 βαθμών κάτω του μηδενός. Ο Nansen αρνείται να κάνει πίσω. Παίρνοντας μαζί του τον ναύτη Hijalmar Johansen, φορτώνει τρία έλκυθρα που τα σέρνουν 28 σκυλιά. Οι δύο άντρες στερεώνουν δύο καγιάκ, καθώς και μερικά επιστημονικά όργανα, οπλίζονται με δύο τουφέκια και 180 φυσίγγια και εφοδιάζονται με τρόφιμα για 100 ημέρες, κυρίως αποξηραμένο κρέας και ψάρι. Έχουν επίσης ο καθένας μία σκηνή από μετάξι, έναν υπνόσακο, φοδραρισμένο με γούνα ταράνδου, και φορούν χονδρά μάλλινα ρούχα, και από πάνω ένα ειδικό ύφασμα που τους προστατεύει από το χιόνι. Η χαοτική παγωμένη έκταση αποπροσανατολίζει, η προς τα πρόσω πορεία είναι γεμάτη κινδύνους, και τελικώς τα αποτελέσματα της επιχείρησης είναι απογοητευτικά. Αγγίζοντας τις 86-14 μοίρες βόρειου γεωγραφικού πλάτους, το πιο βόρειο σημείο στο οποίο ποτέ είχε φτάσει άνθρωπος, ο Nansen εγκαταλείπει την προσπάθεια. Στις 8 Απριλίου 1895 ξεκινά το ταξίδι της επιστροφής. Στις 24 Αυγούστου το λιμάνι του Χάμμερφεστ στη Νορβηγία τον υποδέχεται ως ήρωα.

Στις αρχές του 20ού αιώνα, η ιδέα της κατάκτησης του Βόρειου Πόλου –κάτι ανάμεσα στο όραμα και την παραίσθηση– βρίσκεται σε όλα τα μυαλά, κι οι μυθικές 90 μοίρες γίνονται σε όλους έμμονη ιδέα. Αποφασισμένος «να αποκομίσει τη δόξα ενός Χριστοφόρου Κολόμβου», ο Robert Edwin Peary, μηχανικός του αμερικανικού Ναυτικού, μετά από επτά αποτυχημένες περιπετειώδεις απόπειρες, εμπλέκεται για μια ακόμα φορά, το 1908, στη μεγάλη περιπέτεια. Έχοντας για βάση το ακρωτήριο Κολούμπια, στην γη του Έλλεσμερ, όπου στρατοπέδευσε, ο Peary προετοίμασε μεθοδικά την τελική του εξόρμηση. Το σύνθημα της εκκίνησης δόθηκε την 1η Μαρτίου 1909. Φτάνοντας στο βόρειο γεωγραφικό πλάτος των 87-47 μοιρών, αποφασίζει να διασχίσει μόνος του τα περίπου 200 χιλιόμετρα που τον χωρίζουν ακόμη από τον στόχο του, μόνο με τη βοήθεια του πιστού μαύρου υπηρέτη του, Matthew

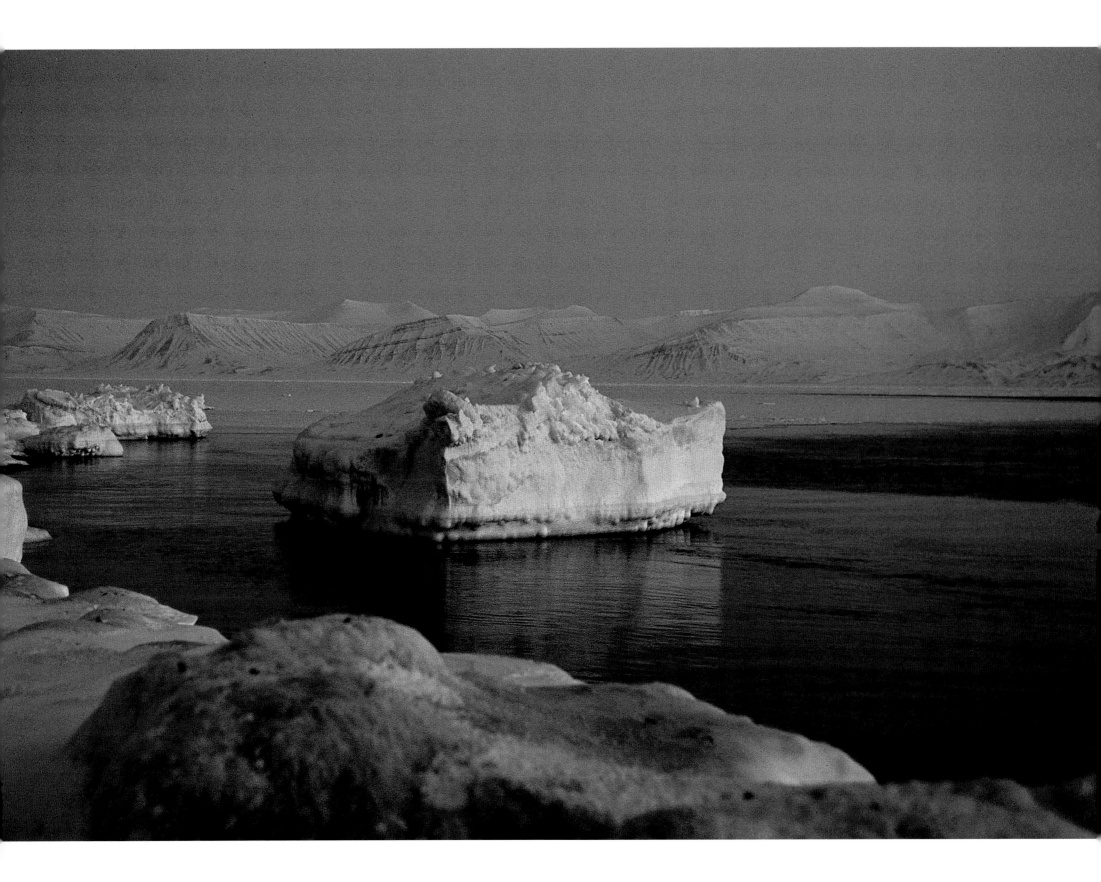

Henson, και με τη συνοδεία τεσσάρων Εσκιμώων. Στις 6 Απριλίου 1909, στις 10 το πρωί, ο Peary ζητωκραυγάζει για τη νίκη του, αφού, σύμφωνα με τα λεγόμενά του, «κάρφωσε την Αστερόεσσα στον Βόρειο Πόλο».

Η χαρά του όμως δεν επρόκειτο να κρατήσει πολύ. Διότι, επιστρέφοντας στο ακρωτήρι Κολούμπια, ο Peary δεν άργησε να πληροφορηθεί ότι ένας άλλος Αμερικανός, ο παλιός του φίλος γιατρός Frederick Cook, ισχυριζόταν ότι είχε επίσης φτάσει στον Βόρειο Πόλο, και μάλιστα έναν χρόνο νωρίτερα, στις 21 Απριλίου του 1908! Όπως ήταν αναμενόμενο, μία τρομερή διαμάχη, στην οποία αναμείχθηκε και ο Τύπος, χώρισε τους δύο άνδρες, που, ούτε ο ένας ούτε ο άλλος, μπορούσαν να προσκομίσουν μία χειροπιαστή απόδειξη για το κατόρθωμά τους. Μία επιτροπή ειδημόνων που διορίστηκε από τη διάσημη National Geographic Society της Ουάσιγκτον για να επιλύσει το ζήτημα, έκλινε τελικώς υπέρ του Peary, τον οποίο έκρινε «άξιο των υπάτων τιμών». Ωστόσο, σήμερα, ύστερα από περίπου έναν αιώνα, η νίκη αυτή αμφισβητείται. Νέες μελέτες, με την υποστήριξη οργάνων μέτρησης μεγάλης ακρίβειας, τείνουν να αποδείξουν ότι ήταν αδύνατο ο Peary να διέσχιζε «πήγαινε-έλα» την απόσταση μέσα στα δεδομένα χρονικά όρια.

Έκτοτε, ο Βόρειος Πόλος «κατακτήθηκε» πολλές φορές: το 1926 από τους Roald Amundsen, Lincoln Ellsworth, και Umberto Nobile μαζί με ένδεκα άλλους, πάνω στο ζέπελιν «Norge», που απογειώθηκε από το Σβάλμπαρντ, και προσγειώθηκε στην Αλάσκα, περνώντας (πάνω) από τον Πόλο στις 13 Μαΐου. Επίσης, το 1958, από το πυρηνικό αμερικανικό υποβρύχιο «Ναυτίλος», που έπλευσε κάτω από το στρώμα πάγου της Αρκτικής. Το 1968, από τον Αμερικανό Ralph Plaisted και τον Καναδό Jean Luc Bombardier, που προσέγγισαν τον Πόλο με μοτοσυκλέττα χιονιού. Στα τολμηρά αυτά κατορθώματα θα προστεθεί εκείνο του Ιάπωνα εξερευνητή Ναομί Βερμούρα, ο οποίος υπήρξε ο πρώτος που, το 1978, πέτυχε να προσεγγίσει, χωρίς άλλον μαζί του, τον Πόλο, με έλκηθρο, συρόμενο από σκυλιά. Επίσης, ένας ακόμα «κατακτητής» του Πόλου ήταν και ο Γάλλος Louis Etienne, που χρησιμοποίησε σκι. Όλα αυτά δείχνουν πως οι εσχατιές της γης εξακολουθούν να προκαλούν τον άνθρωπο και να κεντρίζουν τη φαντασία και το όνειρο.

▷ Φωτεινό φαινόμενο των βόρειων περιοχών, η άλως, μόρια πάγου αιωρούμενα μέσα στην ατμόσφαιρα, σχηματίζει ένα ουράνιο τόξο.

▷▷ Έρμαιοι στους ανέμους και τις θύελλες, συχνά φαινόμενα σ' αυτές τις ζώνες, οι τεράστιοι πάγοι της παγονησίδας του Βόρειου Πόλου αποκόβονται από αυτήν, συγκρούονται μεταξύ τους και δημιουργούν ελεύθερα περάσματα νερού, επάνω στα οποία επιπλέουν, και στην πορεία τους παράγονται «ορφανοί» πάγοι.

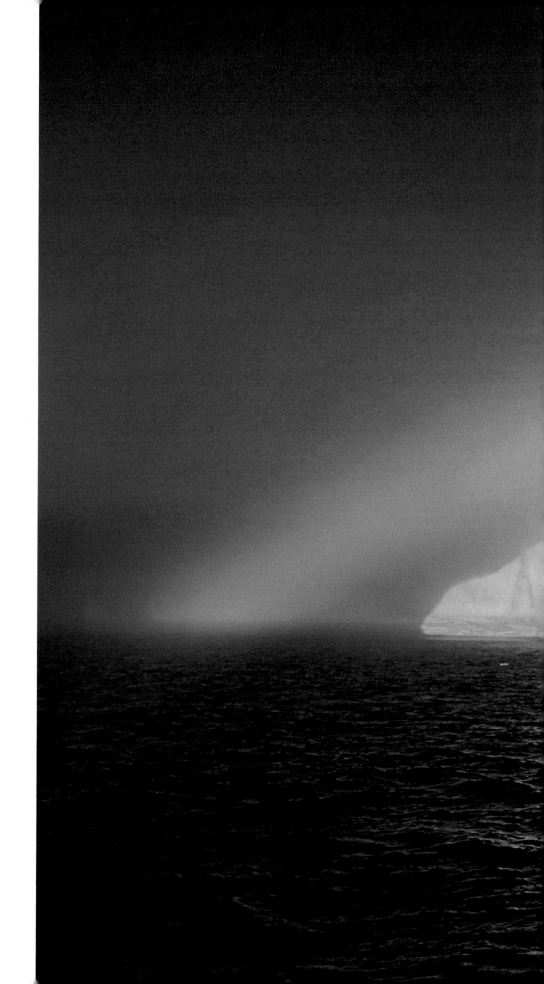

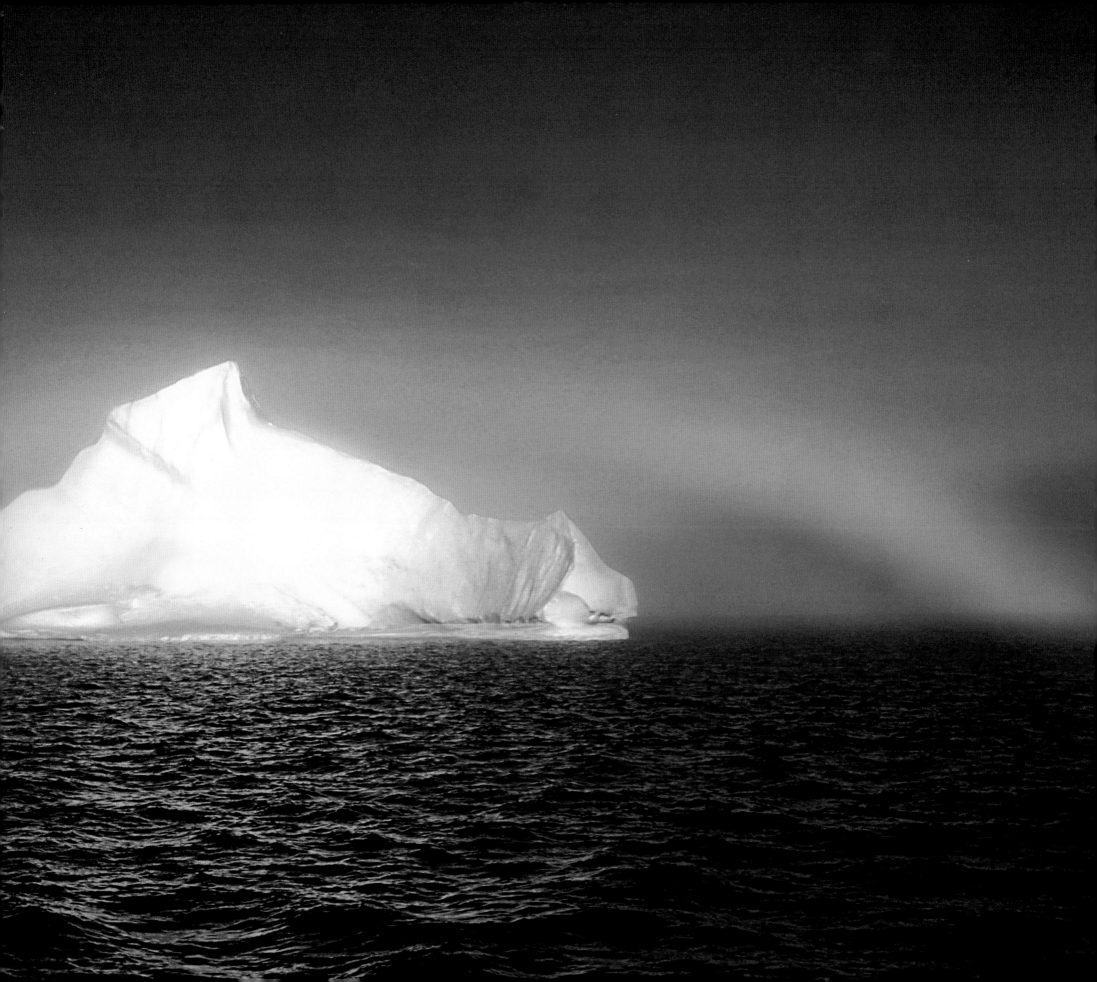

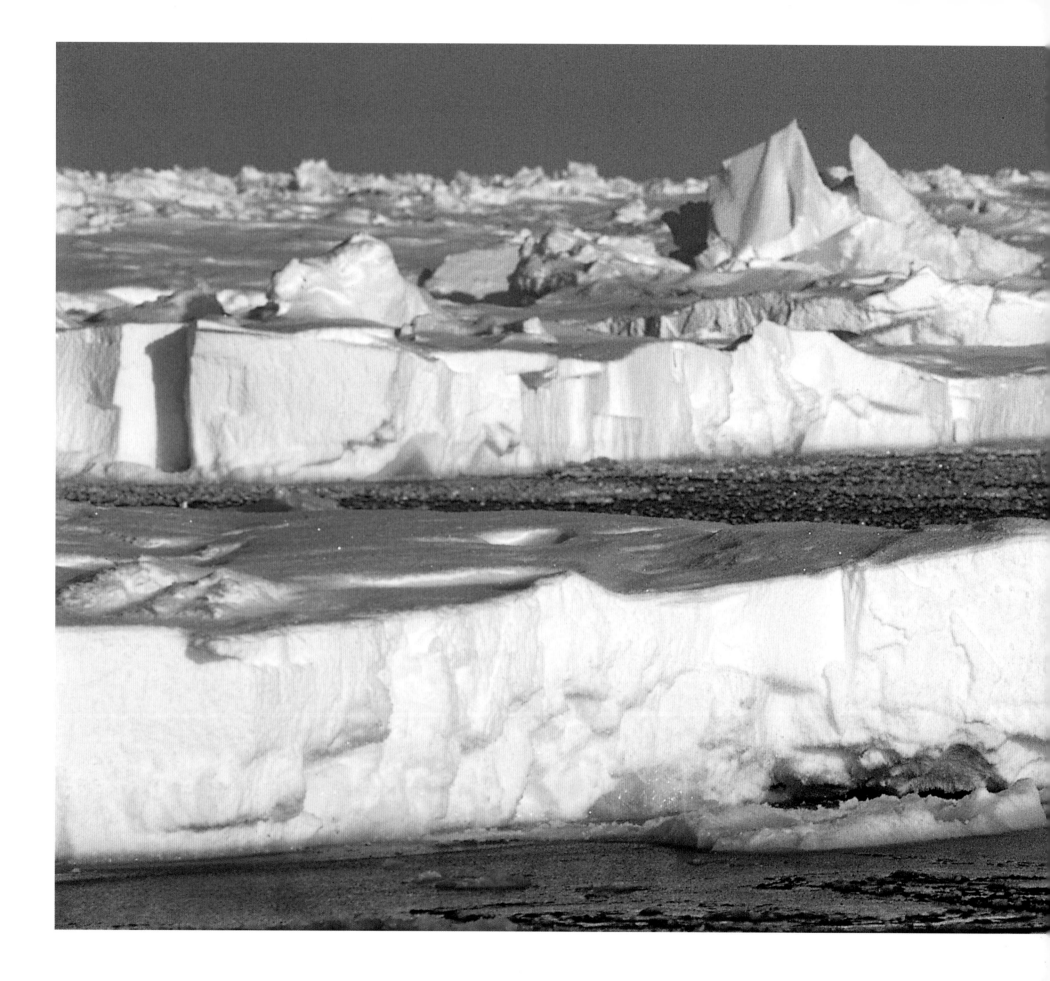

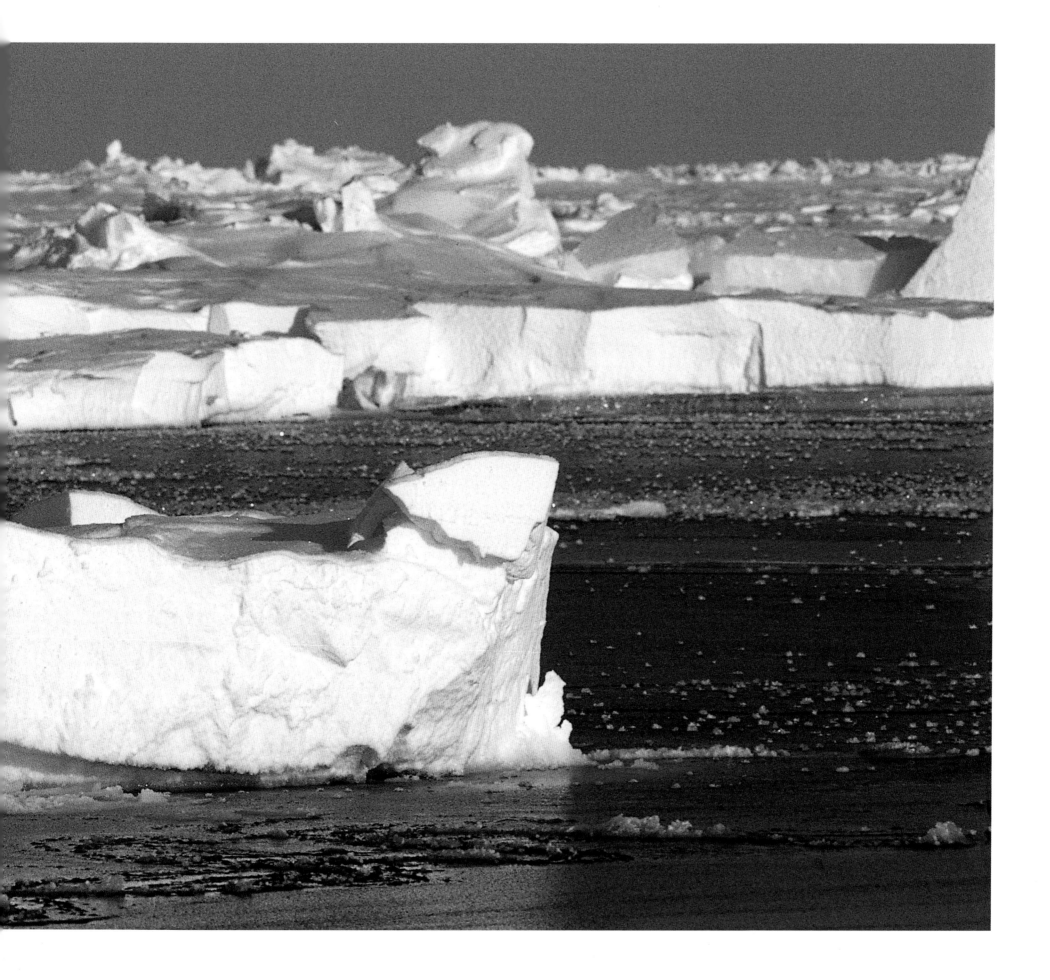

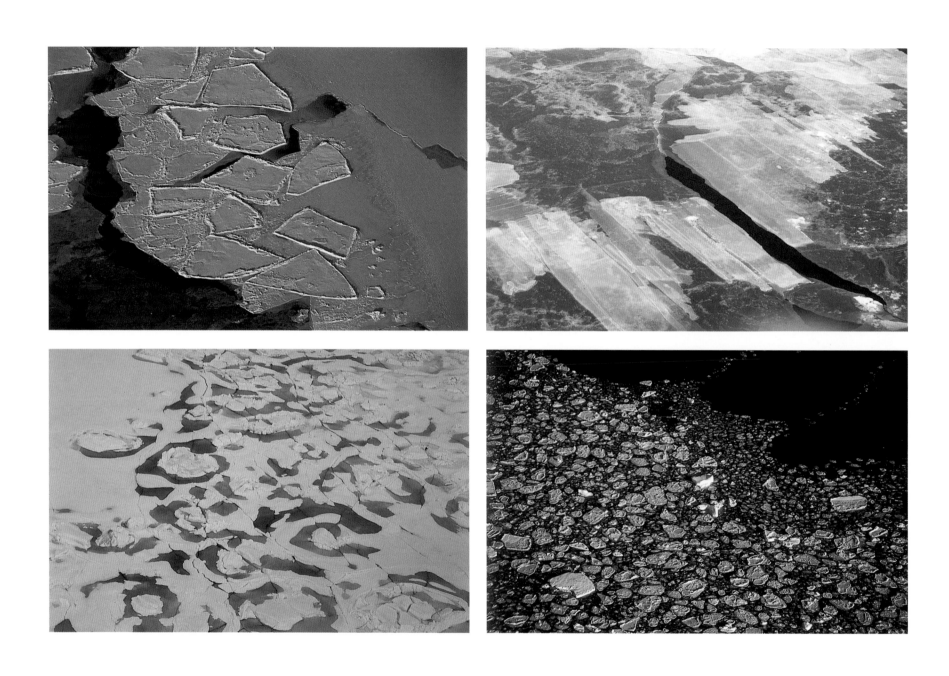

Έτσι όπως φαίνεται από ψηλά, η παγονησίδα της Αρκτικής μοιάζει να
«αραδιάζει» μια σειρά από τα πιο όμορφα έργα της, σχεδιασμένα από την
ασταμάτητη κίνηση του πολικού ρεύματος.

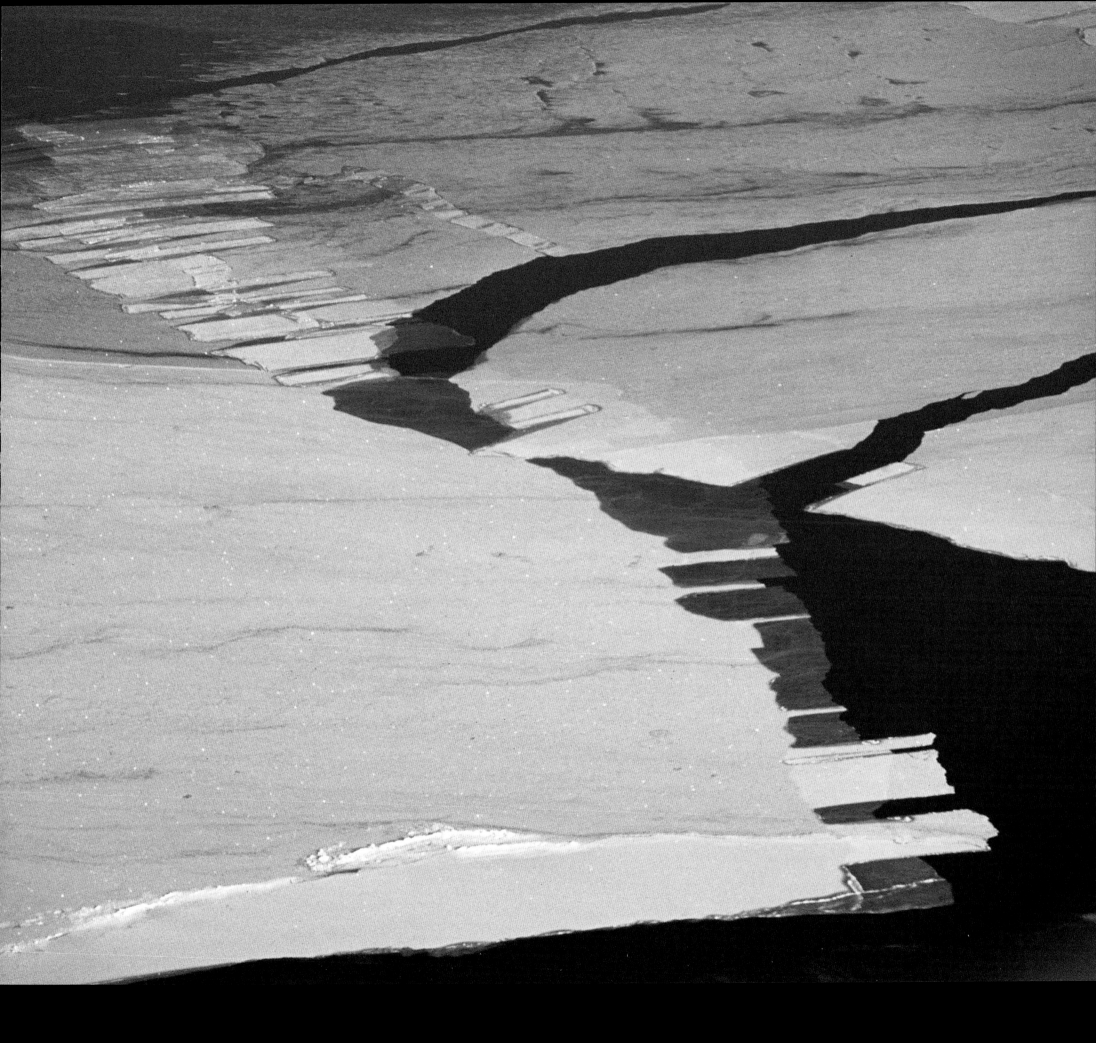

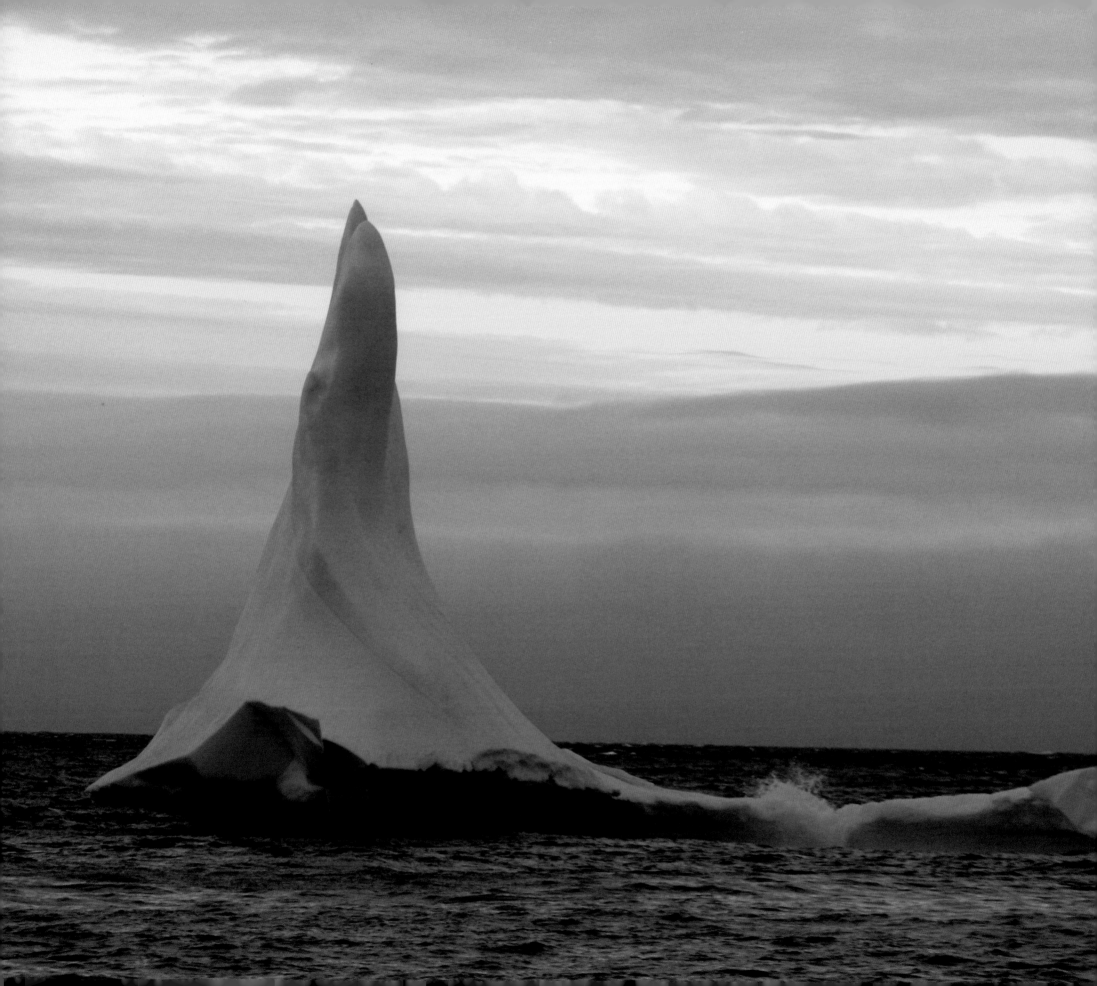

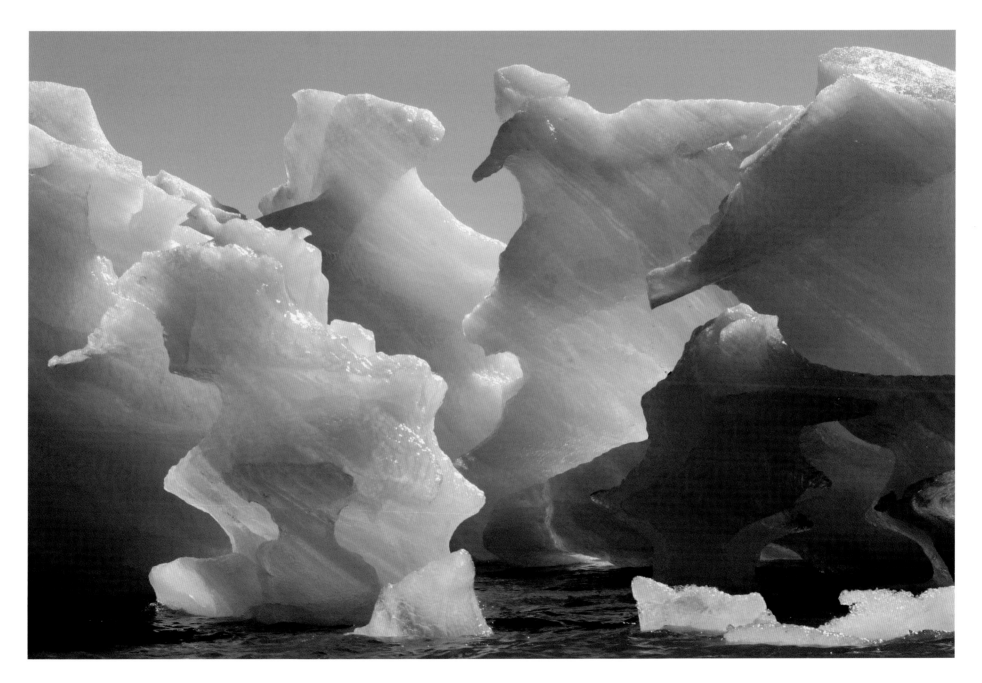

◁△ *Μεταμορφωμένοι από τον άνεμο και τα θαλάσσια ρεύματα σε αμέτρητες γλυπτές συνθέσεις, οι πάγοι παρασύρονται και πλέουν προς τα πιο θερμά γεωγραφικά πλάτη, όπου και θα εξαφανιστούν.*

▷▷ *Με το τέλος της πολικής νύχτας, εμφανίζονται οι πρώτες ακτίνες ενός χλωμού ήλιου, και ο πάγος της παγονησίδας λιώνει, σχεδιάζοντας λιμνούλες από γαλαζοπράσινο νερό.*

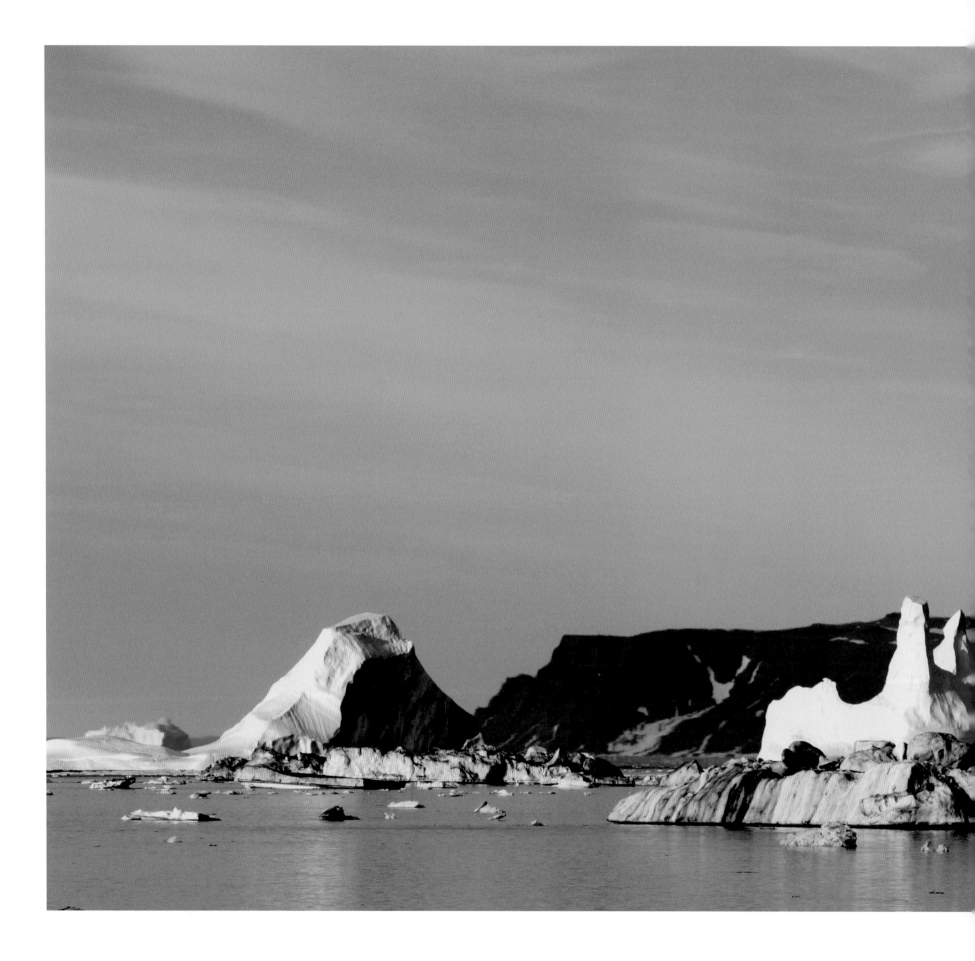

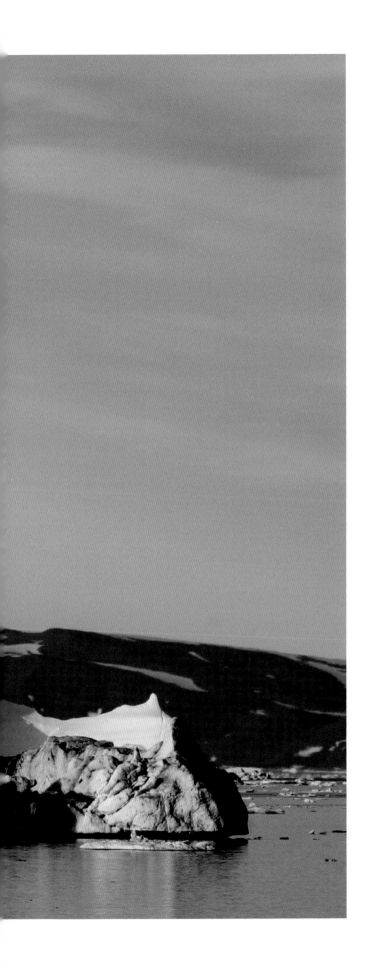

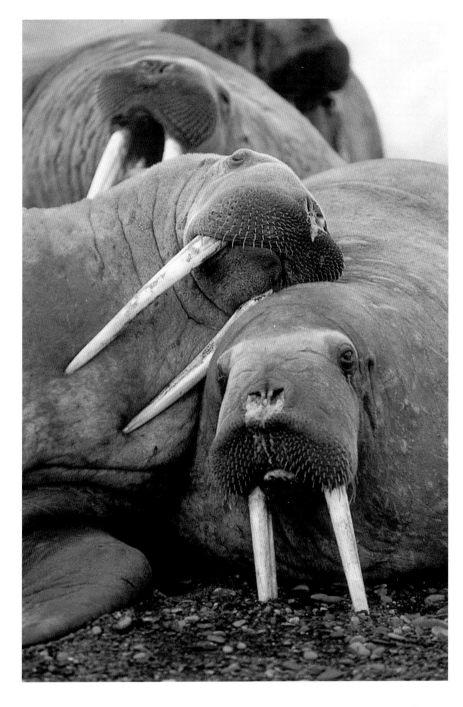

△ Οι θαλάσσιοι ελέφαντες, πτερυγιόποδα όπως οι φώκιες, τρέφονται κυρίως από οστρακοειδή και κογχύλια, σκάβοντας μέσα στα θαλάσσια αποθέματα με τους χαυλιόδοντές τους. Μετά τη βουτιά τους, τεμπελιάζουν στις ακρογιαλιές των νησιών της Αρκτικής.

◁ Στην ανατολική πλευρά της Γροιλανδίας, οι μεγάλοι όγκοι του πάγου, μερικοί από τους οποίους κινούνται πάνω από 20 μέτρα τη μέρα, μεταφέρουν και αποθέτουν αμέτρητα κομμάτια πάγου διαφόρων μεγεθών στα νερά του φιορδ του Scoresby Sund.

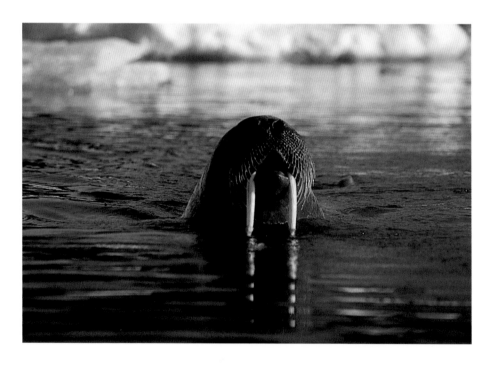

△ Ο θαλάσσιος ελέφαντας έχει προσαρμοστεί στις δύσκολες καιρικές συνθήκες της περιοχής χάρη στο παχύ στρώμα λίπους που καλύπτει το σώμα του και ένα ιδιαίτερο σύστημα κυκλοφορίας του αίματος. Έτσι, μπορεί να παραμένει κάτω από το νερό πάνω από 20 λεπτά για να βρίσκει την τροφή του.

▷ Αυτό το τεράστιο παγόβουνο –το τμήμα που βρίσκεται πάνω από το νερό αντιπροσωπεύει το ένα δέκατο του συνολικού του όγκου– θα μπορούσε να καλύψει με γλυκό νερό την ημερήσια κατανάλωση μιας χώρας όπως η Γαλλία.

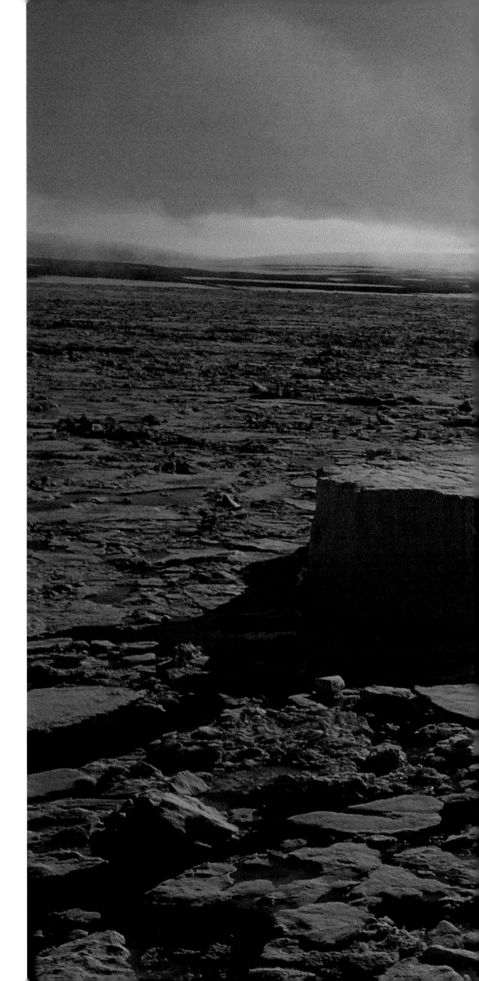

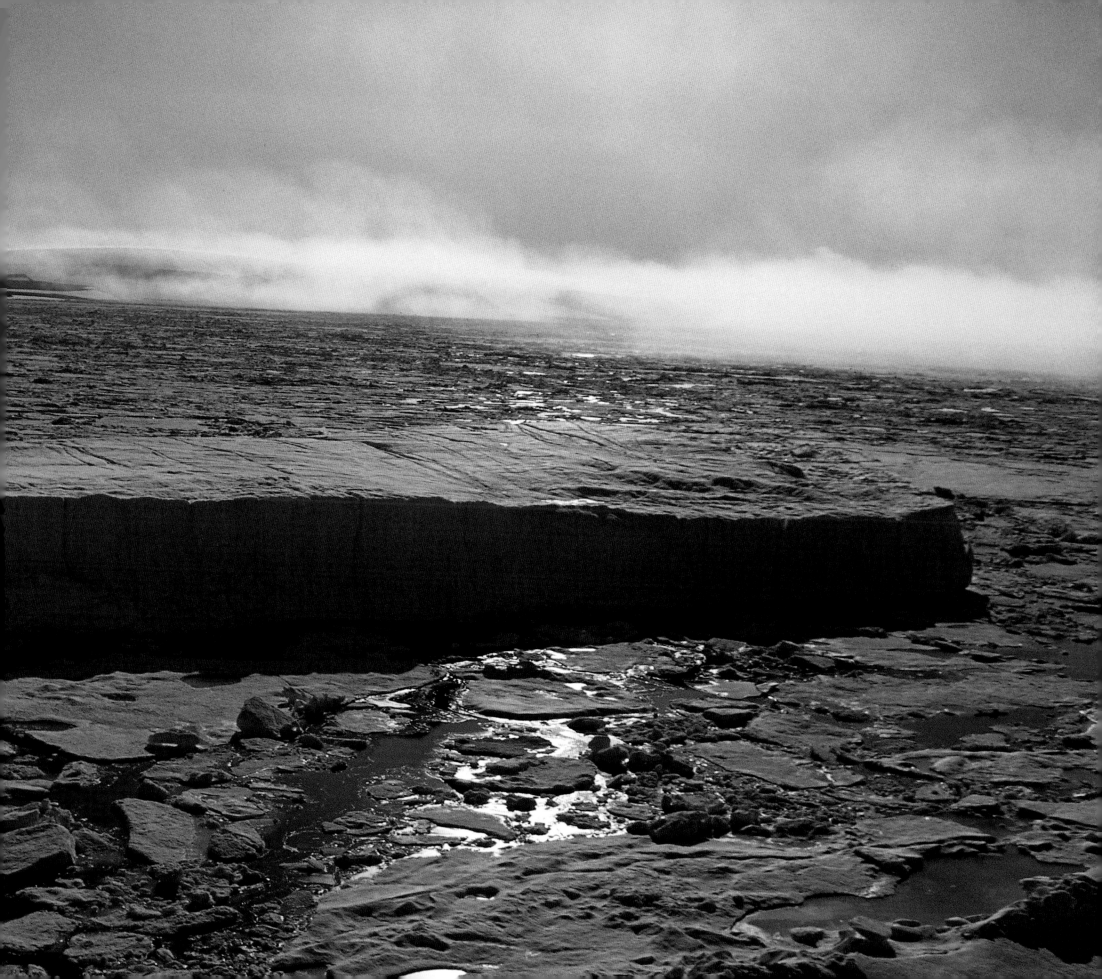

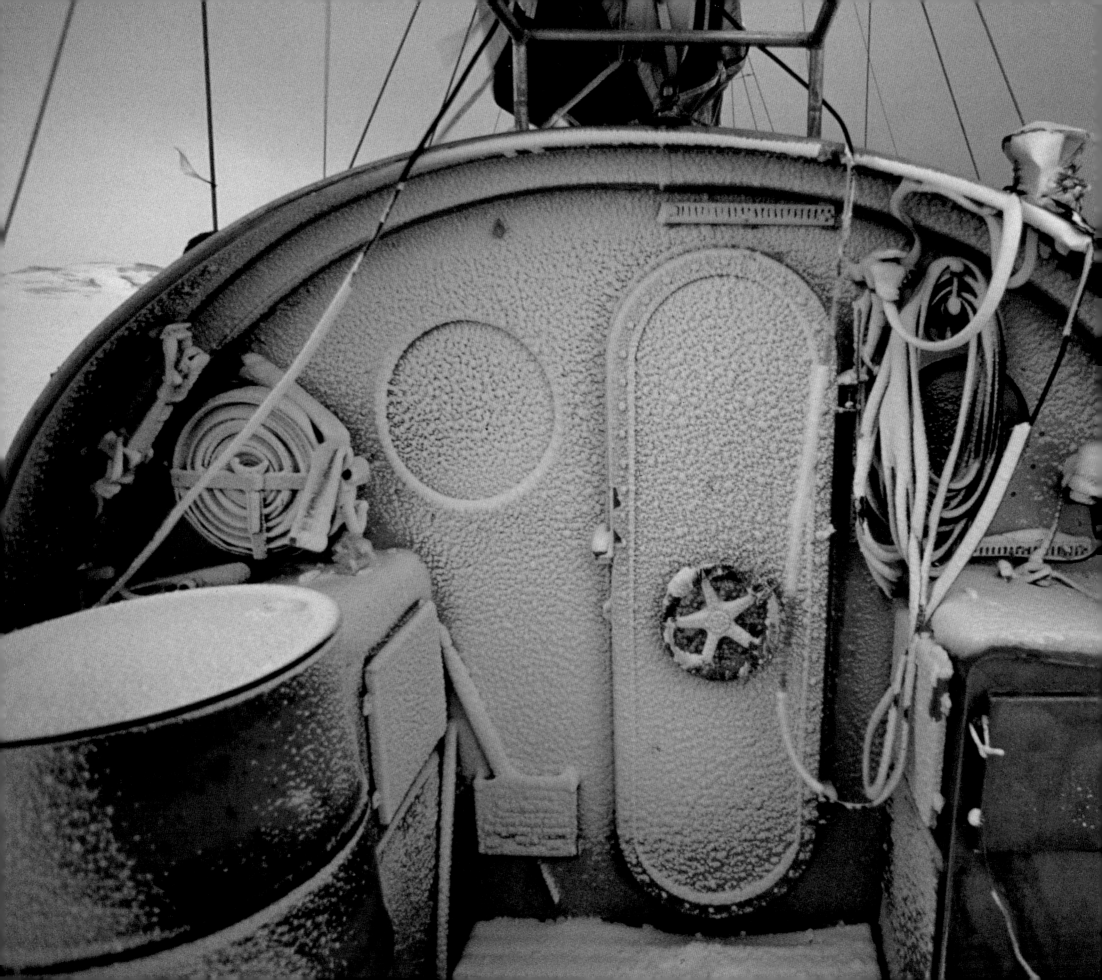

Αιχμάλωτο μέσα στους πάγους του Spitzberg, το πλοίο του γιατρού Jean-Louis Etienne υφίσταται τις συνέπειες από το σκληρό κλίμα: η πάχνη έχει κατακλύσει κάθε σπιθαμή του πλοίου και καλύπτει με λεπτό στρώμα πάγου κατάστρωμα και τοιχώματα του καραβιού.

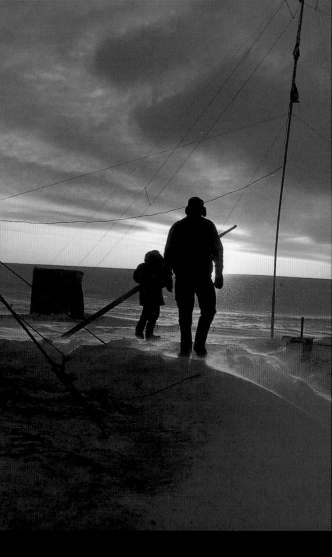

△ Στο Σιβηρικό Βόρειο Πόλο, ο καταυλισμός της ερευνητικής αποστολής «Mammuthus» ξυπνά κάτω από τον φθινοπωριάτικο αρκτικό ήλιο.

▷ Κατά τη διάρκεια της ατέλειωτης πολικής νύκτας, μόνο το φως της πανσελήνου φωτίζει τα κατάρτια του «Antarctica».

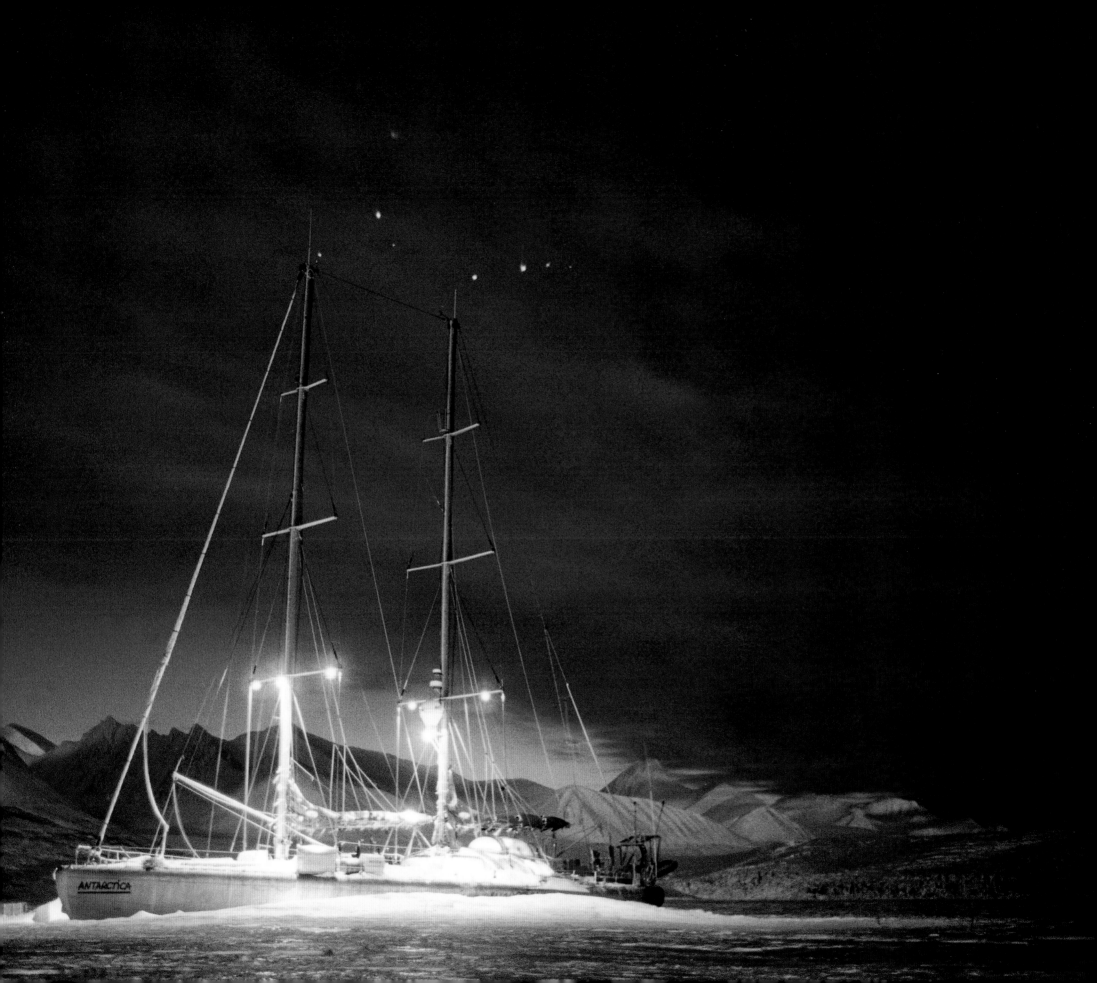

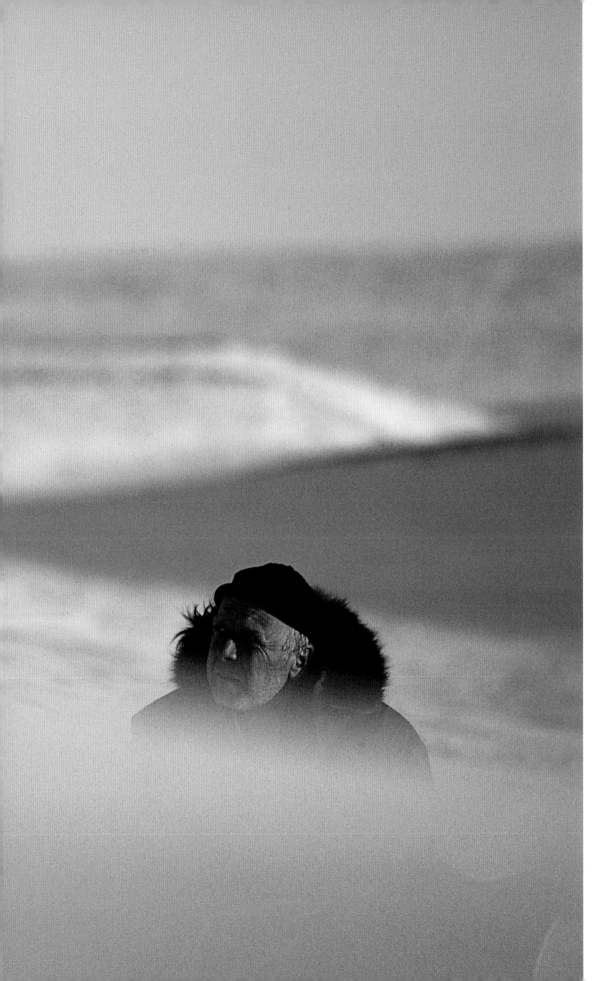

Οι ερευνητές αφουγκράζονται τους πάγους

Το κλίμα, έτσι όπως η μνήμη του διατηρείται ανέπαφη, φυλακισμένη μέσα στους πάγους, η προσπάθεια προσαρμογής των ανθρώπων και των ζώων στις πιο ακραίες συνθήκες, τα μετεωρολογικά φαινόμενα, όπως οι «καταβατικοί» άνεμοι και το βόρειο σέλας, ή πάλι, η εξαιρετικά σαγηνευτική ανακάλυψη ενός μαλλιαρού γερο-μαμούθ, που διατηρήθηκε επί 20.000 έτη μέσα στο *permafrost*, σαν μέσα σε κατάψυξη... Όλα αυτά υποδηλώνουν ότι η επιστήμη –που και στην Ανταρκτική επίσης είναι σε πλήρη δραστηριότητα– έχει άφθονα πεδία έρευνας στις περιοχές που γειτονεύουν με τον Βόρειο Πόλο. Φυσικοί, ειδικοί επιστήμονες του πάγου, ωκεανογράφοι, οικολόγοι, γιατροί, πανεπιστημιακοί και άλλοι ειδήμονες σκύβουν με αγωνία πάνω σε αυτά τα φαινόμενα, θορυβημένοι από τις συνέπειες της υπερθέρμανσης του πλανήτη, φαινόμενο που από τη μια πλευρά προσδίδει στις εργασίες τους κατεπείγοντα χαρακτήρα, ενώ παράλληλα δίνεται η δυνατότητα να συνεχιστεί η παράδοση των μεγάλων αποστολών στους Πόλους.

Επί κεφαλής πολλών αποστολών στην Ανταρκτική, αλλά και τον Βόρειο Πόλο, ο κυβερνήτης Jean Pierre Charcot, που πολύ νωρίς απέκτησε την προσωνυμία «ο ευπατρίδης των Πόλων», δείχνει τον δρόμο, ήδη από το 1908. Το διάσημο πλοίο του «Pourquoi pas?» («Γιατί όχι;») –όνομα φετίχ που δόθηκε διαδοχικά σε πολλά πλοία–, αφού χρησιμοποιήθηκε για κάποιο διάστημα ως εκπαιδευτικό σκάφος, πολλαπλασιάζει τις αποστολές στην Αρκτική, χαρτογραφώντας ακτές μήκους 2.000 χιλιομέτρων, συλλέγοντας απολιθώματα και καταγράφοντας τα είδη της τοπικής πανίδας και χλωρίδας... Τον Ιούλιο του 1934, ο Charcot αποβιβάζει στην ανατολική ακτή

Το 1998, στη Σιβηρία, στη χερσόνησο του Taïmyr, ο Γάλλος εξερευνητής Bernard Buigeues φέρνει στο φως τους δύο θαυμάσιους χαυλιόδοντες ενός μαμούθ «σε κατάψυξη» εδώ και χιλιάδες χρόνια μέσα στο permafrost –το έδαφος που παραμένει μόνιμα παγωμένο.

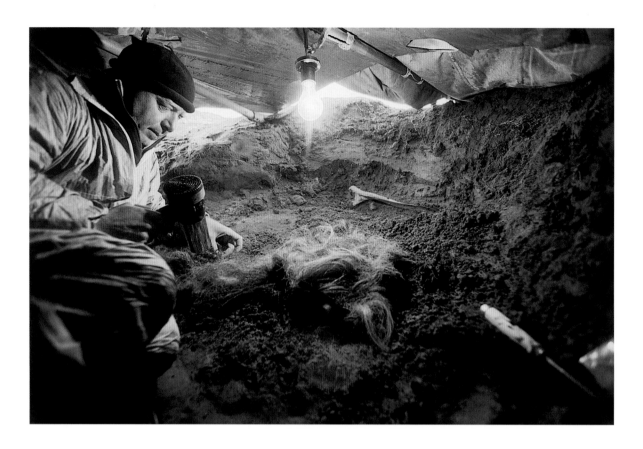

Στην πλάτη του μαμούθ « Jarkov », ο Bernard Buigues, εξοπλισμένος με ένα σεσουάρ, στεγνώνει την παγωμένη άμμο που προστατεύει το νεκρό –εδώ και περισσότερο από 20 χιλιάδες χρόνια– και εξαιρετικά καλά διατηρημένο ζώο. Η μυρωδιά του μαμούθ αναδύεται τότε από το δέρμα και τις μακριές τρίχες που ο παγετός είχε αιχμαλωτίσει εδώ και χιλιετίες.

της Γροιλανδίας τον νεαρό εξερευνητή και εθνολόγο Paul Émile Victor, ηλικίας 27 ετών, ο οποίος προσφέρεται να παραμείνει για έναν χρόνο κοντά στους Εσκιμώους της περιοχής Ammassalik, νομάδες κυνηγούς, για τους οποίους την εποχή εκείνη αγνοούσαμε σχεδόν τα πάντα. Δύο χρόνια αργότερα, τη νύχτα της 15ης προς τη 16η Σεπτεμβρίου 1936, το «Pourquoi pas?» με το πλήρωμά του βυθίστηκε στα ανοικτά της Ισλανδίας. Όσο για τον Paul Émile Victor, αυτός συνέχισε τις περιηγήσεις στα *inlandsis*, αποκαλύπτοντας στον κόσμο τον εκπληκτικό πολιτισμό των Inuits –μάρτυρες αυτού του πολιτισμού είναι τα 4.000 χρηστικά αντικείμενα που συνέλεξε, προορίζοντάς τα για το Μουσείο του Ανθρώπου στο Παρίσι–, προτού ιδρύσει, το 1947, τις διάσημες Γαλλικές Πολικές Αποστολές. Στο μεταξύ, στις 21 Μαΐου 1937, ένα αεροπλάνο είχε αποβιβάσει τον Ρώσο Ivan Dmitrievitch Papanine, μαζί με τρεις συντρόφους του, πάνω στην παγωμένη θάλασσα, προκειμένου να εγκαταστήσουν την πρώτη πλωτή επιστημονική βάση, που μετακινιόταν ανάλογα με τα ρεύματα που παρέσυραν τους πάγους. Έμειναν εκεί 274 ημέρες. Ο κόσμος ολόκληρος παρακολουθούσε, με κομμένη την ανάσα, την αφήγηση, μέρα τη μέρα, των κατορθωμάτων τους, καθώς μεταδίδονταν από το ραδιόφωνο.

Εβδομήντα περίπου χρόνια αργότερα, οι επιστημονικές αποστολές «Ecopolaris» αναβιώνουν το πνεύμα αυτών των πρωτοπόρων. Από το 1998, οι αποστολές αυτές,

καθοδηγούμενες από την Ομάδα Ερευνών στην Οικολογία της Αρκτικής (Groupe de Recherches en Écologie Artistique-GREA, υπό την αιγίδα του Olivier Gilg, ερευνητή στο Πανεπιστήμιο του Ελσίνκι, στη Φινλανδία) αξιολογούν, αποστολή με αποστολή, την επίδραση που έχουν οι κλιματικές μεταβολές στα είδη των ζώων και των φυτών του απώτατου Βορρά. Για τον λόγο αυτόν, μεταξύ Ιουνίου και Σεπτεμβρίου του 2004, η αποστολή «Ecopolaris Tara 5» κινητοποίησε μία διεπιστημονική ομάδα ερευνητών, απαρτιζόμενη από 12 φυσιοδίφες και άλλους Ευρωπαίους επιστήμονες, που επιβιβάστηκαν στο ιστιοφόρο «Τάρα», μήκους 36 μέτρων, κατασκευασμένο από αλουμίνιο, ειδικό για πλεύσεις στις αρκτικές θάλασσες. Επρόκειτο, υπό νέο όνομα, για το «Antarctica», το σκάφος που παλαιότερα ανήκε στον γιατρό και εξερευνητή Jean Louis Etienne. Ανάμεσα στους στόχους της αποστολής ήταν και η περισυλλογή μεγάλου αριθμού ειδών φυτών. Το κύριο, ωστόσο, μέρος του προγράμματος ήταν αφιερωμένο στα θαλασσοπούλια, στην καταμέτρηση των αποικιών τους και στην εξέταση των μεταλλικών ρυπογόνων, καθώς και στην επίδρασή τους στην αναπαραγωγή των πουλιών. Η έρευνα αυτή ανατέθηκε στον Γάλλο οικοτοξικολόγο Renaud Scheifler, του τμήματος της Περιβαλλοντικής Βιολογίας του πανεπιστημίου Franche-Comté. Αυτός ανέλαβε να περισυλλέξει πληθώρα φτερών πουλιών, καθώς και κελύφη από τα αβγά τους –τα οποία κατόπιν θα εξετάζονταν

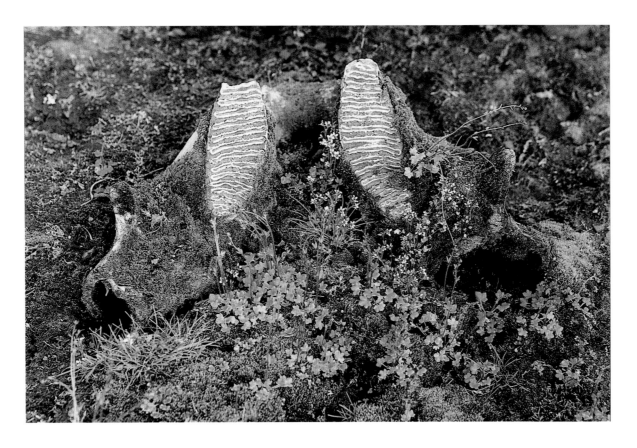

στα πανεπιστημιακά εργαστήρια– και να σημειώσει μεθοδικά πόσα αβγά επωάζονται σε κάθε φωλιά. Του ζητήθηκε τέλος να κάνει αιμοληψίες σε νεοσσούς.

Οι φυσιολόγοι του GREA διαπίστωσαν ότι πολλά είδη ζώων και φυτών, που μέχρι τότε ήταν είτε ανύπαρκτα εκεί, είτε εξαιρετικά σπάνια, πολλαπλασιάζονταν τελευταία εντυπωσιακά, φαινόμενο που αποδεικνύει ότι οι κλιματικές μεταβολές επηρεάζουν ήδη την Αρκτική. Για παράδειγμα, ο γκοελάνδος, το μεγάλο θαλασσοπούλι, που κατά κανόνα ζούσε νοτιότερα, τώρα φωλιάζει στη Γροιλανδία. Ο χρυσόπτερος χαραδριός, ο αγριόκυκνος και η σταχτιά χήνα σύντομα θα κάνουν το ίδιο. Επίσης, ο σεληνιακός βοτρύτης (Botrytis lunaire), ένα είδος πρωτόγονης φτέρης, φυτρώνει τώρα 100 χιλιόμετρα βορειότερα, ενώ εμφανίζονται άγνωστα μέχρι τώρα είδη φυτών. Τέλος, η συρρίκνωση του μόνιμου επιθαλάσσιου στρώματος πάγου γίνεται αισθητή. Και αν ακόμη η τήξη των πάγων αυτών ανοίξει νέες θαλάσσιες οδούς ανάμεσα στον Ατλαντικό και τον Ειρηνικό ωκεανό, συντομεύοντας σημαντικά τη διαδρομή προς την Άπω Ανατολή, καταδικάζει όμως σε αφανισμό ορισμένα είδη ζώων, όπως είναι η πολική αρκούδα. Εξάλλου, σε περίπτωση που το παγωμένο στρώμα που καλύπτει τον Αρκτικό ωκεανό έλιωνε τελείως κατά το θέρος, η στάθμη της θάλασσας θα υψωνόταν περισσότερο από ένα μέτρο. Και αν επί πλέον έλιωνε το κάλυμμα πάγου που καλύπτει τη Γροιλανδία, τότε η στάθμη των ωκεανών θα

ανέβαινε τουλάχιστον επτά μέτρα, κάτι που για πολλές χώρες θα αποτελούσε σοβαρή απειλή. Επιστήμονες άλλων ειδικοτήτων ανησυχούν ιδιαίτερα μήπως μία ενδεχόμενη τήξη του *permafrost*, θα είχε ως συνέπεια, μεταξύ άλλων, την καταστροφή των θησαυρών που, κατεψυγμένοι, σώζονται μέσα του εδώ και χιλιετίες, όπως, για παράδειγμα, οι σκελετοί των μαλλιαρών μαμούθ, που ανακαλύφθηκαν στη Σιβηρία, καθώς και στη ρωσική δημοκρατία της Yakoutie. Αυτά τα ευρήματα συγκαταλέγονται ανάμεσα στα πιο εκπληκτικά που ανακαλύφθηκαν τα τελευταία χρόνια από την επιστημονική έρευνα στο περιβάλλον των Πόλων.

Όλα ξεκίνησαν τον Δεκέμβριο του 1997, στη ρωσική χερσόνησο του Taïmyr, όταν ο αρχηγός της αποστολής, ο Γάλλος Bernard Buigues, «σκόνταψε» πάνω σε ένα απομεινάρι σκελετού, το οποίο εξείχε από το παγωμένο έδαφος της τούντρας. Πρώτο στοιχείο ενός γιγαντιαίου «παζλ», το τεράστιο αυτό οστό προέρχεται από ένα μαμούθ, ζώο-σύμβολο της προϊστορίας. Λίγους μήνες αργότερα, μια οικογένεια κυνηγών της φυλής των Δολγάνων αποκάλυπταν στον Γάλλο ερευνητή μία τοποθεσία που έκρυβε ένα ζευγάρι χαυλιόδοντες, μήκους τριών μέτρων.

Τον Σεπτέμβριο του 1999, η αποστολή «Mammuthus», ένα πρόγραμμα διεθνές, στο οποίο συμμετείχε ο Γάλλος ειδήμων σε θέματα εξελίξεως των ειδών Yves Coppens, εγκατέστησε τη βάση του στο μέσο της τούντρας, 280 χιλιόμετρα από την Khatanga, τον

Το 2000, υπό τη διεύθυνση του Ολλανδού παλαιοντολόγου Dick Mol, οι ερευνητές βρήκαν μέσα στις τρίχες του « Jarkov » ένα σωρό σωματίδια κάθε είδους, όπως αγρωστοειδή, γύρεις, έντομα και διάφορα άλλα ίχνη, όλα μάρτυρες μιας εποχής εξαφανισμένης.

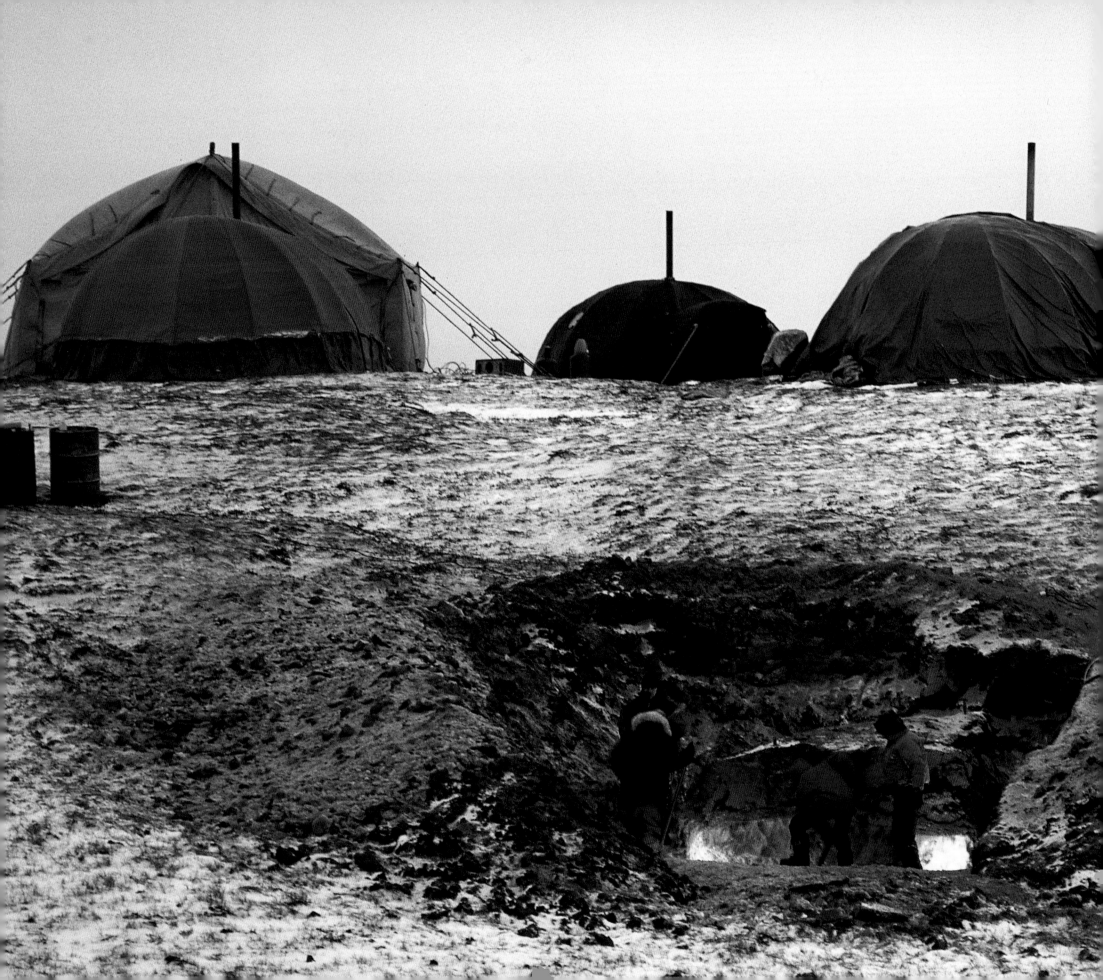

σημαντικότερο οικισμό της περιοχής, με πληθυσμό 3.500 κατοίκων. Επί πέντε εβδομάδες, τα μέλη της αποστολής σπάζουν με τρυπάνι το παγωμένο έδαφος, μέσα σε αντίξοες καιρικές συνθήκες, ενώ σφοδρός άνεμος σαρώνει τα πάντα και η θερμοκρασία αγγίζει τους 40 βαθμούς υπό το μηδέν. Ώσπου, επί τέλους, στις 17 Οκτωβρίου 1999, κάτω από τον χλωμό ήλιο του πολικού φθινοπώρου, το «Zarkov», απεγκλωβίστηκε από τον επί χιλιετίες τάφο του, με τη βοήθεια ενός ρωσικού ελικοπτέρου, τύπου MI-26, του μεγαλύτερου αεροσκάφους της πολιτικής αεροπορίας εκείνης της εποχής. Το μαμούθ, φυλακισμένο μέσα σε ένα περίβλημα από πάγο, βάρους 20 τόνων, αποσπάστηκε από το έδαφος. Το ίδιο το παχύδερμο ζύγιζε τρεις τόνους. Σύμφωνα με τα αποτελέσματα της μεθόδου του άνθρακα 14, το μαμούθ φαίνεται να είχε πεθάνει, σε καλή κατάσταση υγείας, σε ηλικία 47 ετών, πριν από 20.380 χρόνια. Ο «Zarkov» μεταφέρθηκε από αέρος μέχρι τη Khatanga, όπου φυλάσσεται από τότε, μέσα σε ένα υπόγειο εργαστήριο, σε θερμοκρασία 15 βαθμών κάτω του μηδενός. Κτήμα πλέον της επιστήμης, θα επιτρέψει να εξιχνιαστούν οι αιτίες που προκάλεσαν την εξάλειψη του είδους του, αιτίες που παραμένουν ακόμη αβέβαιες.

Πριν απ' αυτόν, και άλλα μαμούθ είχαν ξεθαφτεί από τη σιβηρική τούντρα. Ένα, για παράδειγμα, το 1901, στην Berezovska, στα βορειοανατολικά τής κυρίως Ρωσίας, καθώς και ένα το 1948 και το 1978. Όμως ο «Zarkov» είναι το πρώτο δείγμα μαμούθ που διατηρείται σε τόσο καλή κατάσταση. Ένας άλλος σκελετός είναι εκείνος του Fishhook, που ανακαλύφθηκε επίσης το 2001, καθιστώντας τη χερσόνησο του Taïmyr διάσημο νεκροταφείο μαλλιαρών μαμούθ, ή επιστημονικότερα «Mammuthus primigenius». Έκτοτε, τα θηλαστικά αυτά, που ανήκουν σε μία άλλη εποχή, αρχίζουν να αποκαλύπτουν σιγά σιγά τα μυστικά τους. Αντίθετα εξάλλου προς τις υπάρχουσες προκαταλήψεις, ο «Zarkov» θα πρέπει να έζησε σε ένα περιβάλλον στέππας που σε τίποτε δεν μοιάζει με τη σημερινή τούντρα, και η εξαφάνισή του, όπως και ολόκληρου του είδους του, θα μπορούσε κυρίως να αποδοθεί στη μεταβολή των κλιματικών συνθηκών. Τα πρώτα αποτελέσματα της έρευνας υπόσχονται πολλά προς αυτήν την κατεύθυνση. Και μολονότι οι ερευνητές δεν σπεύδουν ακόμη να δώσουν την οριστική εξήγηση, η παραπάνω εξήγηση φαίνεται μέχρι στιγμής ως η πιο πιθανή.

Κατά συνέπεια, ίσως θα έπρεπε, ακολουθώντας το παράδειγμα του Monsieur de La Fontaine, να βγάλουμε κι εμείς ένα ηθικό δίδαγμα από όλα αυτά. Μήπως δηλαδή η υπερθέρμανση του πλανήτη οφείλεται στο ότι οι κοινωνίες μας «έχουν χάσει τον βορρά τους» (το λογοπαίγνιο στα γαλλικά σημαίνει: «έχουν χάσει τον προσανατολισμό τους»...).

Στην τοποθεσία Bolchoï Balarnaya, στη βόρεια Σιβηρία, ήρθε στο φως το μαμούθ «Jarkov», ύστερα από μια μεγάλη νύχτα 20.387 χρόνων μέσα στο σάβανό του από πάγο.

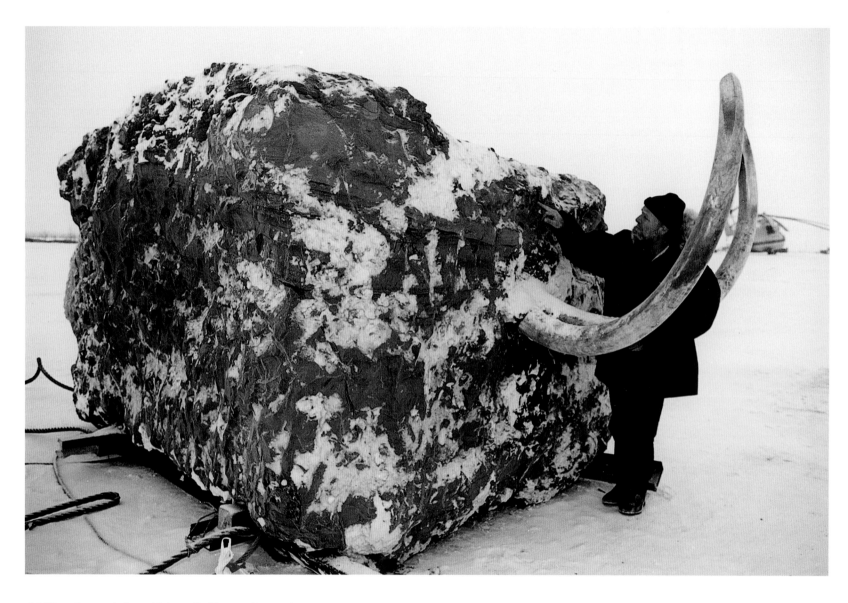

Ο Γάλλος εξερευνητής Bernard Buigues εξετάζει το μεγάλο κομμάτι
της παγωμένης γης που περιέχει τα υπολείμματα του « Jarkov ».

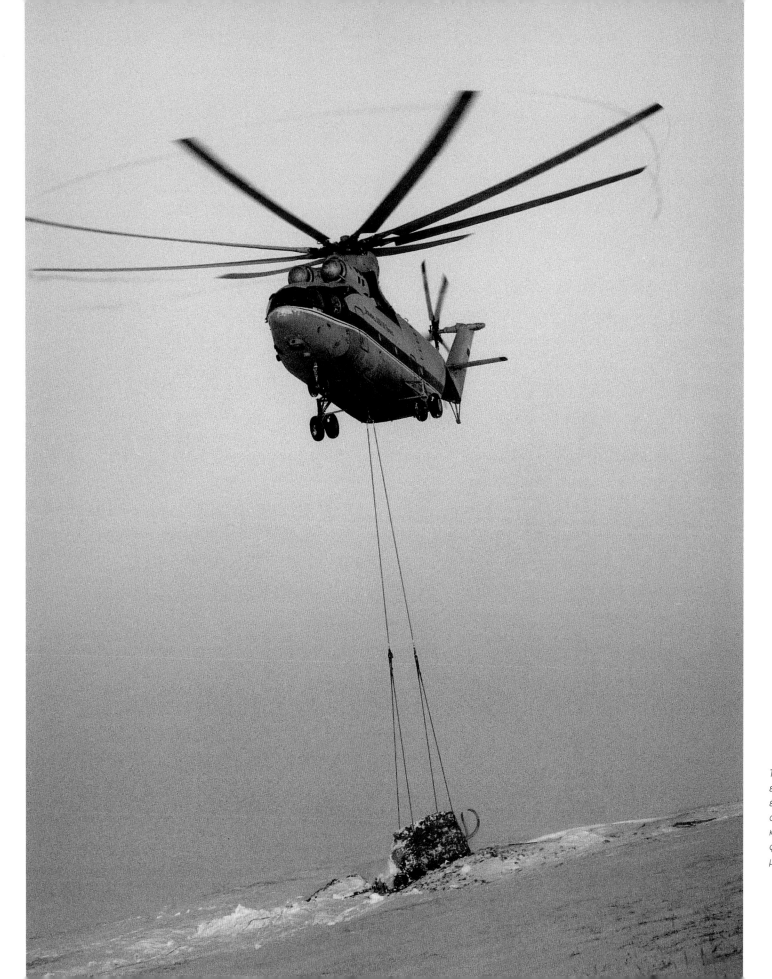

Το πιο μεγάλο πολιτικό ελικόπτερο του κόσμου, ένα ρωσικό MI-26, ξεριζώνει από την τούντρα το πελώριο κομμάτι παγωμένης γης, φέρετρο 20 τόνων του μαμούθ «Jarkov».

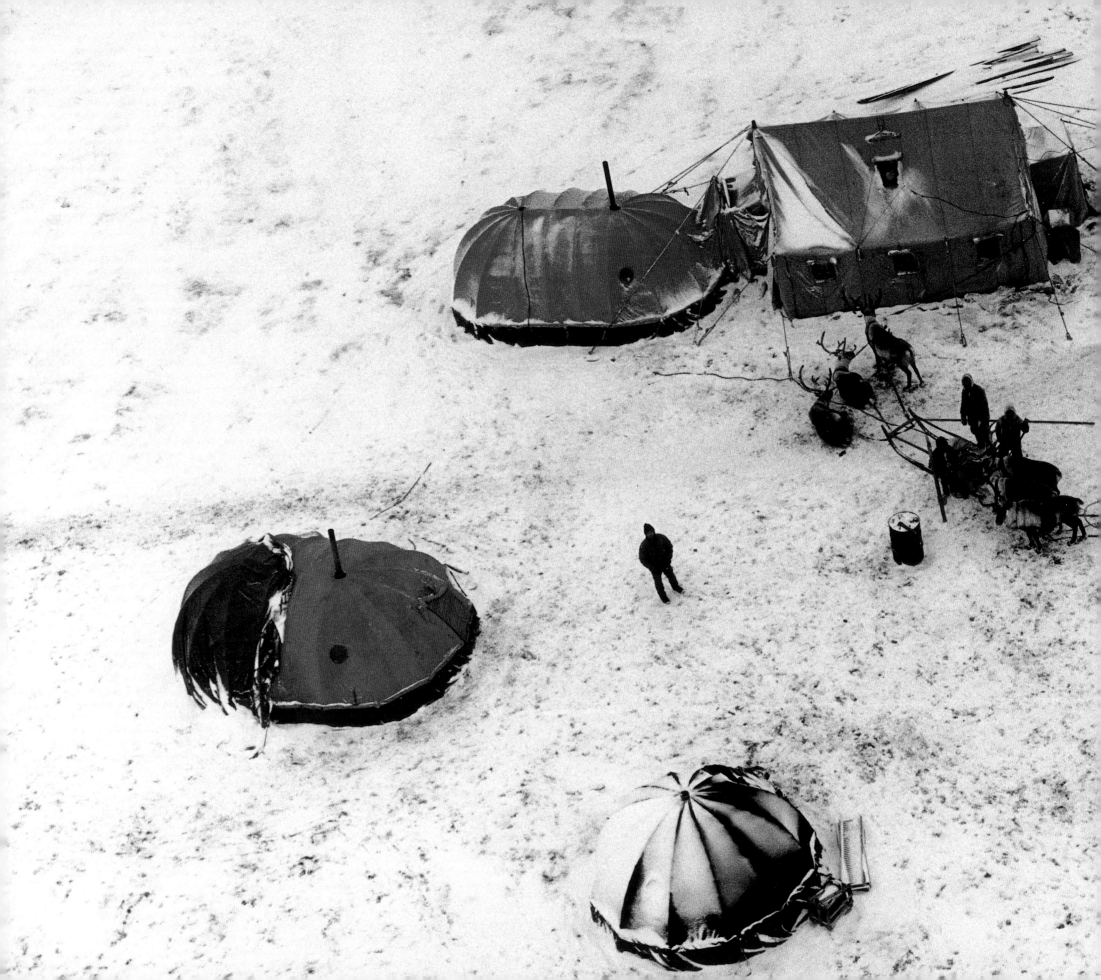

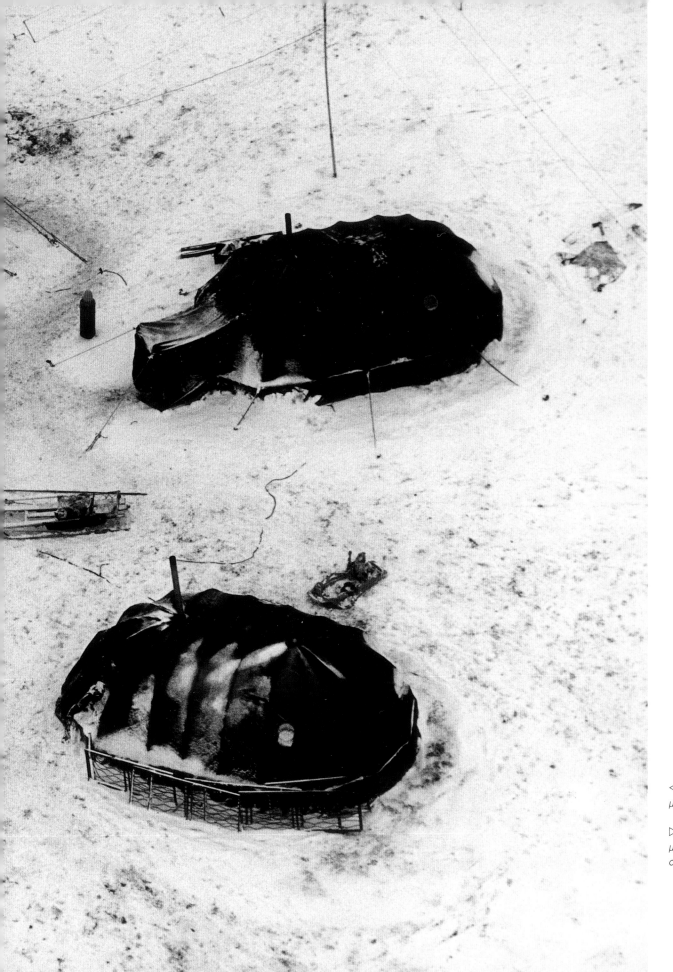

◁ Αεροφωτογραφία του καταυλισμού Bolchoï Balarnaya, ο οποίος, για αρκετούς μήνες (1998-1999), στέγασε τα μέλη της εξερευνητικής αποστολής «Mammuthus».

▷▷ Στο αεροδρόμιο Khatanga, ρυμουλκήθηκε από τα μέλη της αποστολής το μεγάλο κομμάτι που περιείχε τα υπολείμματα του προϊστορικού μαμούθ, για να οδηγηθεί σε ένα υπόγειο μέσα στην παγωμένη γη.

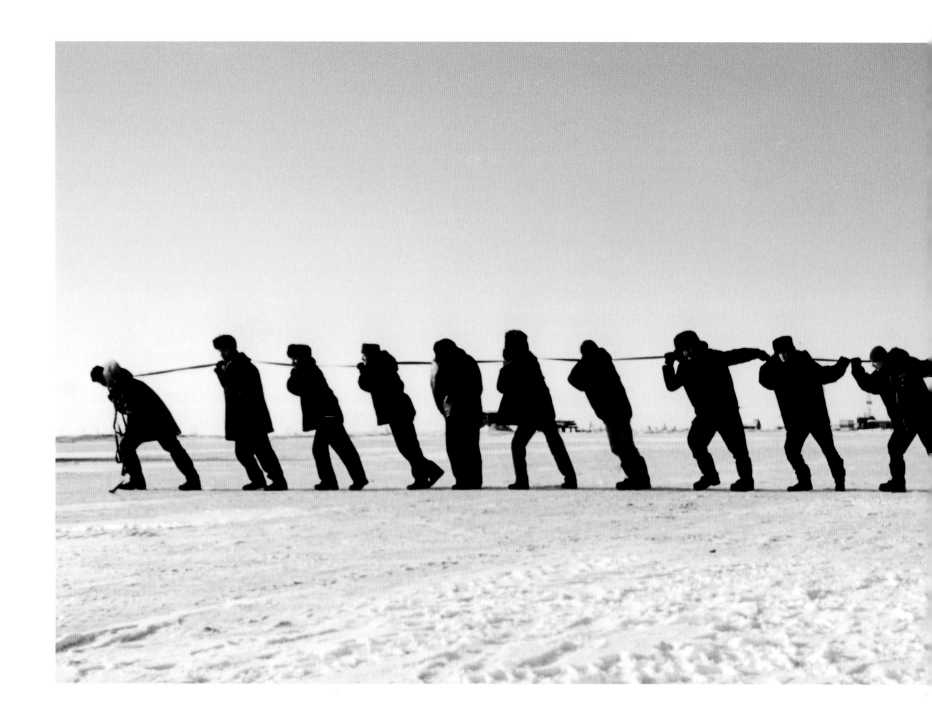

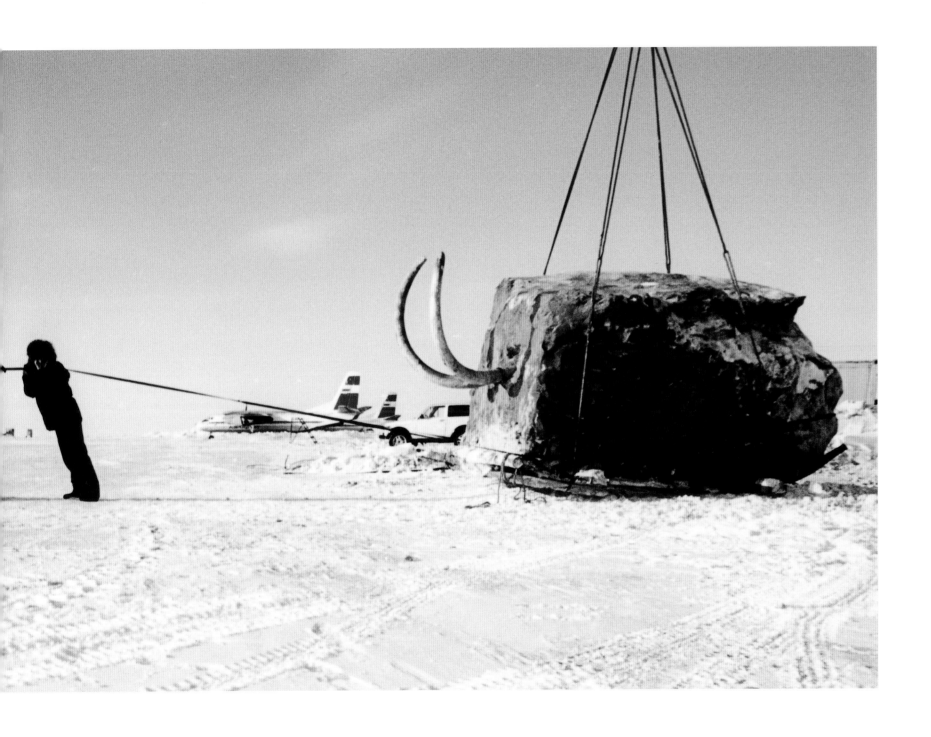

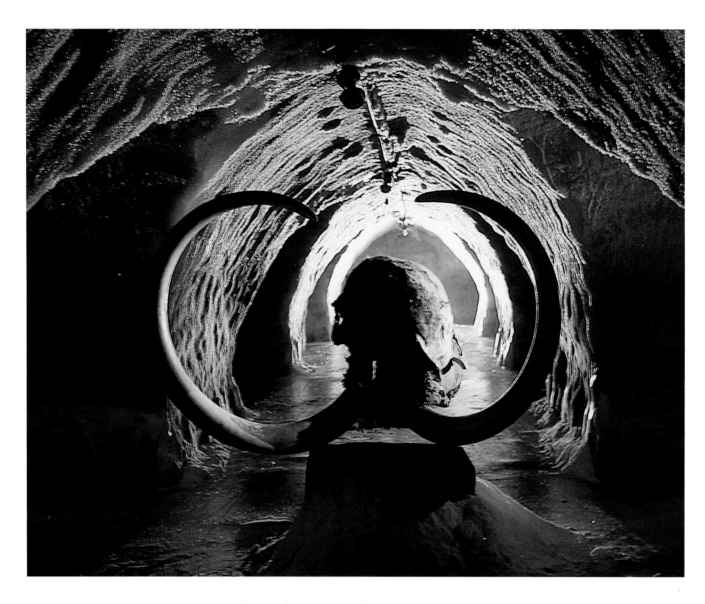

Για να μη διασπαστεί η «αλυσίδα» του ψύχους, το κεφάλι
του μαμούθ « Yukagir » διατηρήθηκε και τέθηκε στη διάθεση
της διεθνούς επιστημονικής κοινότητας σε μια αποθήκη-
εργαστήριο μέσα στην παγωμένη γη του Yakoutie.

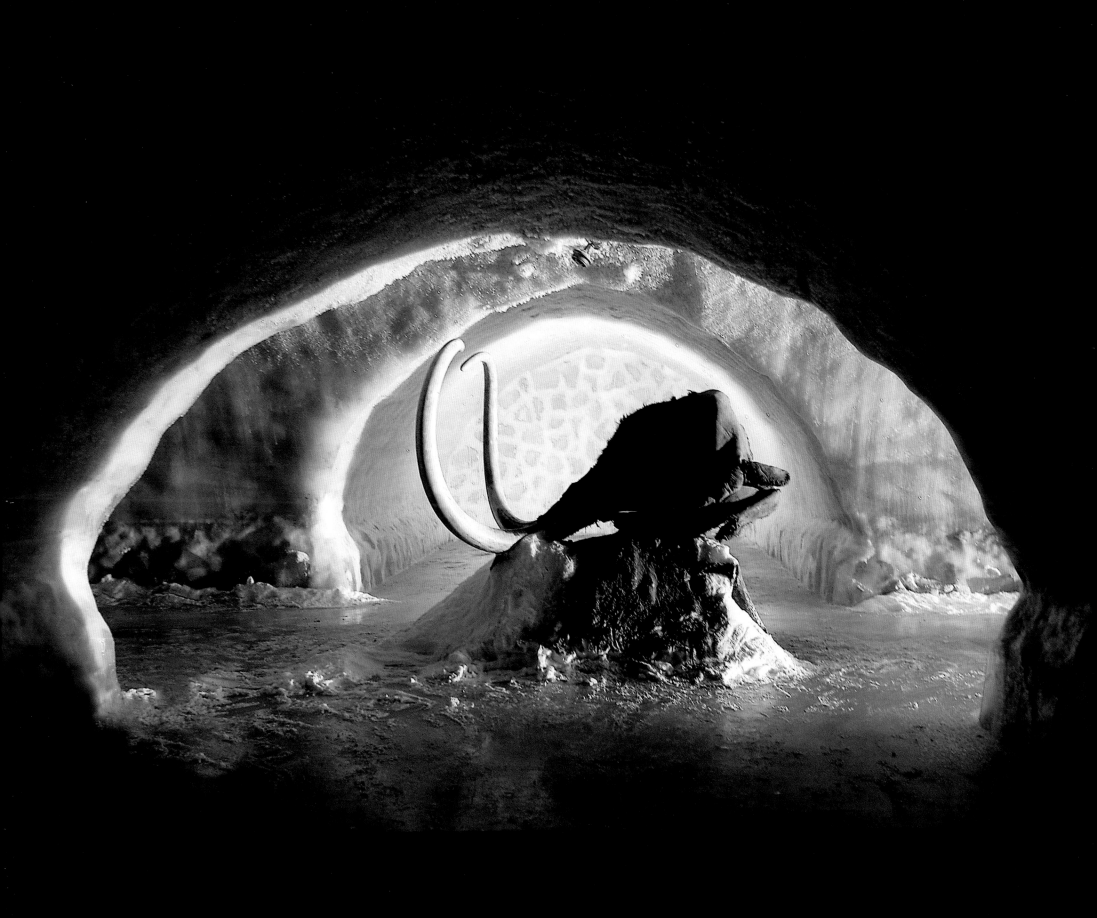

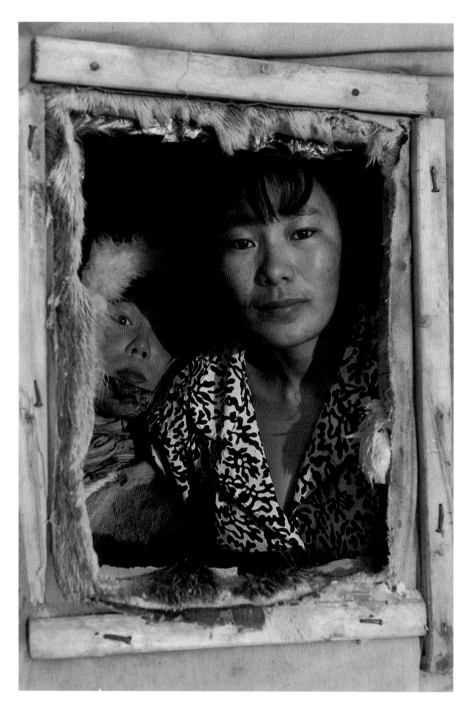

△ Η Όλγα, από τη νομαδική εθνότητα των Δολγάνων, και ο γιος της Kostia, στο παράθυρο του balok, του μικρού σπιτιού που έχουν συναρμολογήσει επάνω σε έλκηθρο.

▷ Στη χερσόνησο του Taïmyr, στα βόρεια της Σιβηρίας, οι Δολγάνοι νομάδες μετακινούνται στο βουνό, μαζί με τα ζώα και τα σπίτια τους, αναζητώντας καινούργια βοσκοτόπια. Τα σπίτια-έλκηθρα, τα baloks, σύρονται από ταράνδους στις απέραντες χιονισμένες εκτάσεις.

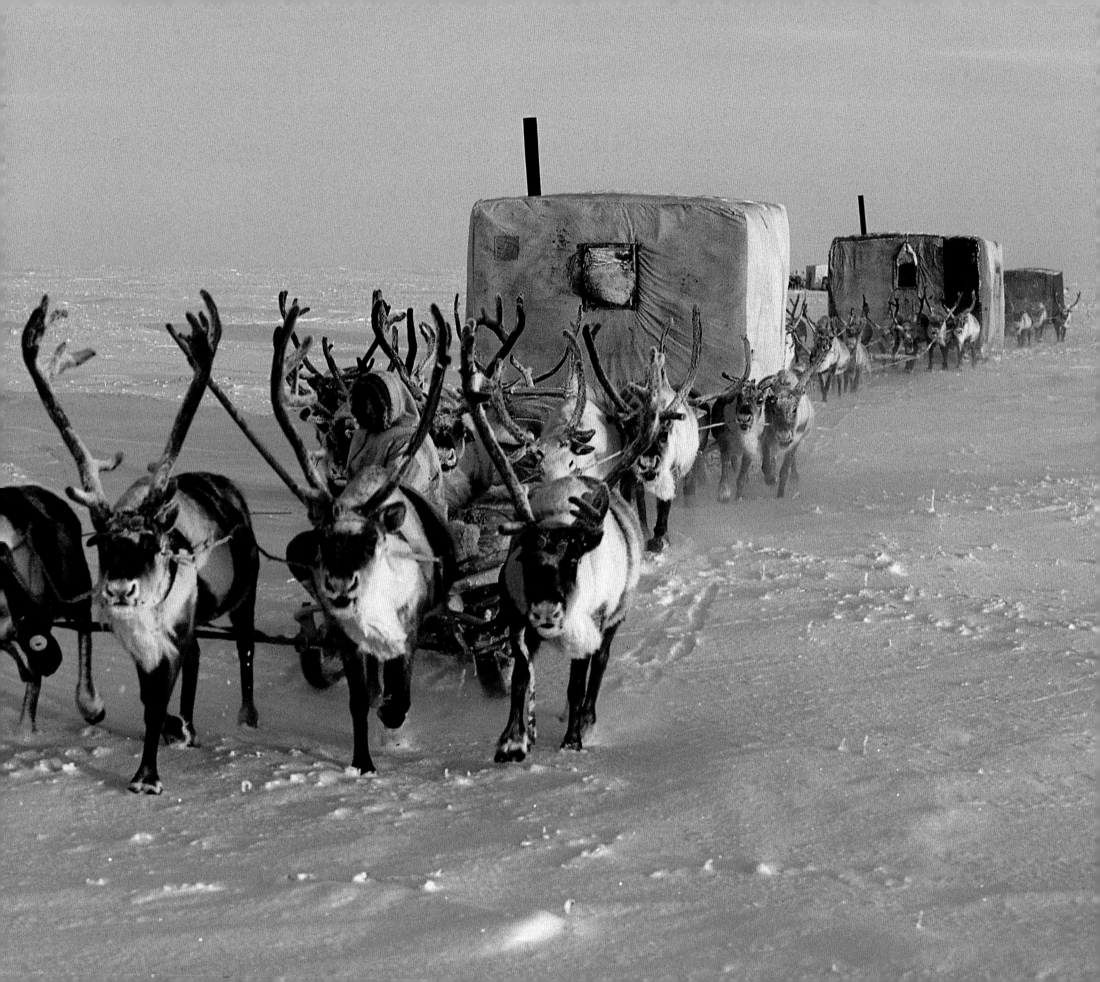

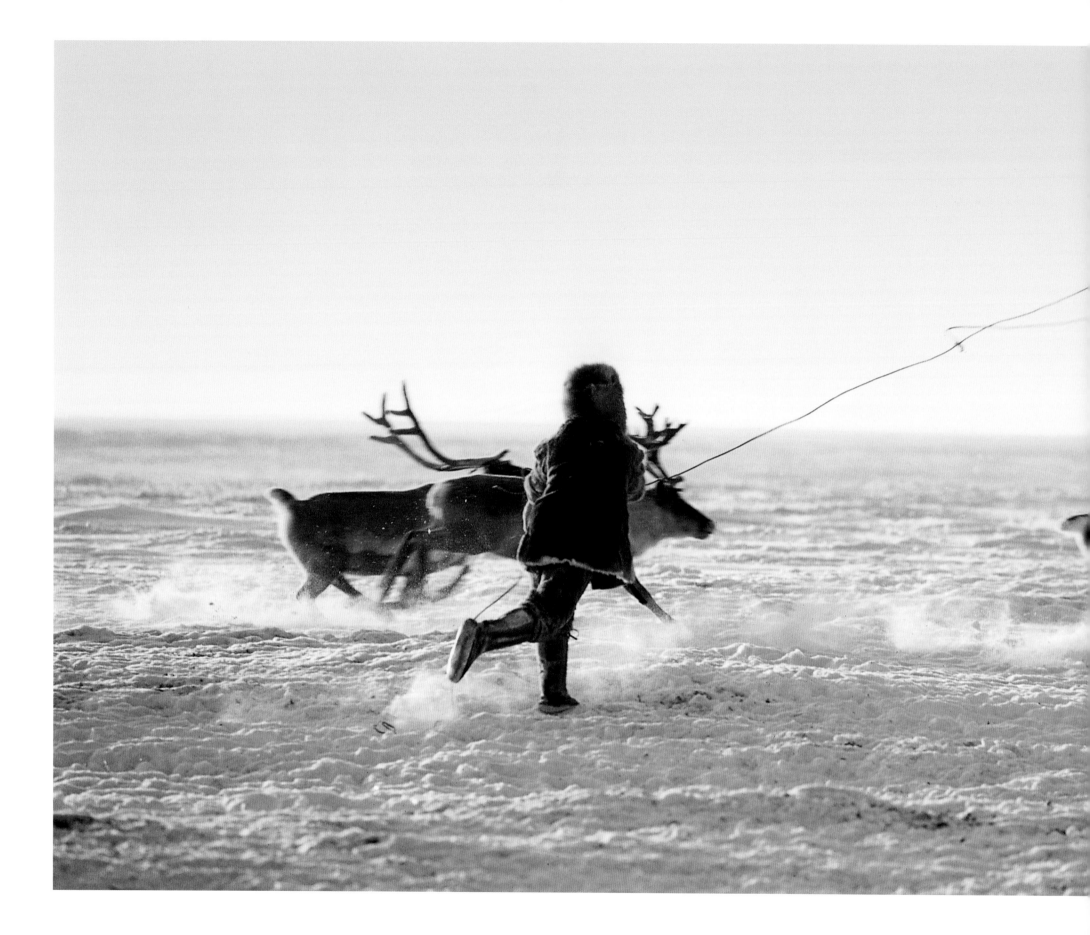

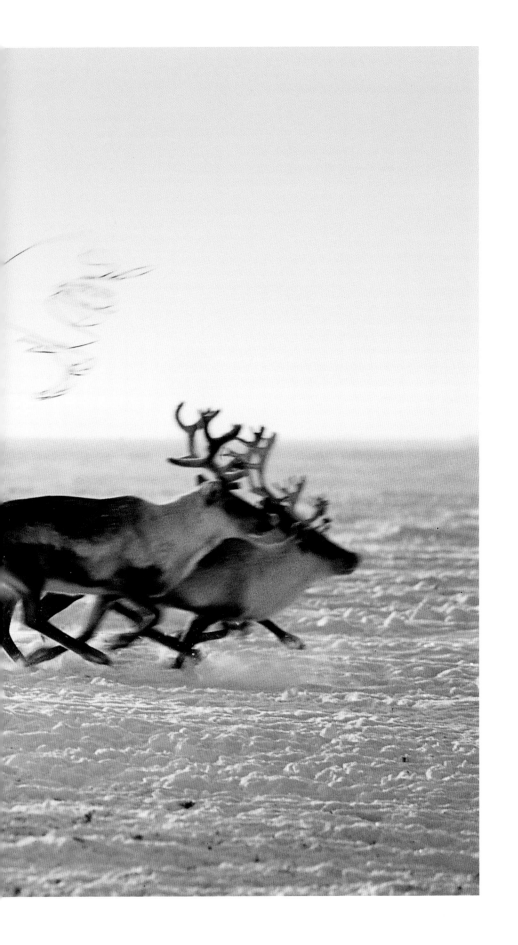
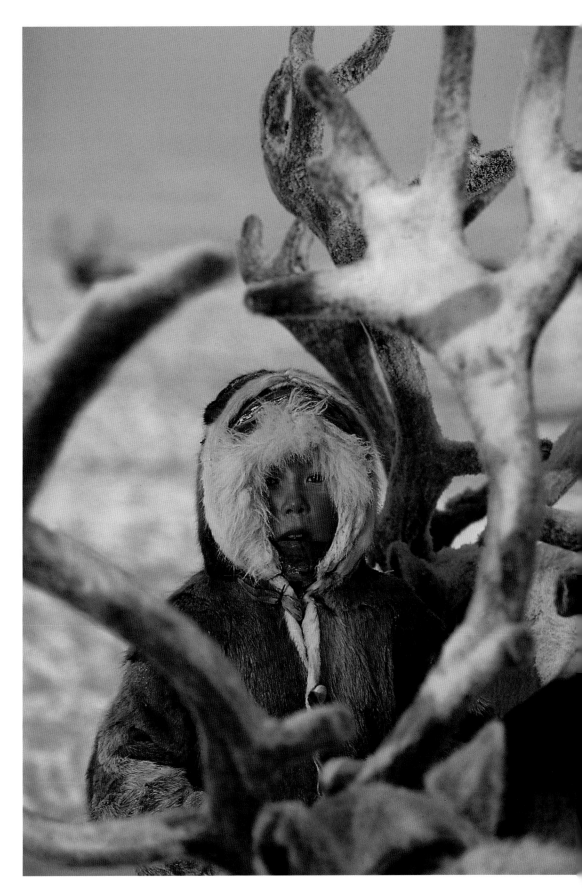

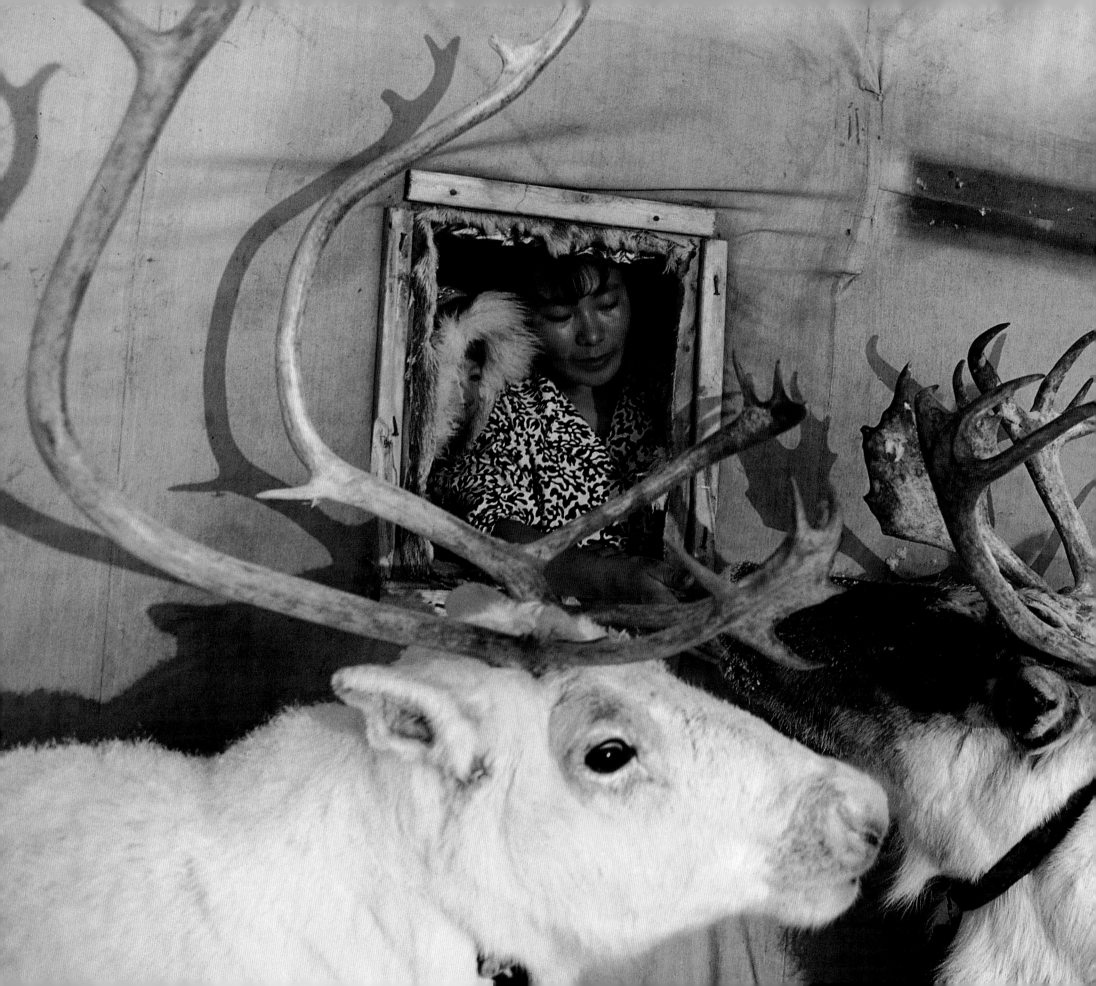

◁◁ Ο μικρός Δολγάνος Kostia αιχμαλωτίζει με λάσο έναν τάρανδο που στη συνέχεια θα χρησιμοποιηθεί από τα καραβάνια για τη μετακόμιση στα βουνά (harguïsch).

◁ Η Όλγα στο παράθυρο του σπιτιού της.

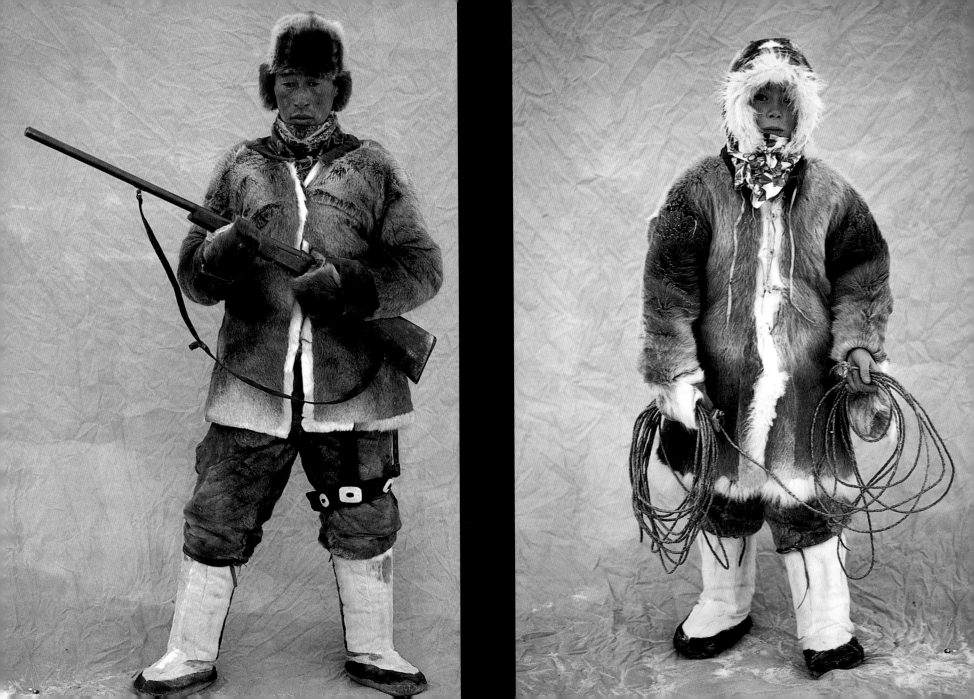

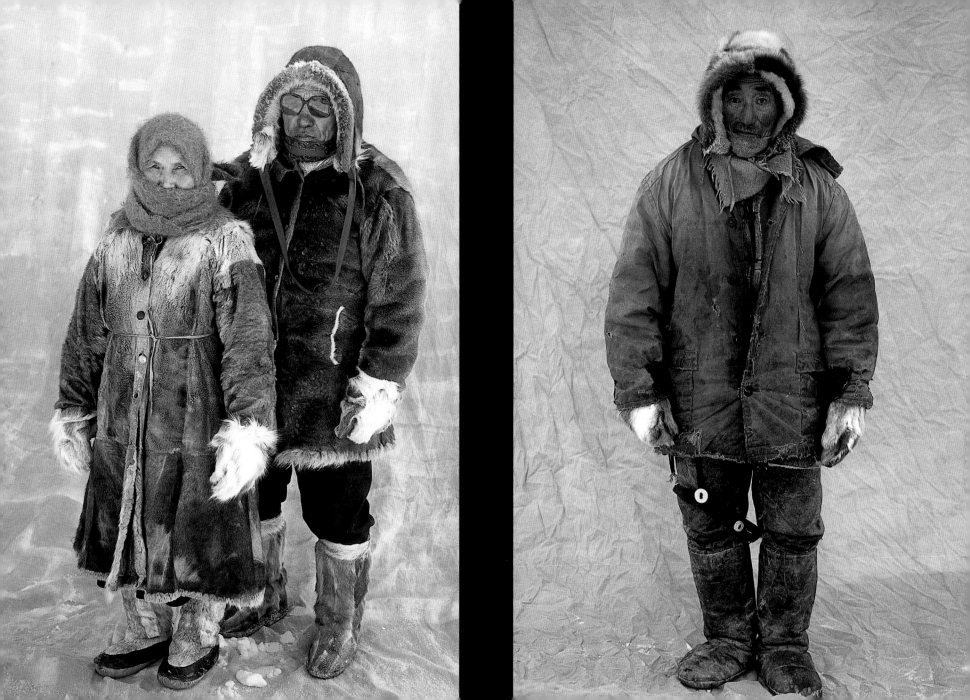

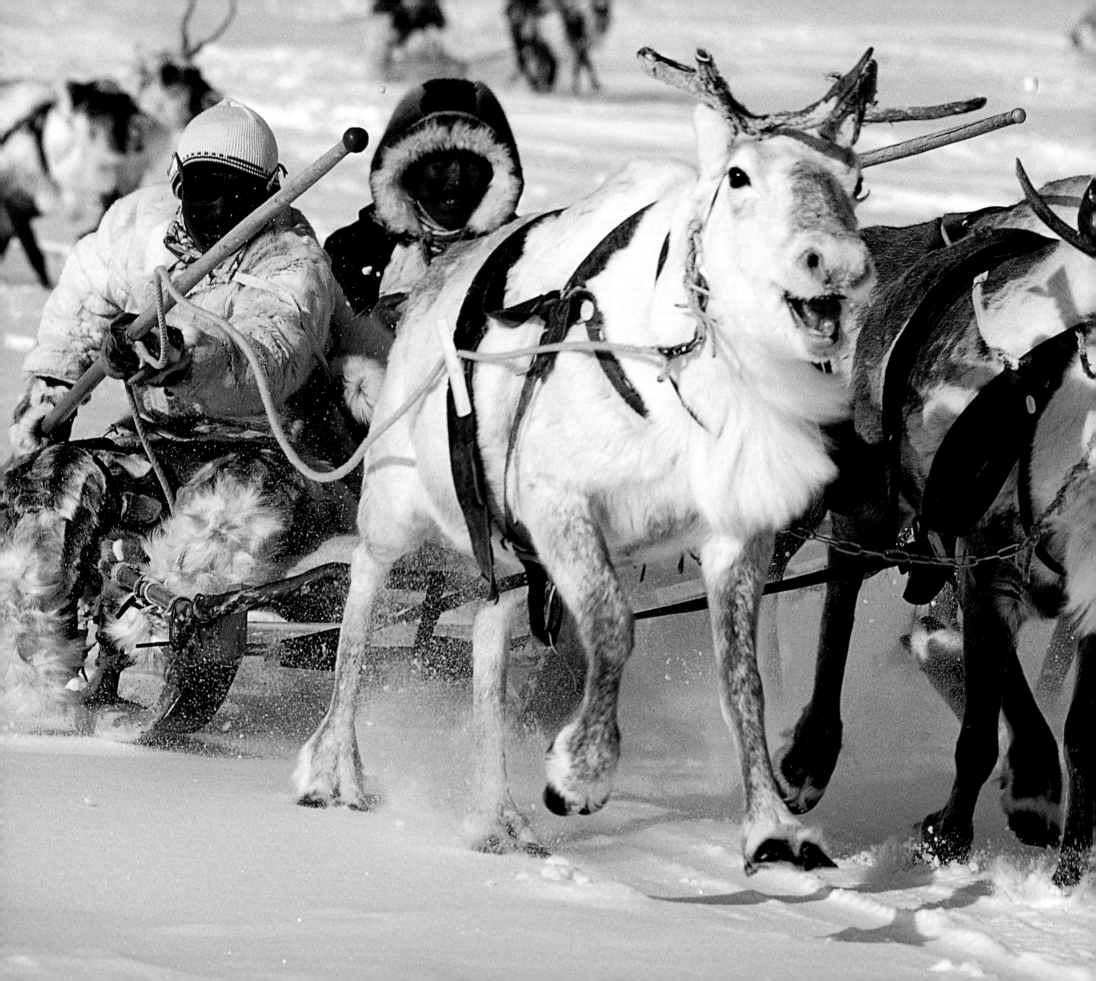

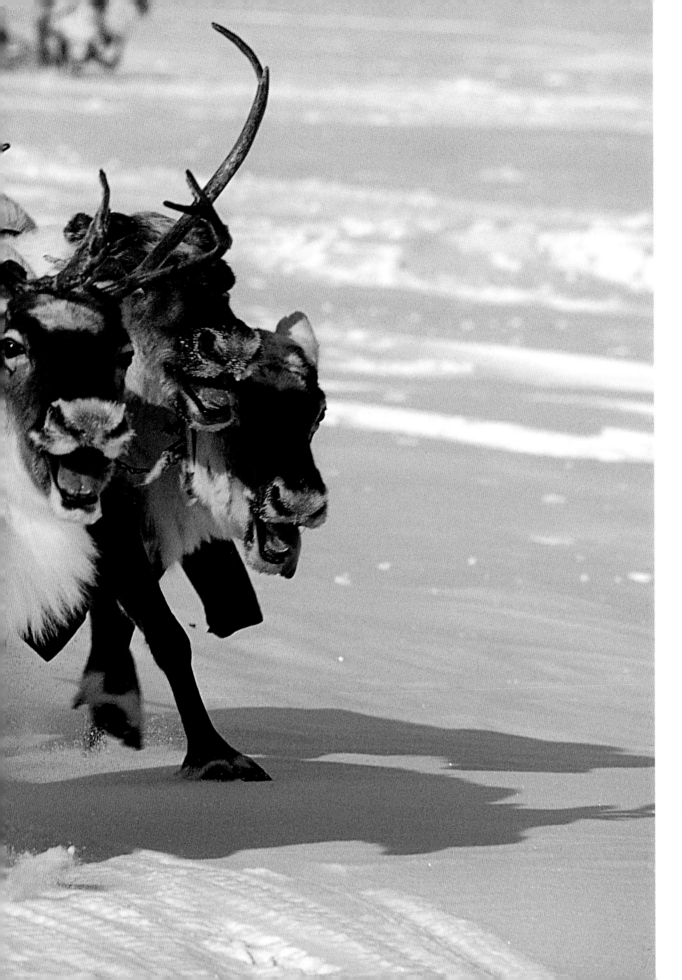

◁◁ Πορτρέτα Δολγάνων νομάδων με τα καθημερινά
ρούχα τους, κατασκευασμένα από δέρματα ταράνδων.

◁ Ο Δολγάνος Alexandre Simarov κερδίζει το Grand Prix
του Popigay, μια εκπληκτική κούρσα ελκήθρων που
συγκεντρώνει την αφρόκρεμα της τούντρας του Taïmyr.

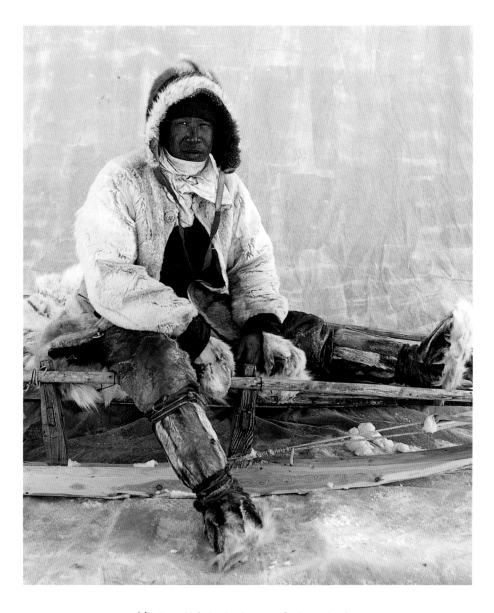

△▷ Στους 32 βαθμούς κάτω του μηδενός, μετά από μια
ξέφρενη κούρσα δώδεκα χιλιομέτρων, άνθρωποι και ζώα
παίρνουν μια ανάσα και προσπαθούν να ανακτήσουν
τις δυνάμεις τους.

▷▷ Κατά τη διάρκεια της μετακίνησης στο βουνό, κάθε δέκα ή
δεκαπέντε μέρες, ο δολγάνικος λαός μεταφέρει μαζί του και
τα ζώα του – 300 με 500 κεφάλια ζώων– για καινούργια
βοσκοτόπια.

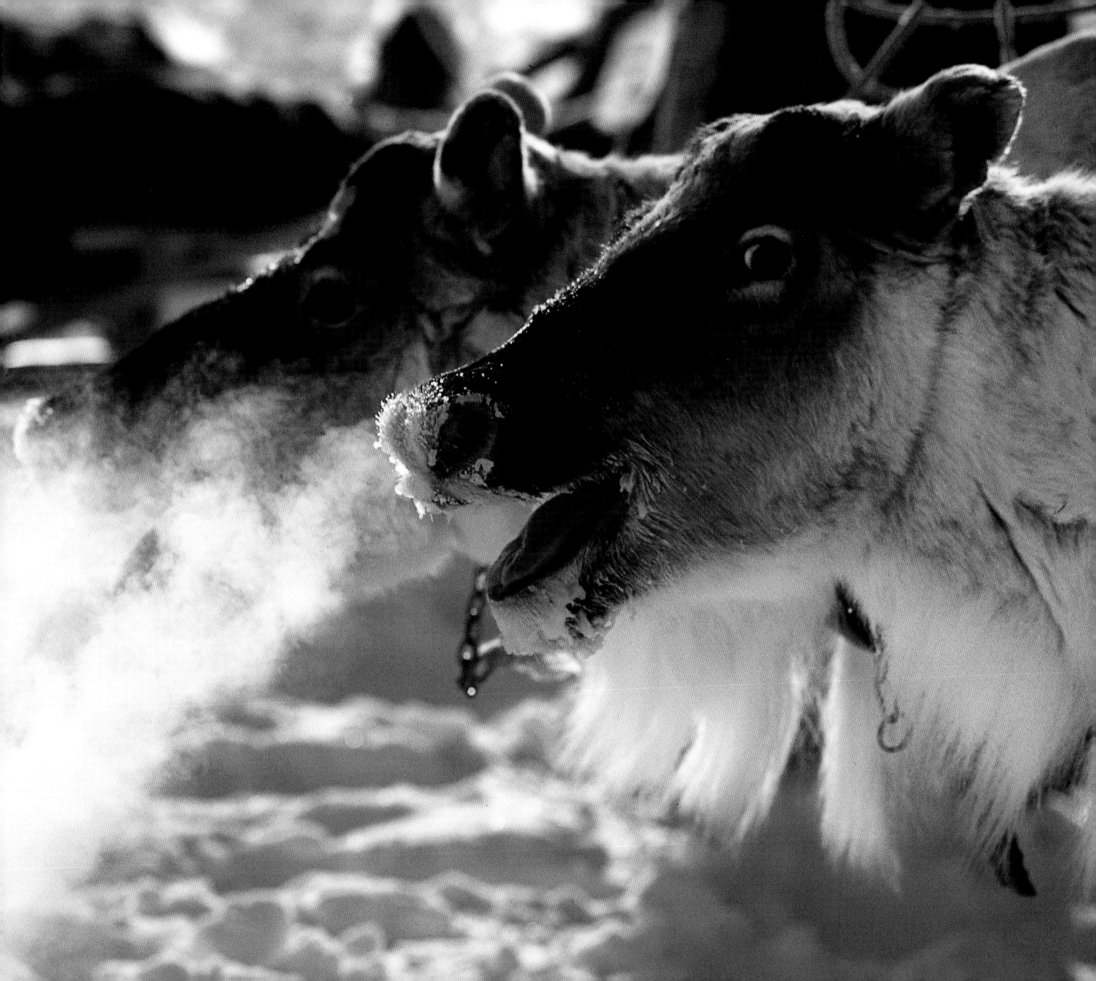

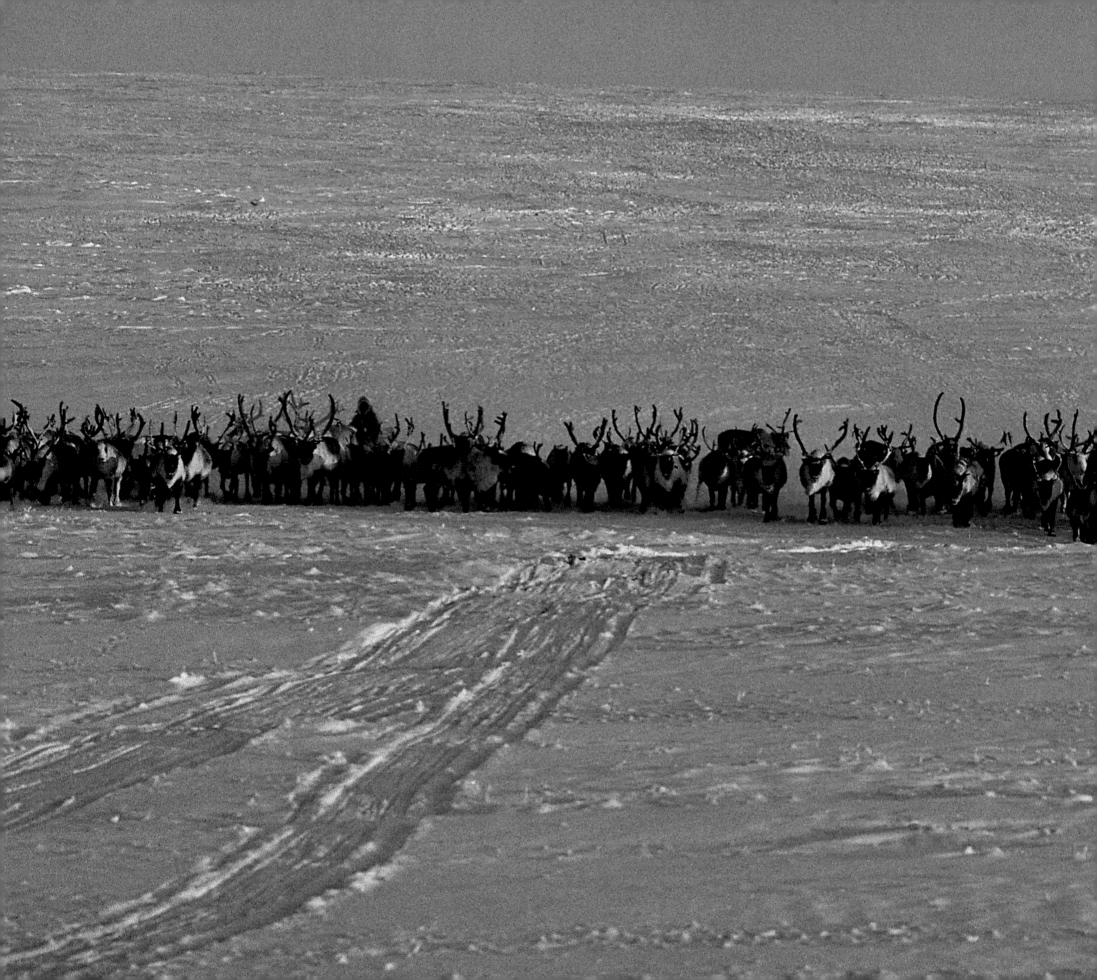

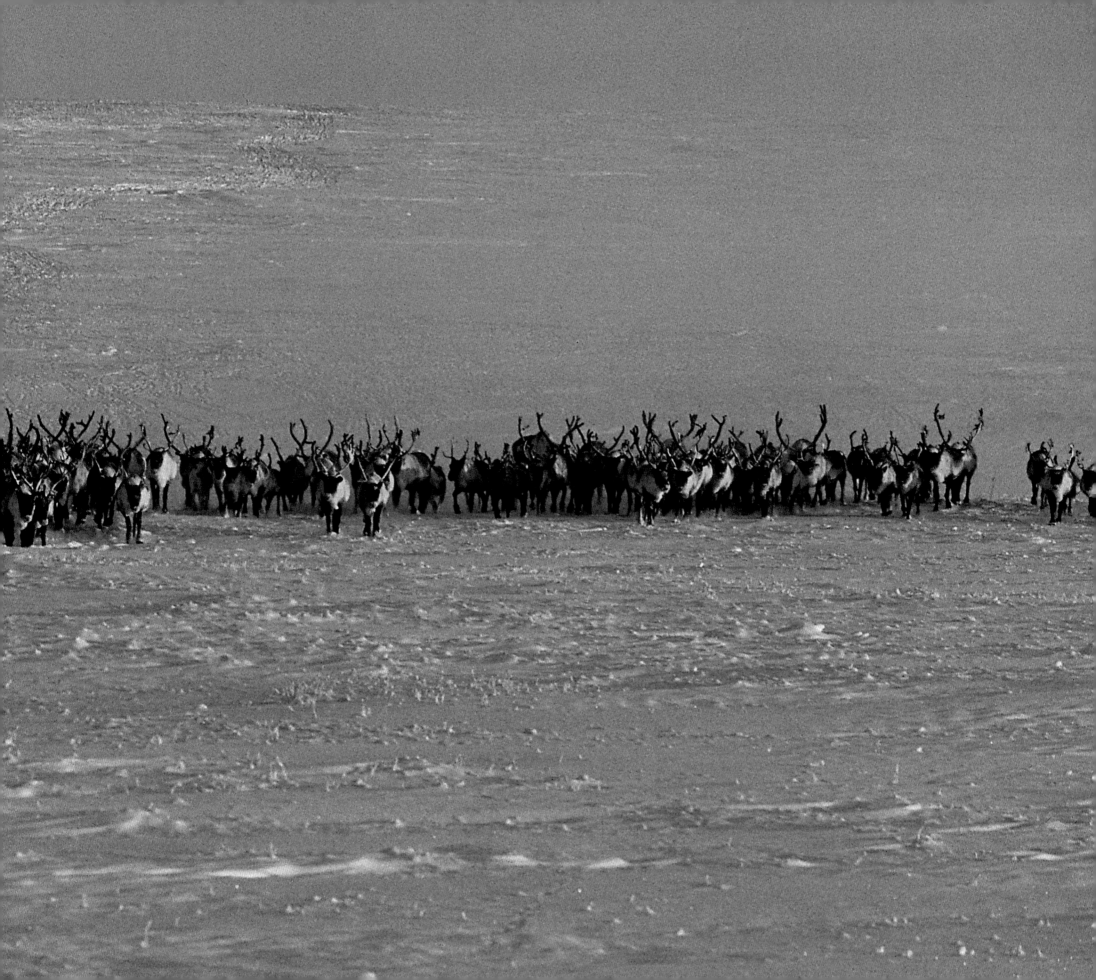

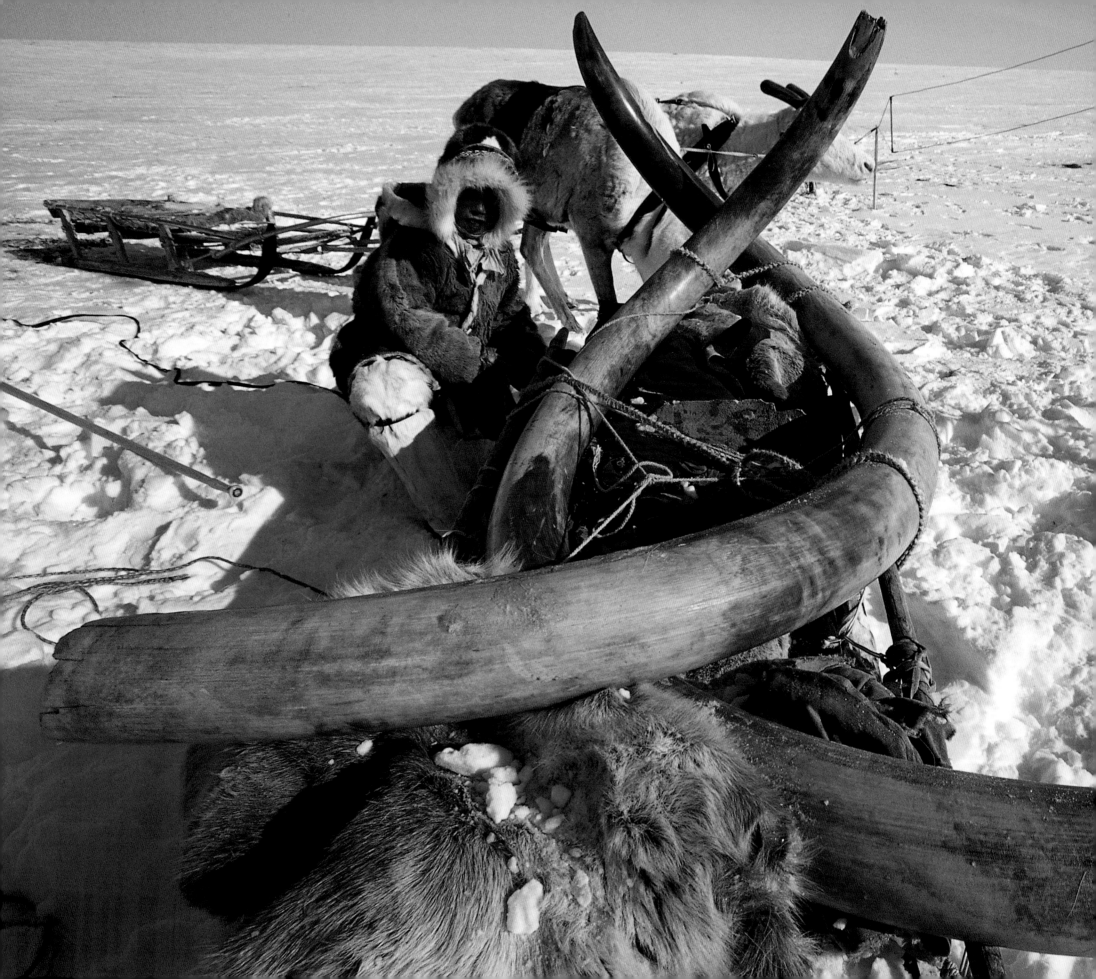

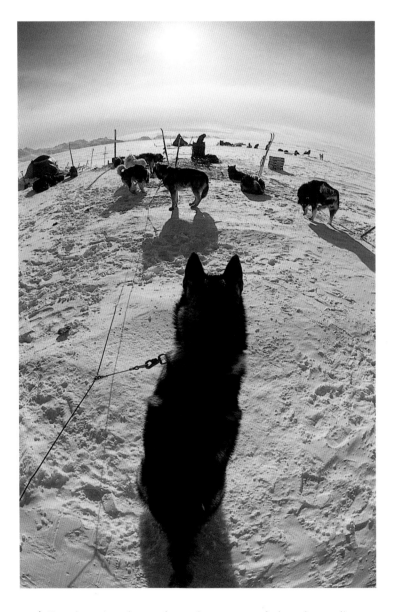

△ Παντού στην Αρκτική, απαραίτητος σύντροφος του ανθρώπου είναι ο σκύλος, χρήσιμος για τη ζεύξη στα έλκηθρα και για να ειδοποιεί κάθε φορά που «μυρίζεται» τυχόν ανεπιθύμητη παρουσία λύκου ή αρκούδας.

◁ Ο Kostia, ο μικρός Δολγάνος, ποζάρει, το 1998, πολύ περήφανος για τη σπουδαία ανακάλυψη των γονιών του: τους χαυλιόδοντες ενός γέρου μαμούθ 20.000 χρονών, που στο εξής θα φέρει για την επιστήμη το όνομα της οικογένειάς του, « Jarkov ».

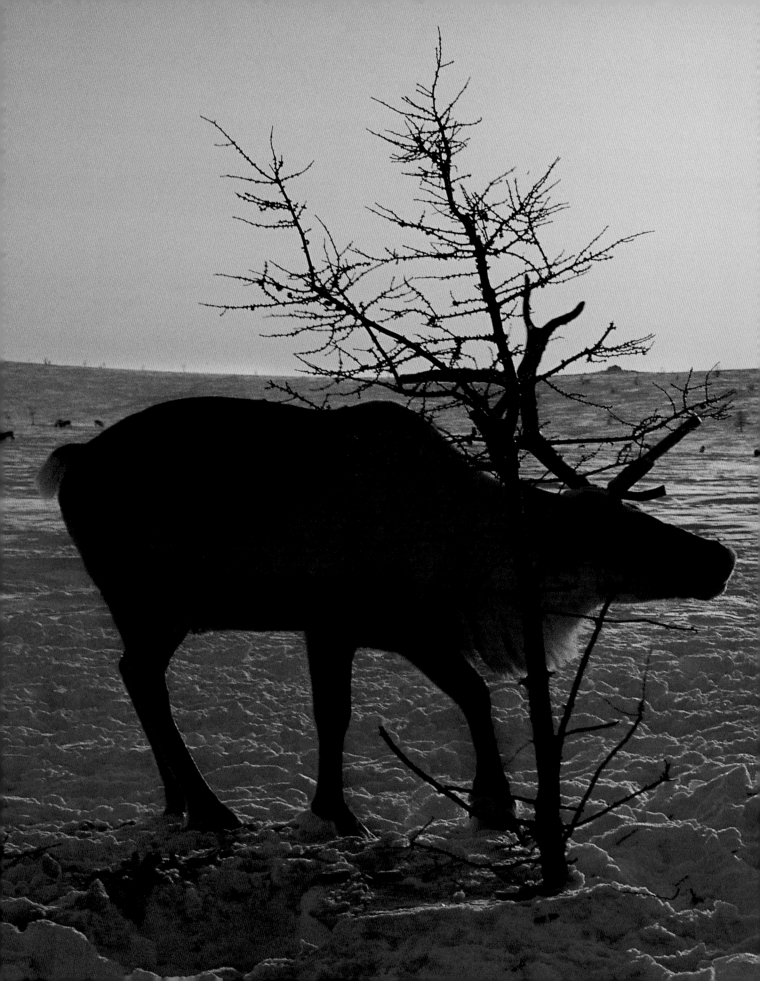

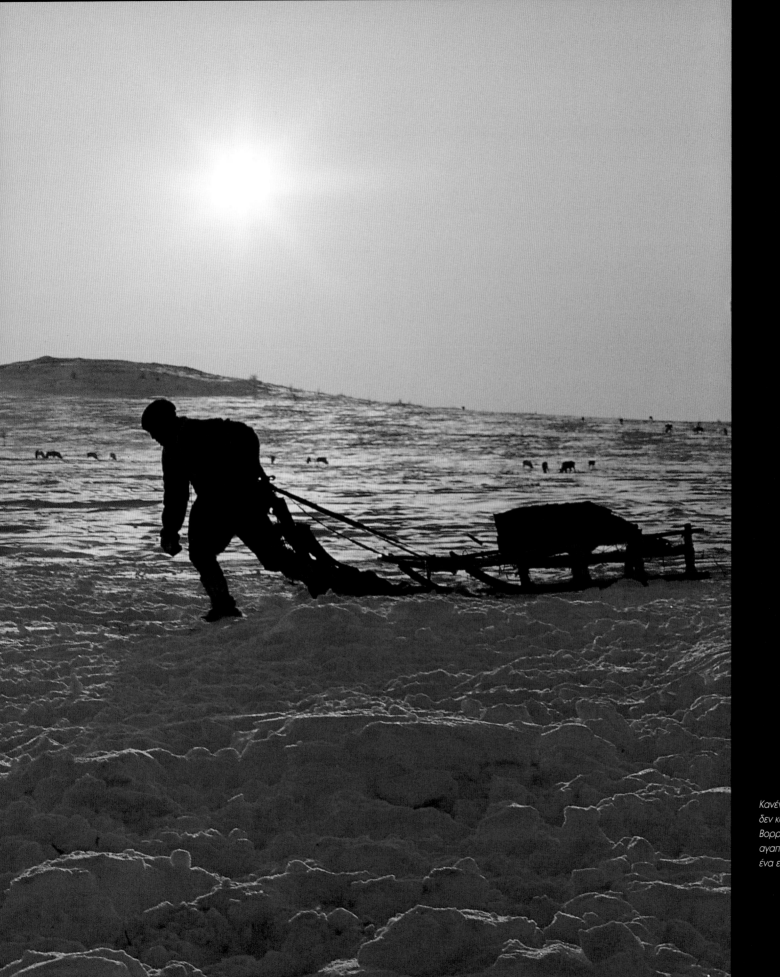

Κανένα δέντρο, με εξαίρεση αυτό το μικρό ρητινοφόρο, δεν καταφέρνει να επιβιώσει στην τούντρα του μακρινού Βορρά. Η βλάστηση αυξάνεται πολύ αργά, οι λειχήνες, αγαπημένη τροφή των ταράνδων, δεν φυτρώνουν παρά ένα εκατοστό κάθε δέκα χρόνια.

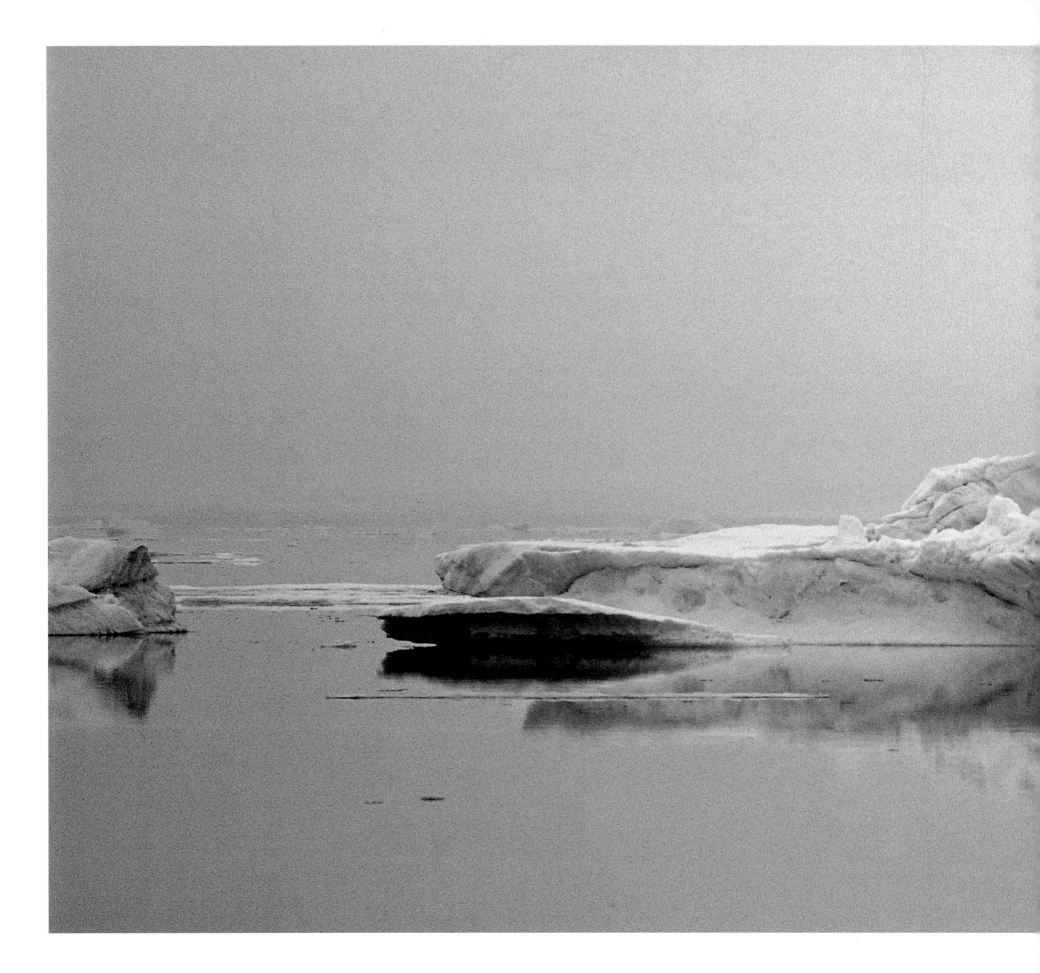

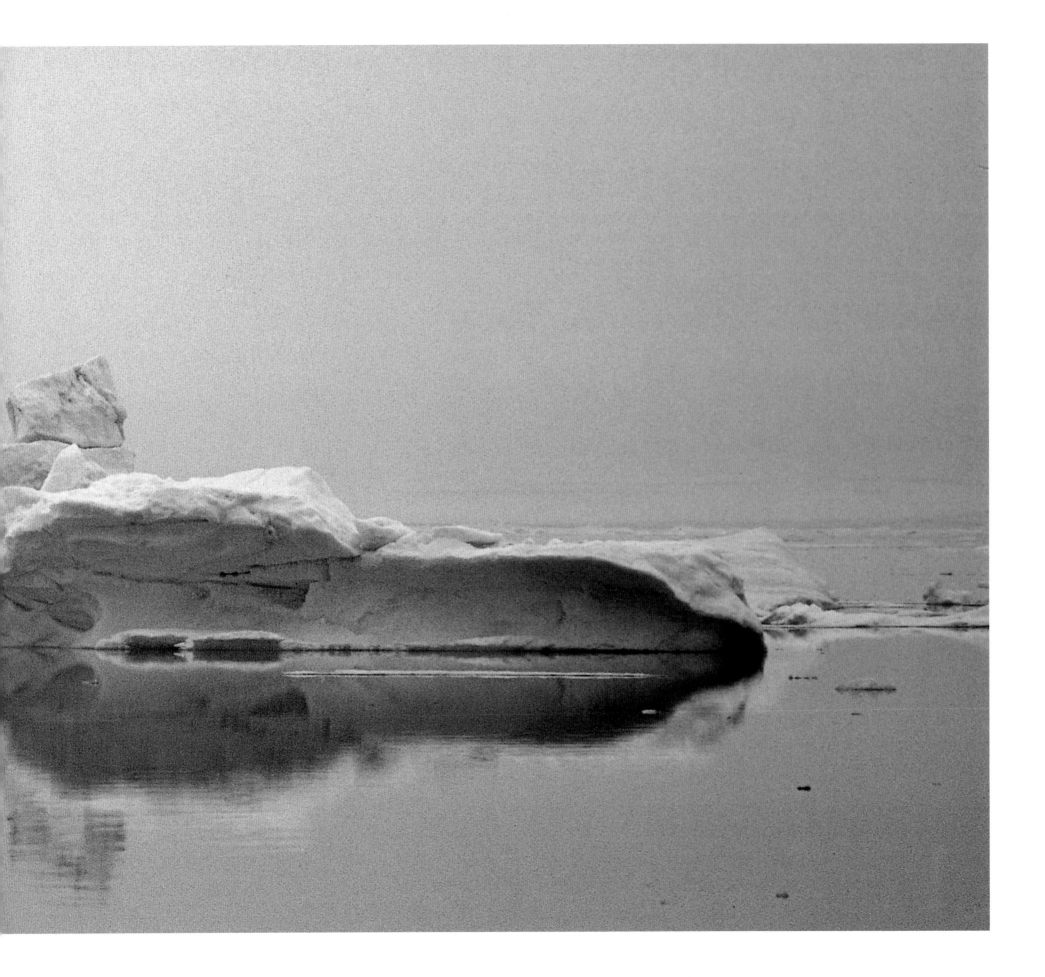

◁◁ Μέσα στην ηρεμία και την ομίχλη της Αρκτικής, ένα μεγάλο κομμάτι πάγου κατευθύνεται ήρεμα στο ρεύμα ενός lead (ελεύθερο πέρασμα νερού).

▷ Η Khatanga, στο μακρινό Σιβηρικό Βορρά, είναι φωτισμένη από τους παρήλιους ή «ψεύτικους ήλιους». Αυτά τα μεγάλου μεγέθους φωτεινά φαινόμενα, με κάθετο προσανατολισμό, δίνουν την αίσθηση ενός περίεργου πολλαπλασιασμού του ήλιου. Μπορούμε έτσι να απολαύσουμε αρκετούς ήλιους να δύουν ταυτόχρονα.

▷▷ Στο Scoresby Sund, ένα φιόρντ στα ανατολικά της Γροιλανδίας, οι άνεμοι και η φουσκοθαλασσιά γλύφουν τα παγόβουνα, δίνοντάς τους εκπληκτικές μορφές.

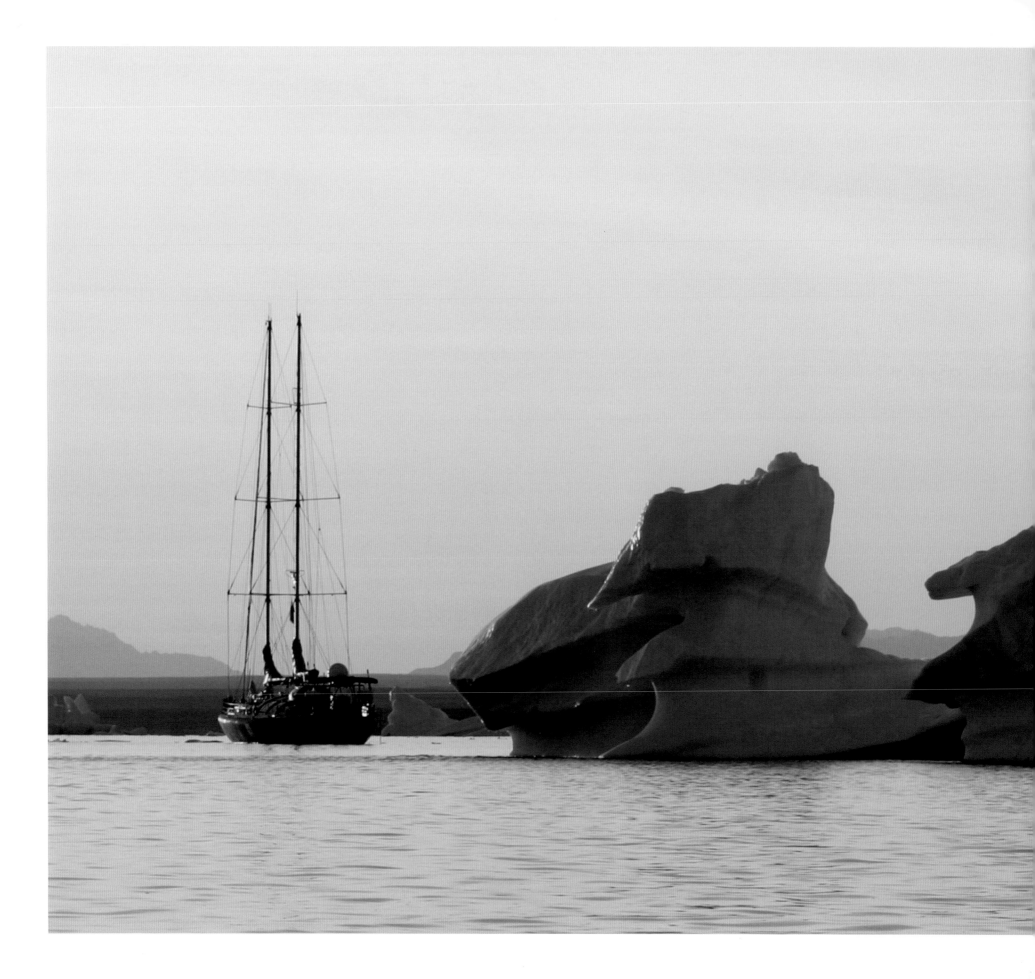

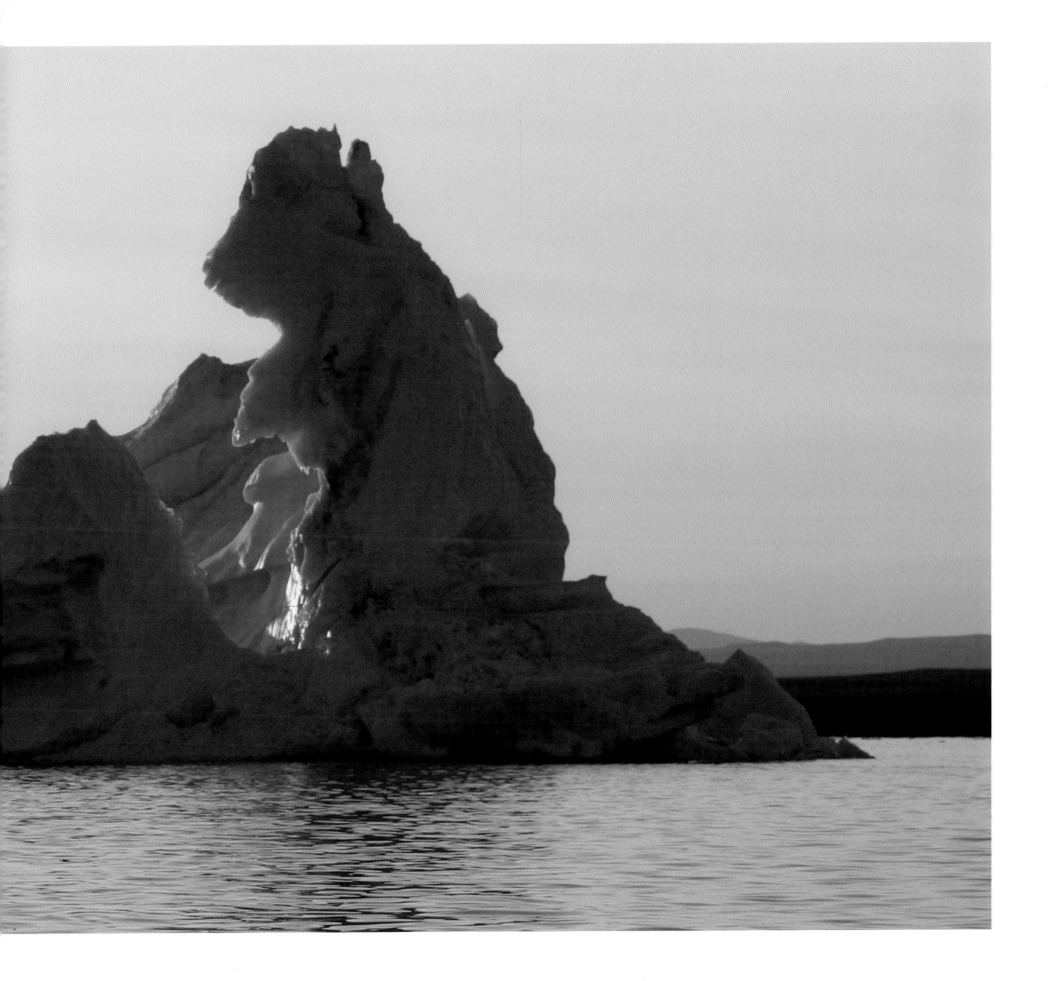

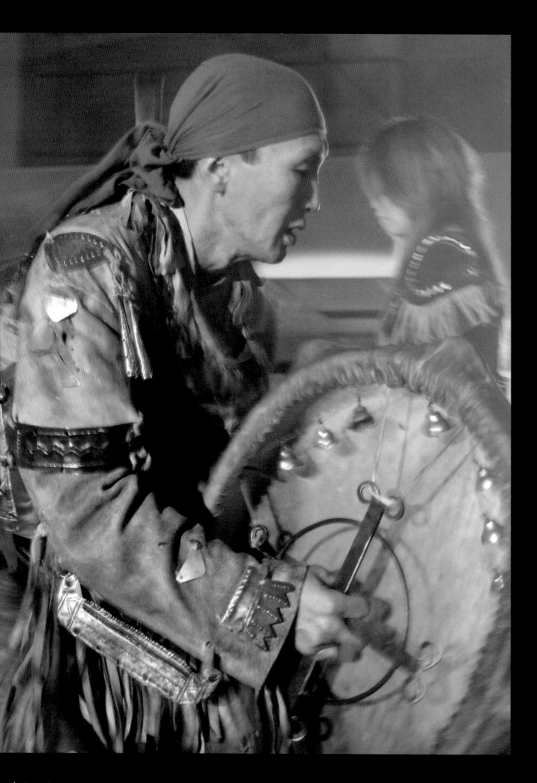

△ Στη Yakoutie, το chaman είναι μέσα στη ζωή των αυτοχθόνων. Το ταμπούρλο είναι το απαραίτητο όργανο που θα δώσει ρυθμό στους χορούς και στα ξόρκια που απευθύνονται στα πολυάριθμα προστατευτικά πνεύματα.

▷ Το Βόρειο Σέλας είναι το πιο θεαματικό φωτεινό φαινόμενο των πολικών περιοχών. Μέσα στην κρύα νύχτα, αυτά τα πολύχρωμα δακτυλίδια ανάβουν στον μελανό ουρανό ένα πλανητικό πυροτέχνημα.

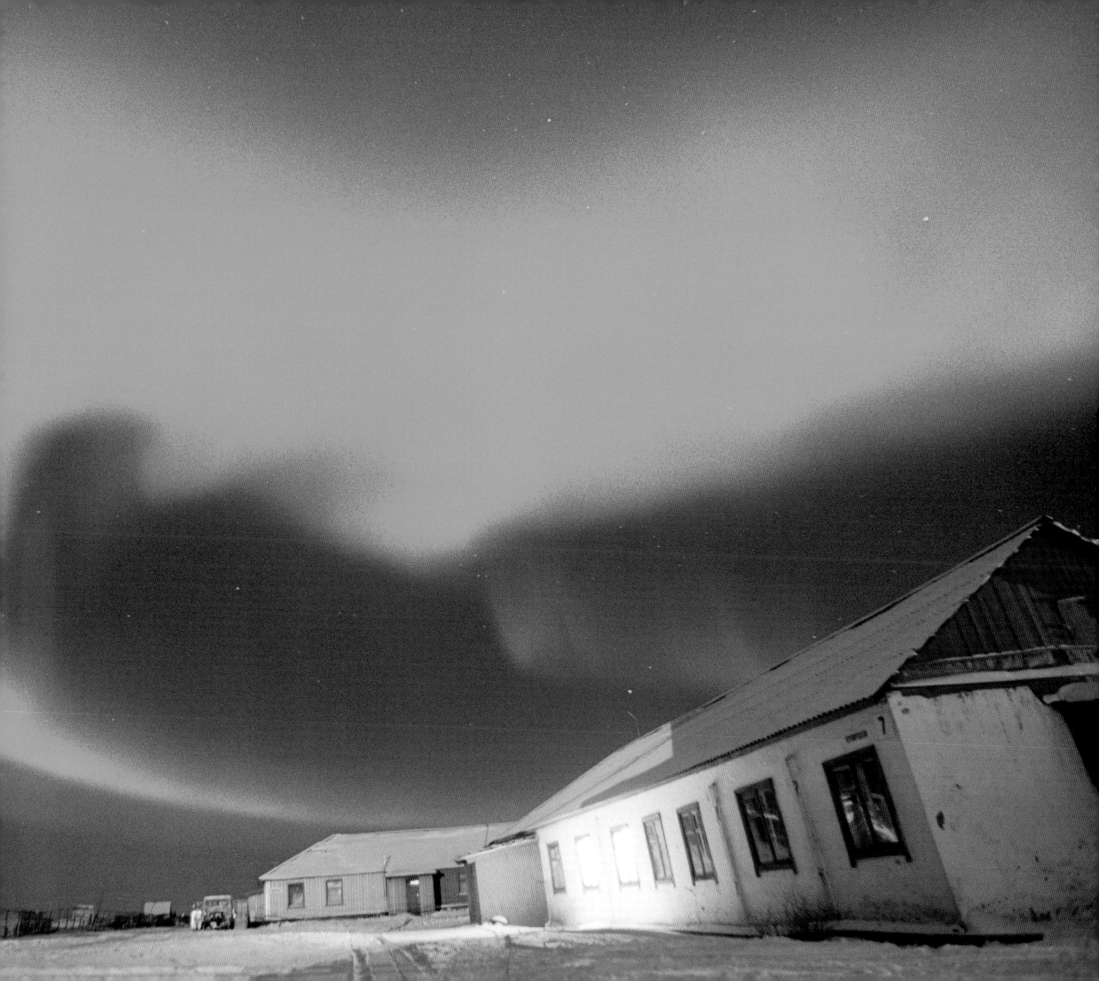

◁▷
▷▷ Σε κάθε αποστολή
στις αφιλόξενες ζώνες της
Σιβηρίας προηγείται μια
σαμανική τελετή που έχει
σκοπό να κατευνάσει τα
πολυάριθμα πνεύματα που
στοιχειώνουν την τούντρα.
Μουσική, χοροί, ξόρκια και
προσφορές περιλαμβάνει
το πρόγραμμα αυτών των
εκδηλώσεων.

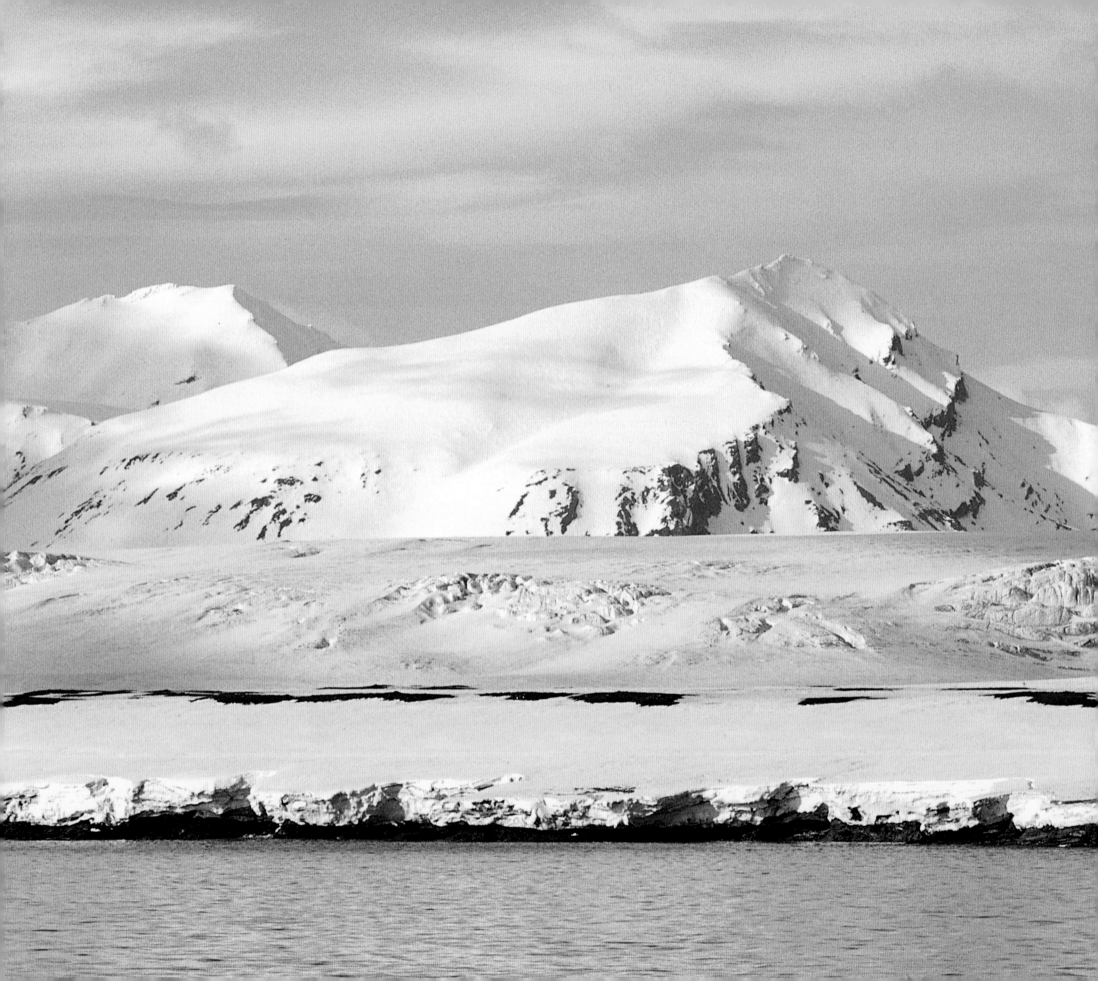

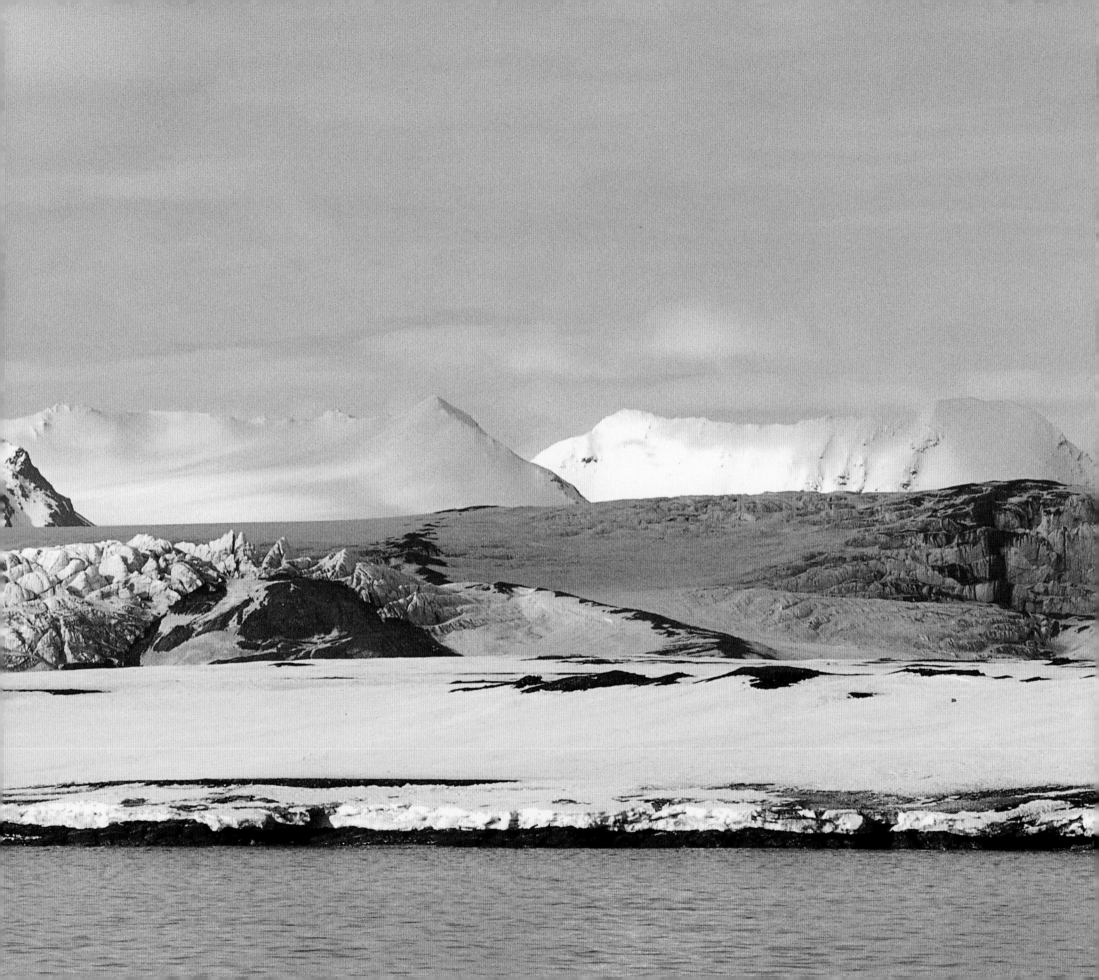

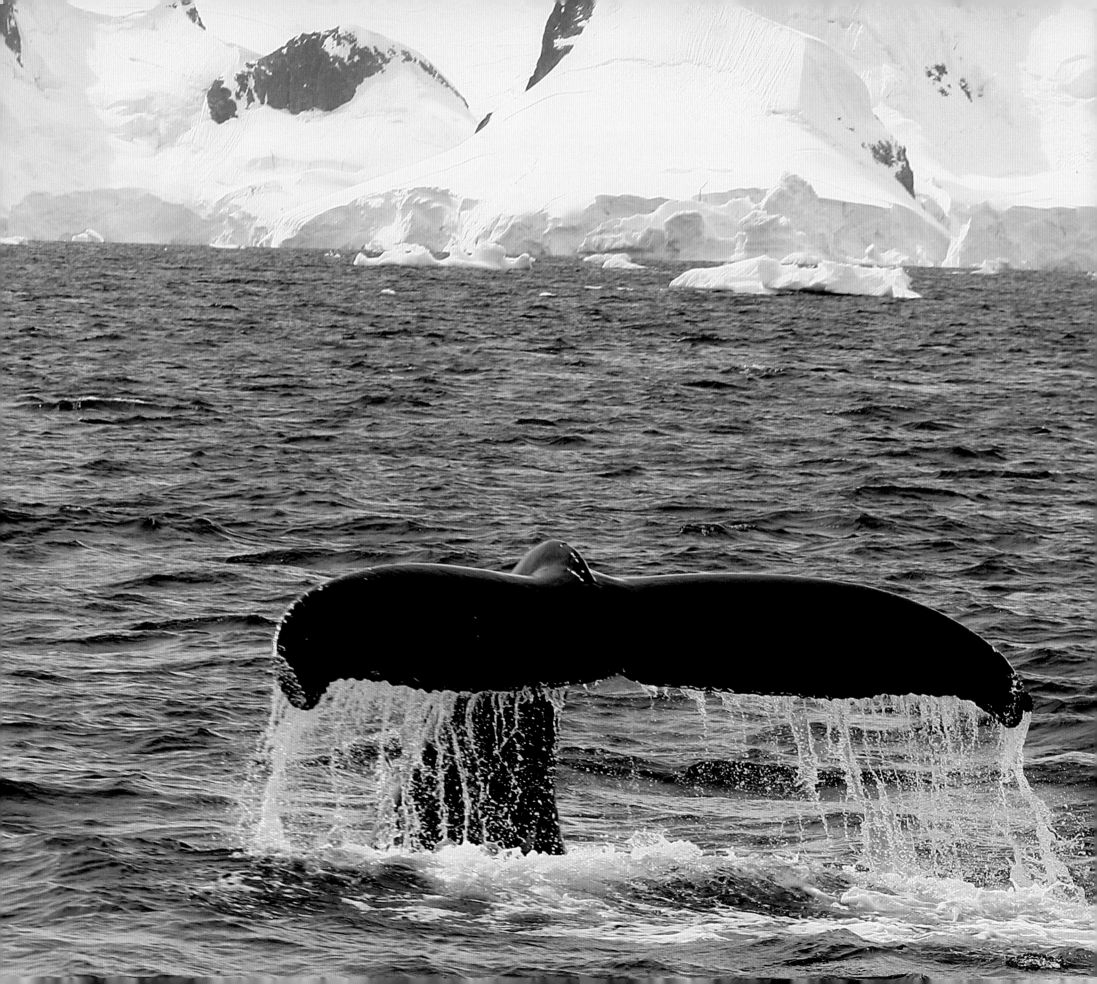

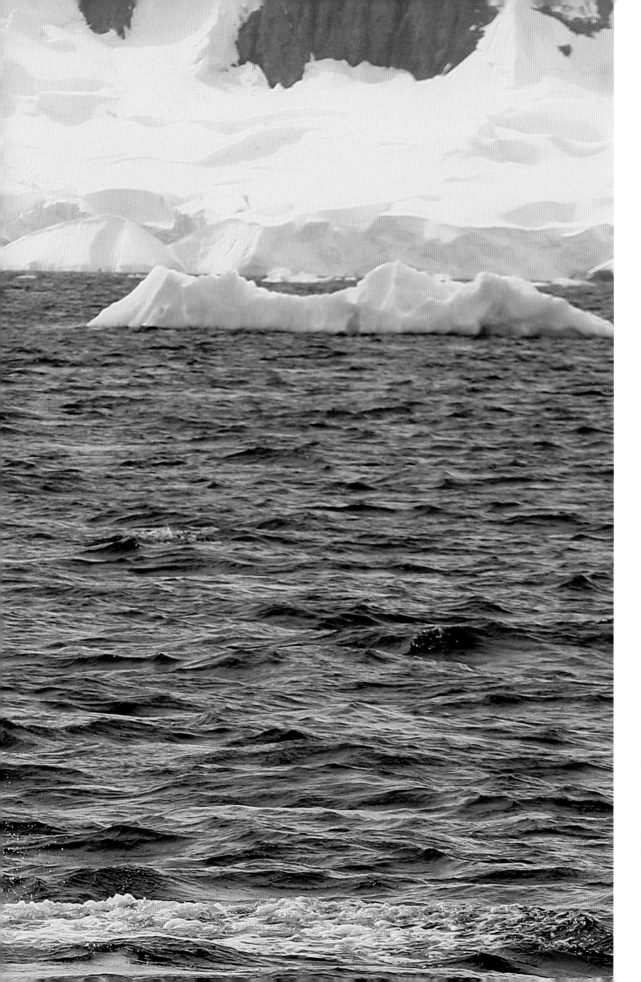

◁◁ Ο παγετώνας είναι ένας παγωμένος ποταμός που κατευθύνεται σιγά σιγά προς τη θάλασσα. Στη Γροιλανδία, προχωρά καθημερινά καμιά εικοσαριά μέτρα και από τα πιο ψηλά του μέρη –αρκετές δεκάδες μέτρα ψηλά– αποκόβονται και σχηματίζονται τα τεράστια παγόβουνα.

◁ Οι φάλαινες συχνάζουν στα κρύα νερά, εκεί όπου βρίσκουν άφθονη τροφή. Από τον Βορρά έως τον Νότο, τις βλέπουμε συχνά κοντά στις ακτές και στις εκβολές ποταμών.

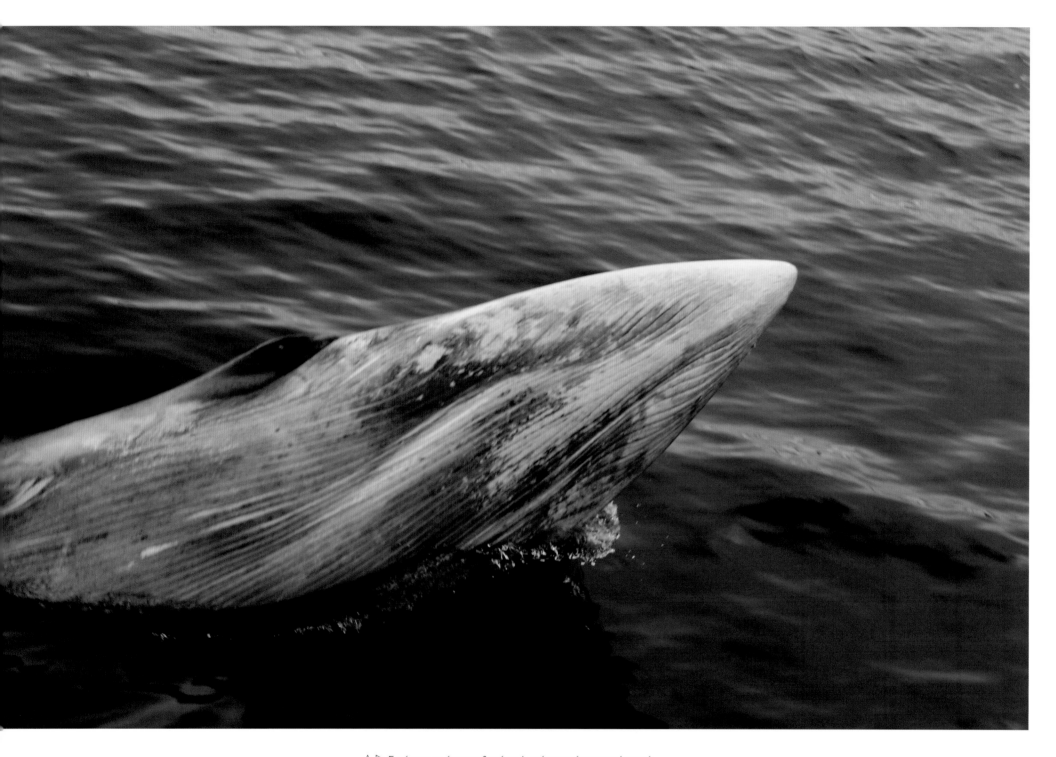

△ ▷ Συνάντηση με ένα συνηθισμένο σ' αυτές τις κρύες περιοχές μικρό
φαλαινόπτερο – ή φάλαινα του Minke–, 6 έως 9 μέτρων μήκους και 8 τόνων βάρους
περίπου, που τρέφεται με krill (είδος γαρίδας) και μικρά ψάρια.

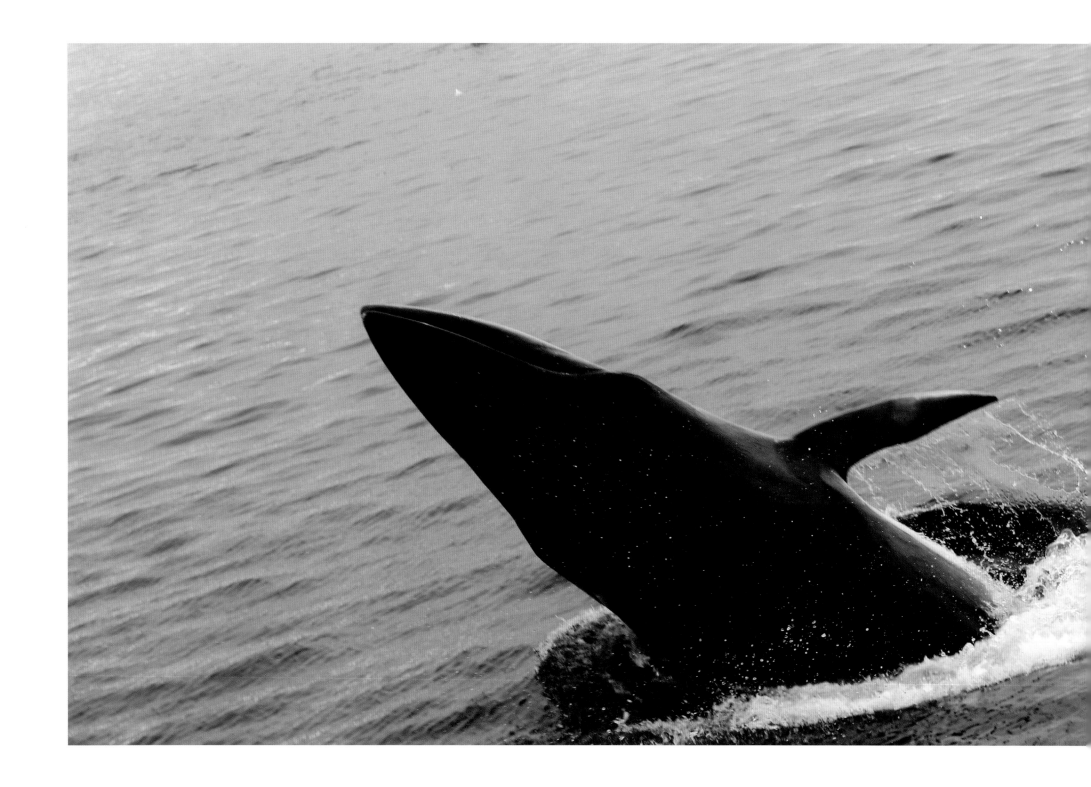

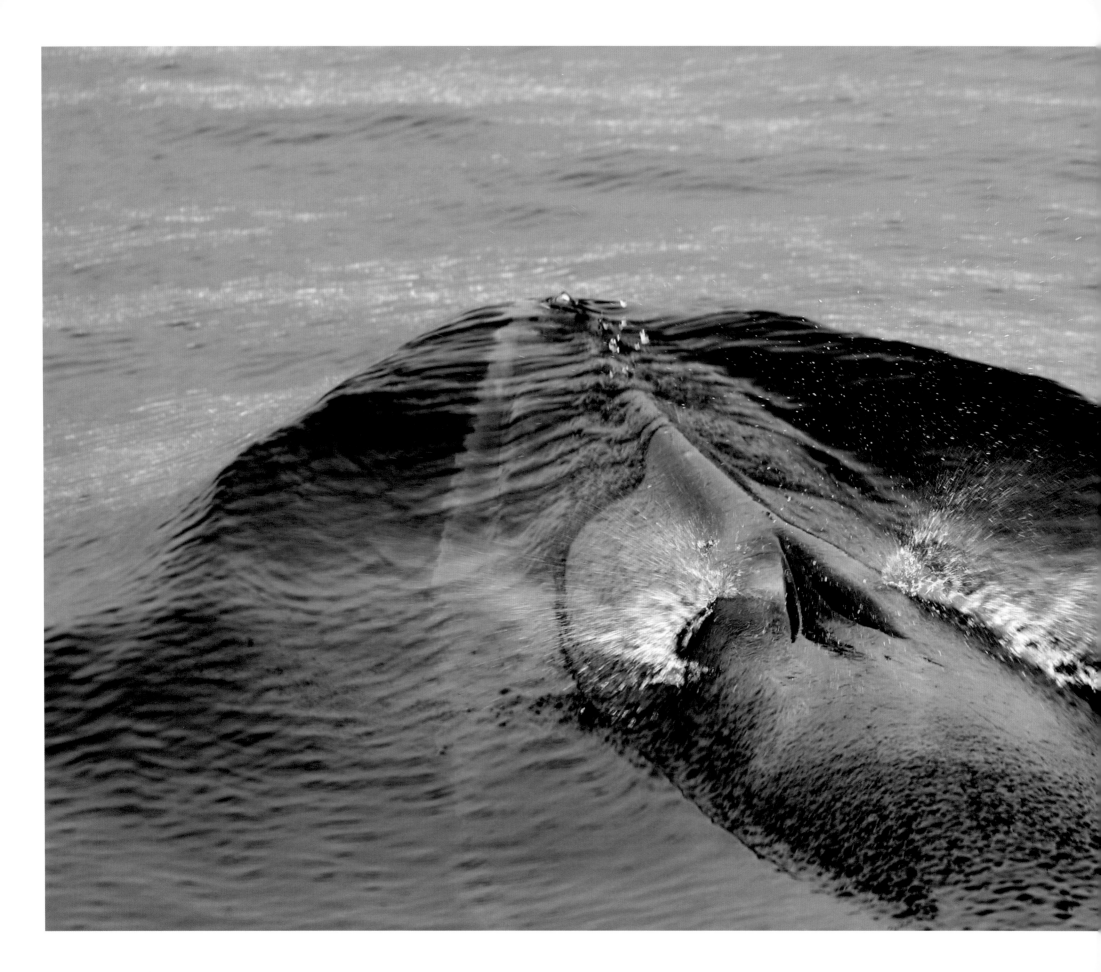

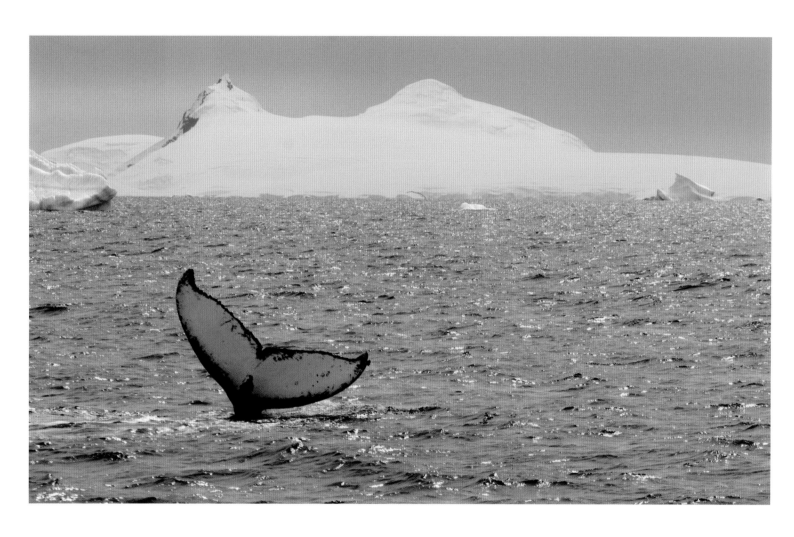

△ Η φάλαινα σηκώνει το ουραίο πτερύγιό της κατακόρυφα και βουτά σε αναζήτηση τροφής. Μπορεί να παραμείνει περίπου δύο ώρες κάτω από το νερό και να φτάσει σε βάθος 1.000 μέτρων.

◁ Όταν βγαίνει στην επιφάνεια το φαλαινόπτερο, αφήνει να φανεί το χαριτωμένο μουσούδι του και, σαν υποβρύχιο, σχίζει την επιφάνεια του νερού, αφήνοντας ένα πηχρό φύσημα.

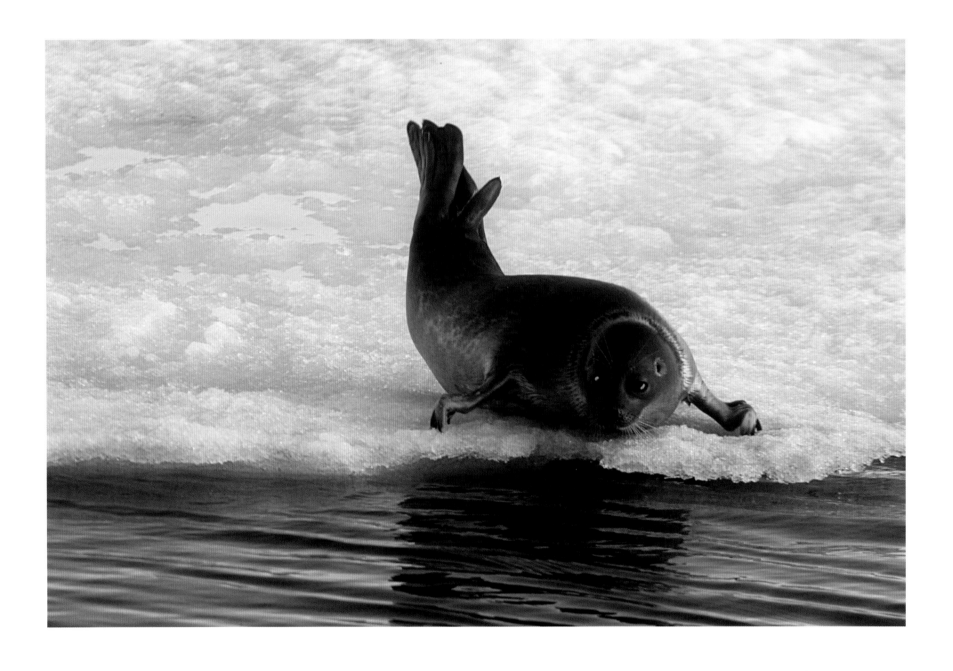

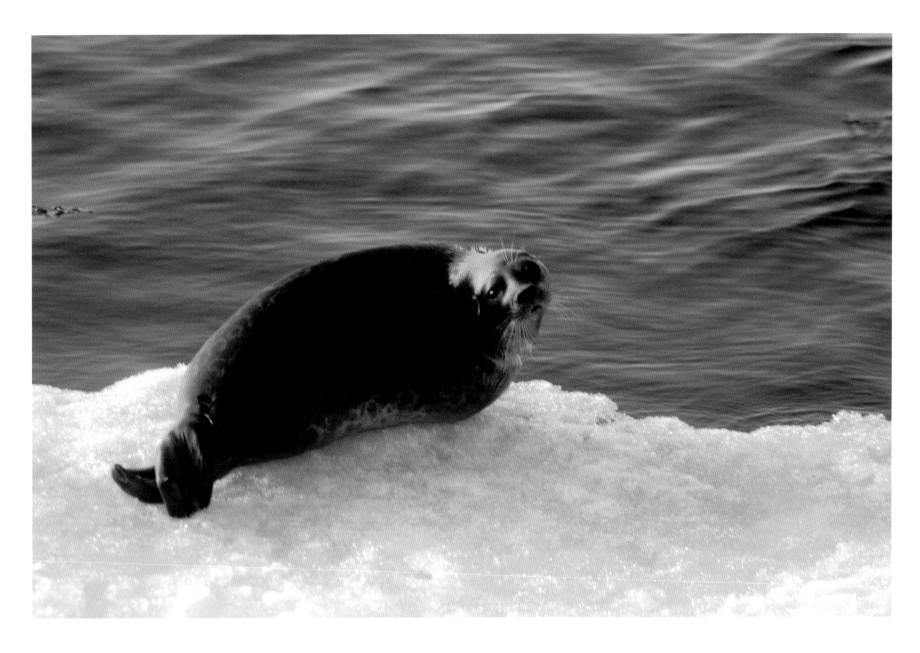

Αυτή η μικρή φώκια της Γροιλανδίας που στρογγυλοκάθεται πάνω στον πάγο της
είναι η αγαπημένη λεία της αρκούδας, που συχνάζει πάντα σ' αυτά τα μέρη.

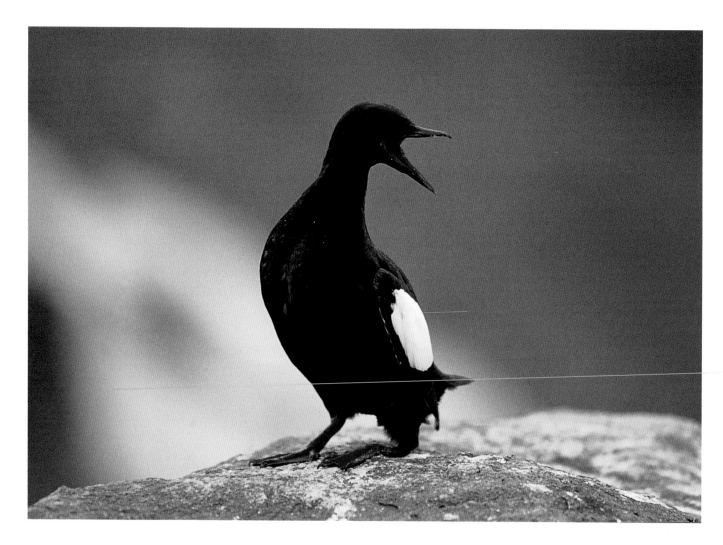

Στο Begitchev, ένα νησάκι που χάθηκε από την Αρκτική και βρίσκεται στη θάλασσα του Laptev, οι απόκρημνες ακτές προσφέρονται για το χτίσιμο της φωλιάς στο είδος αυτό των πιγκουίνων (guillemots - Uria Aalge), με ράμφος και πόδια κόκκινα, πουλιά που φωλιάζουν πολυάριθμα μέσα σε αυτά τα απρόσιτα βραχώδη τοιχώματα.

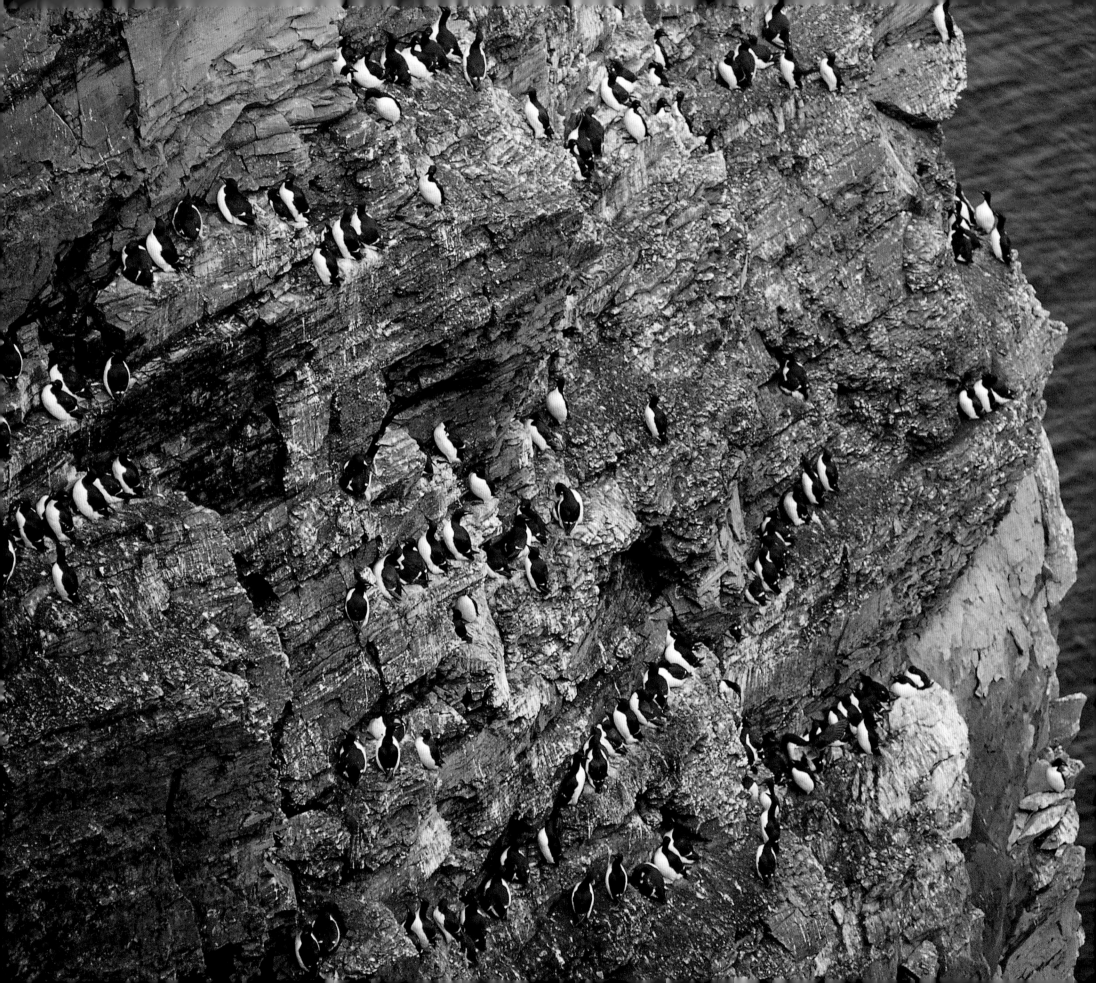

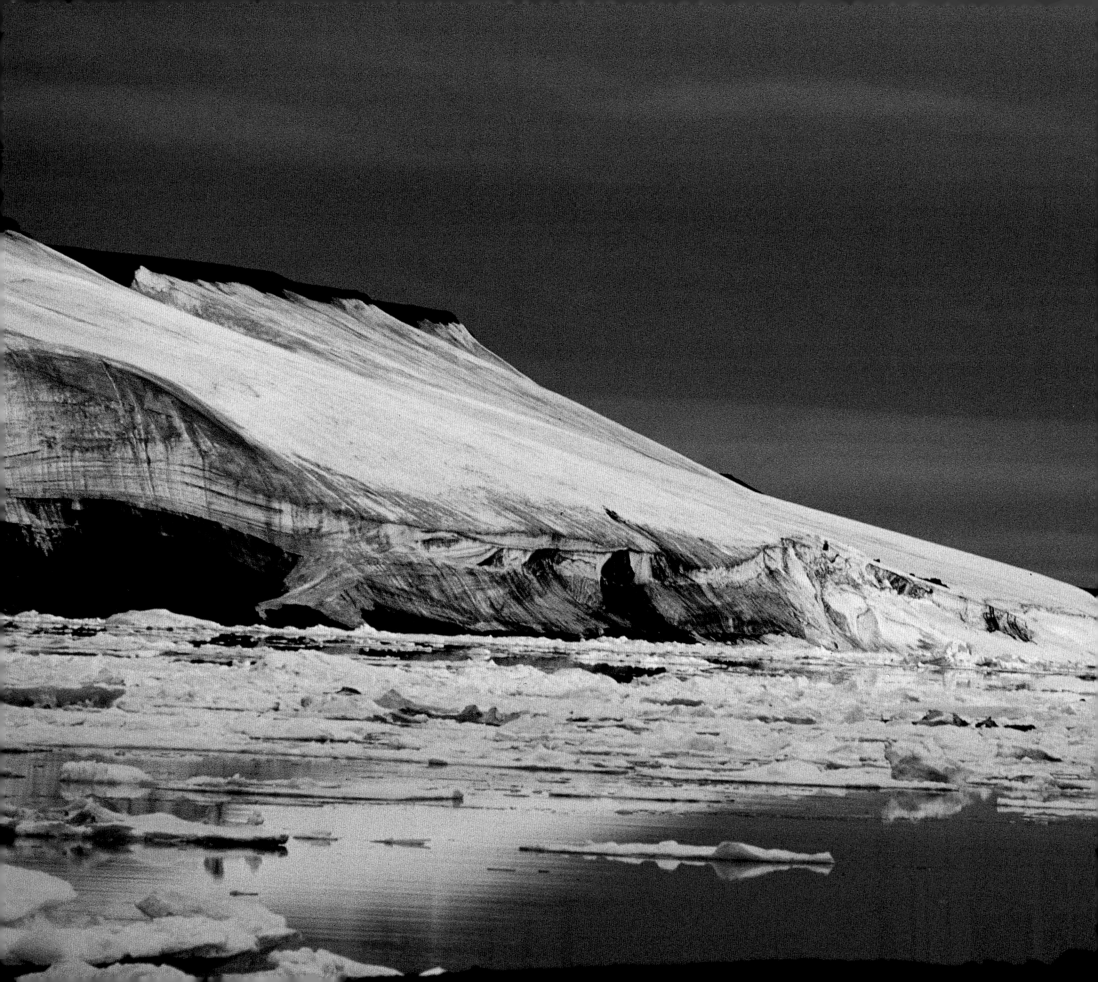

Στο αρχιπέλαγος François-Joseph, στα βόρεια της Σιβηρίας, οι πάγοι, αυτήν τη καλοκαιρινή εποχή, θα κατευθυνθούν προς τις περιοχές του νότου, όπου θα λιώσουν και να διαλυθούν.

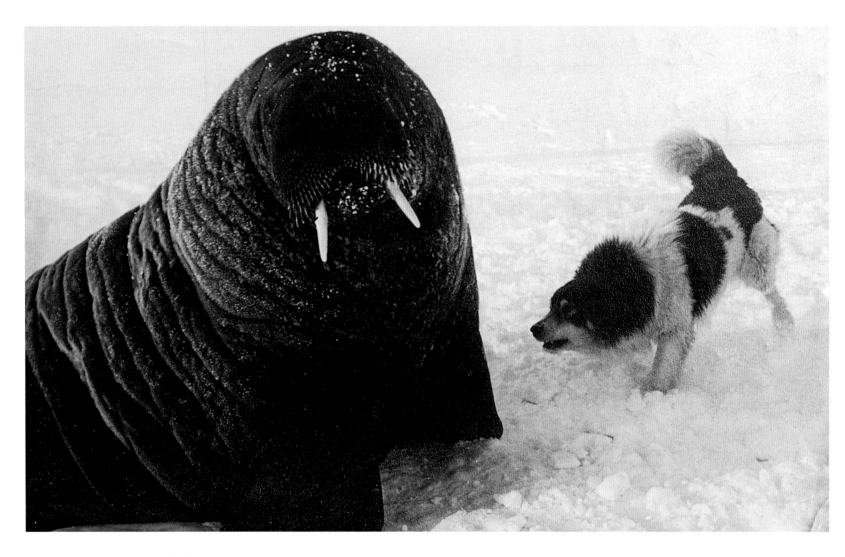

Οι εθνότητες του Μακρινού Βορρά κυνηγούν τον θαλάσσιο ελέφαντα, τη φώκια και τη φάλαινα από καταβολής κόσμου. Δεν υπόκεινται στις ισχύουσες απαγορεύσεις και συνεχίζουν να ψαρεύουν και να κυνηγούν, για να εξασφαλίσουν την επιβίωσή τους.

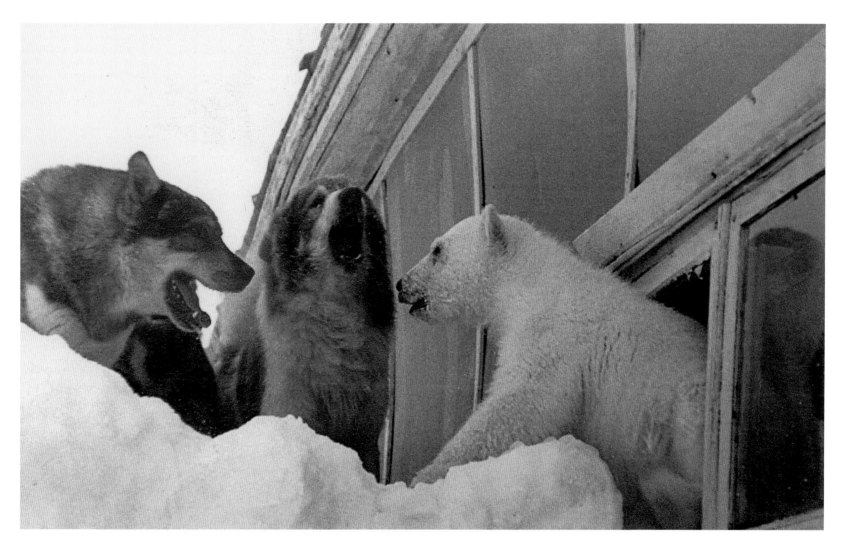

Ο σκύλος, απαραίτητος σύντροφος του ανθρώπου σε αυτές τις πολικές περιοχές, βρίσκεται μόνιμα σε εγρήγορση, προκειμένου να ειδοποιήσει το αφεντικό σε κάθε τυχόν εμφάνιση κάποιου παρείσακτου.

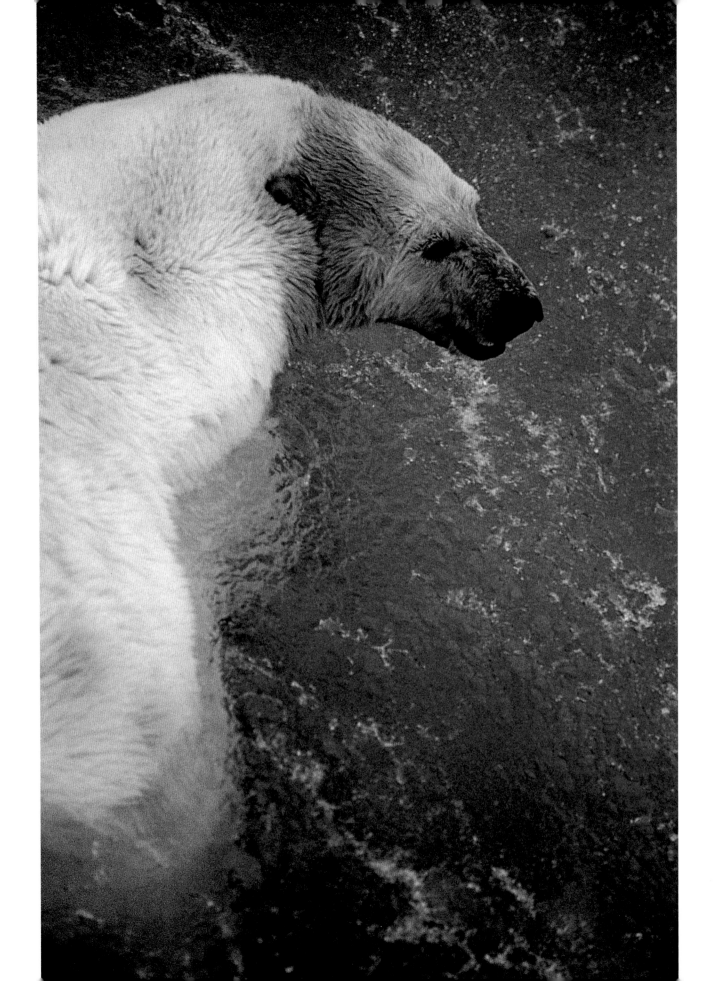

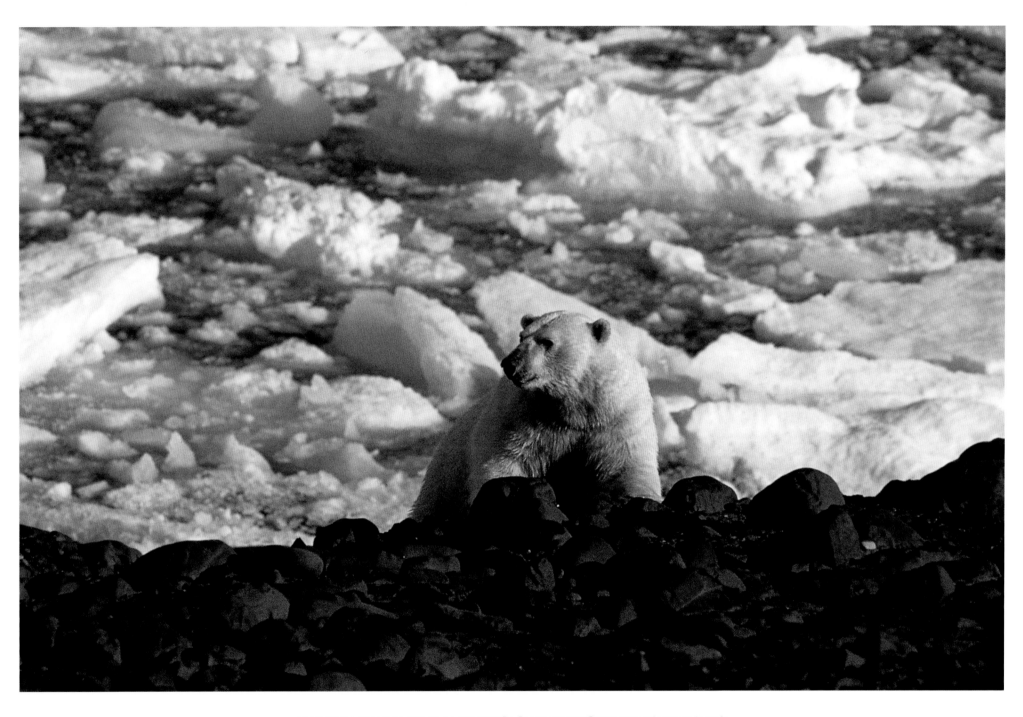

Το πιο μεγάλο σαρκοφάγο της γης, η λευκή αρκούδα, ζει στην παγονησίδα και στους πάγους της Αρκτικής.
Η κύρια τροφή της είναι οι φώκιες. Βάρους από 350 έως 800 κιλά, η πολική αρκούδα μπορεί να διανύσει
περισσότερα από 5.000 χιλιόμετρα τον χρόνο. Είναι επίσης εξαιρετικός κολυμβητής.

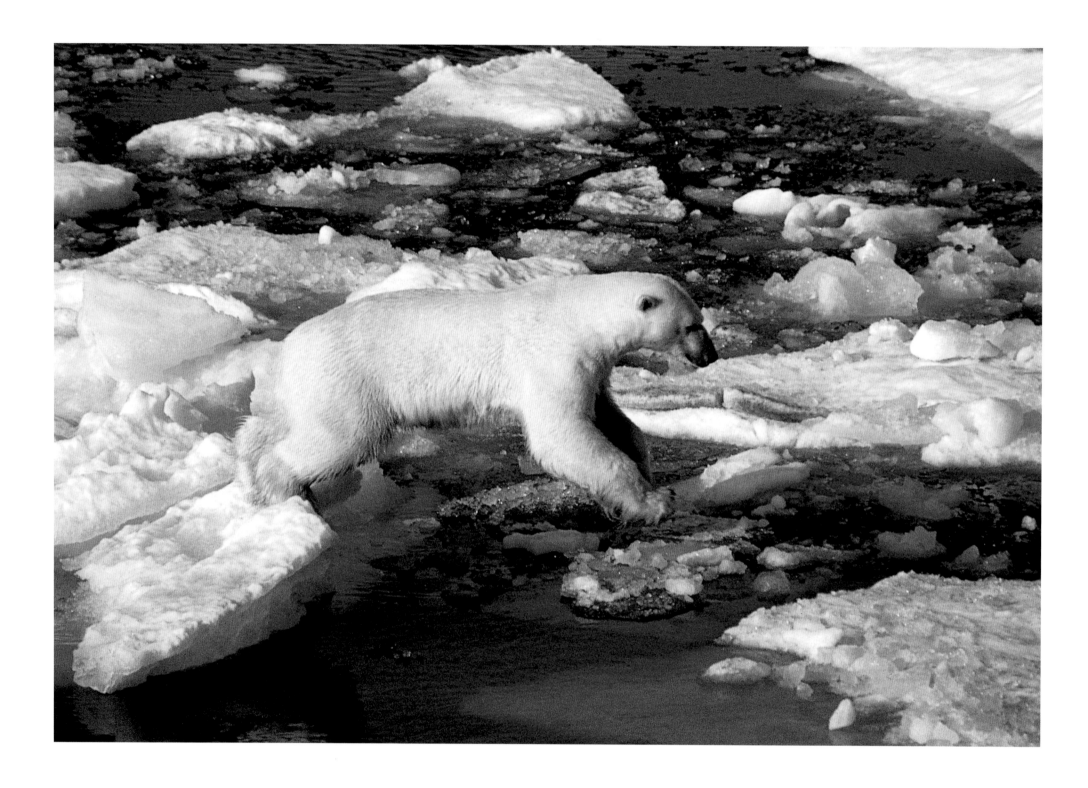

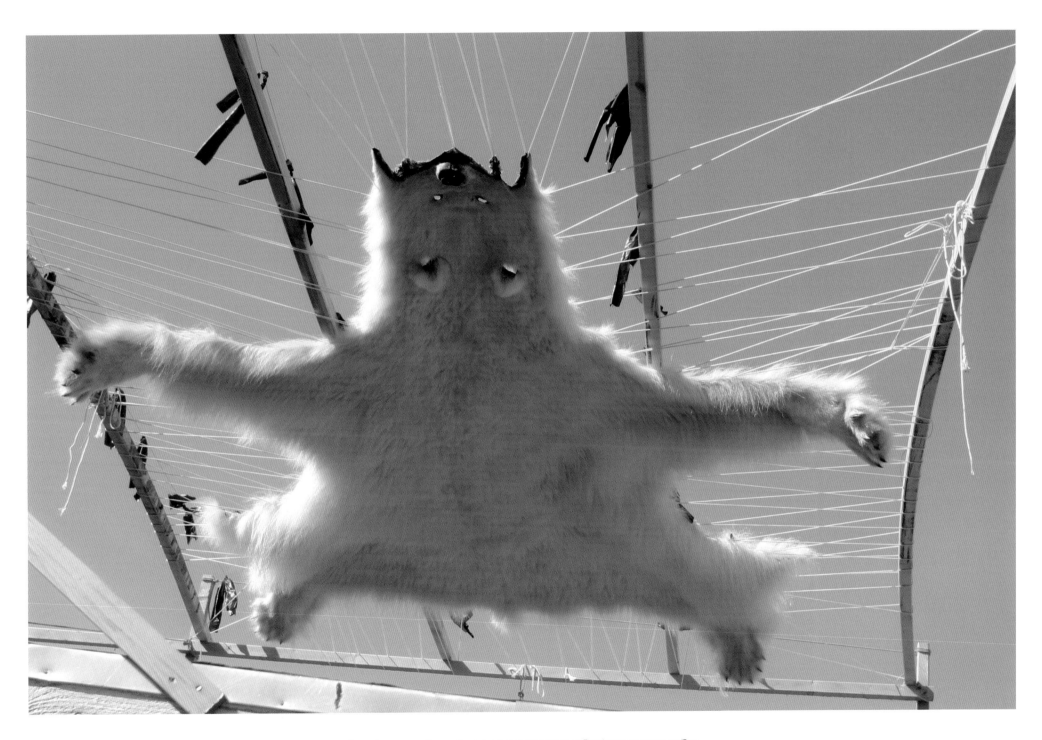

Το κυνήγι της αρκούδας –είδους απειλούμενου λόγω της εξαφάνισης της παγονησίδας–
υπόκειται σε κανονισμούς και οι Inuits είναι οι μόνοι που συνεχίζουν να την κυνηγούν για το
κρέας και το δέρμα της, με το οποίο κατασκευάζουν παντελόνια, μπότες και παντόφλες.

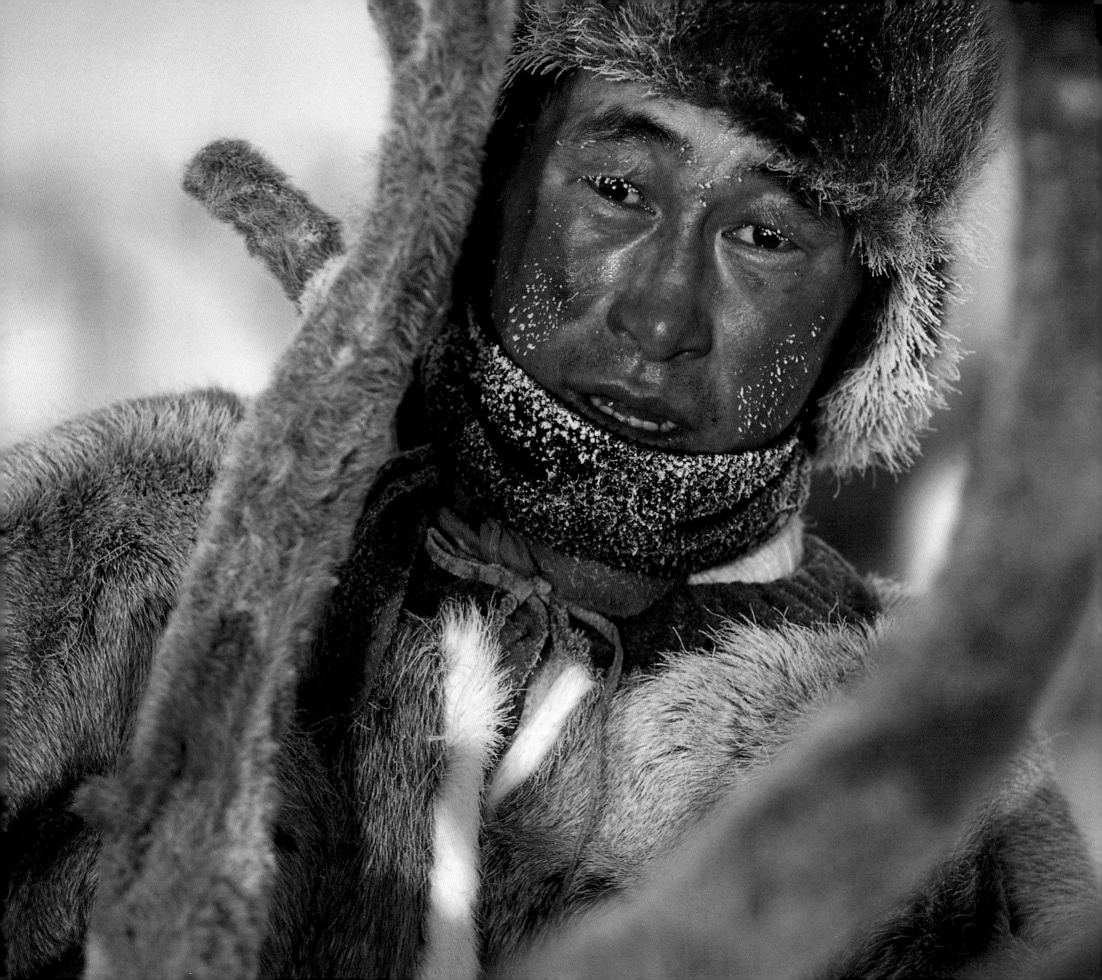

Ο Gavril, Δολγάνος κυνηγός που χρησιμοποιεί παγίδες, μόλις σκότωσε έναν λύκο
που απειλούσε το κοπάδι του από τάρανδους. Το δέρμα στεγνώνει στον
καταυλισμό, και μετά την κατεργασία του, θα χρησιμοποιηθεί για την κατασκευή
έτοιμων ρούχων και chapkas (σκούφων).

▷ Άποψη από αέρος της τούντρας κατά τη διάρκεια του πολικού καλοκαιριού. Ο ποταμός, καθώς ξεπαγώνει, κυλάει ελικοειδώς, και γίνεται τότε η μόνη οδός πρόσβασης σε κάποιους απομονωμένους καταυλισμούς.

▷▷ Στη Σιβηρία, λένε πως «ο χειμώνας δεν διαρκεί παρά δώδεκα μήνες». Παρ' όλα αυτά, το καλοκαίρι υπάρχει, έστω κι αν είναι πολύ σύντομο. Κατά τη διάρκεια αυτών των λίγων εβδομάδων, ο Piotr, ο γέρος Δολγάνος, στήνει έναν καταυλισμό κοντά σε περιοχές, όπου μπορεί να ψαρεύει.

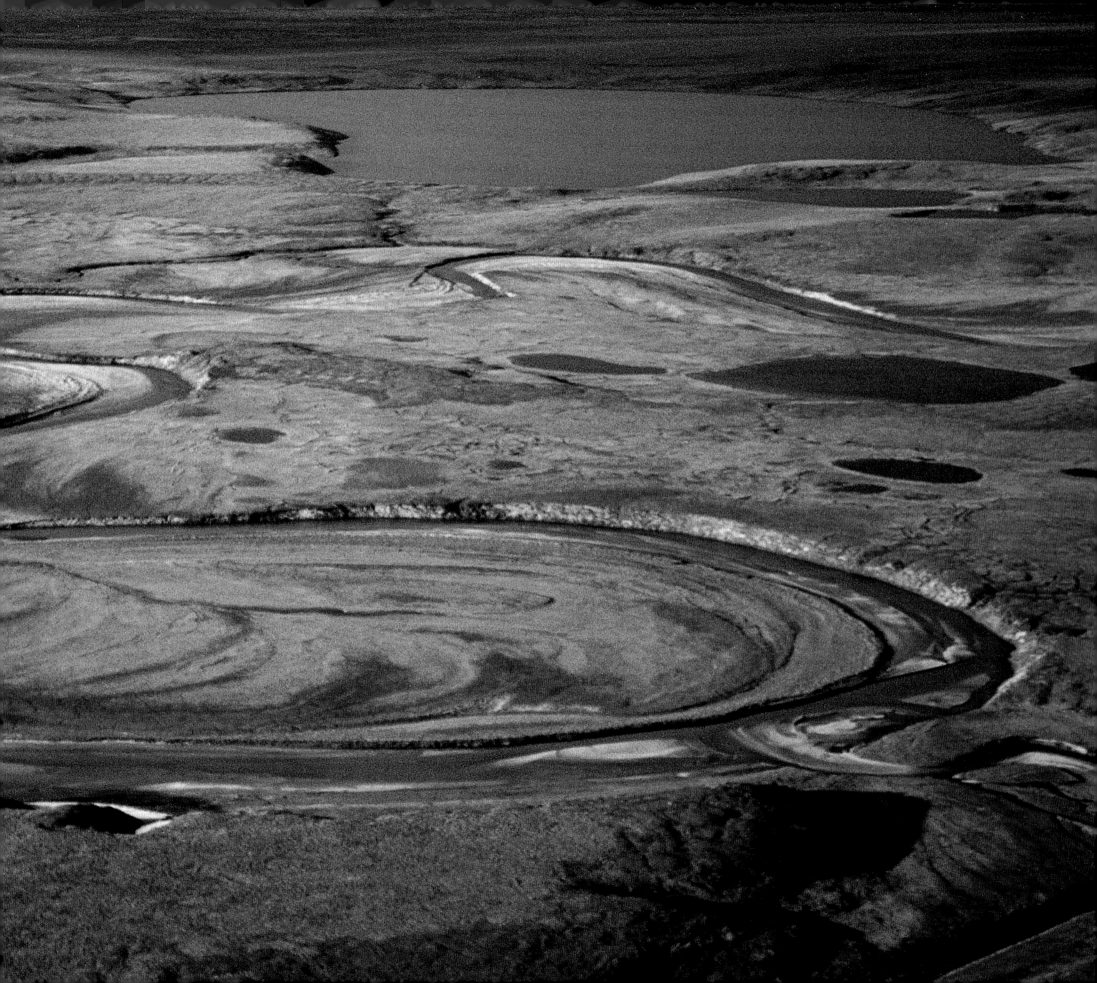

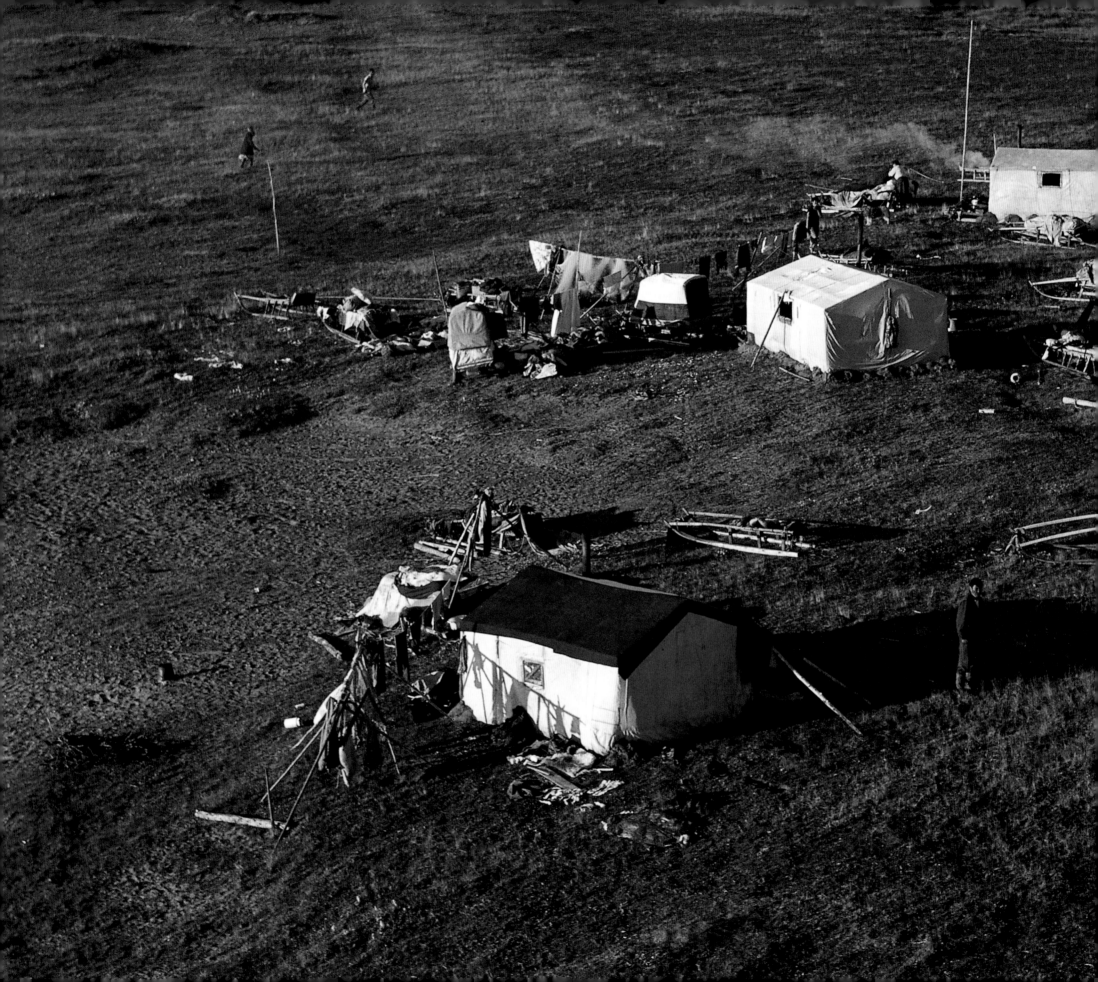

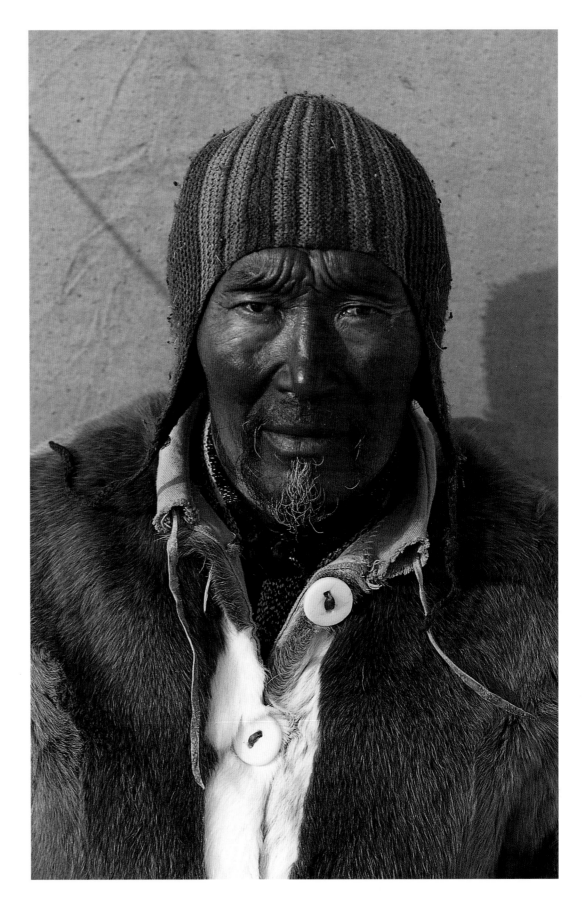

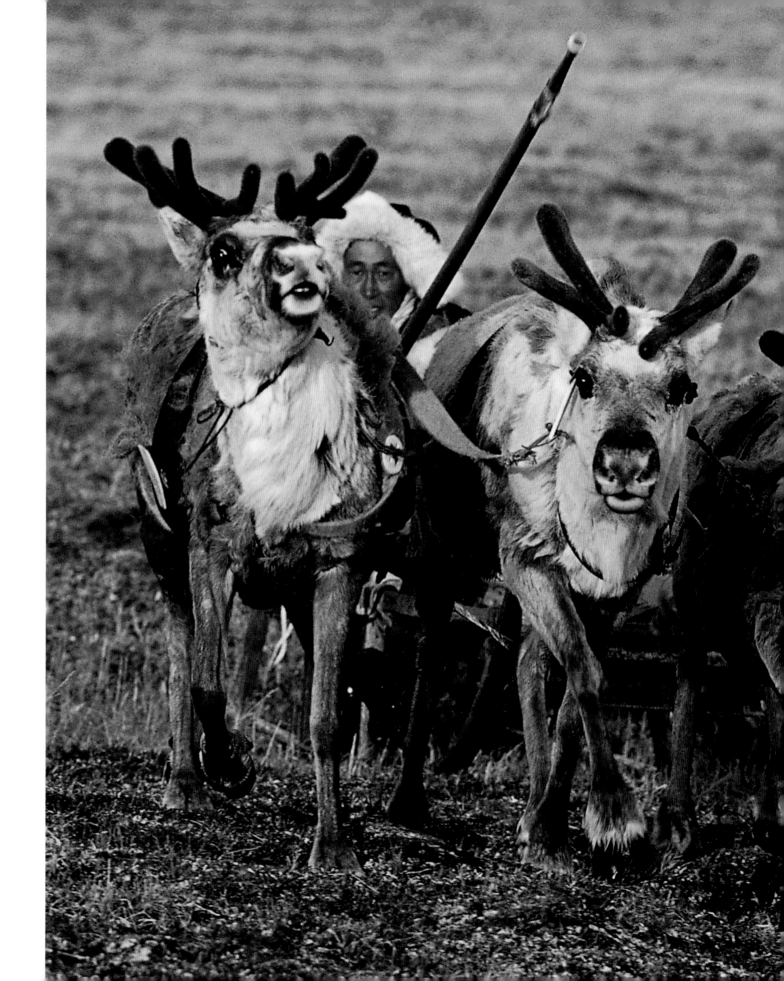

Με αυτό το ελαφρύ έλκηθρο ο Guenadi,
νομάδας από το Taïmyr, διασχίζει την τούντρα,
για να μαζέψει τα επιπλέοντα ξύλα που
παρασύρουν οι ποταμοί και που έρχονται από
τη μακρινή τάιγκα. Αυτά τα ξύλα είναι τα μόνα
καύσιμα που χρησιμοποιούν οι νομάδες.

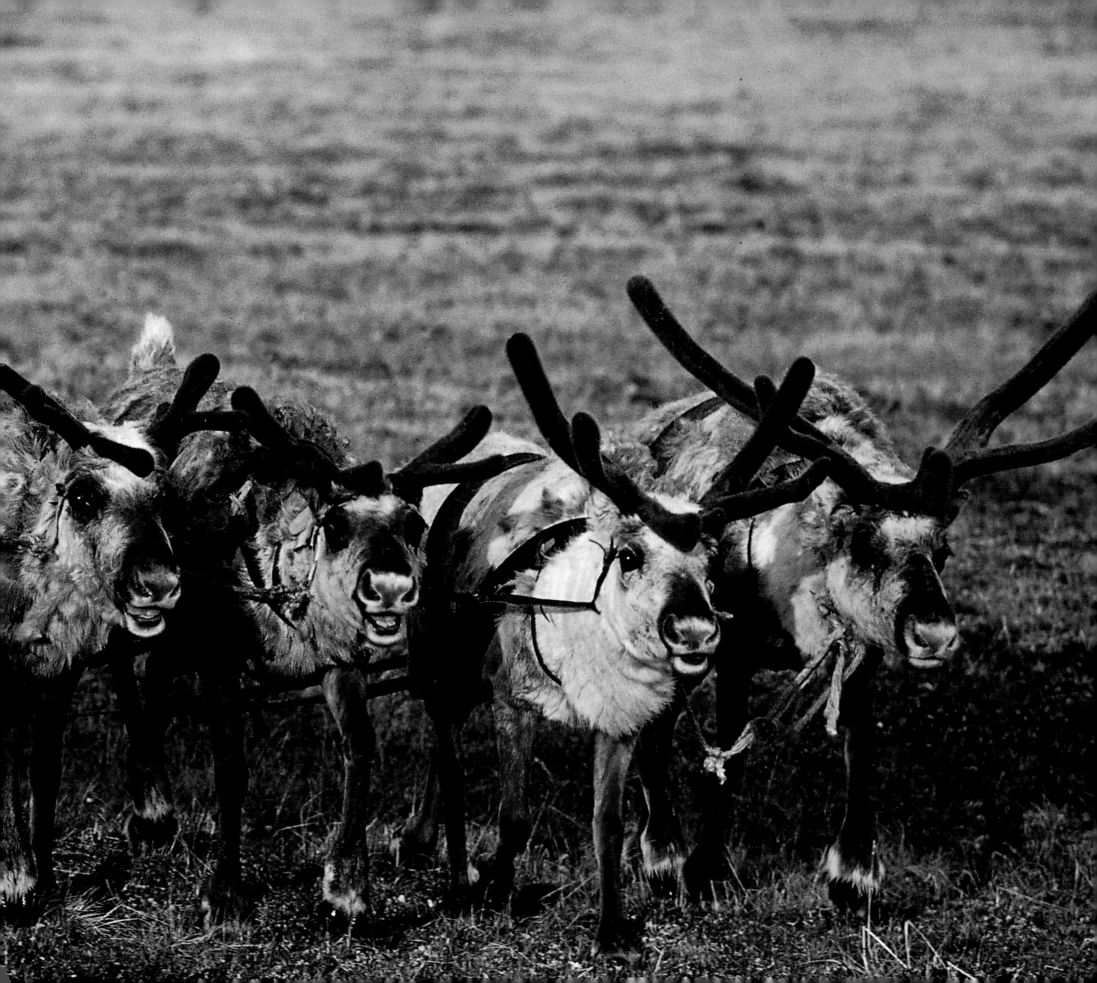

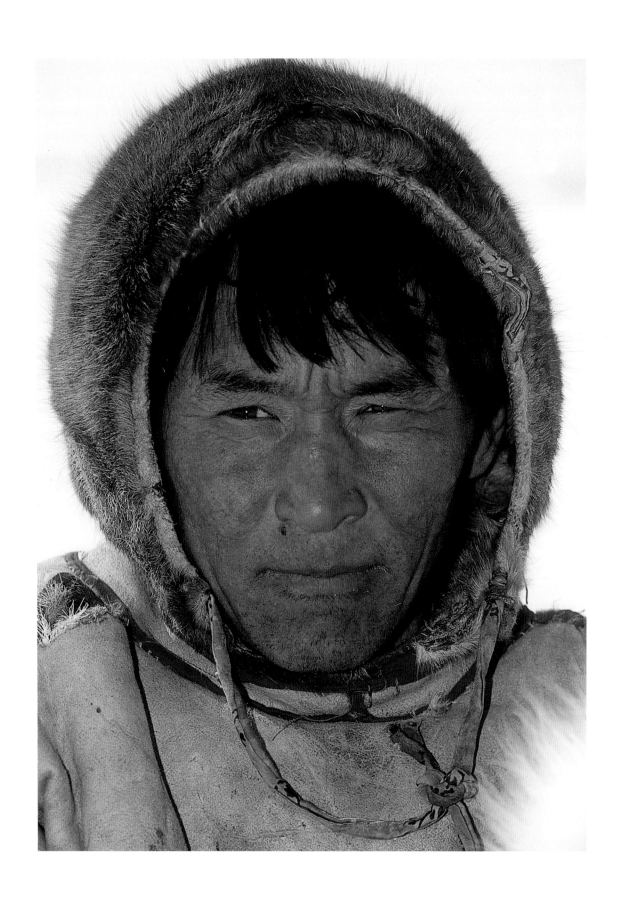

O Guenadi είναι υπεύθυνος μιας
δολγάνικης «ταξιαρχίας».
Μια «ταξιαρχία» περιλαμβάνει μια
οικογένεια ή νομάδες ταξιδιώτες.

Ζώντας με τους λαούς του Βορρά

Οι πληθυσμοί της Αρκτικής διαθέτουν όλοι ένα κοινό χαρακτηριστικό: από τα βάθη των αιώνων καλλιέργησαν μια πραγματική «τέχνη επιβίωσης» σε περιοχές έρημες, ουσιαστικά παγωμένες, όπου δεν υπάρχουν δένδρα, η βλάστηση είναι σπάνια και η πολική νύκτα διαρκεί τους περισσότερους μήνες του χρόνου. Κυνηγοί, ψαράδες, κτηνοτρόφοι και ανέκαθεν νομάδες, οι Εσκιμώοι, παρόντες στη Γροιλανδία, στον Βορρά του Καναδά και μέχρι την Αλάσκα, έχουν κατά πολλούς δημιουργήσει έναν «πολιτισμό της φώκιας», σύμφωνα με την εύστοχη έκφραση του Γάλλου εξερευνητή και συγγραφέα Paul Émile Victor. Άλλοι, όπως οι Λάπωνες, οι Σάμι της Σκανδιναβίας και οι «μικροί λαοί» της Σιβηρίας προσανατολίστηκαν προς τον «πολιτισμό του ταράνδου». Πάντα έξω από τις εξελίξεις του σύγχρονου κόσμου, οι λαοί αυτοί σήμερα είναι όλο και λιγότερο νομαδικοί όλο και περισσότερο «αστικοποιημένοι», με ελάχιστες εξαιρέσεις, όπως αυτήν των Δολγάνων στην αυτόνομη περιοχή του Taïmyr στη Ρωσία, που είναι από τους τελευταίους νομάδες των πάγων.

Κι όμως, οι αυτόχθονες πληθυσμοί του πολικού κύκλου έχουν μακρά παράδοση νομαδικότητας. Για παράδειγμα, ήδη από την ανακάλυψή τους το 1576 στη Γροιλανδία, από τον Άγγλο τυχοδιώκτη και πειρατή Martin Frobisher, η παρουσία των Inuits (όνομα που δίνουν οι Εσκιμώοι στους εαυτούς τους και που σημαίνει Άνθρωπος) στο μεγαλύτερο νησί του κόσμου δημιουργεί απορίες. Η παρουσία αυτή εξηγείται λόγω μιας μεγαλειώδους μετανάστευσης που επιχειρήθηκε από μικρές ομάδες των είκοσι ή τριάντα ατόμων που έψαχναν μια καλύτερη ζωή πάντα με κατεύθυνση προς ανατολάς. Οι πρώτοι πρόγονοι των Εσκιμώων που έφτασαν ίσως από τη Μογγολία, είχαν πιθανόν ξεκινήσει από τα βορειοανατολικά της Σιβηρίας. Οι εθνολόγοι δεν γνωρίζουν με ακρίβεια ούτε το πότε ούτε το πώς. Θα είχαν διασχίσει τον Βερίγγειο πορθμό για να εγκατασταθούν στην Αλάσκα, όπου αρχαιολογικοί χώροι επιβεβαιώνουν την παρουσία τους γύρω στο 10.000 π.Χ. Κυνηγημένοι από τις πιο βόρειες ινδιάνικες φυλές, προχώρησαν στην Καναδική Αρκτική, ψαρεύοντας φάλαινες κοντά στα νησιά του Μπαφέν και του Σόμερσετ. Κάποιοι συνέχισαν την πορεία

τους, τρεφόμενοι με φώκιες, κυνήγι και ψάρια. Έτσι, πιθανόν έφτασαν στη Γροιλανδία από τη βορειοδυτική ακτή ανάμεσα στο 2050 και το 1700 π.Χ. Ακολούθησαν και άλλα μεταναστευτικά κύματα. Εξοικειωμένοι με τη ζωή στην Αρκτική, οι Εσκιμώοι αντιστάθηκαν στην ψύχρανση του κλίματος που οδήγησε σε μια μικρή περίοδο παγετώνων γύρω στο 1500. Είναι πάντοτε αυτάρκεις, μετακινούνται με έλκηθρα που τα σέρνουν σκύλοι, ταξιδεύουν στη θάλασσα με καγιάκ, στη διάρκεια του σύντομου καλοκαιριού. Το κυνήγι της φώκιας, του θαλάσσιου ελέφαντα, της φάλαινας και μερικές φορές και της πολικής αρκούδας τούς εξασφαλίζει τα βασικά: γούνες, δέρματα, κρέας και λάδι για φωτισμό.

Οι καιροί όμως έχουν σημαντικά αλλάξει. Στη Γροιλανδία, που της έχει παραχωρηθεί καθεστώς αυτονομίας από το βασίλειο της Δανίας, οι αυτόχθονες (περίπου 55.000) κατοικούν πλέον στις παράκτιες πόλεις, ενώ οι Καναδοί Εσκιμώοι εγκαθίστανται στα παλιά χωριά-σταθμούς επεξεργασίας γούνας. Κατάφεραν να δημιουργήσουν το 1999 μια περιοχή 2 εκατ. τετραγωνικών χιλιομέτρων, το Nunavut (που σημαίνει «η γη μας», στη διάλεκτό τους). Η περιοχή αυτή είναι από τις πιο αραιοκατοικημένες στον κόσμο. Χωρισμένοι σε 28 κοινότητες, περίπου 21.250 Εσκιμώοι (το 85% του πληθυσμού) προσπαθούν σήμερα να ανακτήσουν την επαφή με τις παραδόσεις τους.

Τις ίδιες παραδόσεις προσπαθούν να διατηρήσουν και οι τελευταίοι νομάδες, οι Δολγάνοι. Από τη μακρινή τους καταγωγή, αυτοί οι κυνηγοί και κτηνοτρόφοι ταράνδων διηγούνται έναν μύθο, σύμφωνα με τον οποίο γεννήθηκαν εδώ, στην τούντρα του Taïmyr, όταν σβώλοι χώματος έπεσαν από το βουνό και κύλησαν πάνω στην άμμο. Οι σβώλοι έδωσαν ζωή σε ένα αγόρι και ένα κορίτσι που τρέφονταν με χόρτα. Τα παιδιά μεγάλωσαν και συνάντησαν τους ταράνδους, τους οποίους έδεσαν με ένα χορταρένιο σχοινί. Έπειτα, η κοπέλα απέκτησε δύο παιδιά και ο θηλυκός τάρανδος δύο μικρά... κ.λπ., κ.λπ., μέχρι την ημέρα που οι τάρανδοι έσπασαν τα δεσμά τους, έφυγαν και σχημάτισαν κοπάδια καριμπού.

Σήμερα οι Δολγάνοι (περίπου 7.000) αποτελούν, μαζί με τους Nganassanes, τον μοναδικό αυτόχθονα πληθυσμό τού Taïmyr, μιας απέραντης περιοχής

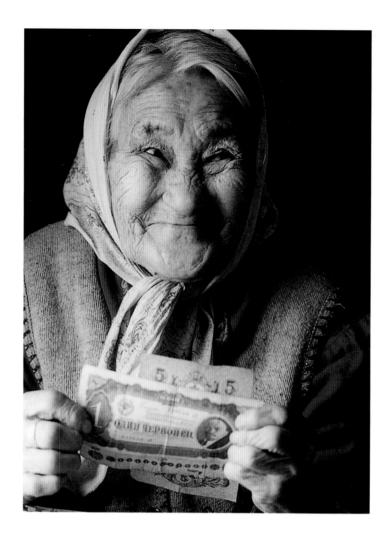

Η Anna Antonova είναι η πιο ηλικιωμένη Δολγάνα. Γνώρισε την εποχή του Λένιν και κρατά ευλαβικά ένα χαρτονόμισμα με την εικόνα του ηγέτη τής επανάστασης των μπολσεβίκων.

(862.100 τετραγωνικά χιλιόμετρα), της πιο βόρειας της Σιβηρίας. Αποτελούν μέρος των 26 φυλών που καταγράφηκαν στον βορρά των ευρωπαϊκών και ασιατικών περιοχών της πρώην Σοβιετικής Ένωσης, το 1925, με την ονομασία «μικροί λαοί του Βορρά». Οι Δολγάνοι που, κάτω από την πίεση της σοβιετικής διοίκησης, σταμάτησαν τον νομαδικό βίο και εγκαταστάθηκαν στα εδάφη τους, συνεχίζουν να ζουν στις πόλεις, όπου δεν έχουν καταφέρει να ξεφύγουν από τη φτώχεια και το αλκοόλ. Ο μέσος όρος ζωής τους (ή προσδοκία ζωής) είναι κατώτερος των 50 ετών.

Αλλά η τούντρα φιλοξενεί ακόμη μια φούχτα ανθρώπουν που δεν άλλαξαν, διακόσια πενήντα περίπου άτομα που συνεχίζουν, παρά το χιόνι και το ακραίο κρύο (μέχρι και 60 βαθμούς κάτω του μηδενός), τη νομαδική ζωή και τη συμβίωσή τους με τον κόσμο των πάγων. Οι πρόγονοί τους που προήλθαν από τη μείξη των φυλών Evenks και Ρώσων αποίκων που εγκαταστάθηκαν στην περιοχή τον 18ο αιώνα, γνώριζαν τον Βορρά και είχαν εγκλιματιστεί εκεί.

Έστησαν ταπεινές καλύβες και συχνά μέσα σε ένα σπίτι διέμεναν πολλές οικογένειες. Λίγο λίγο οι ίσμπες αυτές μετεξελίχθηκαν σε κωνικές στρογγυλές κατασκευές που σκεπάζονταν με πλάκες γης. Ονομάζονταν *golomos* και χρησίμευαν για τις μέρες του χειμώνα, ενώ το καλοκαίρι κατοικούσαν στα *tchoums* που ήταν φτιαγμένα από δέρματα ταράνδων. Στην αρχή, έστηναν παγίδες, ιδιαίτερα στα ζώα με πολύτιμη γούνα, αργότερα όμως οι Δολγάνοι άρχισαν να κυνηγούν άγριους ταράνδους. Εξερεύνησαν νέες περιοχές, μελέτησαν τα βοσκοτόπια και εκμεταλλεύτηκαν τα πιο παραγωγικά από αυτά. Ο πολιτισμός του ταράνδου τους υποχρέωσε να ζουν νομαδικά χρόνο με χρόνο και έτσι υιοθέτησαν το *balok*, ένα μικρό σπίτι-έλκηθρο. Η επέκτασή τους έγινε με γοργούς ρυθμούς έως τις αρχές του 20ού αιώνα.

Τη δεκαετία του 1930, οι Σοβιετικοί δημιούργησαν κολχόζ μέσα στην τούντρα, που βασίζονταν στην κοινή ιδιοκτησία των κοπαδιών και των εργαλείων κυνηγιού ή ψαρέματος. Δεκαετίες επιβολής μιας καινούργιας

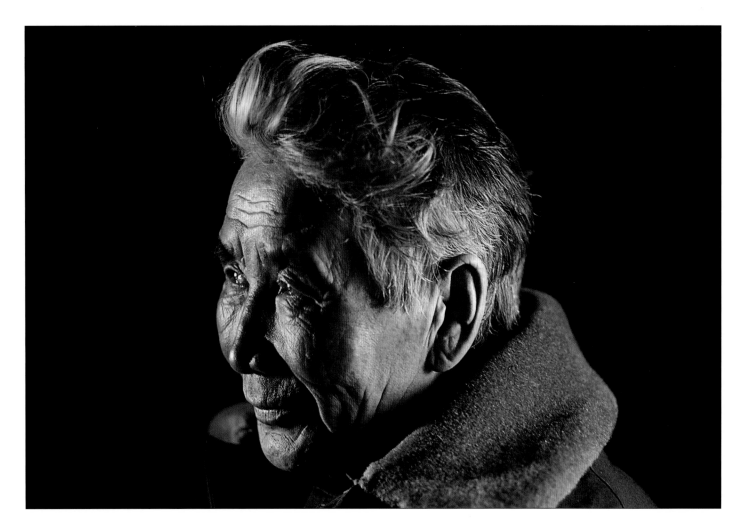

κουλτούρας προκάλεσαν αμετάκλητη καταστροφή στον παραδοσιακό τρόπο ζωής των Δολγάνων. Επί πλέον, η εκβιομηχάνιση της περιοχής έβλαψε σοβαρά το οικοσύστημα της ντόπιας πανίδας. Το Taïmyr φιλοξενεί τις μεγαλύτερες αγέλες άγριων ταράνδων στον κόσμο, που σήμερα υπολογίζεται ότι αριθμούν περίπου ένα εκατομμύριο κεφάλια, όμως η φρικτή μόλυνση, προερχόμενη από τα εργοστάσια παραγωγής νίκελ, χαλκού και κοβαλτίου γύρω από βιομηχανική περιοχή Norilsk, υποχρέωσε τα κοπάδια να μεταβάλουν τις συνήθειές τους και να αναζητήσουν νέα βοσκοτόπια γύρω από την πόλη Khatanga, βορειότερα στη χερσόνησο. Οι νέες αυτές μετακινήσεις διαταράσσουν την ισορροπία των οικόσιτων ταράνδων που καταφέρνουν και ξεφεύγουν από κάθε επιτήρηση, για να ακολουθήσουν τα εντυπωσιακά άγρια αρσενικά, όταν μία φορά τον χρόνο περνούν από τα μέρη τους. Εξάλλου, τόσο οι οικόσιτοι όσο και οι άγριοι τάρανδοι ανταγωνίζονται μεταξύ τους στην αναζήτηση λειχήνων που αποτελούν τη βάση της διατροφής τους. Για να επιβιώσουν, πολλοί Δολγάνοι που μέχρι

χθες έτρεφαν ταράνδους, τα τελευταία χρόνια στράφηκαν στο κυνήγι, δραστηριότητα πολύ πιο αβέβαιη, καθώς είναι απολύτως εποχική.

Οι οικονομικές δυσκολίες που αντιμετώπισαν οι Δολγάνοι μετά την περεστρόικα, το 1985, και το τέλος του κράτους πρόνοιας, επιδεινώθηκαν λόγω της ανόδου των τιμών, ιδιαιτέρως της αύξησης των τιμών μεταφοράς που τη χρεώνονται οι παραγωγοί ταράνδων και η οποία επηρεάζει την πώληση του κρέατος. Επί πλέον, οι Δολγάνοι που θεωρούνται οι φύλακες του «ελεφαντοστού» του μαμμούθ, του οποίου οστά βρίσκονται παντού μέσα στο έδαφός τους, αντιμετωπίζουν την απληστεία των ασυνείδητων εμπόρων. Μετά από την απαγόρευση εμπορίας του ελεφαντοστού, οι τιμές των οστών του μαμμούθ εκτινάχθηκαν στα ύψη, με αποτέλεσμα καθημερινά να αποδεκατίζονται αυτά τα απομεινάρια, που εδώ και χιλιετίες βρίσκονταν θαμμένα μέσα στο παγωμένο έδαφος. Οι τελευταίοι νομάδες Δολγάνοι δεν εγκρίνουν αυτό το εμπόριο: φοβούνται ότι εξαντλούν τους πόρους της τούντρας. Πιστοί στους προγονικούς

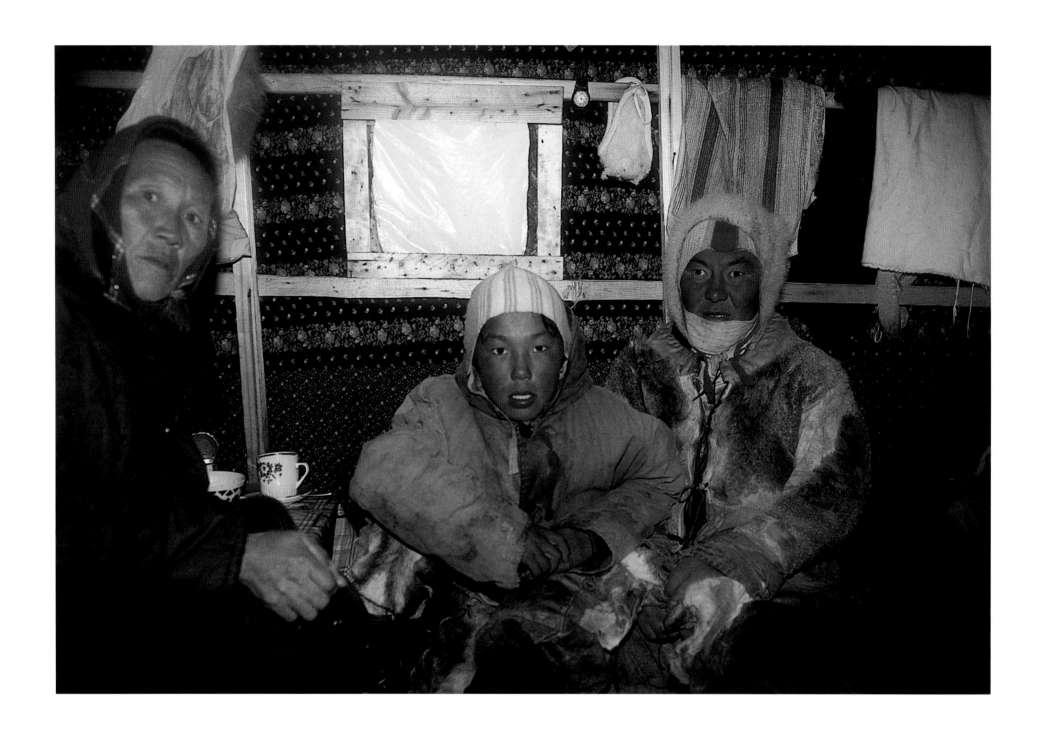

Καθημερινή ζωή μιας οικογένειας νομάδων μέσα στο balok (το μικρό σπίτι, μήκους τριών και πλάτους δύο μέτρων) που είναι σκεπασμένο από δέρματα ταράνδων και συναρμολογημένο επάνω σε έλκηθρα.

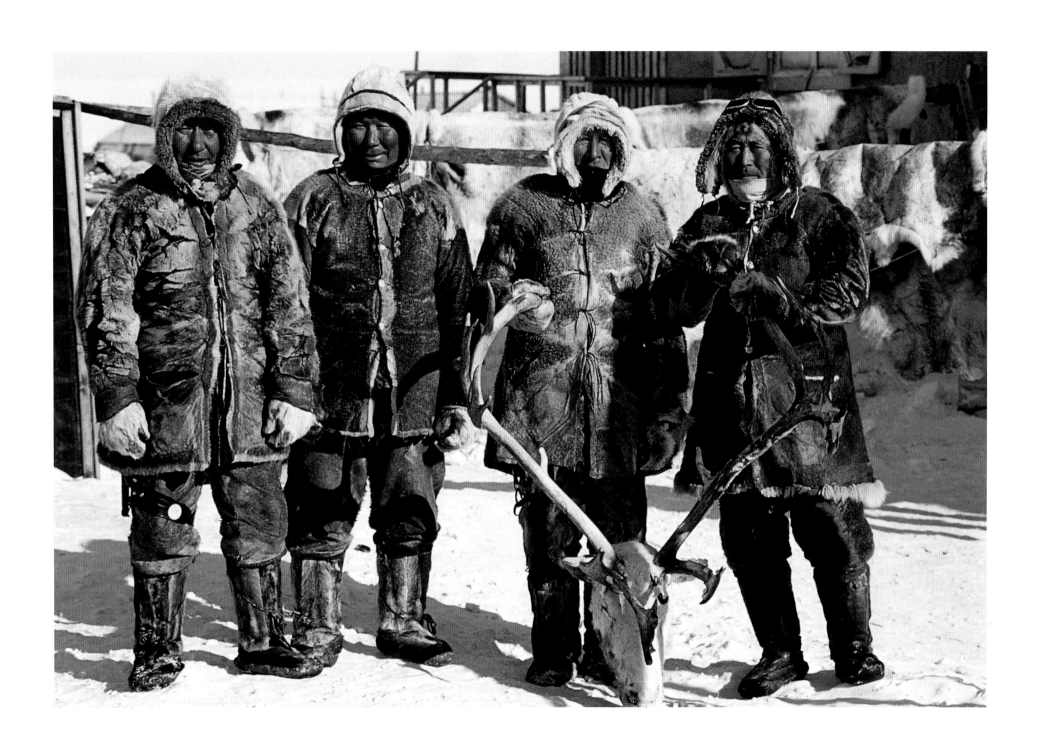

Οι Nganassanes, μια από τις εθνότητες του Ταϊμύρ, ποζάρουν μαζί με το τρόπαιό τους,
φτιαγμένο με το κεφάλι και τα κέρατα ενός άγριου τάρανδου.

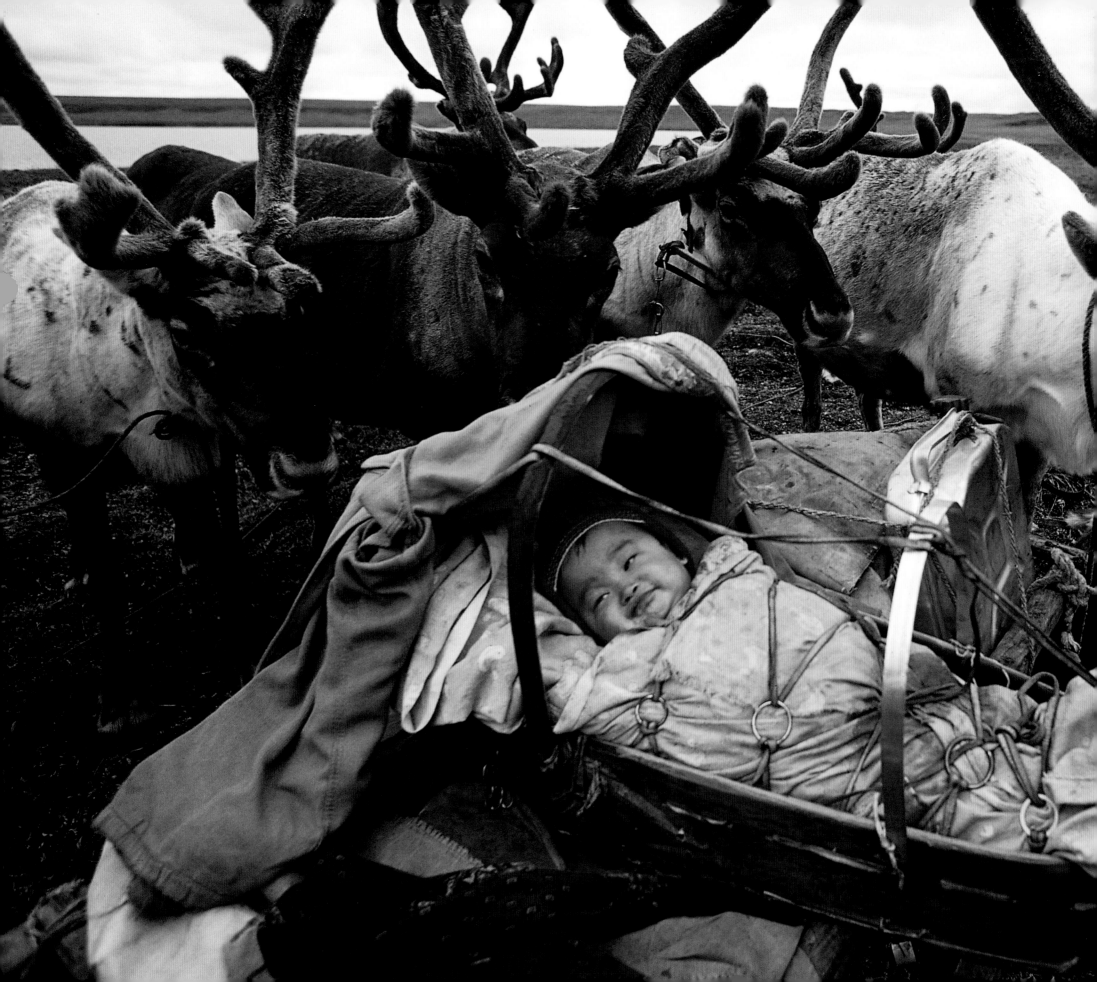

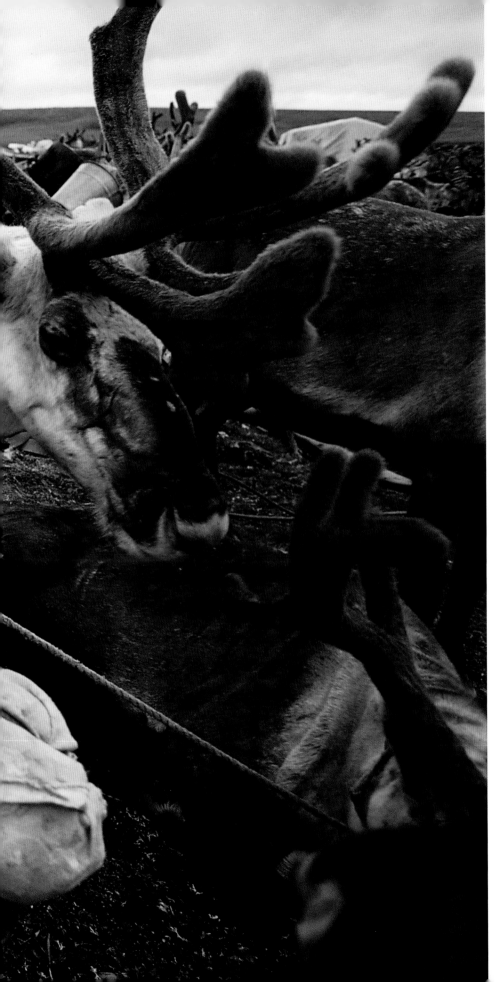

τους νόμους, με βαθιές ρίζες στον σαμανισμό, γνωρίζουν ότι είναι απαραίτητο να ζει κανείς σε αρμονία με τη γη και να σέβεται αυτό που του δίνει.

Μετά την κατάρρευση της σοβιετικής αυτοκρατορίας, οι Δολγάνοι πασχίζουν να επανασυνδεθούν με τις παραδόσεις τους, όπως είναι η γιορτή του Popigay, που στο τέλος του Απριλίου χαιρετίζει την επιστροφή του ήλιου. Η κοινότητα μαζεύεται τότε για να κάψει το σκιάχτρο που συμβολίζει τη μακρά και δύσκολη πολική νύχτα. Η θερμοκρασία ανεβαίνει, η φύση επωφελείται, οι τάρανδοι γεννούν, τα αποδημητικά πουλιά επιστρέφουν...

Για όλους τους Εσκιμώους, τους Λάπωνες και τις μικρές φυλές της Σιβηρίας το τέλος της πολικής νύχτας είναι μια στιγμή χαράς και οι γιορτές που την εκφράζουν ανάγονται στις απαρχές της νομαδικής ζωής. Όμως οι λαοί της Αρκτικής δεν χαίρονται καθόλου με την αύξηση της θερμοκρασίας του πλανήτη, η οποία, αντί να κάνει πιο ήπια τη ζωή τους, κινδυνεύει να τους οδηγήσει στην καταστροφή.

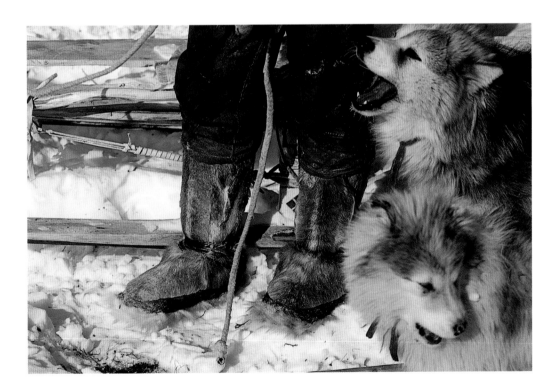

Το μωρό των Δολγάνων, από τους πρώτους κιόλας μήνες της ζωής του, ταξιδεύει πάνω στο έλκηθρο των γονιών του και θα συνεχίσει να τους συνοδεύει σε όλη τη διάρκεια της αδιάκοπης εποχικής μετακίνησής τους.

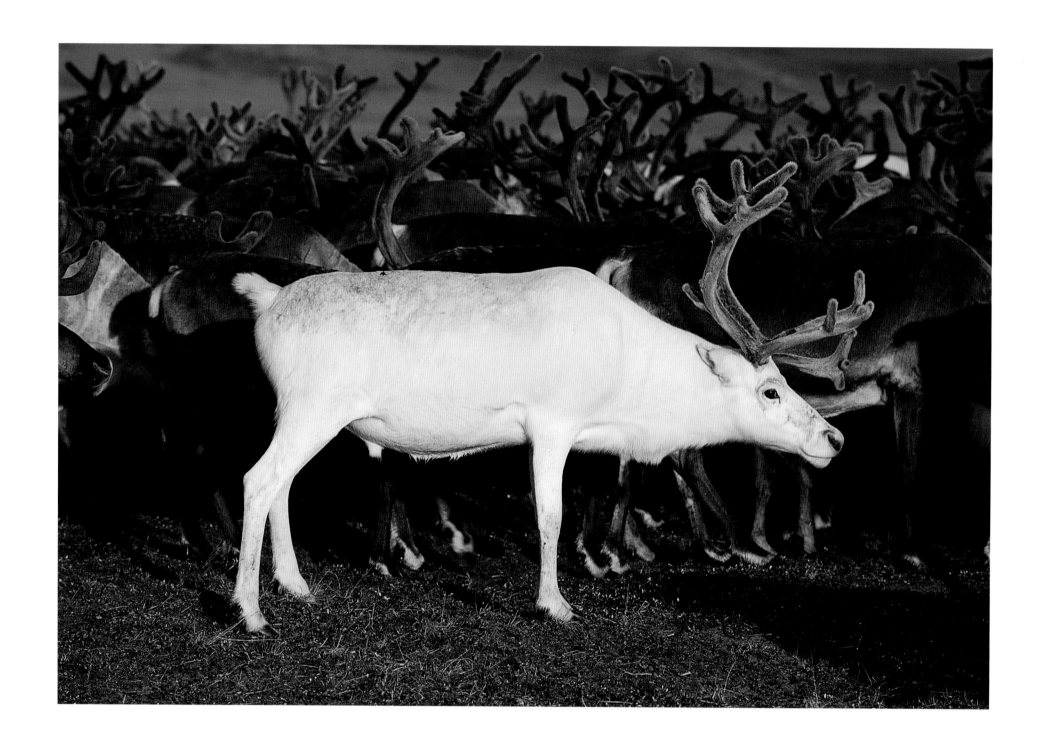

Για τους Δολγάνους, ο άσπρος τάρανδος είναι δώρο των πνευμάτων της τούντρας.
Προορισμός τού ζώου είναι να γίνει προσφορά σ' έναν ιερό χώρο, με σκοπό να
εξασφαλιστεί η προστασία εκ μέρους των πνευμάτων.

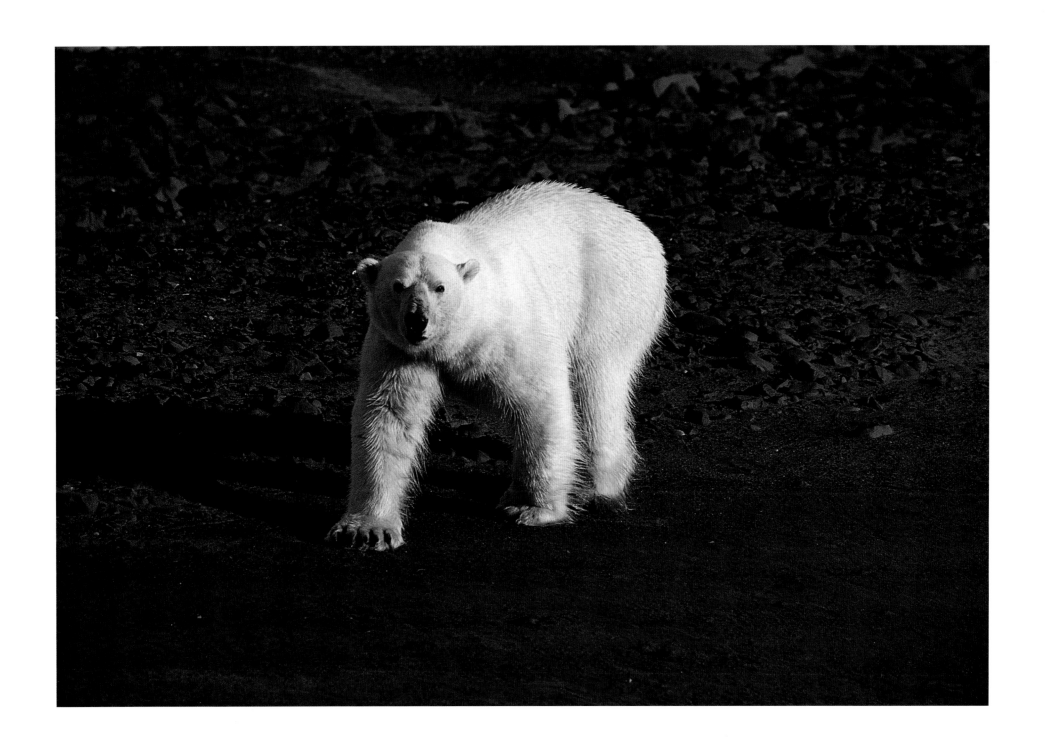

Κατά τη διάρκεια του σύντομου καλοκαιριού του Βορρά, η λευκή αρκούδα αναζητά την τροφή της. Καθώς οι πάγοι έχουν εξαφανιστεί, ψάχνει για μικρά στεριανά θηράματα, όπως ο λέμμος ή τα πουλιά που φτιάχνουν τις φωλιές τους.

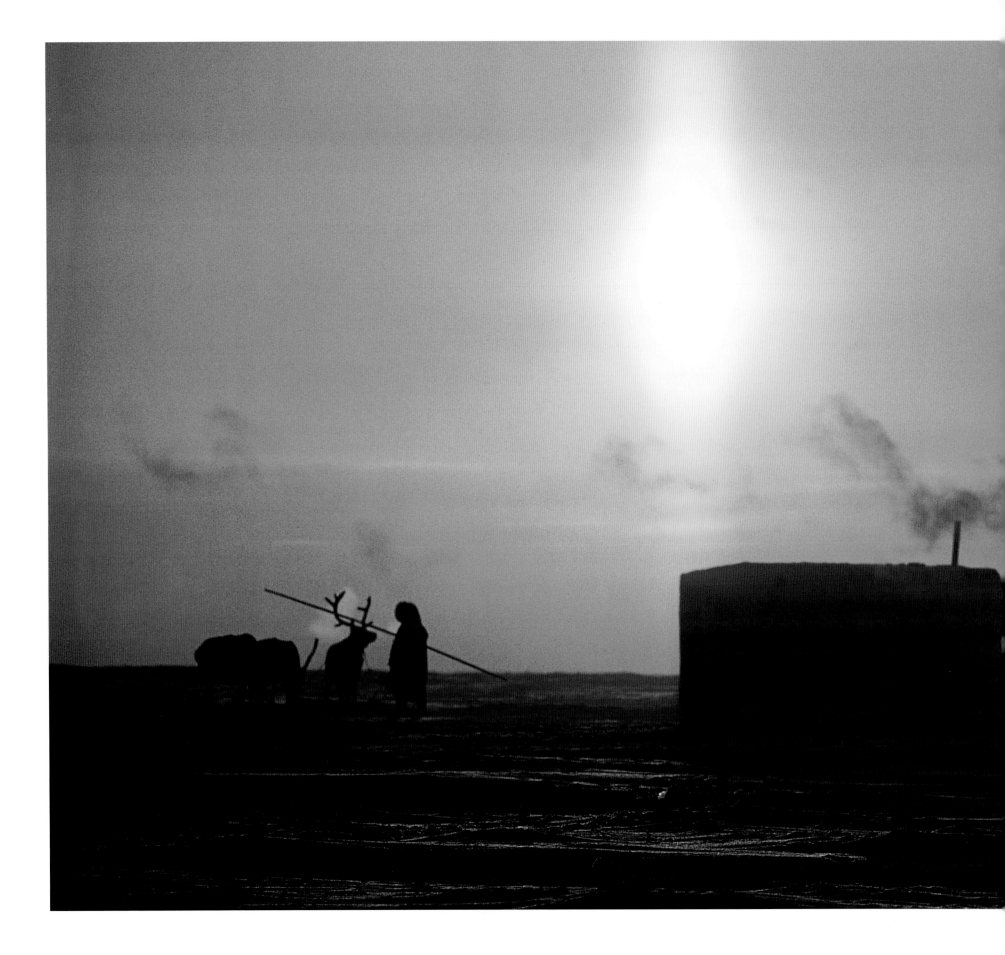

Κάτω από τον ήλιο με τις κόκκινες ανταύγειές του στο τέλος του φθινοπώρου, ο καταυλισμός των νομάδων ετοιμάζεται για τη μακριά πολική νύχτα, που θα τους απομονώσει από τον υπόλοιπο κόσμο για τέσσερις μήνες.

127

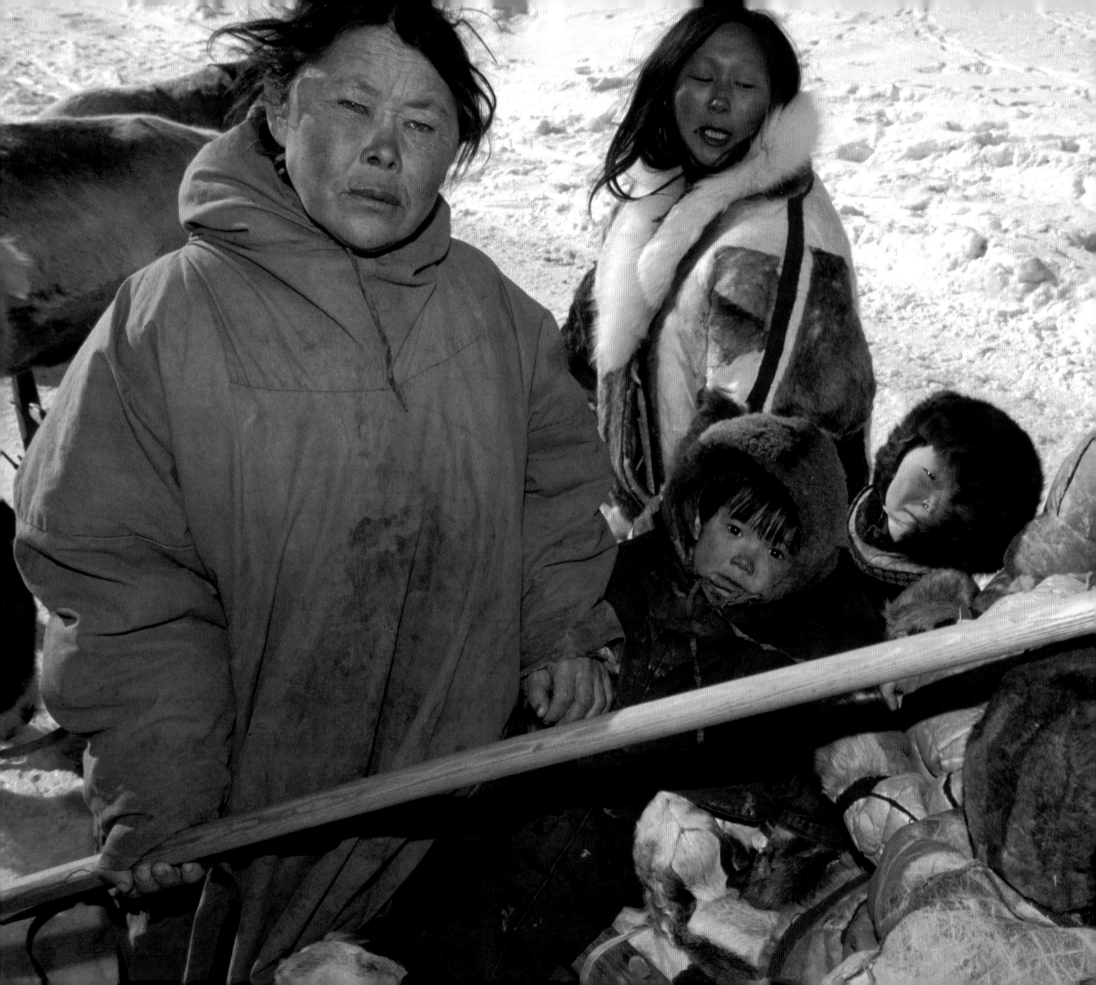

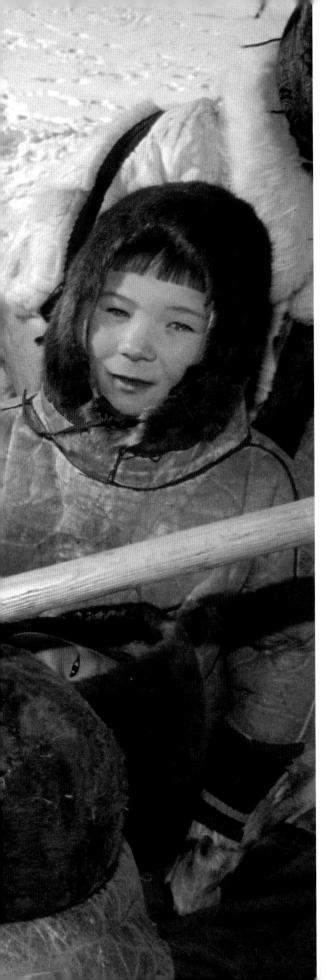

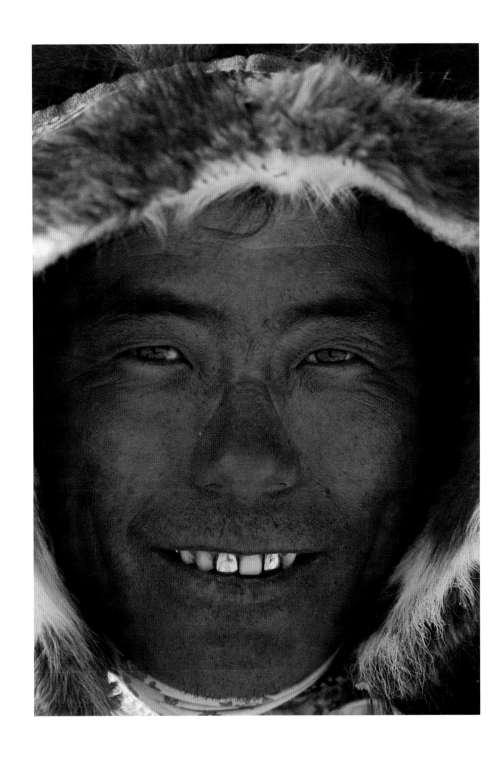

Η κοινότητα Nganassane είναι ένας από του είκοσι έξι «μικρούς λαούς» της Σιβηρίας, όπως τους αποκαλούσε ο Στάλιν.

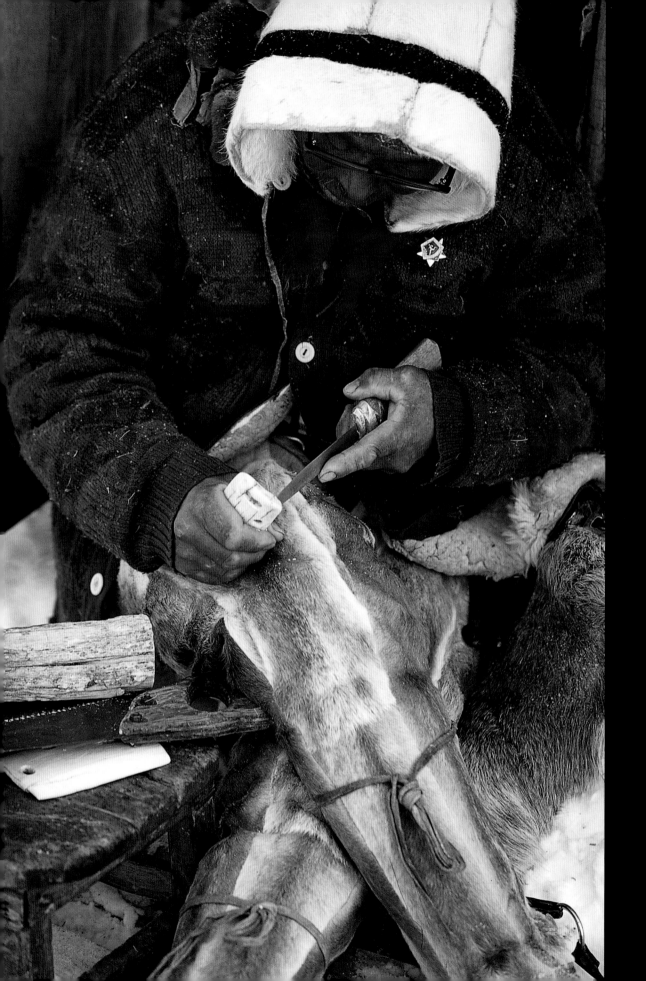

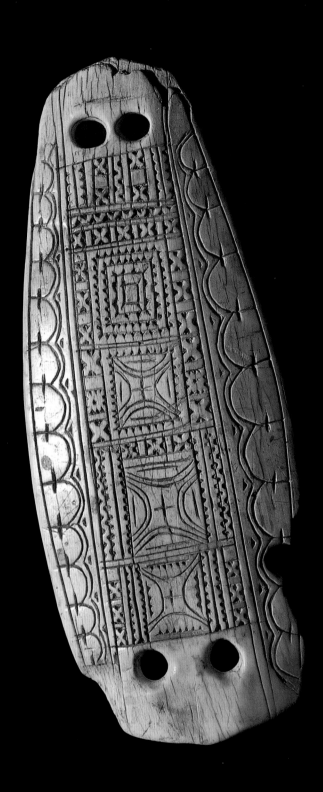

Ο Victor, ο ηλικιωμένος Δολγάνος, σκαλίζει και χαράζει
αντικείμενα και σκεύη σε κόκαλο από χαυλιόδοντα μαμούθ,
ένα από τα σπάνια υλικά που βρίσκει κάποιος στην τούντρα.

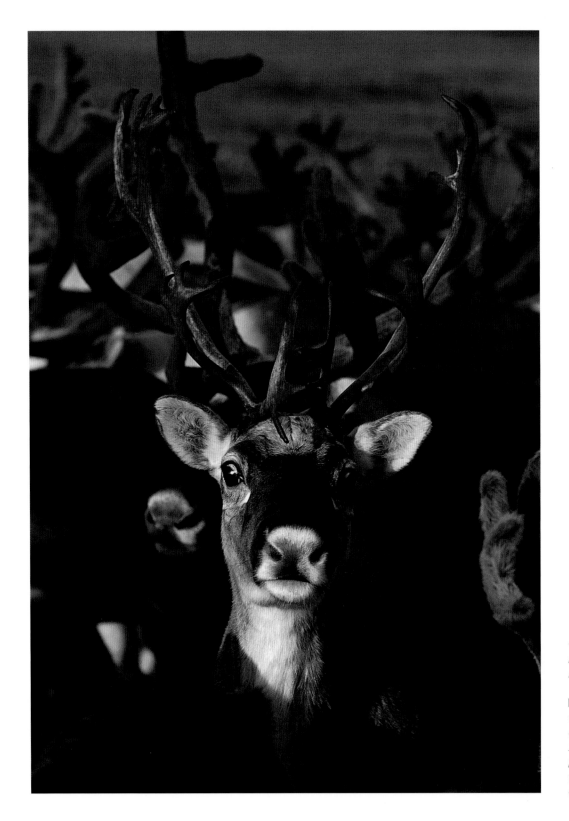

◁ Καθώς πλησιάζει ο χειμώνας, τα κέρατα του τάρανδου ματώνουν και πέφτουν. Την άνοιξη θα φυτρώσουν ξανά.

▷ Κοντά στους καταυλισμούς των νομάδων, εξημερωμένοι τάρανδοι αναζητούν μια θετή οικογένεια. Συχνά «ορφανοί», αυτοί οι τάρανδοι, μεγαλωμένοι με μπιμπερόν, μένουν για όλη τους τη ζωή προσκολλημένοι στους ανθρώπους.

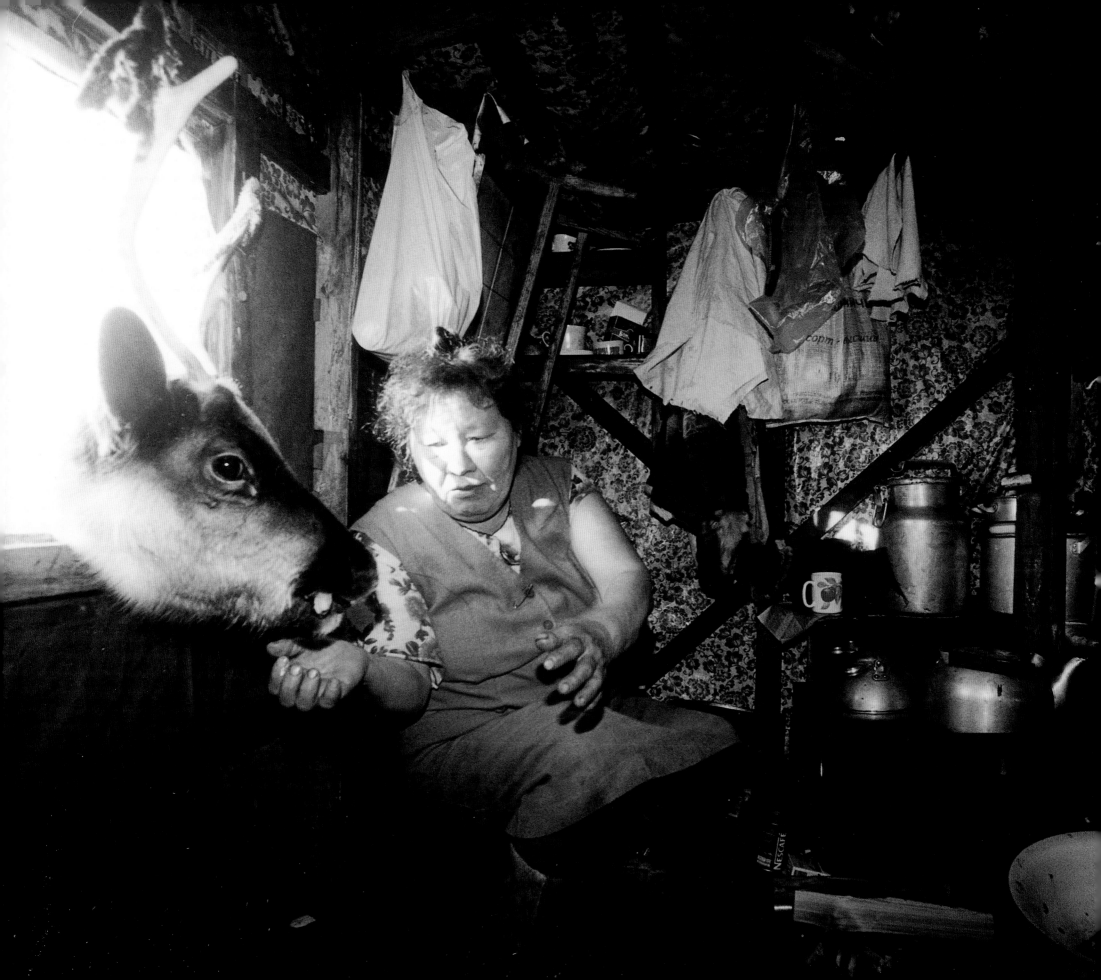

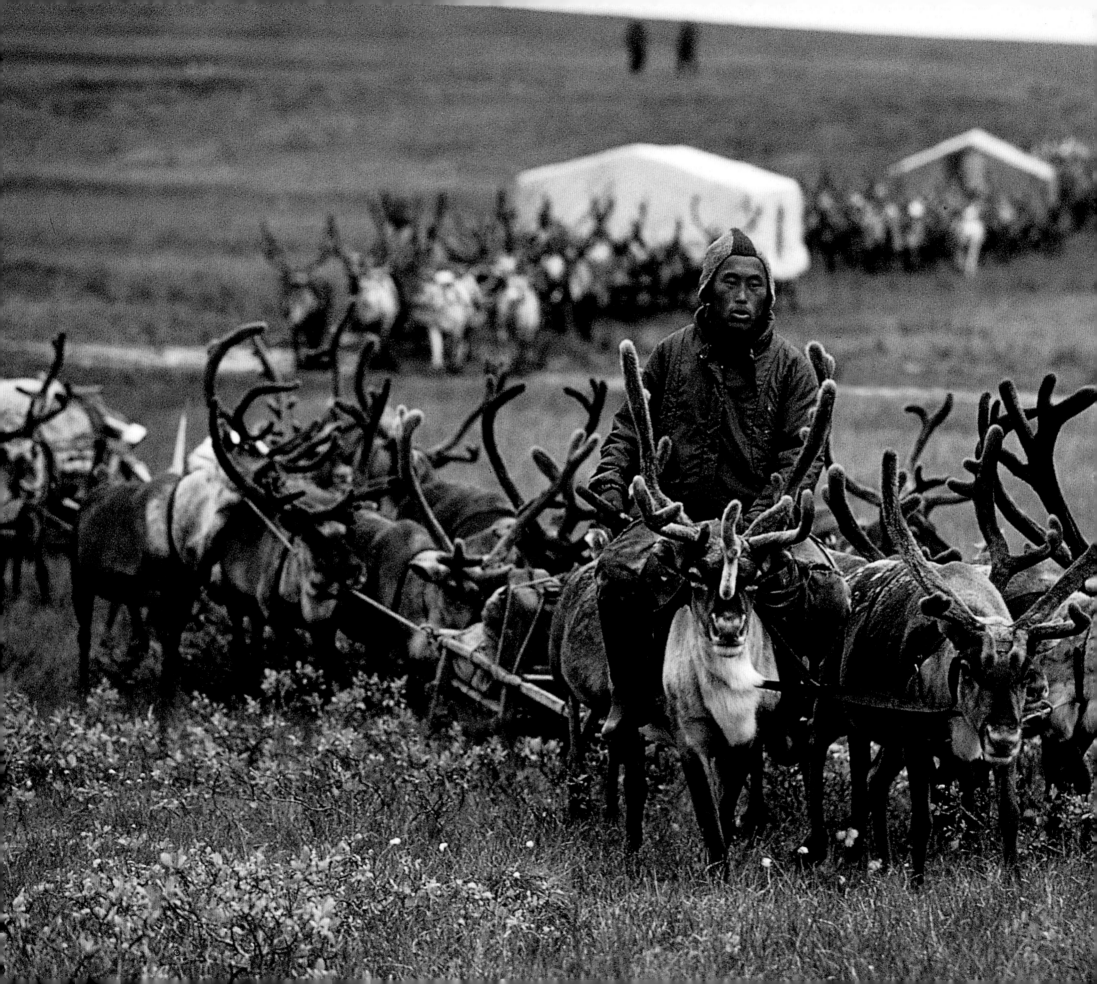

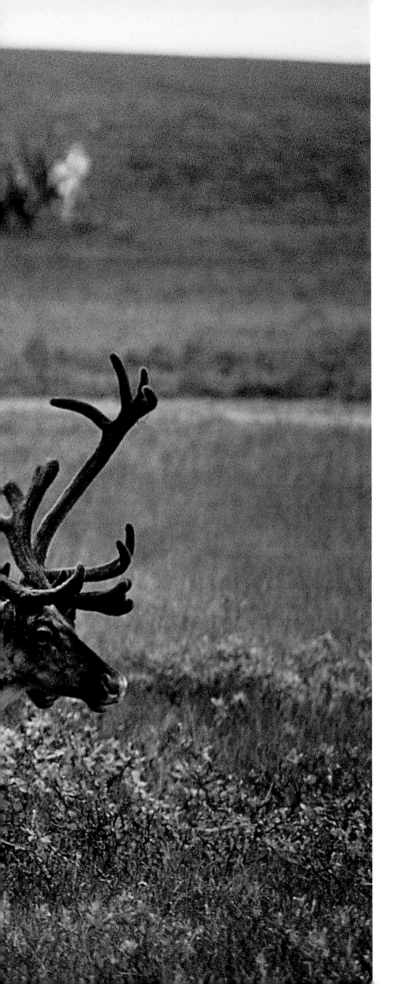

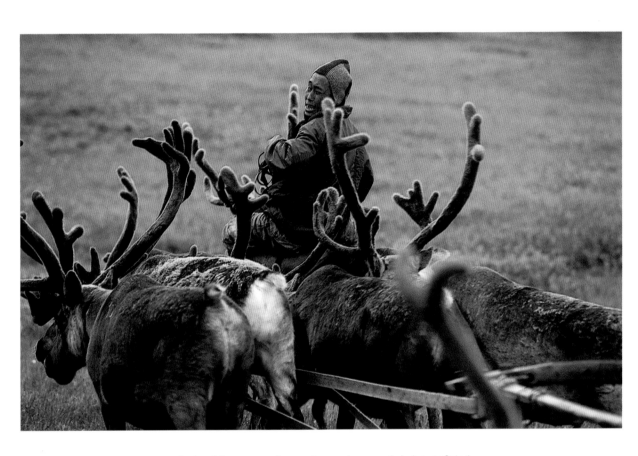

*Κατά τη διάρκεια της καλοκαιρινής μετακόμισης, οι Δολγάνοι κουβαλούν
μαζί τους και τις ελαφριές κατοικίες τους κοντά στις ακτές των ποταμών,
όπου μπορούν να ψαρεύουν.*

Το μόνο μέσο για να μετακινηθεί κανείς σ' αυτές τις ζώνες του Μακρινού Βορρά, το ελικόπτερο –ένα ρωσικό MI-8–, επιτελεί καλοκαίρι και χειμώνα τις αποστολές του για ανεφοδιασμό των κατοίκων.

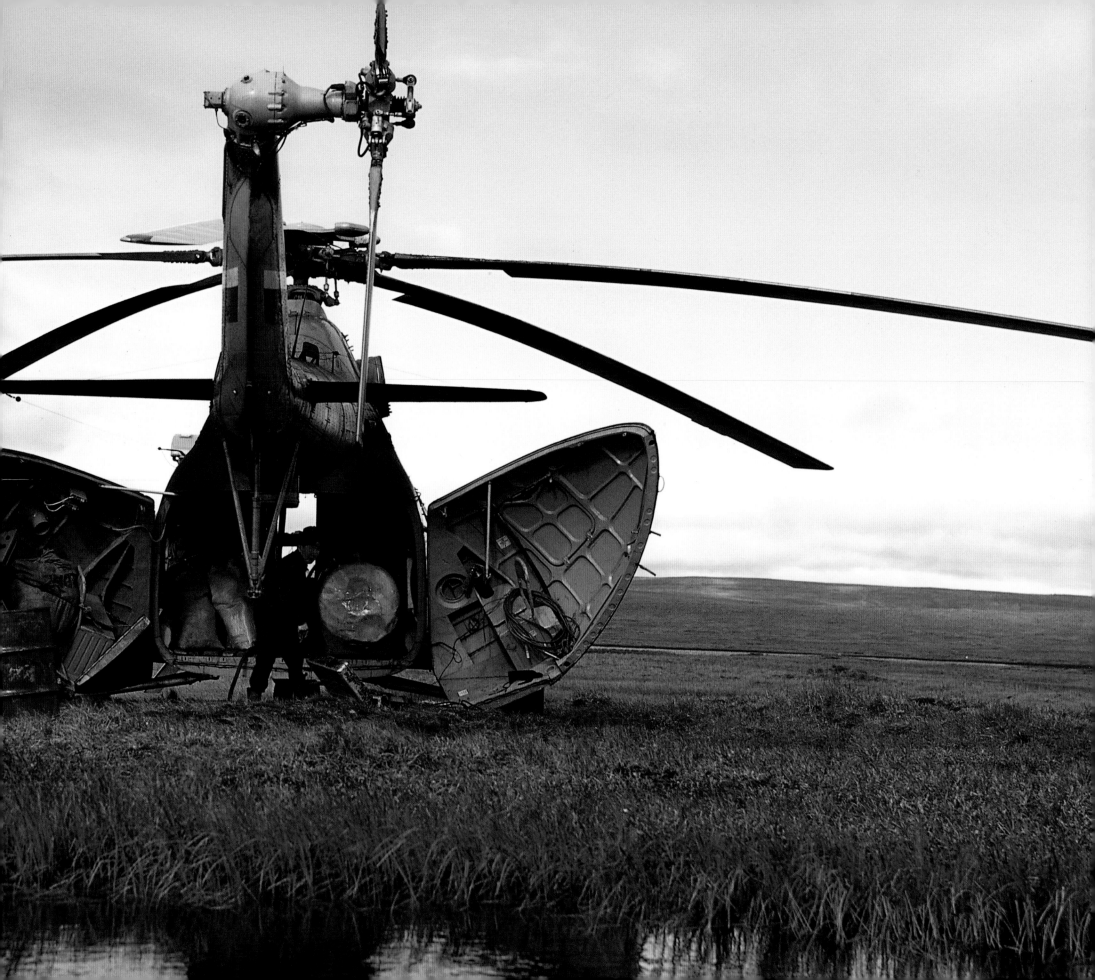

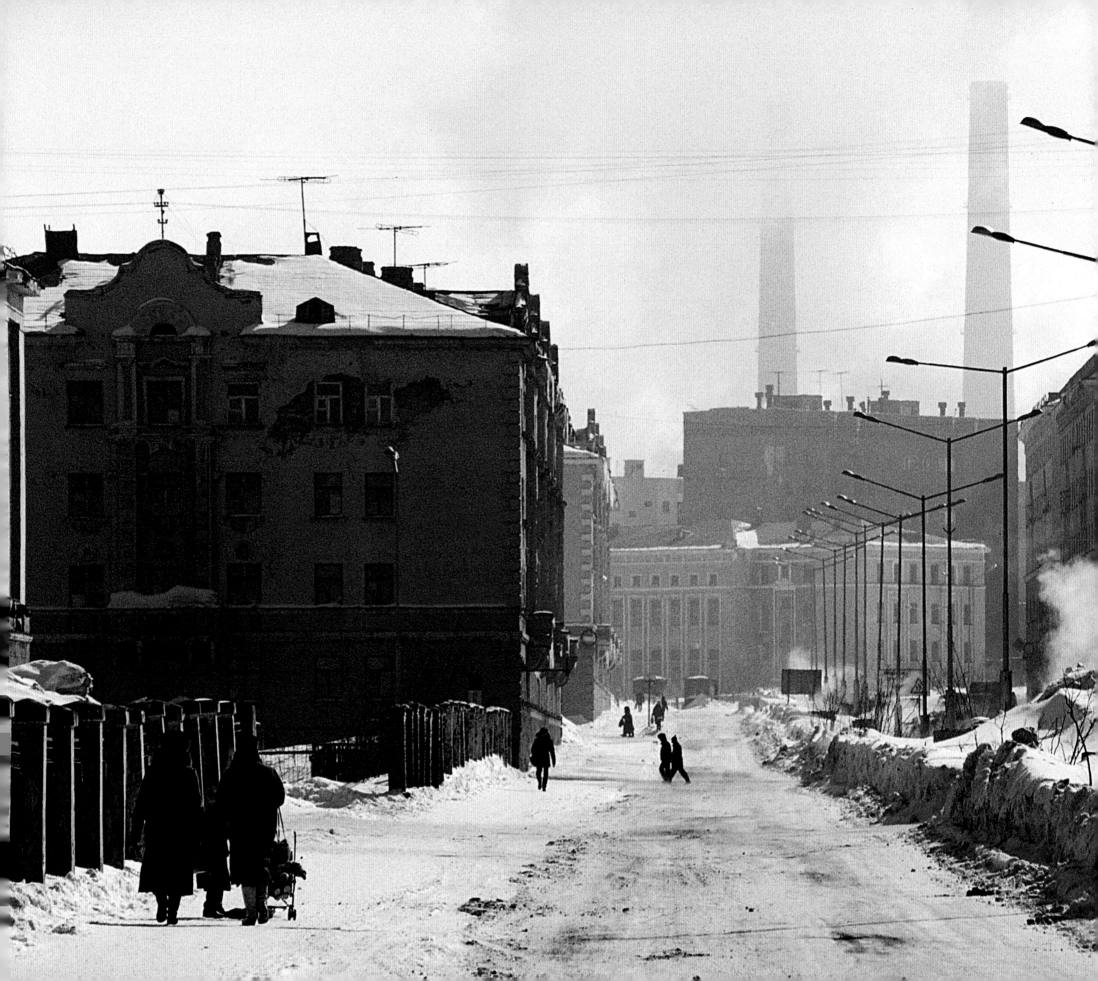

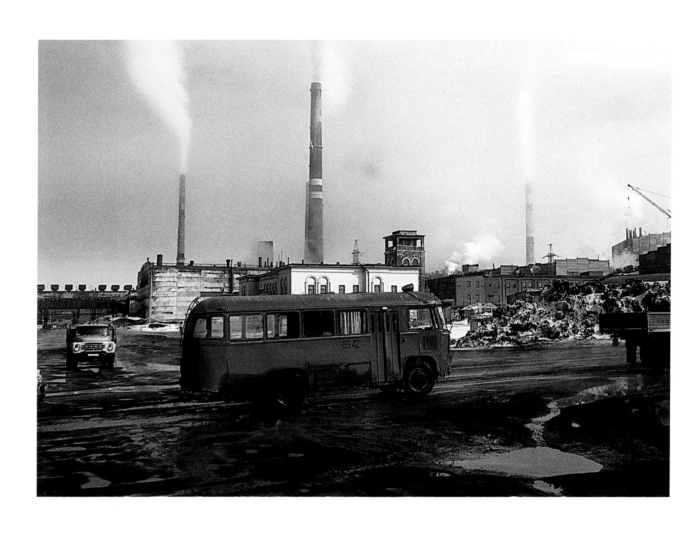

Η Norilsk, μια πόλη με ορυχεία στη Σιβηρία, είναι από τις πιο μολυσμένες πόλεις του βόρειου ημισφαίριου. Τριακόσιες χιλιάδες άνθρωποι ζουν εκεί, μέσα σε πολύ δύσκολες κλιματικές συνθήκες.

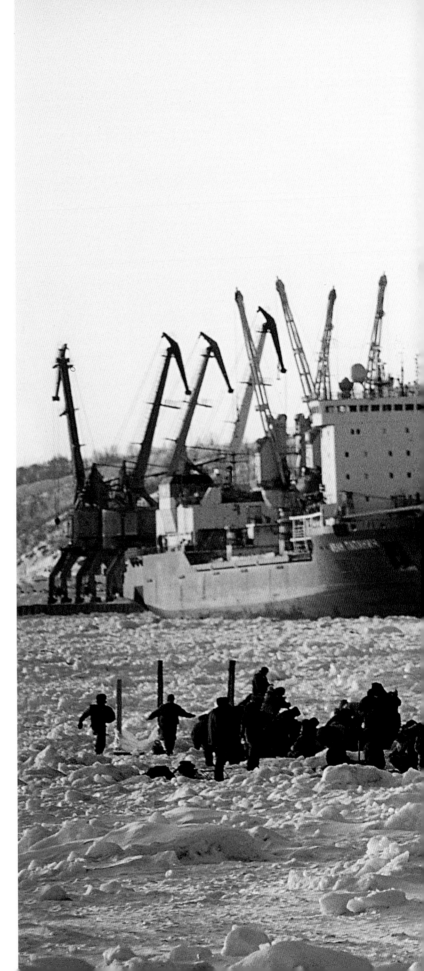

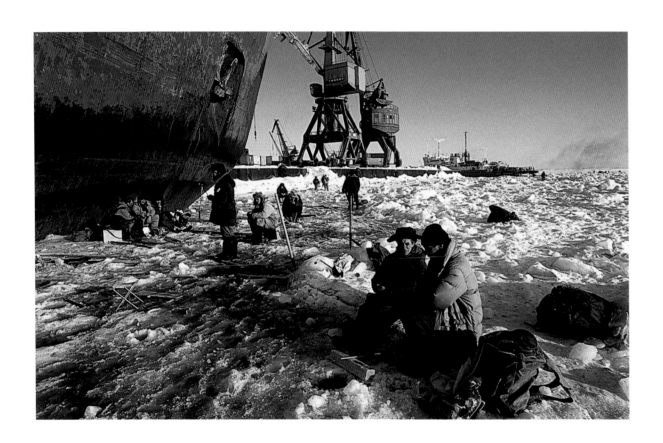

△▷ Το λιμάνι Doudinka, στο ποτάμι Ienisseï στη Σιβηρία, έχει αποκλειστεί από τους πάγους. Κοντά στα φορτηγά πλοία, οι ντόπιοι ψαράδες προσπαθούν να «ταρακουνήσουν» τα ψάρια κάτω από τον πάγο, καθώς η ακραία θερμοκρασία που έχει πέσει στην περιοχή, τα καταψύχει αμέσως.

▷▷ Η ομίχλη είναι μόνιμη στη λεκάνη του Norilsk, και η πόλη αποπέμπει τοξικούς καπνούς που, σε μια ακτίνα αρκετών εκατοντάδων χιλιομέτρων, μολύνουν λειχήνες και βλάστηση, απωθώντας όλο και πιο μακριά τα κοπάδια των ταράνδων και την πανίδα.

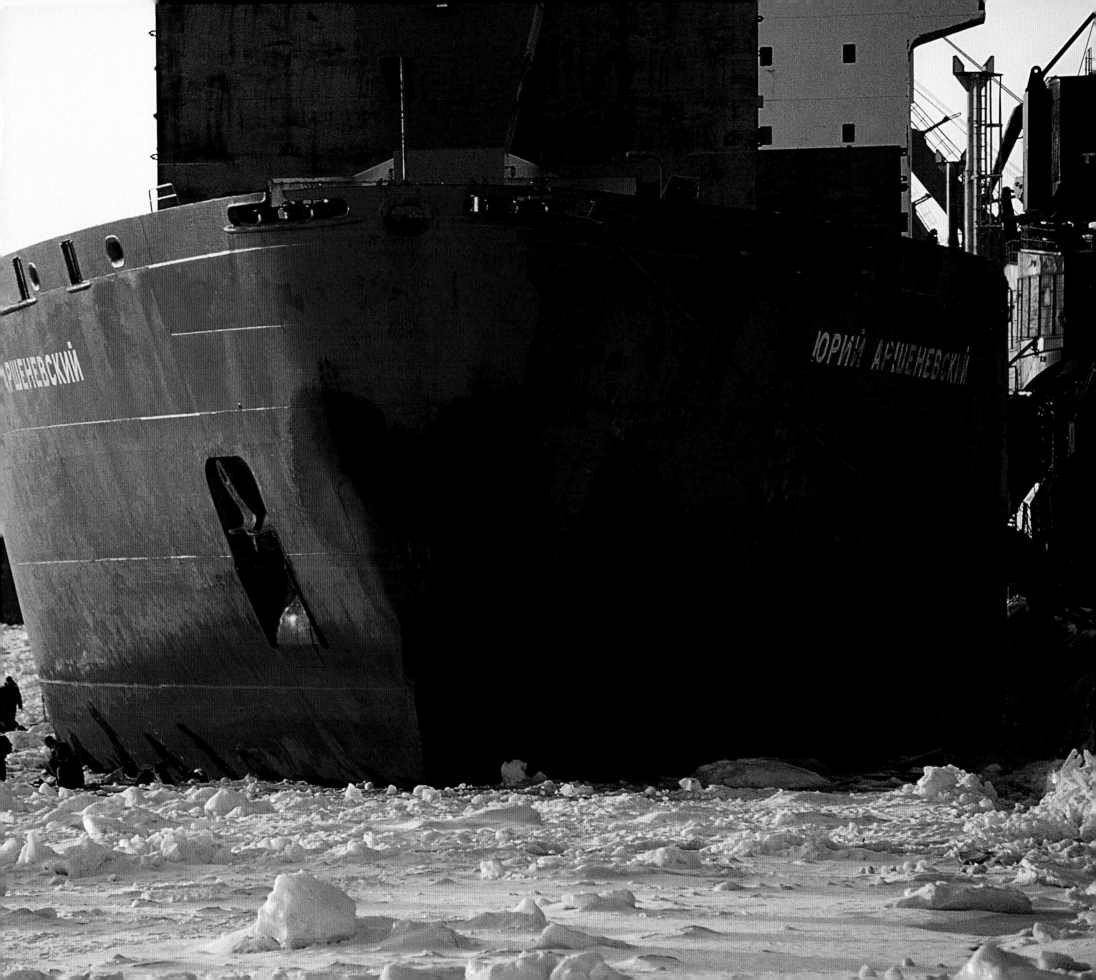

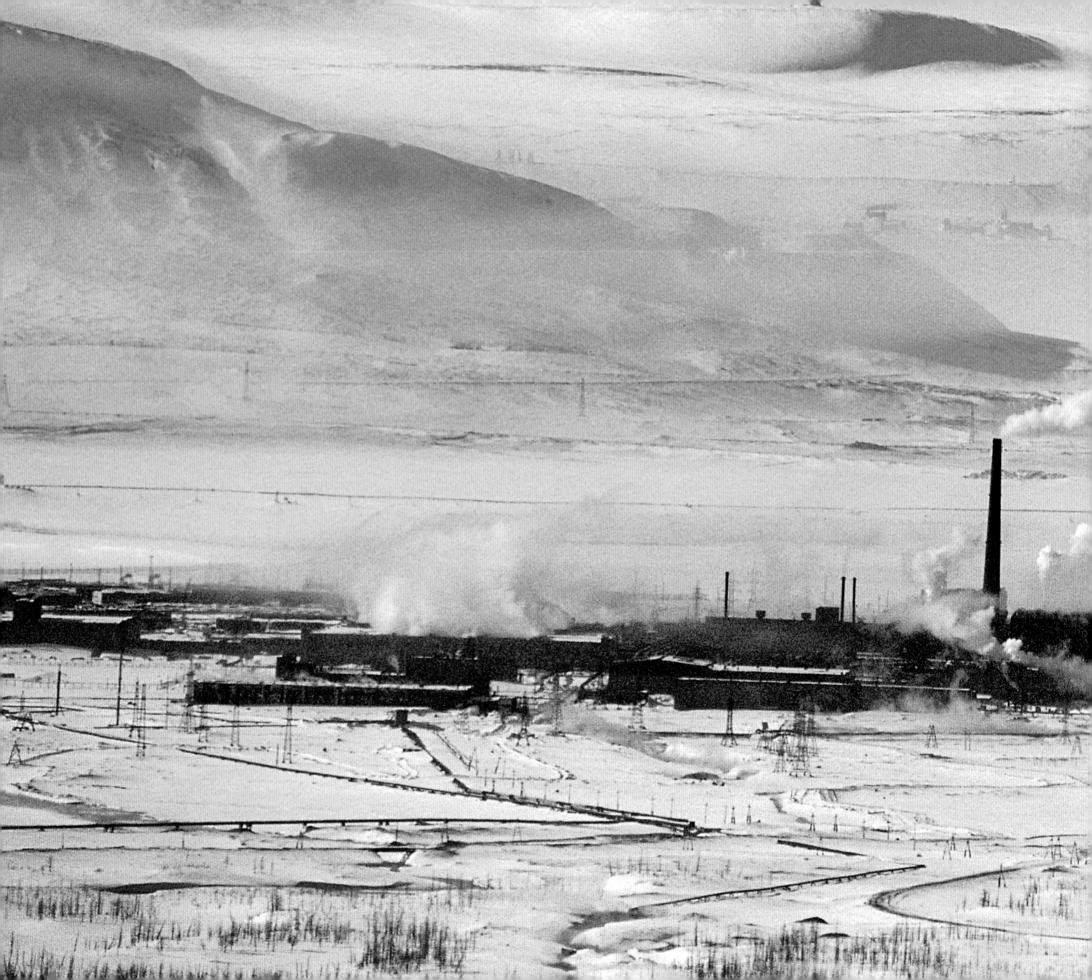

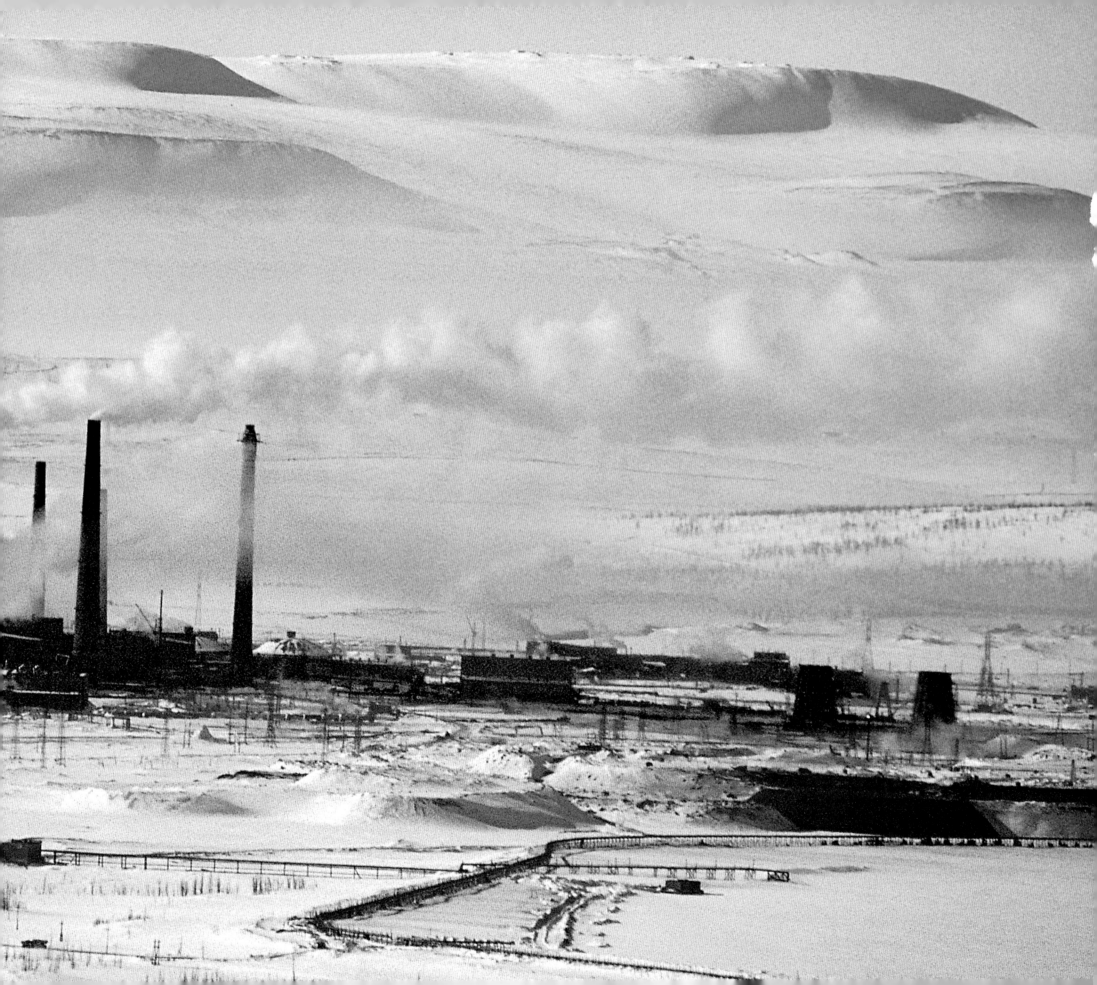

Στο Dickson, στην εκβολή του Ienisseï, ένα μικρό κορίτσι κουκουλωμένο
κοιτάζει μέσα από ένα τζάμι σκεπασμένο με πάχνη. Το παλιό σπίτι έχει
διατηρήσει τα χρώματα και τη διακόσμηση της προσταλινικής εποχής.

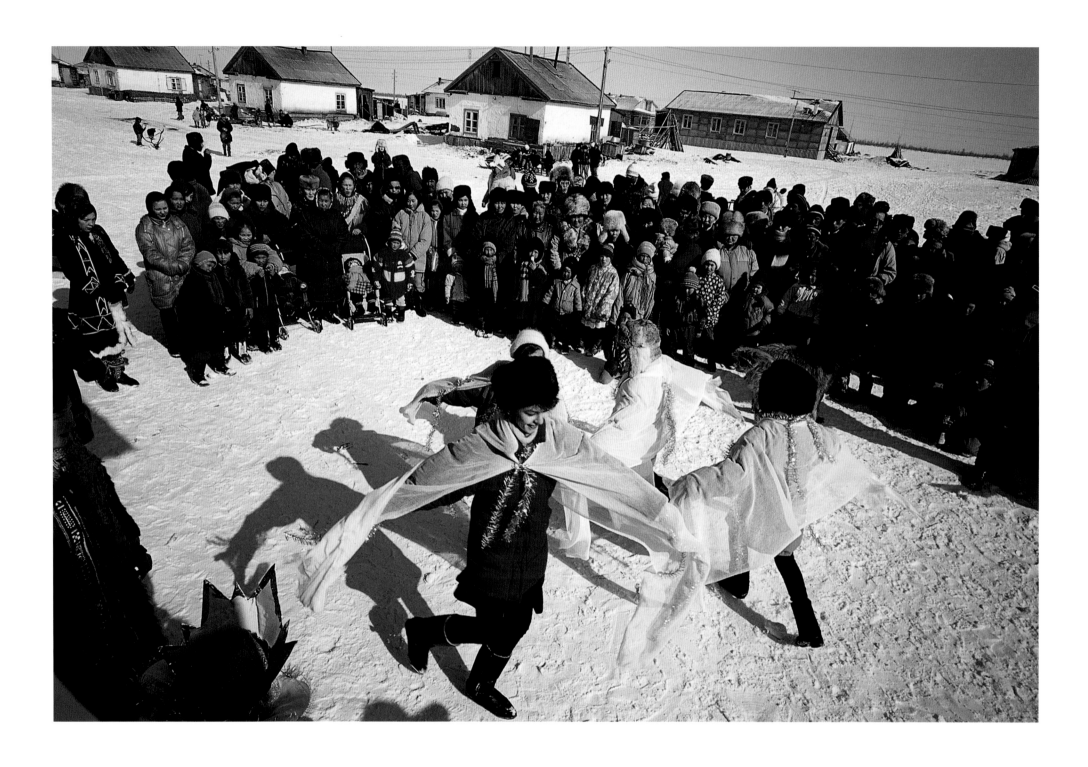

Στο χωριό Christie, στον ποταμό Khatanga, το τέλος του πολικού
χειμώνα και ο ερχομός της άνοιξης γιορτάζονται με χορούς.

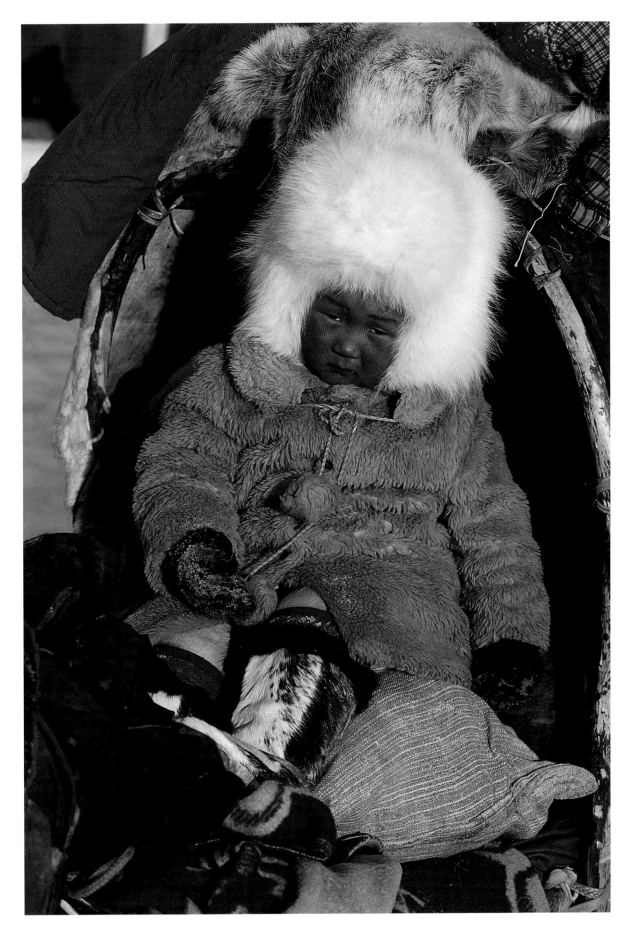

Η chapka (γούνινος σκούφος) αυτού του μικρού κοριτσιού έχει κατασκευαστεί από το δέρμα μιας αλεπούς της Αρκτικής.

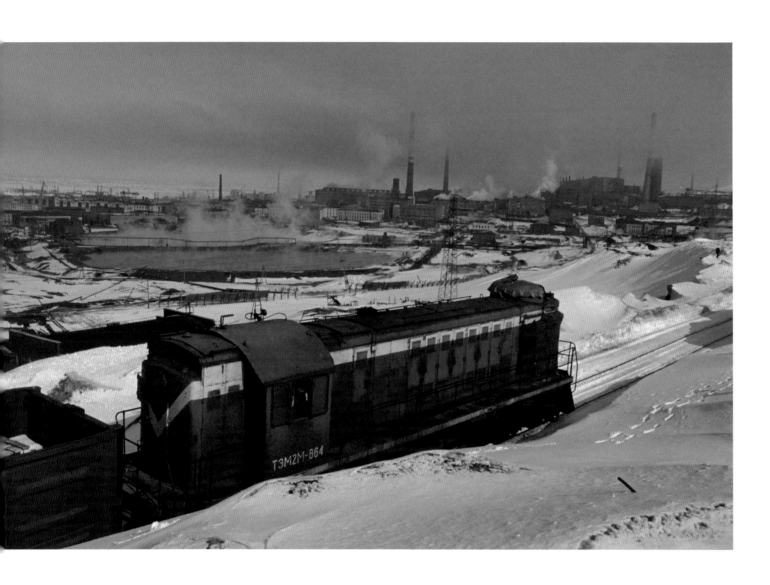

Την άνοιξη, στο λιμάνι Doudinka, κοντά στο σιδηρόδρομο, με τον οποίο μεταφέρεται όλο το μετάλλευμα νίκελ που προέρχεται από το Norilsk, οι τεράστιοι γερανοί φόρτωσης έχουν μετακινηθεί στις ψηλές περιοχές της πόλης, επειδή, με το σπάσιμο της παγωμένης επιφάνειας του ποταμού –όπως ανακοινώθηκε– θα ανέβει η στάθμη των νερών του ποταμού περισσότερο από 25 μέτρα.

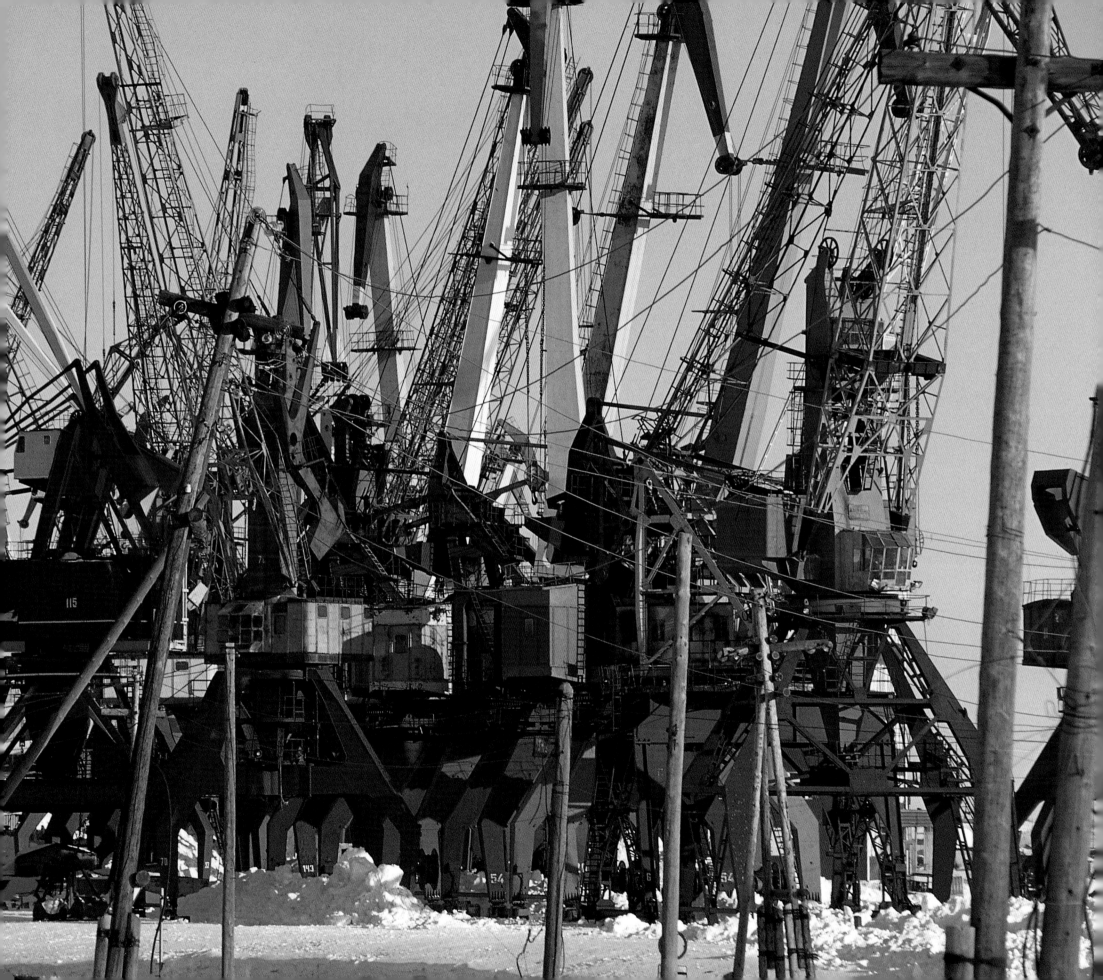

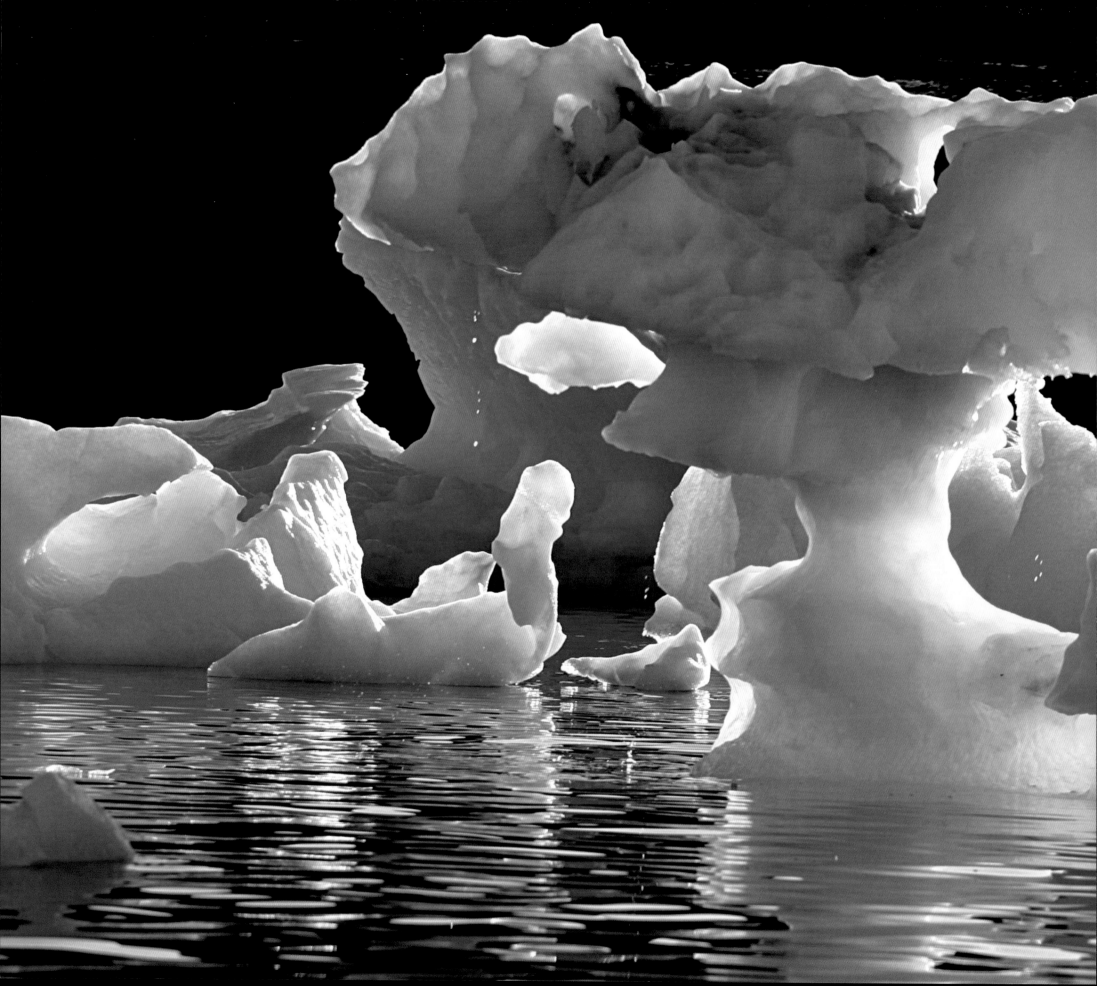

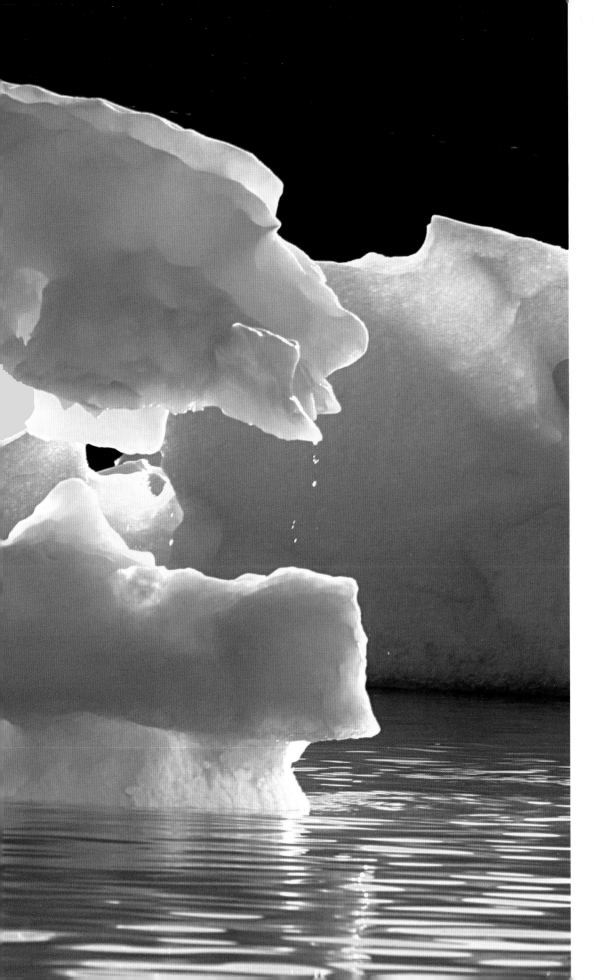

Η εισβολή ζέστης
στον Αρκτικό κόσμο

Οι περιοχές γύρω από τους πόλους είναι τα πρώτα θύματα από την αλλαγή του κλίματος προς το θερμότερο και από τις ραγδαίες επιπτώσεις της ανόδου της θερμοκρασίας. Σύμφωνα με μελέτη που δημοσιεύτηκε τον Νοέμβριο του 2004 από τον φορέα Μελέτης των Επιπτώσεων της Αλλαγής του Αρκτικού Κλίματος (ACIA), η θερμοκρασία στην Αρκτική αυξάνεται με διπλάσιο ρυθμό απ' ό, τι στις άλλες περιοχές του πλανήτη, και μάλιστα, κάτω από την επίδραση των αερίων που προκαλούν το φαινόμενο του θερμοκηπίου, η αύξηση της θερμοκρασίας αναμένεται να είναι της τάξης των 4 έως 7 βαθμούς Κελσίου μέχρι το τέλος του 21ου αιώνα. Ήδη η παχιά κρούστα του πάγου (ή θάλασσα των πάγων) έχει χάσει περισσότερο από το 8% της επιφάνειάς της και το 40% του πάχους της στη διάρκεια των τελευταίων 30 ετών. Με τέτοιους ρυθμούς, το κάλυμμα του πάγου, το *inlandsis* , της Γροιλανδίας (1,7 εκατομμύρια τετραγωνικά χιλιόμετρα και το 90% των αποθεμάτων γλυκού νερού στην επιφάνεια του βόρειου ημισφαιρίου) έχει αρχίσει να λιώνει. Παντού στις περιοχές αυτές γίνονται αισθητές οι επιπτώσεις της αύξησης της θερμοκρασίας που απειλούν το σύνολο των ντόπιων πληθυσμών, δηλαδή 3,5 εκατομμύρια ανθρώπους, από τους οποίους οι 500.000 είναι αυτόχθονες, καταστρέφοντας την ισορροπία των οικοσυστημάτων.

Όλες οι ενδείξεις επιβεβαιώνουν αυτήν την τάση: μέσα σε πενήντα χρόνια η θερμοκρασία αυξήθηκε κατά 2 βαθμούς στην Αλάσκα και στη Σιβηρία, καταλήγοντας σε έναν μέσο όρο των -14,7 βαθμών Κελσίου. Στο βορειοδυτικό τμήμα του Καναδά οι χειμώνες έγιναν ηπιότεροι κατά περίπου 3 βαθμούς Κελσίου, με μέσο όρο τους -13,8ο. Οι μεγάλοι παγετώνες της Γροιλανδίας υποχωρούν χρόνο με τον χρόνο, το μαγικό Sermeq Kujalleq, από το οποίο δημιουργούνται τα τεράστια παγόβουνα στο φιορδ της Kangia έως το Ilulisat, στη δυτική ακτή, υποχώρησε κατά 11 χιλιόμετρα από τη δεκαετία του 1960. Το επιβλητικό Kangerdlugssuaq, στην ανατολική ακτή, έγινε ένα από τα «ταχύτερα» παγόβουνα του κόσμου και μετακινείται με 14 χιλιόμετρα τον χρόνο, ενώ το 1988 η ταχύτητά του ήταν μόλις 5 χιλιόμετρα. Όσο για την τεράστια επιφάνεια πάγου Ward Hunt (443 τετραγωνικά χιλιόμετρα) που σχηματίστηκε εδώ και τρεις χιλιάδες χρόνια στον βορρά του Nunavut, στον

Τα παγόβουνα που προέρχονται από τους μεγάλους παγετώνες του Καναδά και της Γροιλανδίας ραγίζουν κάτω από τις ακτίνες του καλοκαιριάτικου ήλιου, και, στη συνέχεια, λιώνουν και εξαφανίζονται.

Καναδά, έσπασε το 2003. Από τότε, γλυκό νερό εισέρχεται στον Αρκτικό ωκεανό, αλλάζοντας την περιεκτικότητά του σε αλάτι και επηρεάζοντας τον πολλαπλασιασμό στα φύκια και το φυτικό πλαγκτόν, που αποτελούν τον πρώτο κρίκο της διατροφικής αλυσίδας των ψαριών και των θαλάσσιων θηλαστικών.

Αυξάνεται επίσης και η θερμοκρασία του *permafrost* (παγωμένου εδάφους) που αποτελείται από γη, φυτικά κατάλοιπα και πάγο που προστίθενται το ένα επάνω στο άλλο σε πάχος εκατοντάδων μέτρων (καμιά φορά φτάνει τα 500 μέτρα). Το παγωμένο αυτό έδαφος καλύπτει περίπου 10,5 εκατομμύρια τετραγωνικά χιλιόμετρα στη

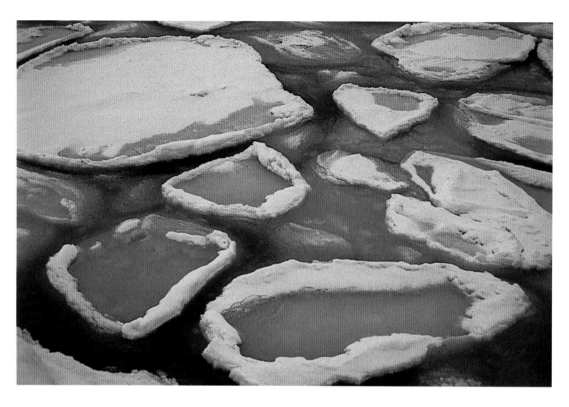

Σιβηρία, τον Καναδά και την Αλάσκα. Η επιφάνειά του, που ονομάζεται «ενεργή ζώνη», βάθους μερικών εκατοστών έως τεσσάρων μέτρων, ξεπαγώνει προσωρινά το καλοκαίρι, αφήνοντας να δημιουργηθεί μια πολύ εύθραυστη βλάστηση που εξαφανίζεται με την επιστροφή του κρύου. Όμως, σύμφωνα με διάφορες μελέτες, ανάμεσα στις οποίες και αυτή του Ρώσου βοτανολόγου Sergei Kripotin, έχει ήδη ξεκινήσει το ξεπάγωμα του εδάφους σε βάθος, και μάλιστα σε κλίμακα τέτοια που είχε να συμβεί εδώ και 11.000 χρόνια. Αυτό ενέχει τον κίνδυνο να μετατραπεί η τούντρα σε έλος, απελευθερώνοντας τεράστιες ποσότητες μεθανίου. Το μεθάνιο είναι αέριο που «απολιθώνεται» μέσα στον πάγο και η απελευθέρωσή του αποτελεί τρομακτικό κίνδυνο, λόγω των επιπτώσεων που θα έχει στην επιδείνωση του φαινομένου του θερμοκηπίου. Ο αστροφυσικός Hubert Reeves το παρομοίασε με «δράκο που κοιμάται».

Ήδη οι ντόπιοι πληθυσμοί πληρώνουν το τίμημα της αύξησης της θερμοκρασίας. Το λιώσιμο του *permafrost* αποσταθεροποιεί τις υποδομές, καταστρέφει τους δρόμους, μεταμορφώνει το τοπίο. Πόλεις, αεροδρόμια, αγωγοί απειλούνται στη Σιβηρία και οι 600 Inupiak κάτοικοι του χωριού Shishmaref στην Αλάσκα ζουν συνεχώς με έναν εφιάλτη από τότε που το νησί τους δεν προστατεύεται πλέον από το φράγμα του πάγου (*embâcle*): τον κίνδυνο να παρασύρουν οι καταιγίδες του χειμώνα τη γη τους, τα αγαθά τους, την αυλή του σχολείου τους, τις κατασκευές όπου στεγνώνουν τα ψάρια τους... Από το 1997 και έπειτα, 20 περίπου σπίτια μεταφέρθηκαν. Γερανοί τα τοποθέτησαν πάνω σε έλκηθρα και τα έσυραν πάνω στον πάγο προς τόπους λιγότερο ευάλωτους. Οι κάτοικοι του Shishmaref και άλλων 20 περίπου χωριών είναι τα πρώτα θύματα μιας νέας μορφής μετανάστευσης, της μετανάστευσης λόγω κλίματος.

Οι κυνηγοί και οι ψαράδες βλέπουν τις παραδοσιακές δραστηριότητές τους να μειώνονται δραστικά. Οι παγονησίδες, παράδεισος κάποτε για τις φώκιες, σχηματίζονται πλέον πολύ αργότερα και είναι εύθραυστες. Οι Inuits που αποτολμούν να τον πατήσουν κινδυνεύουν να πνιγούν και έτσι η κυνηγετική τους περίοδος μειώνεται. Στον βορρά της Γροιλανδίας, μάλιστα, κάποιοι αναγκάστηκαν να σκοτώσουν τα σκυλιά που έσερναν τα έλκηθρά τους, γιατί ήταν πλέον άχρηστα και η διατροφή τους πολυέξοδη. Παντού παρουσιάζονται ανατροπές της ισορροπίας. Η αύξηση της θερμοκρασίας έχει ως επακόλουθο να διαλύονται οι φωλιές στον πάγο, παρεμποδίζοντας έτσι την αναπαραγωγή των λέμων και των μικρών αρουραίων. Οι φυσικοί εχθροί τους, η ερμίνα και το *harfang* (λευκή κουκουβάγια), ή η νυφίτσα, είναι κι αυτοί με τη σειρά τους καταδικασμένοι. Το καλοκαίρι, βρίθουν τα κουνούπια και οι μύγες, καθώς η ζέστη τα ευνοεί. Η βλάστηση επίσης αυξάνεται. Το πολικό δάσος τείνει να πάρει τη θέση της αρκτικής τούντρας, ευνοώντας τον πολλαπλασιασμό σε διάφορα είδη βλαβερών εντόμων.

Τα βρύα και οι λειχήνες που αποτελούν το 70% της τροφής των ταράνδων και των καριμπού πλήττονται επίσης από την αύξηση της θερμοκρασίας. Οι Λάπωνες, ή Σάμι, κτηνοτρόφοι στο βόρειο τμήμα της Νορβηγίας, που φροντίζουν περίπου 200.000 ημιάγριους ταράνδους, αντιλαμβάνονται ότι τα ζώα τους συνεχώς μειώνονται. Γιατί, οι τάρανδοι, αν και είναι ικανοί να αντιληφθούν την ύπαρξη λειχήνων, ακόμη και αν βρίσκονται πολλά εκατοστά κάτω από το χιόνι, δεν καταφέρνουν πλέον να τις ξεθάψουν. Εδώ και κάποια χρόνια, τα νορβηγικά βοσκοτόπια συνεχώς παγώνουν και ξεπαγώνουν, πράγμα που έχει ως αποτέλεσμα τη δημιουργία μιας κρούστας πάγου πάνω στο έδαφος που τα ζώα είναι ανίκανα να σπάσουν με τις οπλές τους. Εξουθενώνονται και υποφέρουν από υποσιτισμό. Οι Εσκιμώοι του Καναδά παρατηρούν ανάλογα φαινόμενα. Για παράδειγμα, ο αριθμός των καριμπού του Peary που ζουν επάνω στο νησί Ellesmere έχει υποστεί δραστική μείωση, από 26.000 το 1961, σε 1000 το 1997.

Όμως αναμφίβολα το πιο εκτεθειμένο θύμα της ανόδου της θερμοκρασίας είναι η πολική αρκούδα (Ursus maritimus, όπως είναι το επιστημονικό της όνομα), το μεγαλύτερο σαρκοβόρο, το ζώο-μύθος του Βορρά. Σήμερα δεν ζουν πλέον παρά 25.000 περίπου λευκές

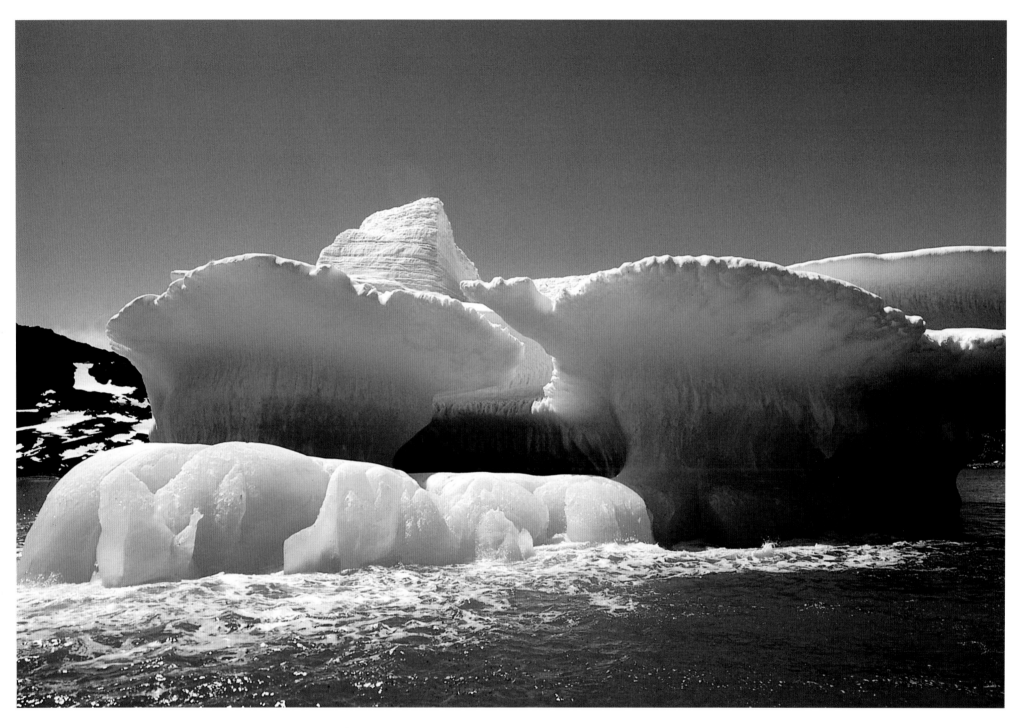

◁ Στους 2 βαθμούς κάτω του μηδενός, τα νερά παγώνουν και μεταμορφώνονται σε νούφαρα,
πριν ενωθούν μεταξύ τους και σχηματίσουν την παγονησίδα.

△ Στην επαφή με τα ζεστά νερά, οι πλάκες της παγονησίδας μεταμορφώνονται σε ημιδιάφανα γλυπτά.

αρκούδες στον αρκτικό κύκλο. Η αρσενική λευκή αρκούδα ζυγίζει έως 800 κιλά και η θηλυκή έως 300, με την προϋπόθεση όμως ότι μπορούν να ζήσουν από τον Νοέμβριο μέχρι τον Μάιο πάνω στις παγονησίδες, όπου τα μοναχικά αυτά ζώα κυνηγούν τη λεία τους, τη φώκια και τον σολωμό μπελούγκα. Τρώνε ώσπου να χορτάσουν και αποθηκεύουν αποθέματα λίπους που τους επιτρέπουν έπειτα να επιστρέψουν στη στεριά. Εκεί, οι θηλυκές κατασκευάζουν τις φωλιές τους και γεννούν.

Με την υποχώρηση των πάγων, σαν να λέμε με την καταστροφή του χώρου όπου παίζουν αλλά και τρέφονται, οι λευκές αρκούδες τελούν υπό εξαφάνιση. Αντιμέτωπες με το πρόωρο λιώσιμο του πάγου, οι 12.000 αρκούδες που ζουν δυτικά του κόλπου του Hudson εμφανίζουν δείγματα ευπάθειας. Σύμφωνα με την Καναδική Υπηρεσία Αγρίων Ζώων, οι γεννήσεις έχουν μειωθεί τα τελευταία 15 χρόνια, καθώς οι μη επαρκώς σιτιζόμενες θηλυκές είναι πολύ αδύναμες και δεν μπορούν πλέον να αντιμετωπίσουν συγχρόνως τη χειμερία νάρκη και το τάισμα των μικρών τους. Επί πλέον, τα αρκουδάκια που γεννιούνται προς το τέλος του χρόνου και που περνούν τους πρώτους μήνες μέσα στη φωλιά μαζί με τη μητέρα τους, βγαίνουν πρώτη φορά προς τα τέλη Μαρτίου, για να μάθουν να βρίσκουν μόνα τους την τροφή τους... Ακριβώς τη στιγμή που ο πάγος στη θάλασσα αρχίζει πλέον να λεπταίνει και να γίνεται επικίνδυνος. Αποτέλεσμα: έχουν χάσει το 15% του βάρους τους.

Πιο ανησυχητικό ακόμη είναι το ότι οι πολικές αρκούδες πλήττονται σοβαρά και από τους οργανικούς ανθεκτικούς ρύπους (POP =polluants organiques persistants) των εντομοκτόνων και των χημικών ουσιών που απελευθερώνονται στη φύση, και ιδιαίτερα στο νερό, από τις βιομηχανίες, συμπεριλαμβανομένων και αυτών των γεωργικών φαρμάκων. Οι ρύποι αυτοί «μεταναστεύουν» από τη ζέστη προς το κρύο μέσω των θαλάσσιων ρευμάτων. Κολλούν πάνω στα φύκια που τρώνε τα ψάρια, τα οποία με τη σειρά τους τρώνε οι φώκιες... για να ξαναβρεθούν συγκεντρωμένα σε ισχυρές δόσεις, στο τέλος της διατροφικής αλυσίδας και μέσω του φαινομένου της βιοεξάπλωσης, στον οργανισμό της πολικής αρκούδας, όπου οι τοξίνες προκαλούν εξασθένηση της ανοσοποιητικής τους άμυνας. Επηρεάζουν επίσης την ικανότητα αναπαραγωγής και προκαλούν γεννετικές δυσπλασίες.

Σύντομα, οι πολιτισμοί του Βορρά και οι περιβαλλοντικές τους παράμετροι θα οδεύουν προς την καταστροφή. Συνειδητοποιώντας τον κίνδυνο, οι αυτόχθονες φυλές σχημάτισαν ομάδες πίεσης, και τον Μάιο του 2005 στις Βρυξέλλες, οι αντιπρόσωποι του Συμβουλίου της Αρκτικής, ενός διακρατικού φόρουμ που δημιουργήθηκε το 1996 στην Οτάβα με σκοπό την προώθηση της συνεργασίας των κρατών που βρίσκονται στους Πόλους, έκρουσαν τον κώδωνα του κινδύνου: «Αυτό που συμβαίνει στην Αρκτική είναι το βαρόμετρο για το τι θα συμβεί στον υπόλοιπο πλανήτη...». Μένει να μάθουμε αν ο υπόλοιπος πλανήτης θα μπορέσει να ακούσει αυτήν την κραυγή και να στραφεί προς μια οικονομική ανάπτυξη πιο «πράσινη» και σεβόμενη το περιβάλλον. Σε κάθε περίπτωση, οι επιστήμονες, που είναι αποφασισμένοι να λύσουν τα μυστήρια των πάγων της Αρκτικής, προσπαθούν να περάσουν αυτό το μήνυμα παντού.

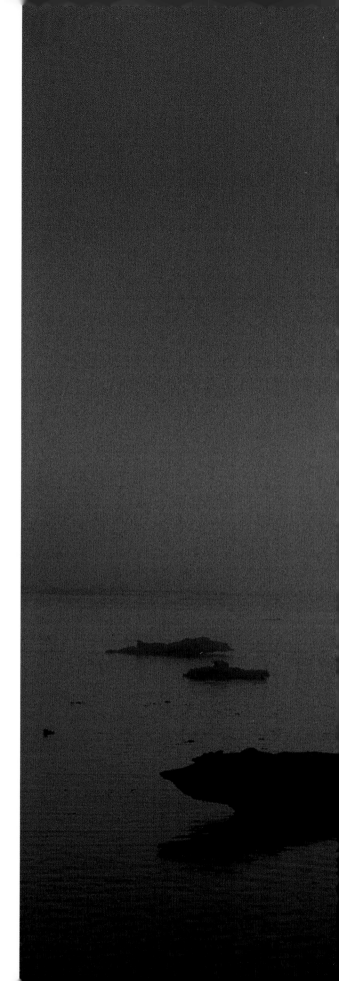

Στα ανοικτά του Resolute Bay, μέσα στον Καναδικό Μακρινό Βορρά, ο ήλιος, αχνός, πλημμυρίζει την «υπό προθεσμία» παγονησίδα και αναγγέλλει την άνοδο της θερμοκρασίας.

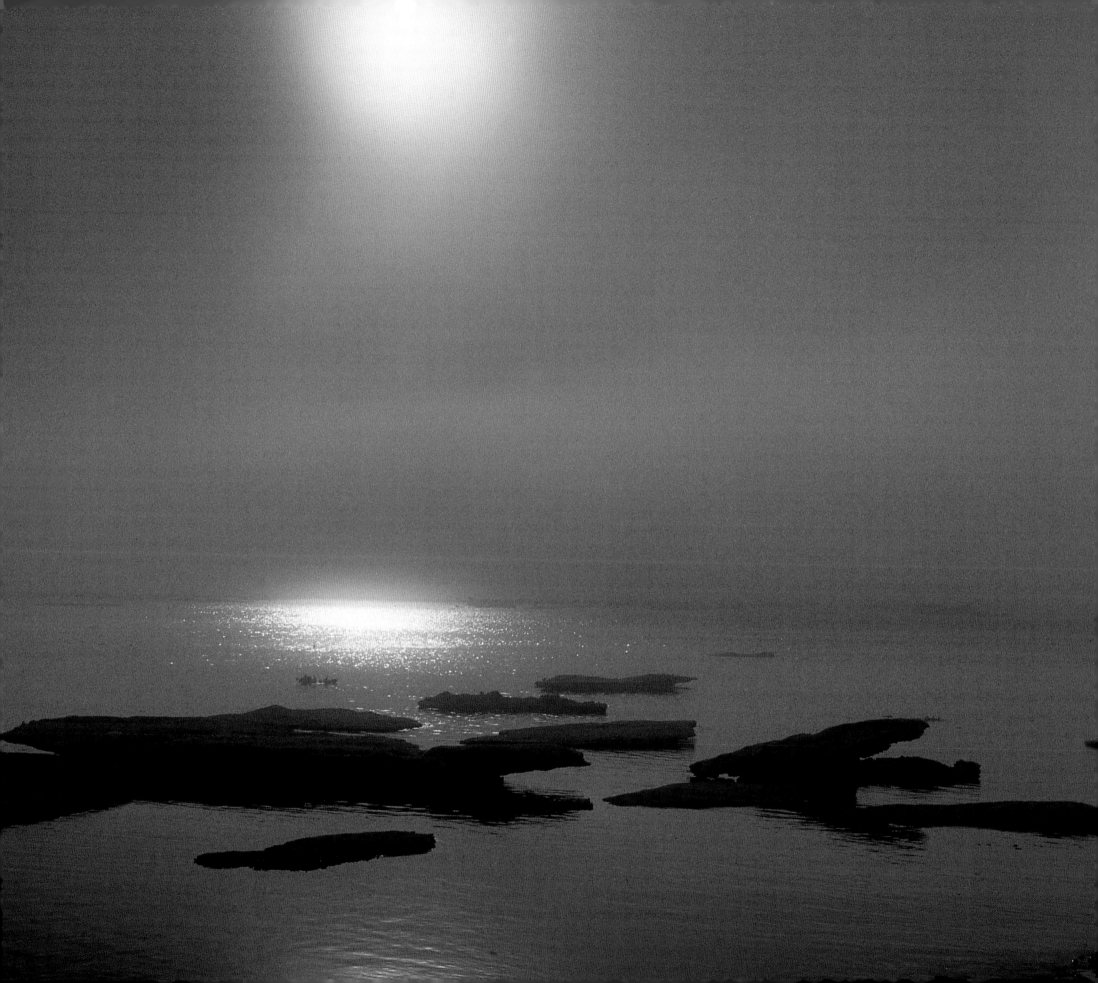

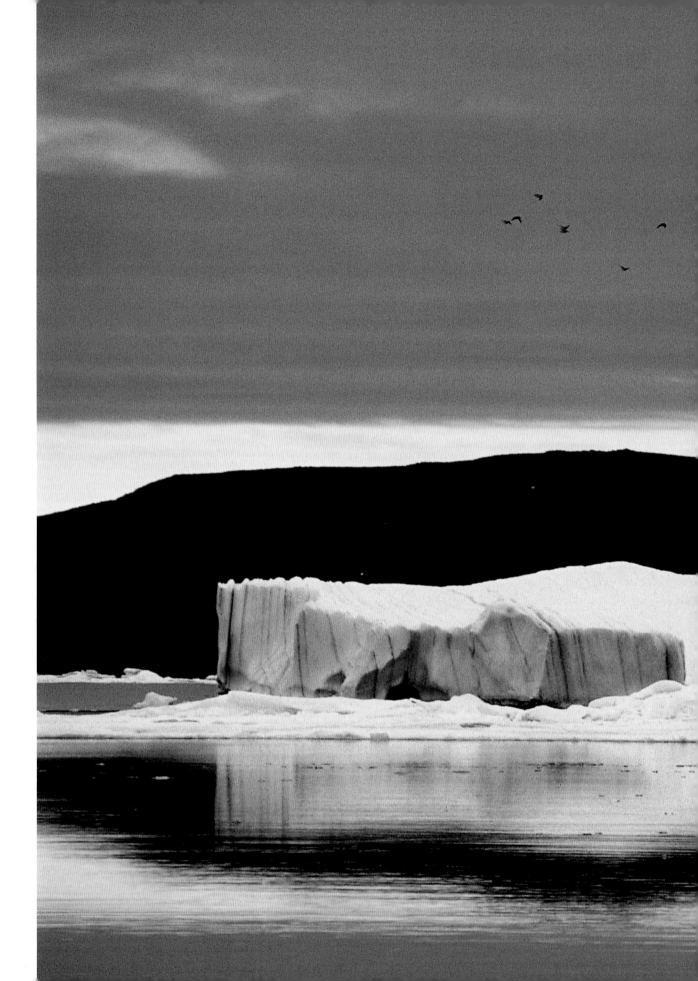

Θυελλώδες καλοκαίρι στις όχθες του κόλπου Tikhaya, στο François-Joseph, ένα αρχιπέλαγος χαμένο μέσα στις απεραντοσύνες του Αρκτικού ωκεανού.

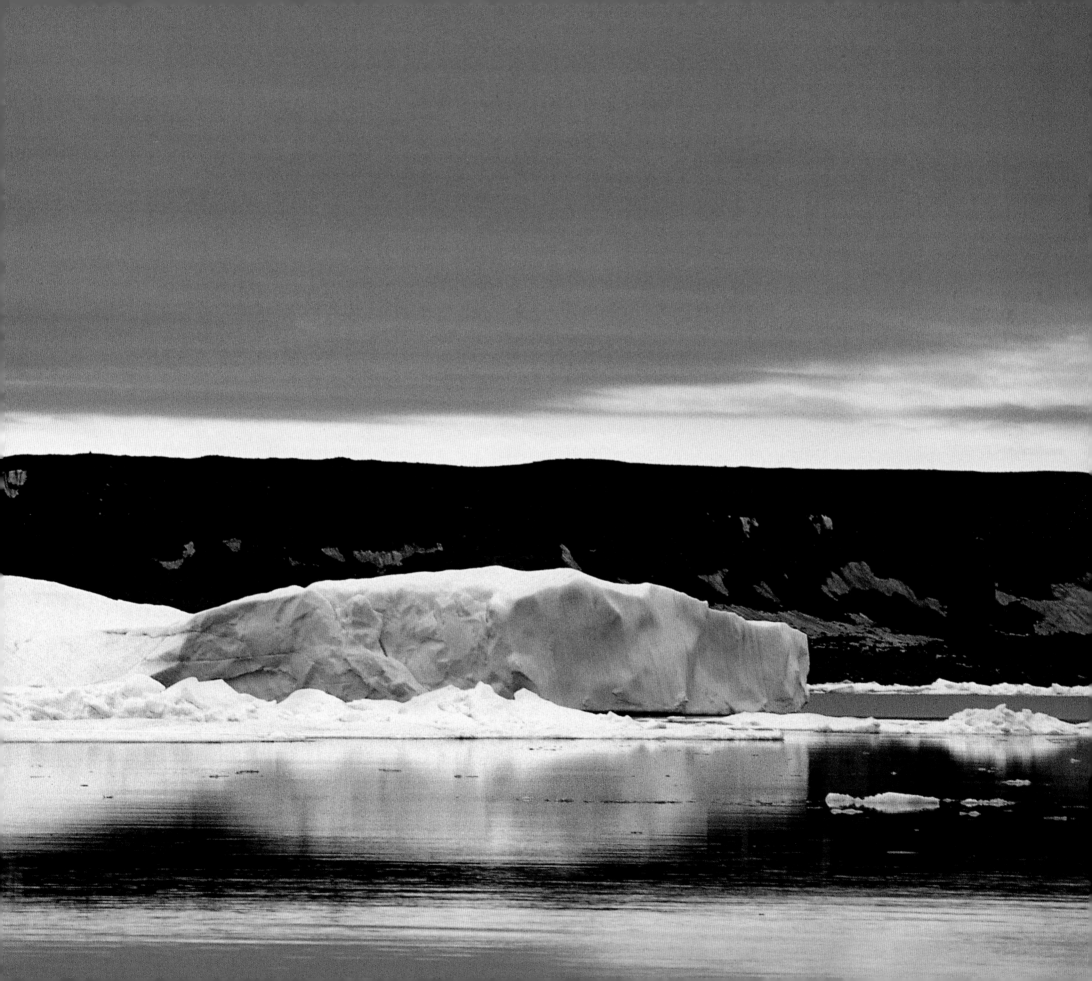

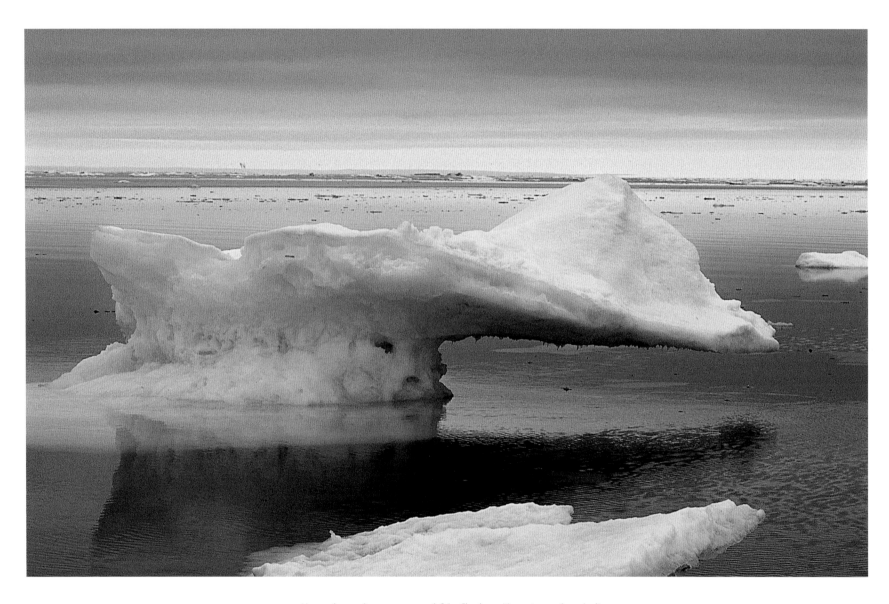

Μετακινήσεις πάγων στην περιοχή *Grise Fiord*, στο *Nunavut*, χωριό των *Inuits*
του Μακρινού καναδικού Βορρά.

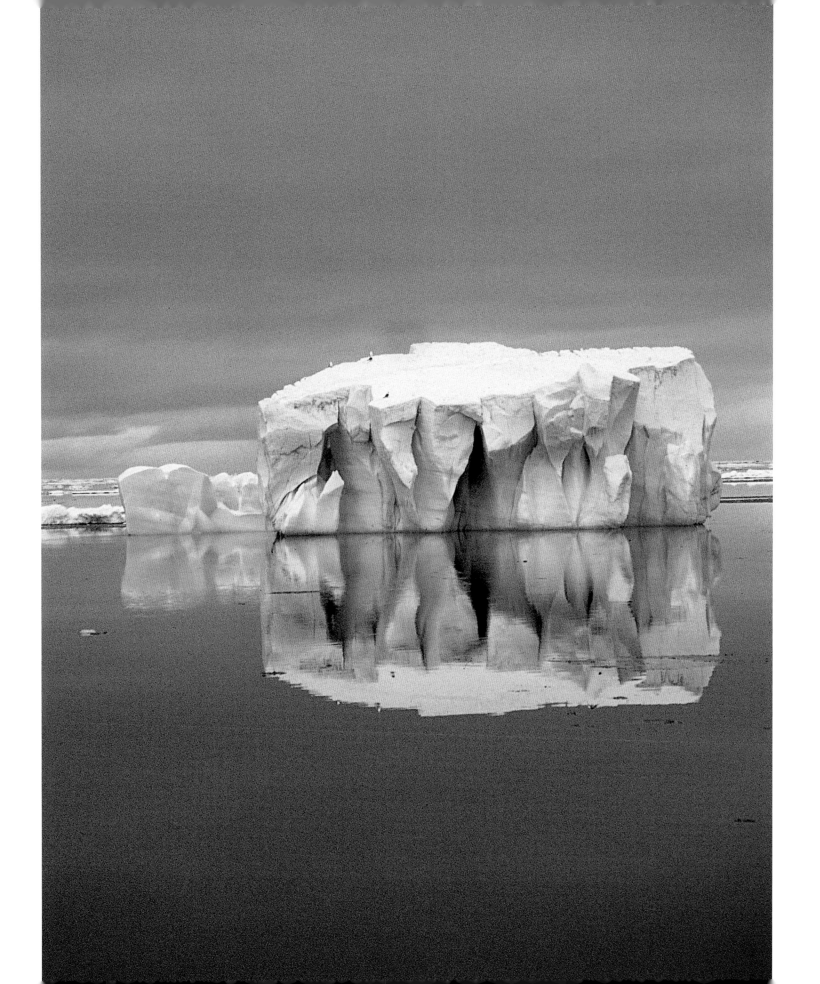

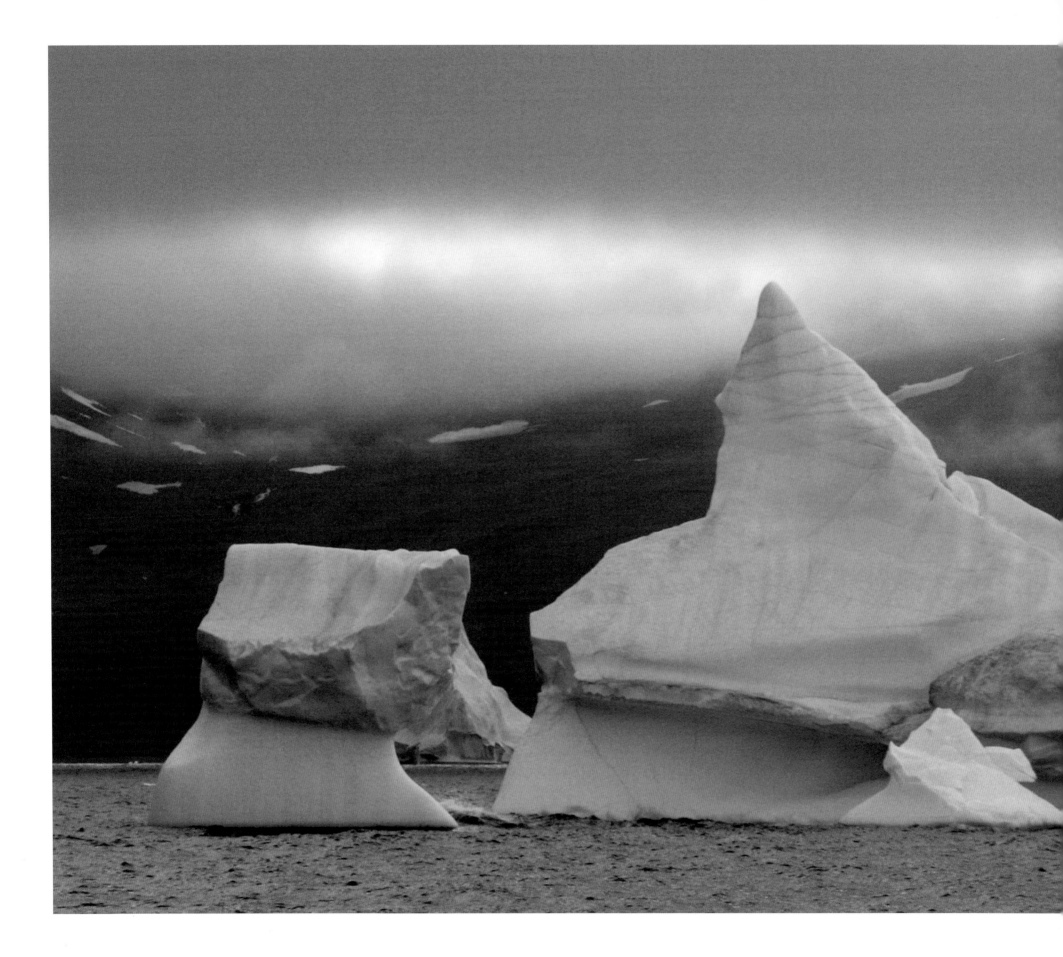

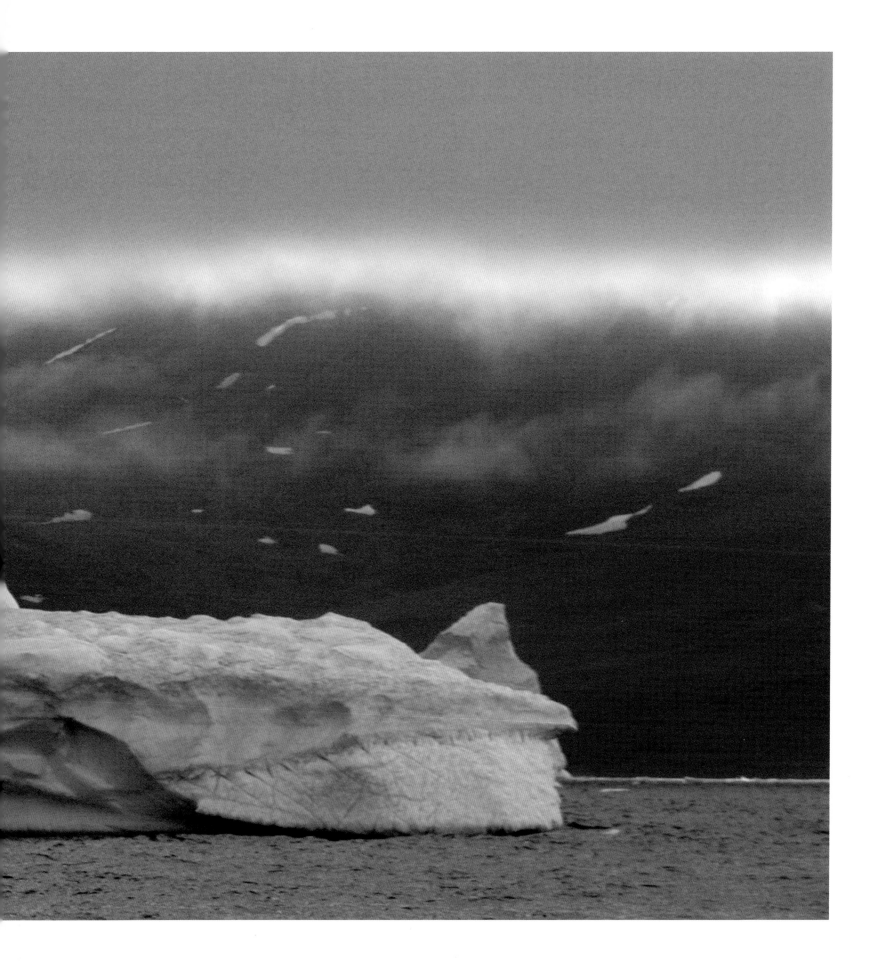

Μέσα στην παγωμένη ομίχλη,
ένα παγόβουνο περνάει δίπλα
από την ανατολική ακτή της
Γροιλανδίας, κοντά στην
περιοχή Ammassalik,
το αγαπημένο χωριό
του Paul-Émile Victor.

161

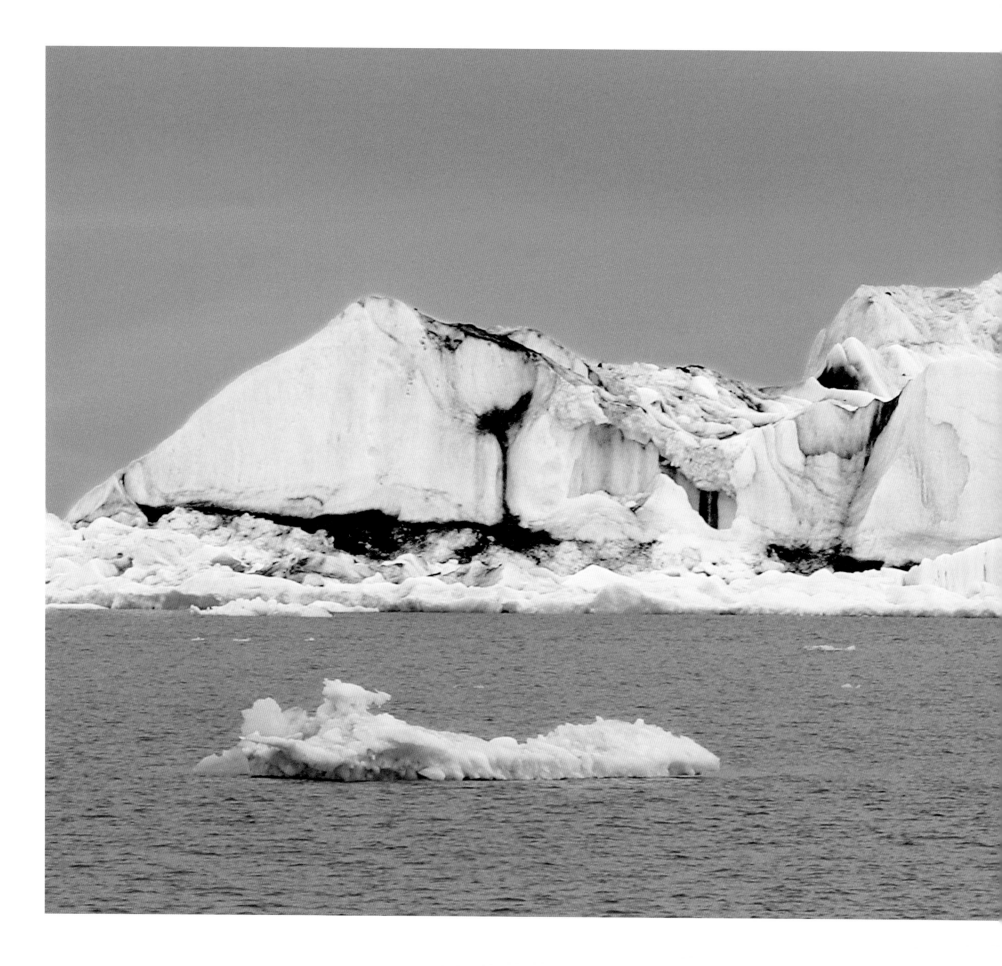

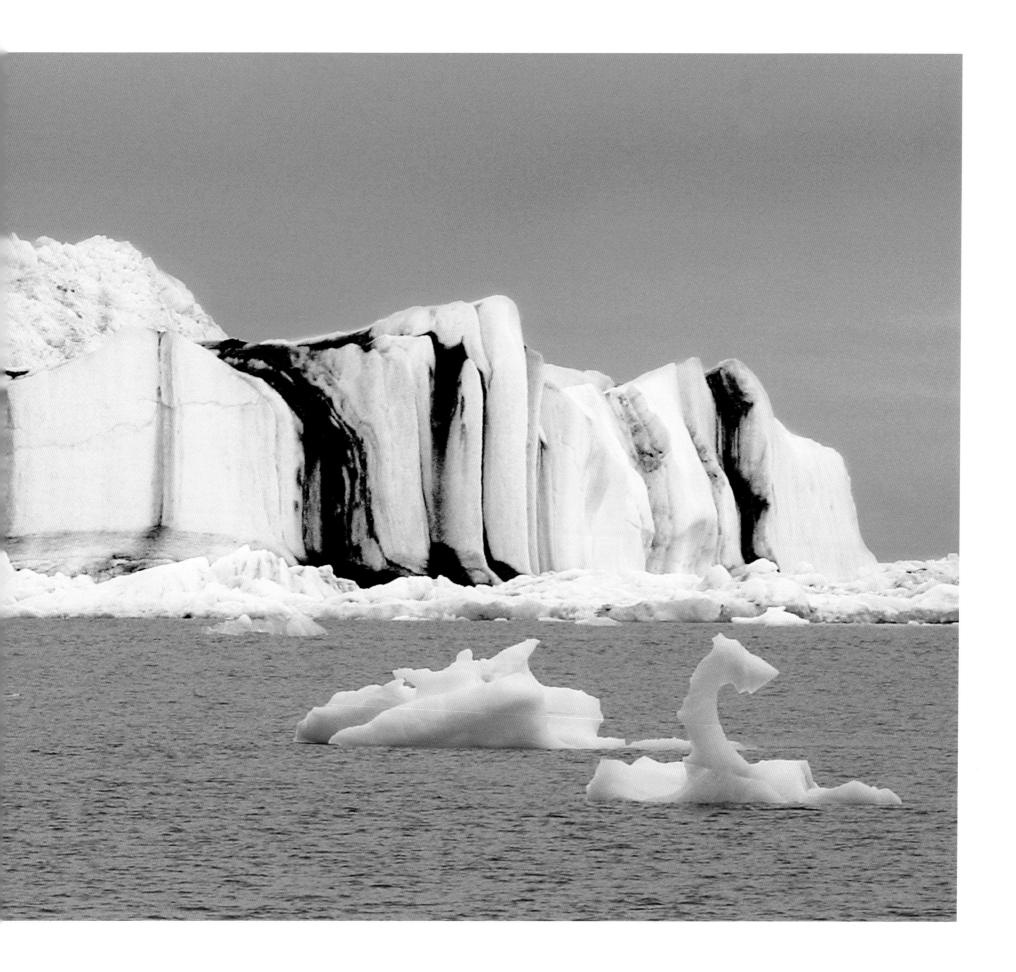

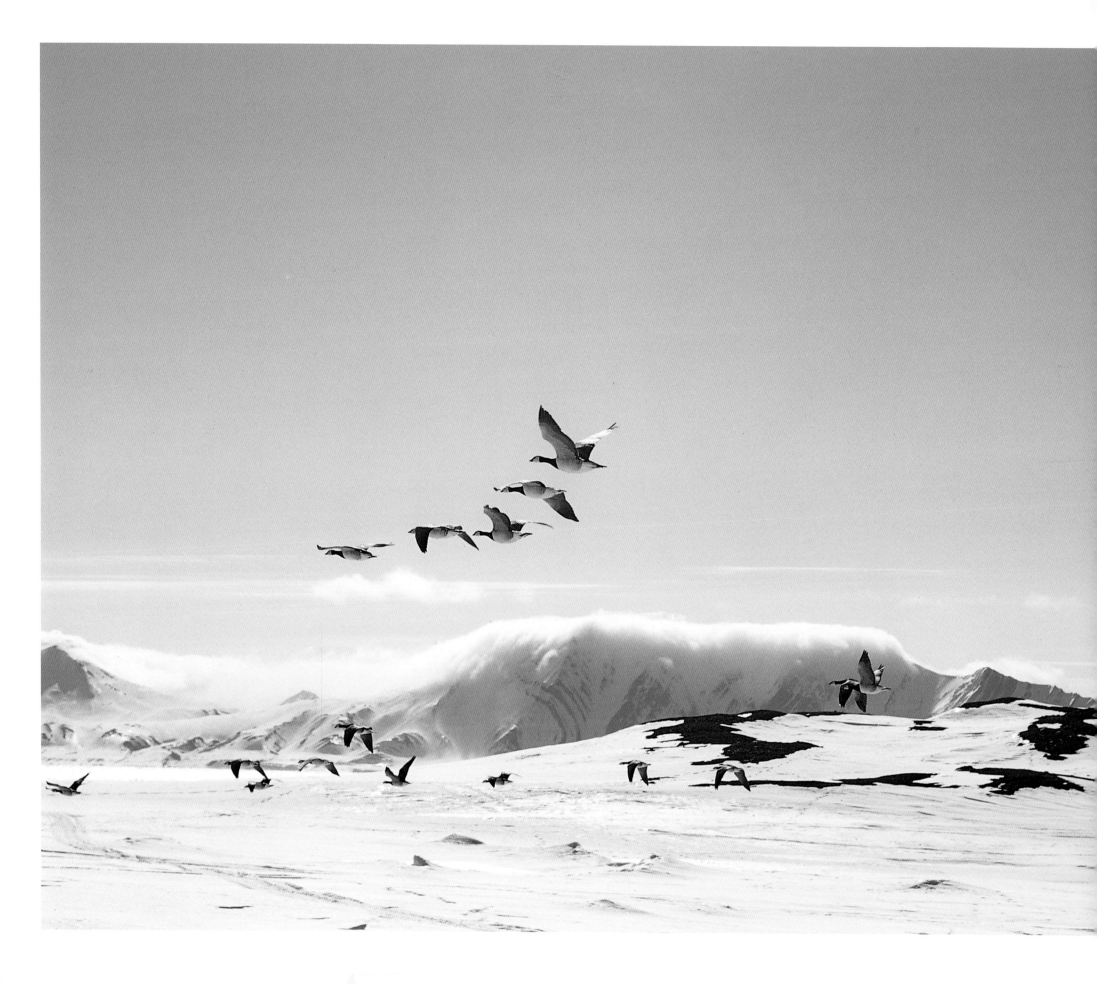

◁◁ Οι παγετώνες «γεννούν» τεράστια παγόβουνα, που πολλές φορές μαυρίζουν από τη λάσπη που κολλάει επάνω τους, από τους ποταμούς πάγου που πλέουν δίπλα τους.

◁ Στη Σιβηρία, όπως σε όλες τις αρκτικές περιοχές, η άνοιξη είναι η εποχή επιστροφής των αποδημητικών πουλιών. Οι αγριόχηνες έρχονται να κάνουν τη φωλιά τους σ' αυτά τα μέρη, όπου υπάρχει άφθονη τροφή.

▷ Ένα βουνό του αρχιπελάγους François-Joseph, στα βόρεια της Ρωσίας, αντανακλάται στα ήρεμα νερά του κόλπου Tikhaya.

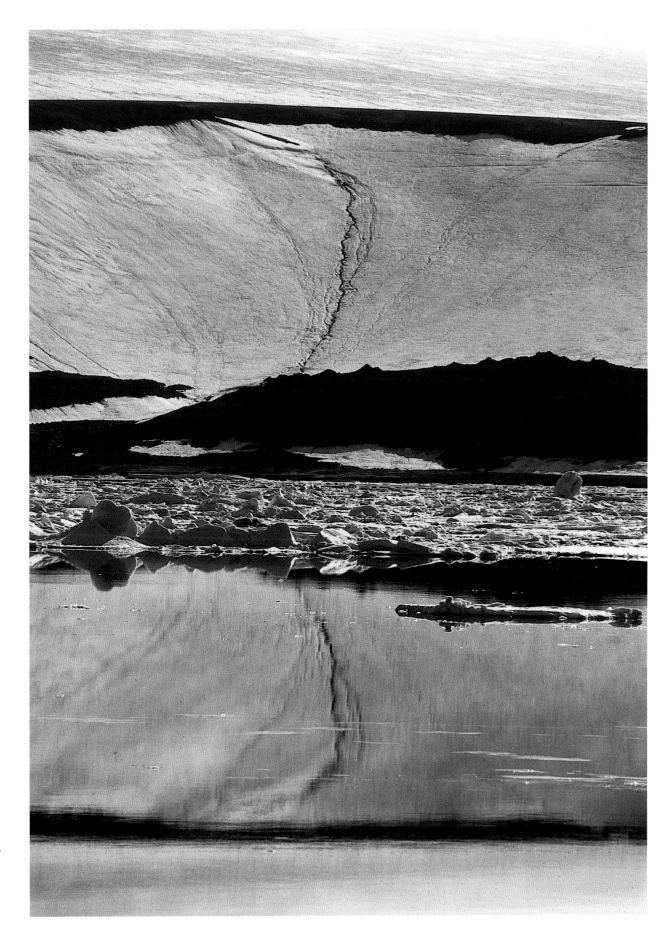

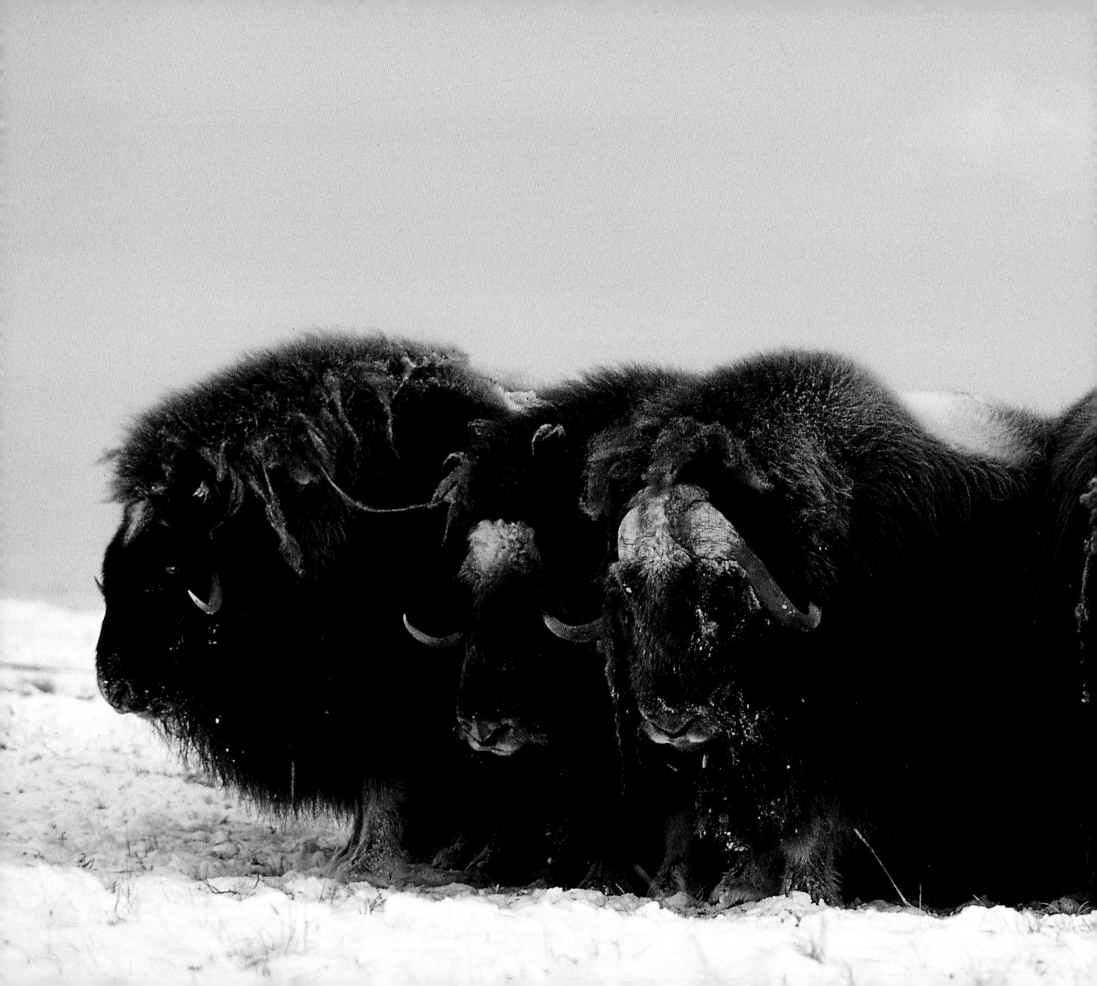

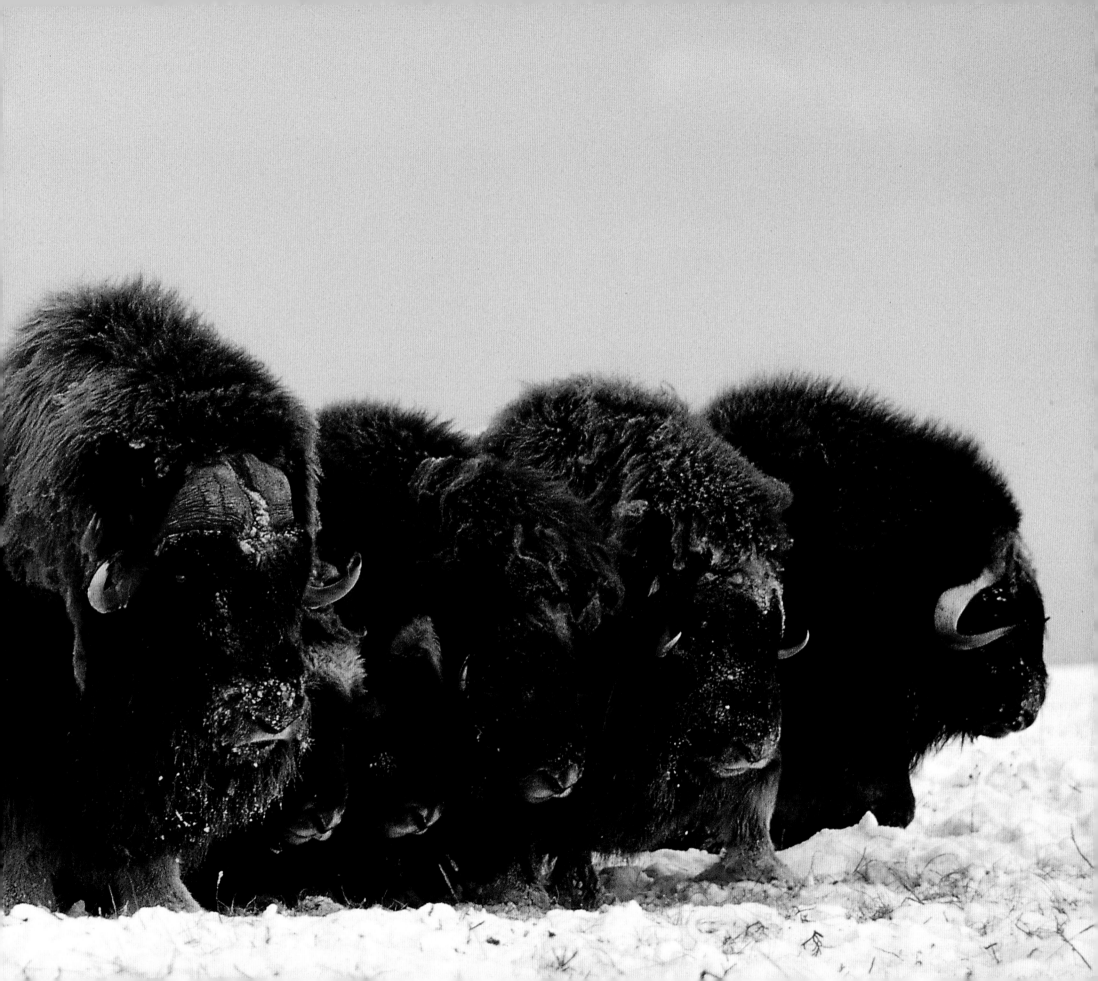

△ ▷ Το καλοκαίρι, η βλάστηση πυκνώνει και, σε λίγες μέρες, φυτρώνουν τα αρκτικά αφιόνια, τα βούρλα, οι λειχήνες και τα μανιτάρια.

◁◁ Τα μαλλιαρά αυτά βόδια (oribos moschatus), χορτοφάγα σύγχρονα των μαμούθ, τα συναντάμε στις τούντρες του Καναδά και της Γροιλανδίας. Σε περίπτωση κινδύνου, τα μεγάλα αρσενικά προστατεύουν τα θηλυκά και τα μικρά τους, αντιμετωπίζοντας κάθε επικείμενο εχθρό.

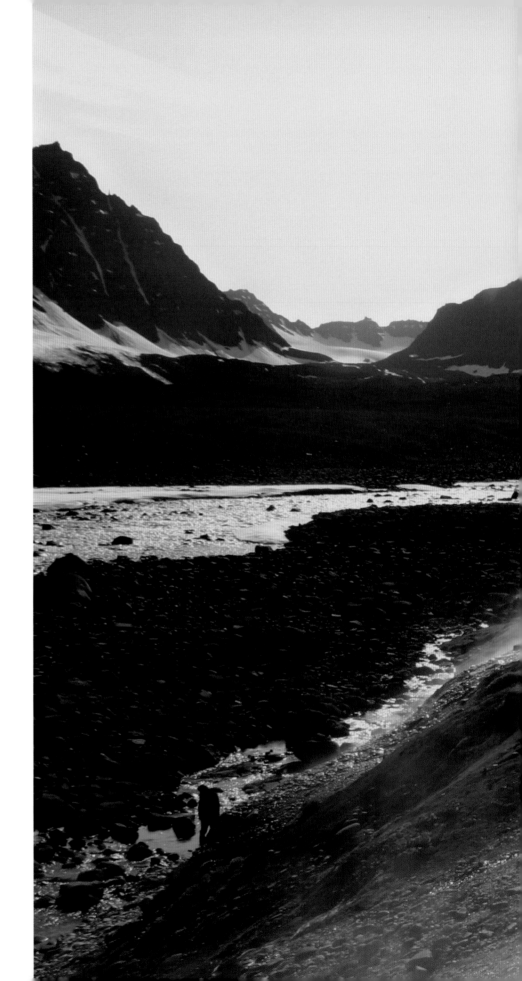

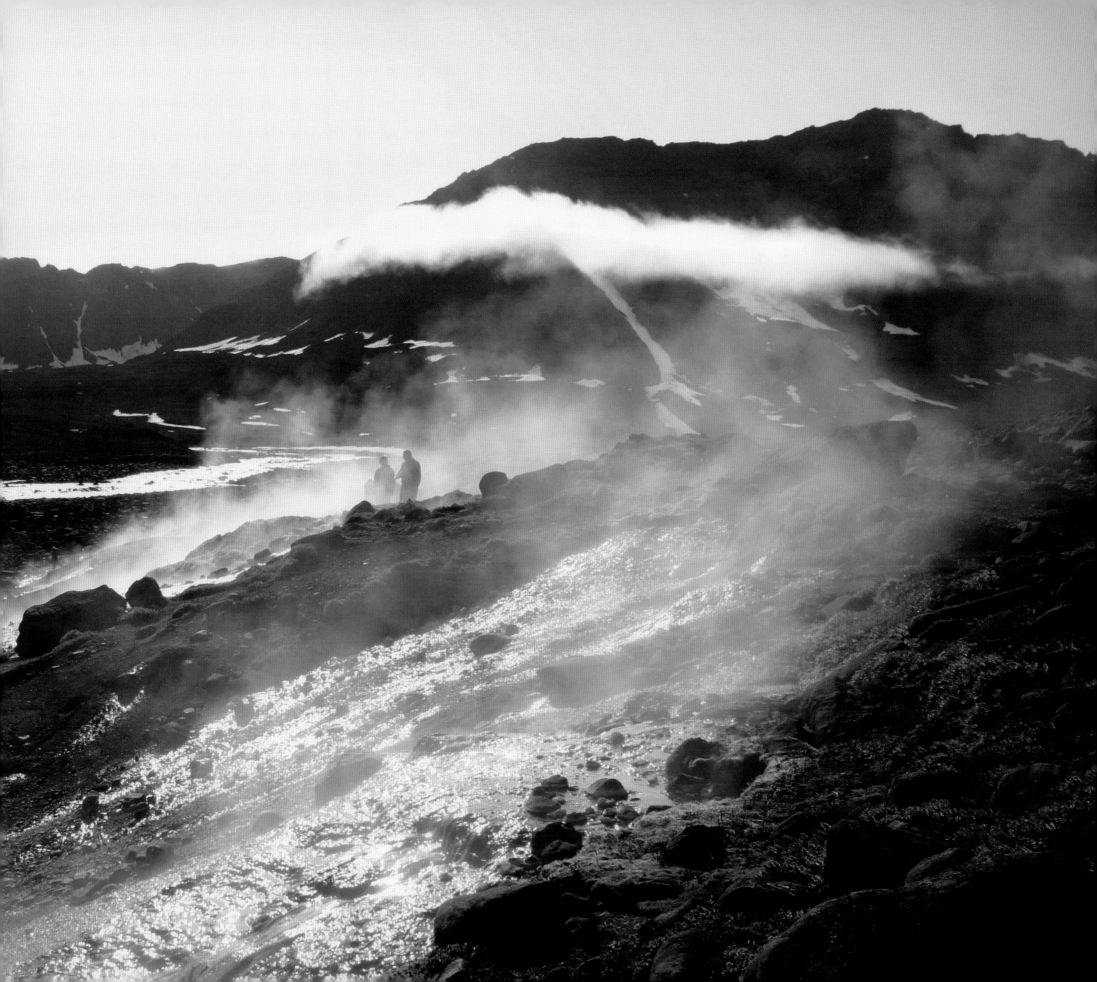

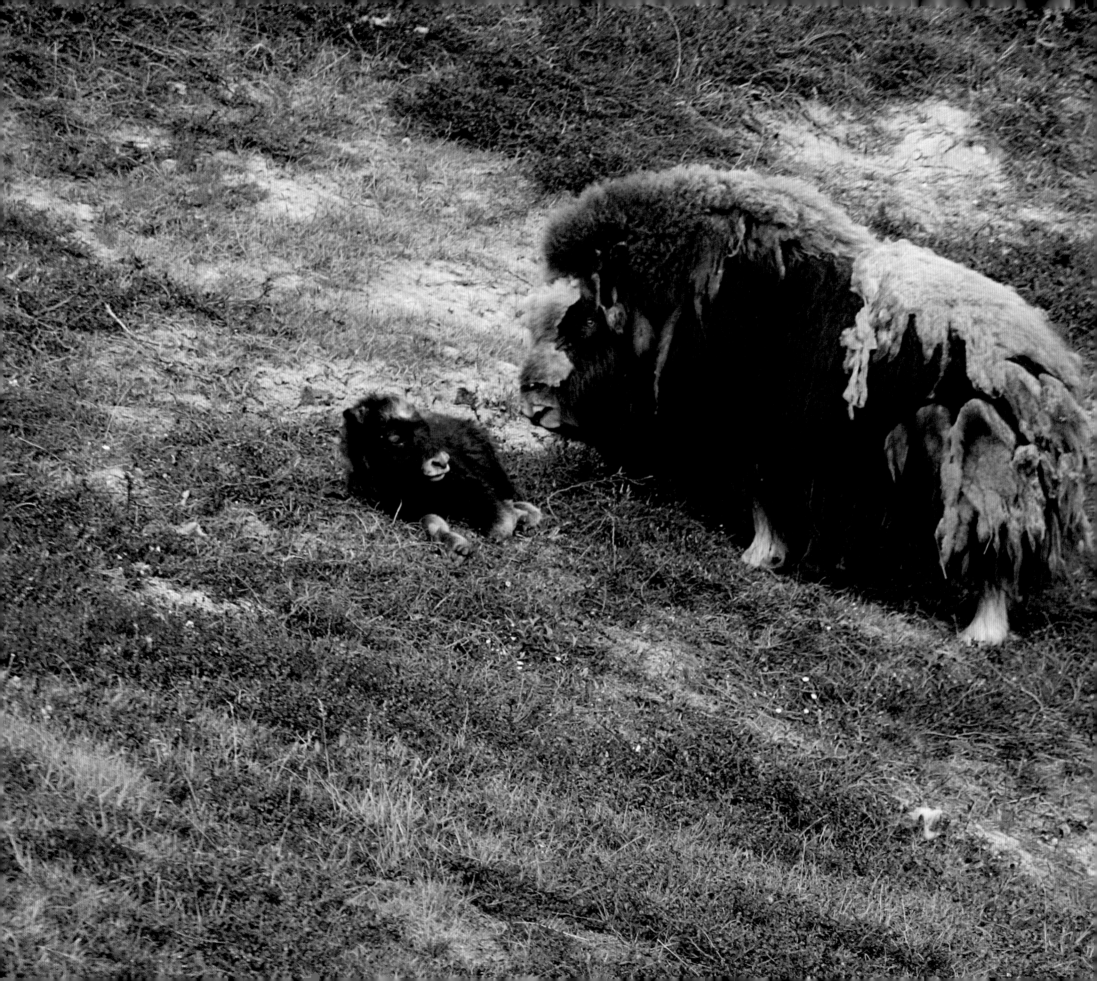

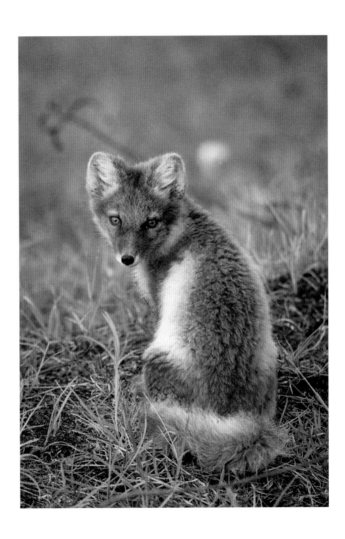

△ Στη Σιβηρία, στη μέση ενός χωραφιού με βούρλα ή βαμβακόχορτα, μια αλεπού παραμονεύει έναν λέμμο, την αγαπημένη της λεία.

◁ Ένα βόδι προστατεύει το μικρό του. Όταν φτάσει το καλοκαίρι, το ζώο χάνει το πυκνό του τρίχωμα.

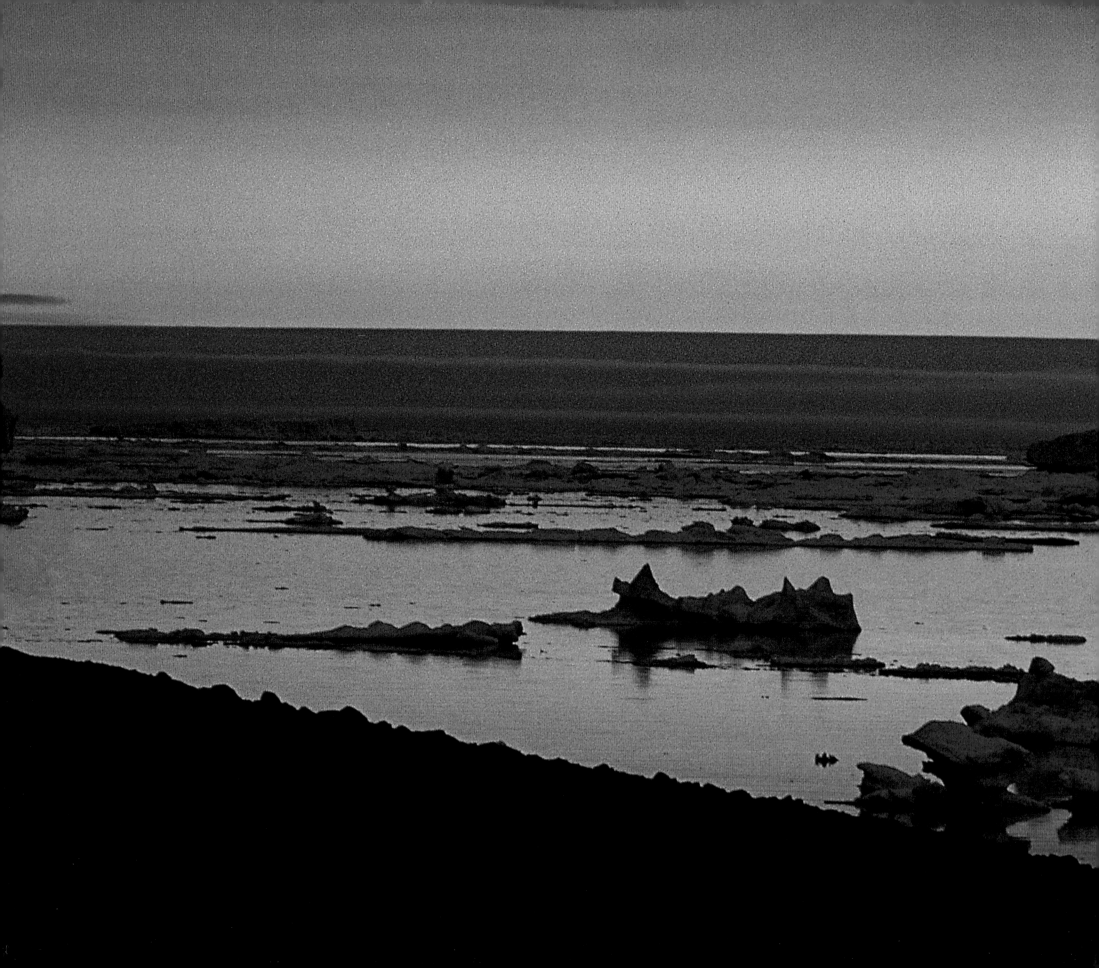

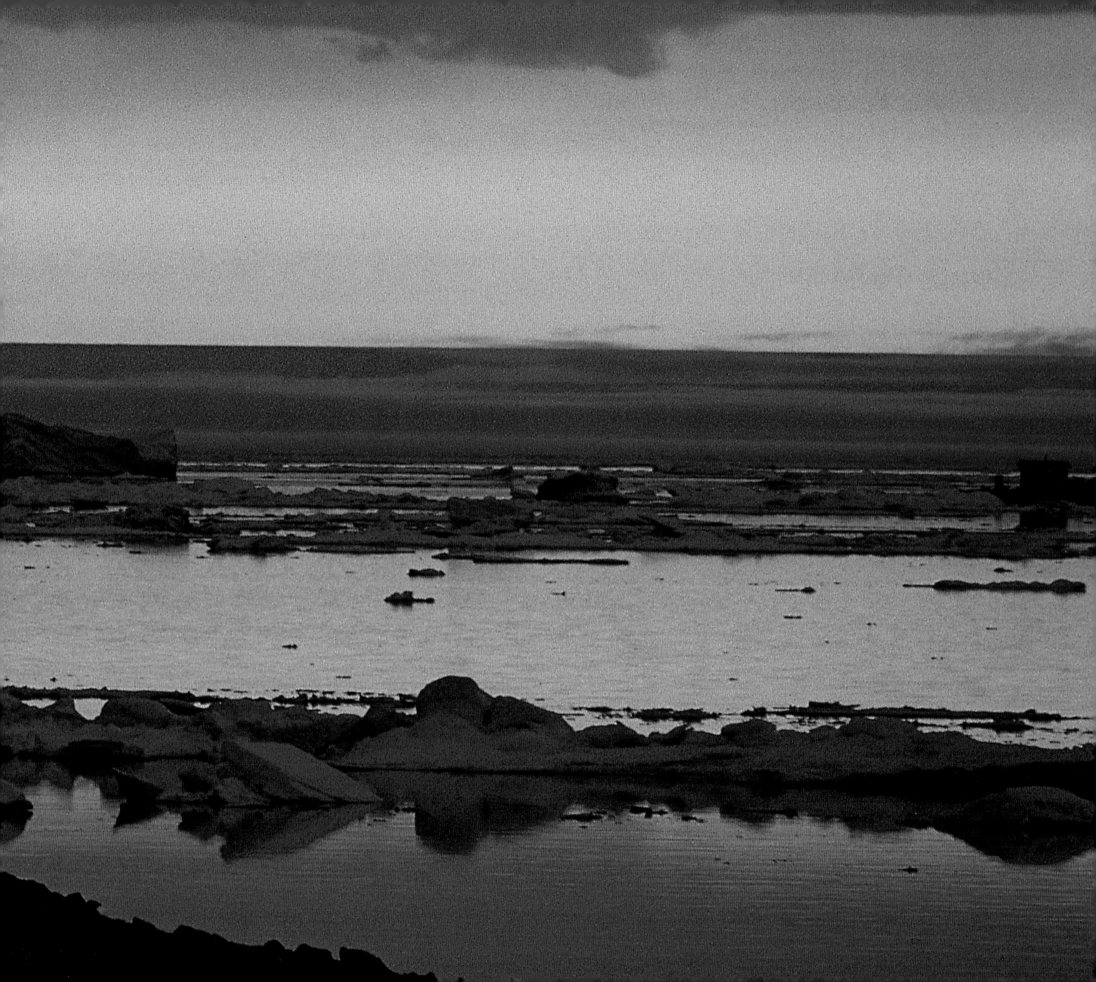

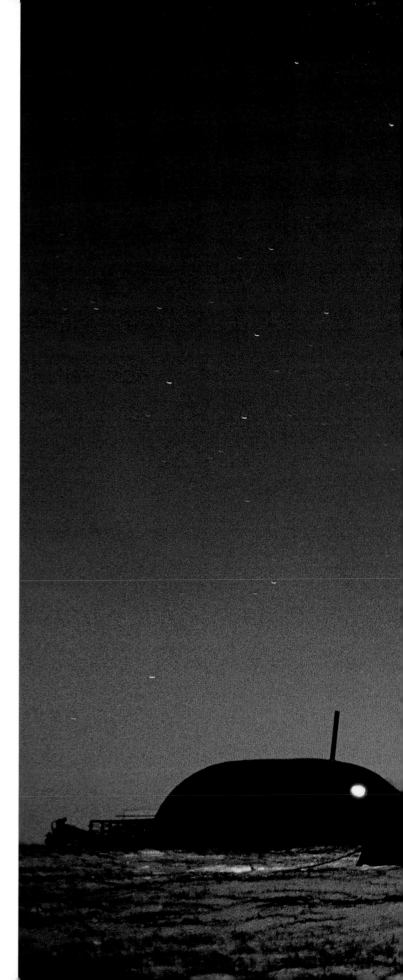

◁◁ *Η άνοιξη μπήκε στον κόλπο Agarbukta. Στα ανατολικά του Spitzberg, οι παγωμένες εκτάσεις λιώνουν κάτω από τις πρώτες αχτίδες του ήλιου.*

▷ *Μέσα στην παγωμένη ατμόσφαιρα της πολικής νύκτας, ο καταυλισμός της αποστολής «Mammuthus» φωτίζεται από το Βόρειο Σέλας.*

▽ *Οι Δολγάνες γυναίκες, όσο διαρκούν οι μεγάλες χειμωνιάτικες νύχτες, φτιάχνουν κεντήματα επάνω στα δέρματα των ταράνδων.*

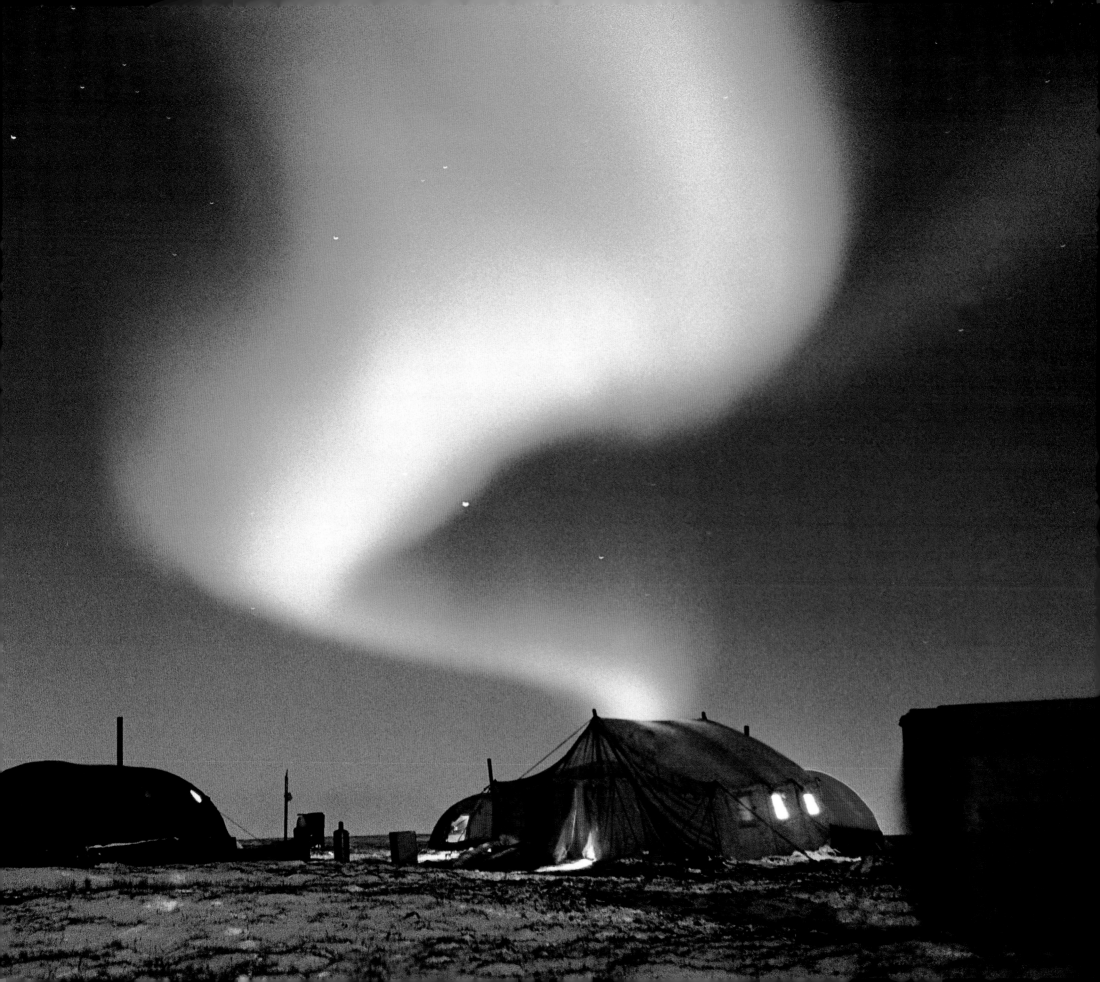

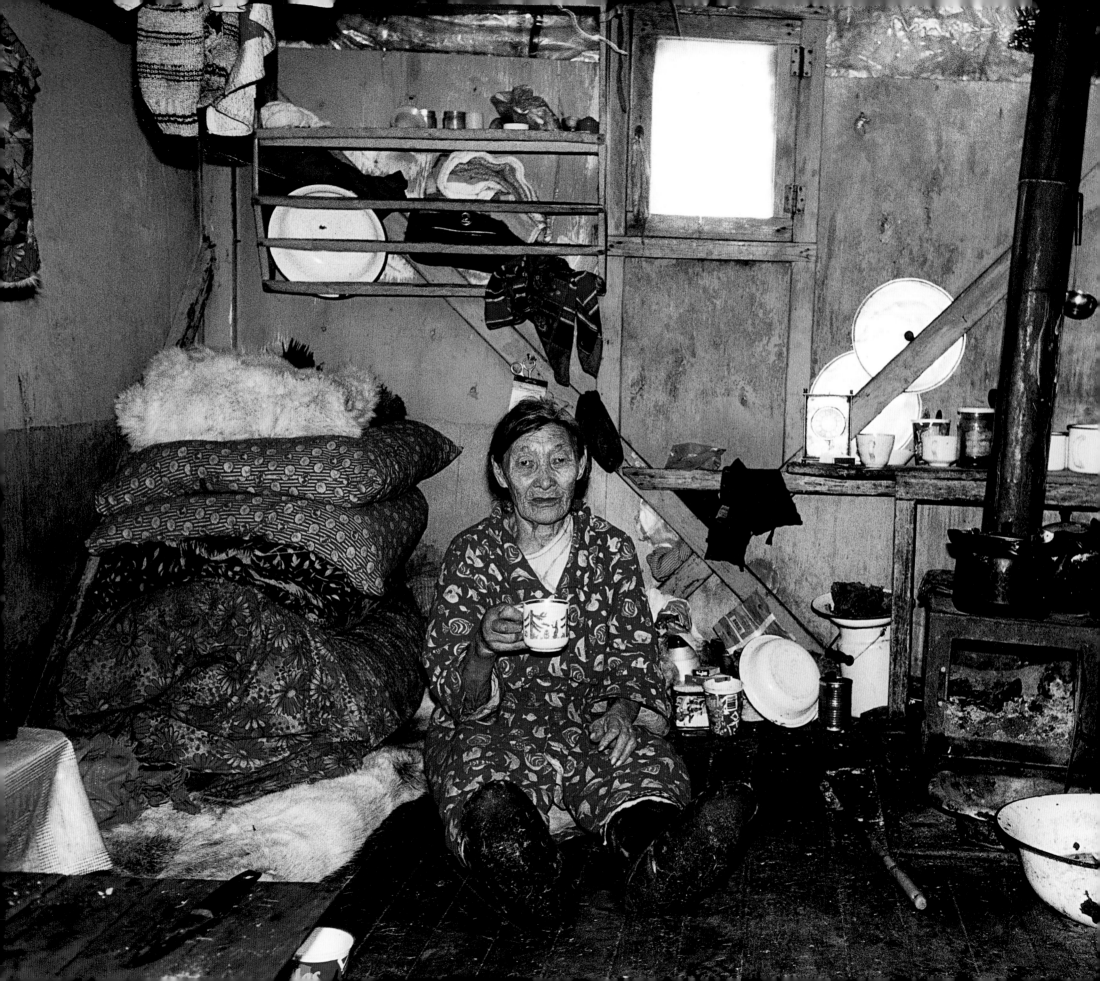

Μια ηλικιωμένη Δολγάνα φροντίζει την εστία αυτού του balok. Μια σόμ[...]
και μερικά σκεύη αποτελούν όλα της τα υπάρχοντα.

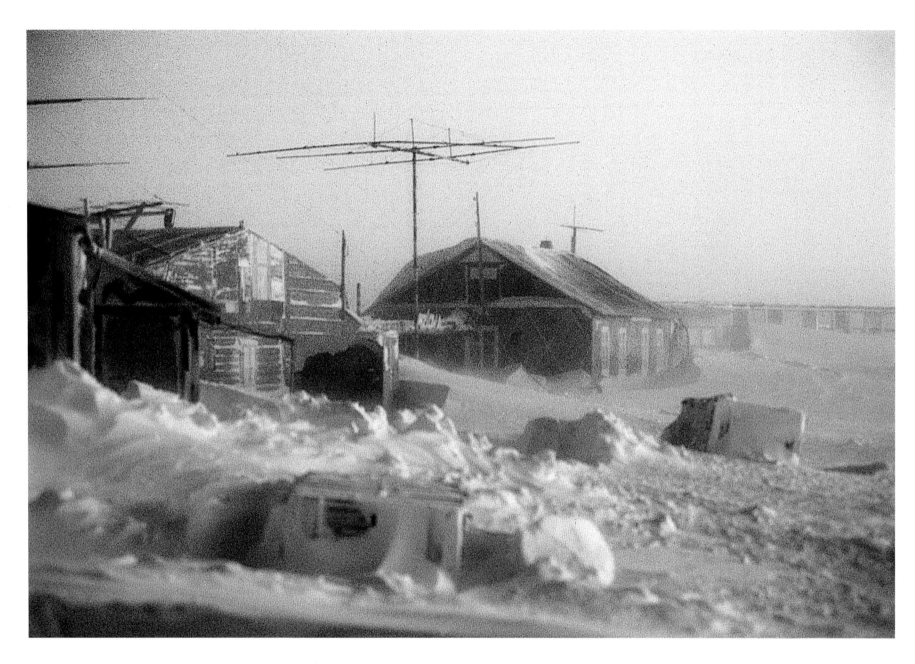

△ Στο αρχιπέλαγος François-Joseph, η μετεωρολογική βάση του Krenkel υφίσταται την «έφοδο» του δυνατού βόρειου παγωμένου αέρα (blizzard).

▷ Στο λιμάνι Dickson, αυτό το πλοιάριο, αποκλεισμένο μέσα στους πάγους του πολικού χειμώνα, περιμένει να έρθουν καλύτερες μέρες.

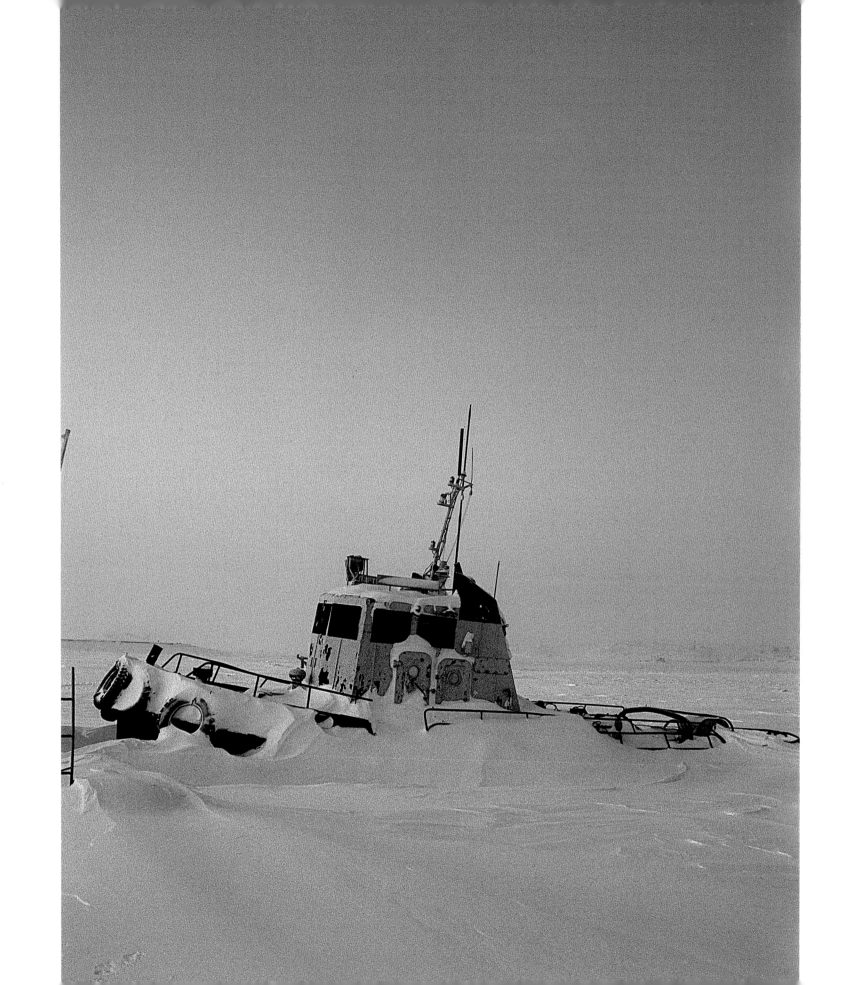

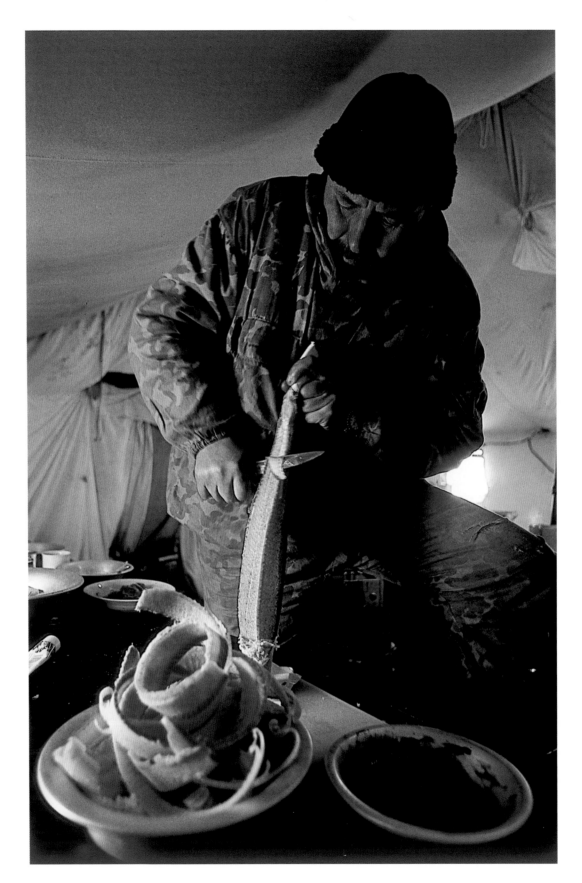

▷ Παραδοσιακό έδεσμα των κατοίκων της Σιβηρίας, ωμό ψάρι κατεψυγμένο, το επονομαζόμενο stroganina, τεμαχισμένο σε πολύ μικρά και λεπτά κομματάκια σαν ροκανίδια, τρώγεται με αλάτι και πιπέρι.

▷ Στον Βόρειο Πόλο, μετά την καταιγίδα, πρέπει να απελευθερωθούν οι σκηνές του καταυλισμού των Ρώσων επιστημόνων από τη βάση, που για τρεις μήνες ήταν τοποθετημένη επάνω στην αρκτική παγονησίδα.

▷▷ Τα μεσάνυχτα, μέσα στην τούντρα που την έχει σαρώσει ο δυνατός βόρειος παγωμένος αέρας (blizzard), ο ήλιος πηγαινοέρχεται στον ορίζοντα, χωρίς ποτέ να εξαφανίζεται.

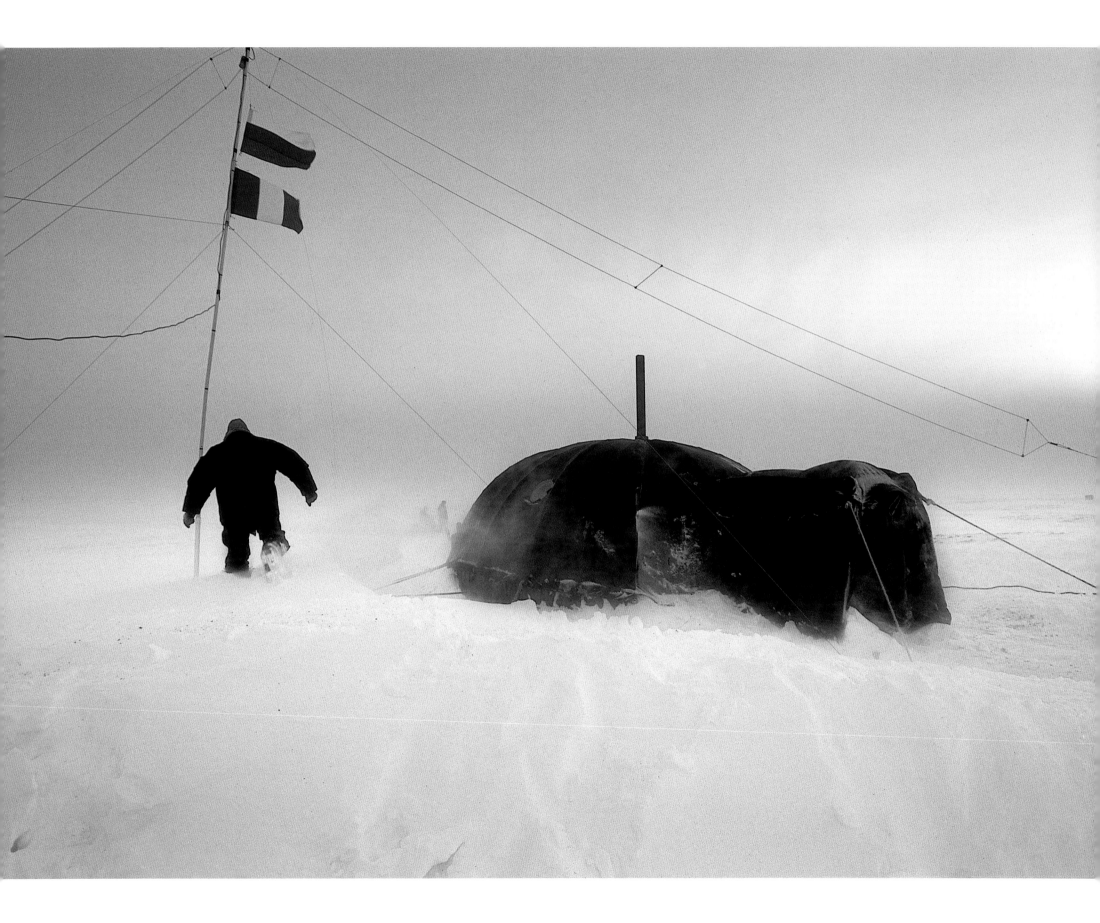

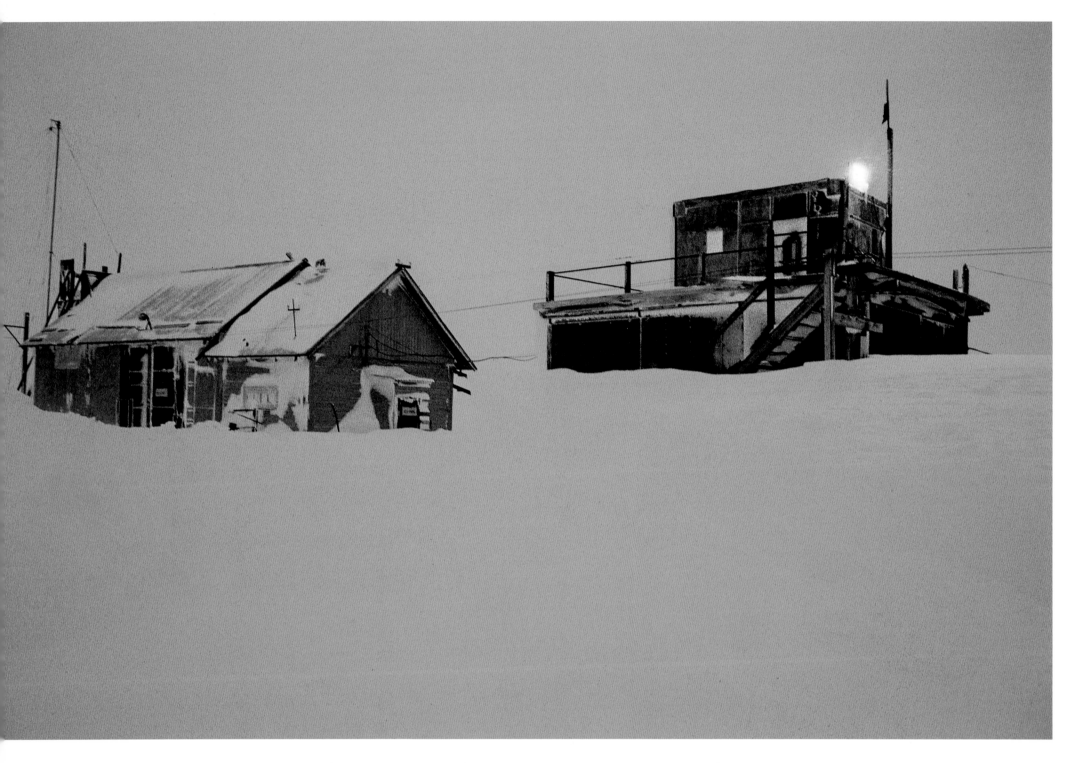

Η πιο βορεινή από τις μετεωρολογικές βάσεις έχει εγκατασταθεί στο αρχιπέλαγος François-Joseph. Κάθε μέρα οι μηχανικοί προσπαθούν, μέσα σε ακραίες καιρικές συνθήκες, να εκτοξεύσουν μετεωρολογικά μπαλόνια και να συντάξουν δελτία καιρού, εξαιρετικά πολύτιμα στα εύκρατα γεωγραφικά μας πλάτη.

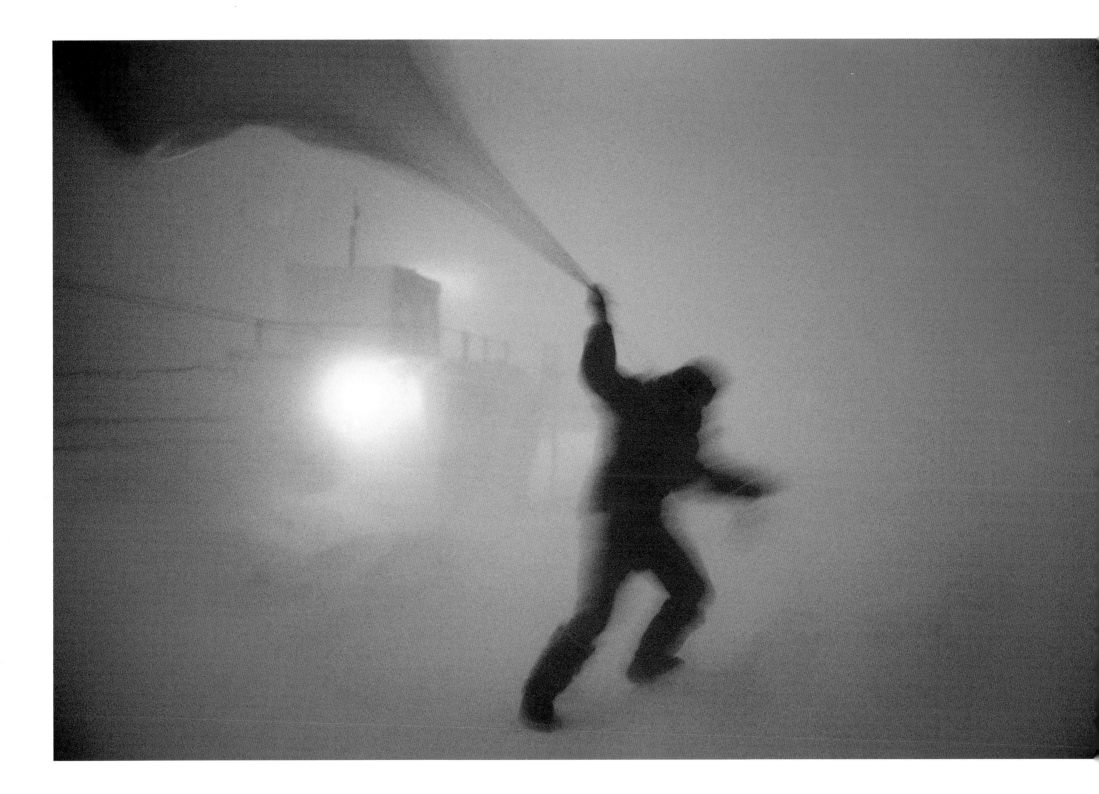

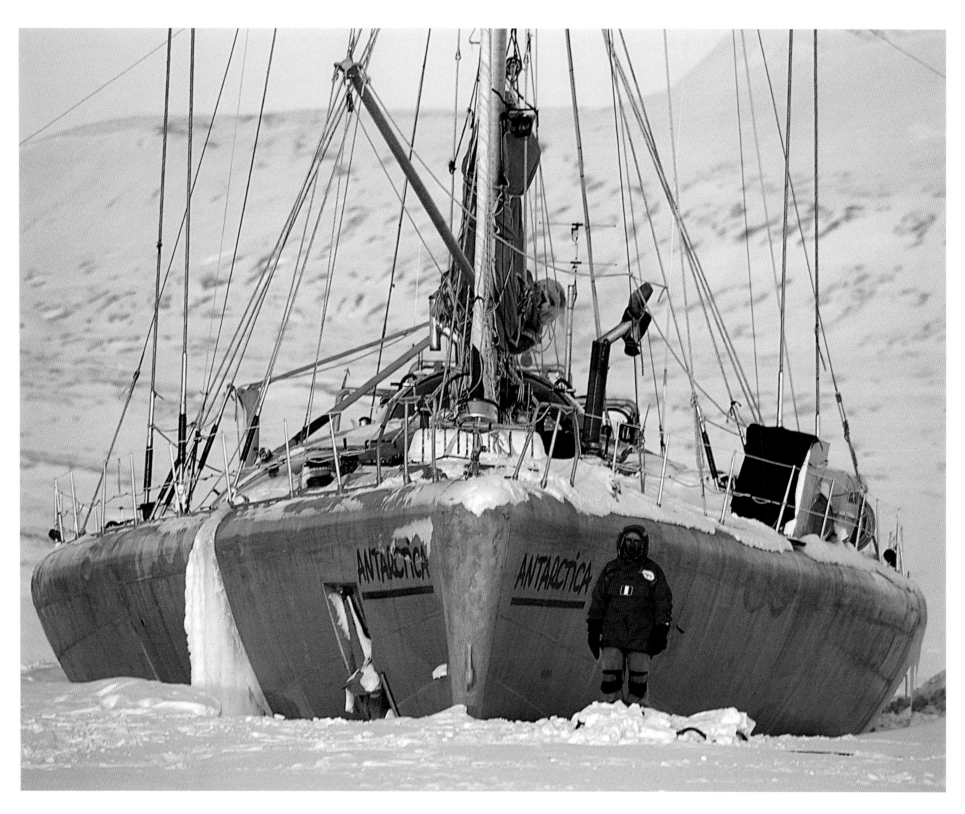

Το «Antarctica», το πλοίο του γιατρού-εξερευνητή Jean-Louis Etienne, παγιδευμένο μέσα στους πάγους του Spitzberg κατά τη διάρκεια της διαχείμασής του.

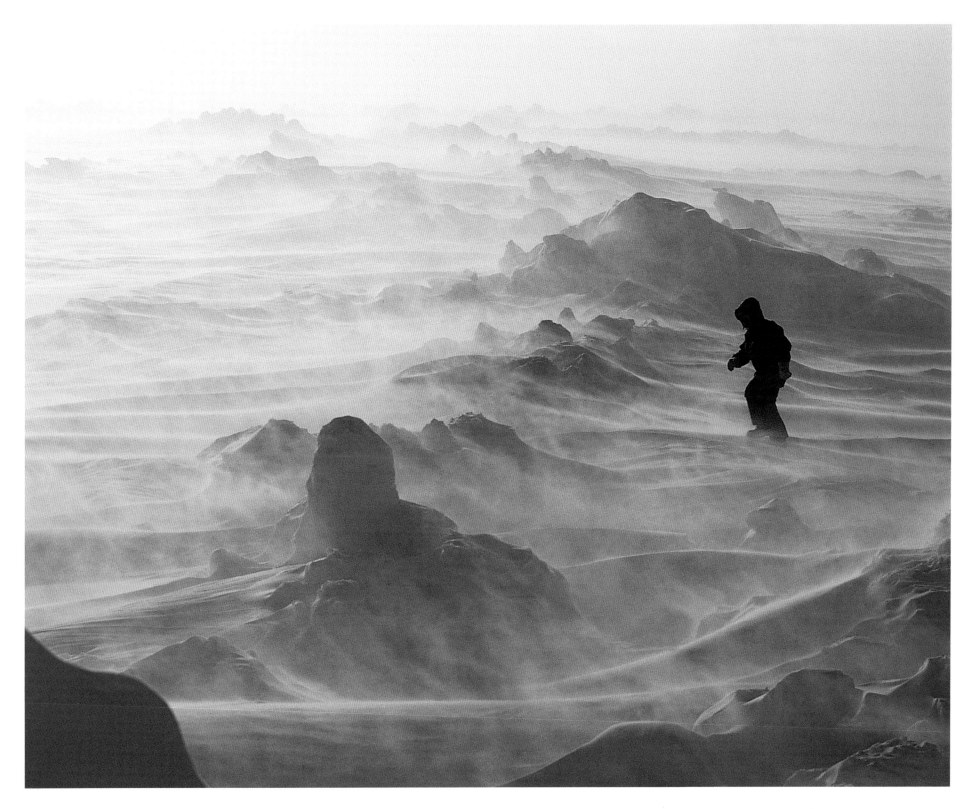

Κατά τη διάρκεια της αποστολής «Mission Banquise», ο Jean-Louis Etienne αντιμετωπίζει
τον δυνατό βόρειο παγωμένο αέρα (blizzard) που φυσά στην περιοχή.

Αιχμάλωτη των πάγων, εδώ και οκτώ μήνες, μέσα σε ένα παγωμένο φιορντ του Spitzberg, η πολική γολέτα «Antarctica», με τον ερχομό του καλοκαιριού, απελευθερώνεται τελικά, για να ξαναβρεθεί στα ελεύθερα νερά.

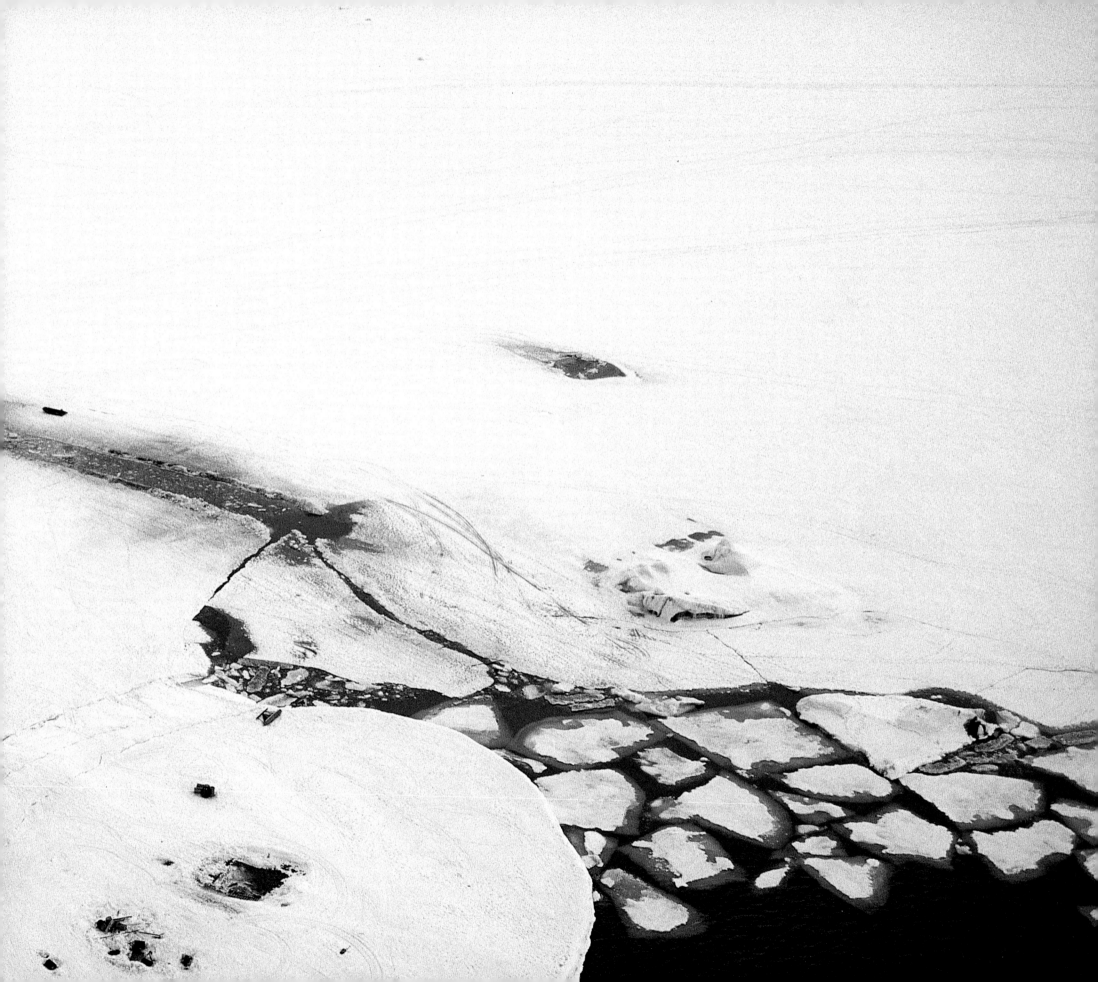

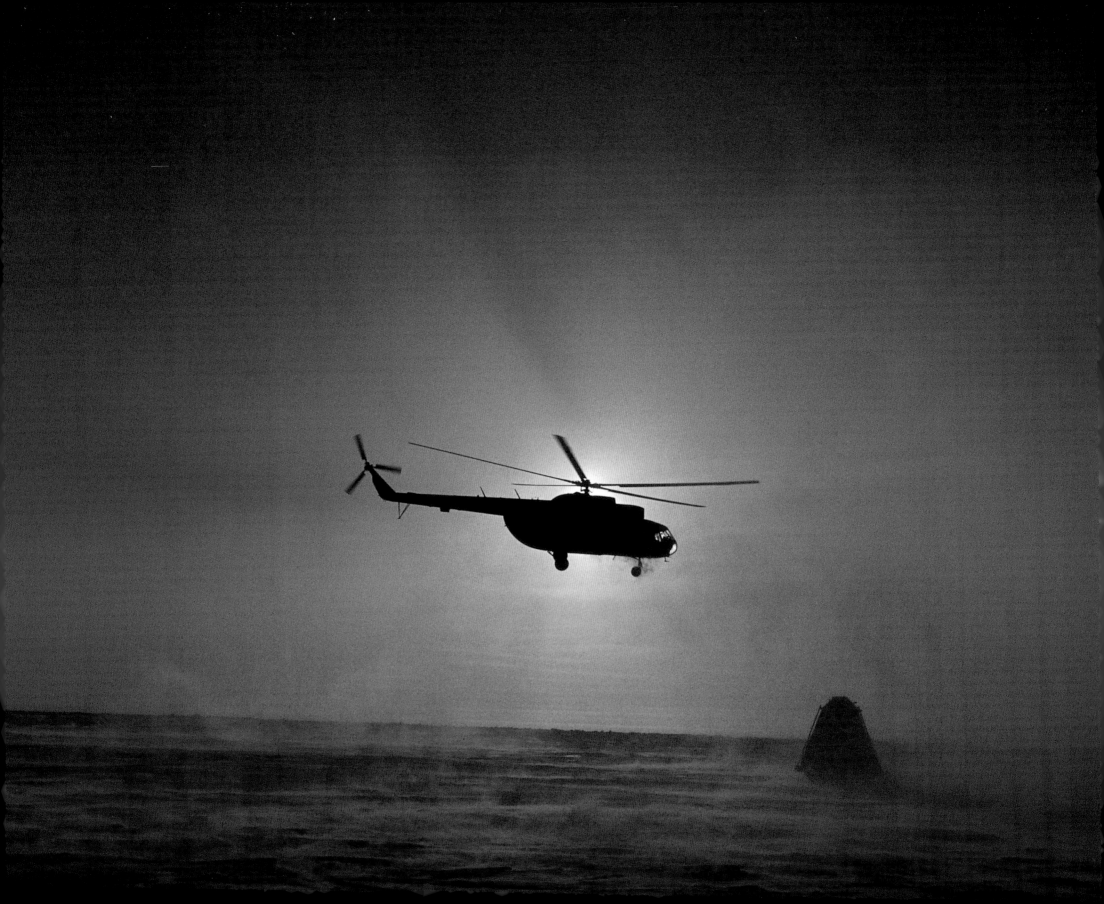

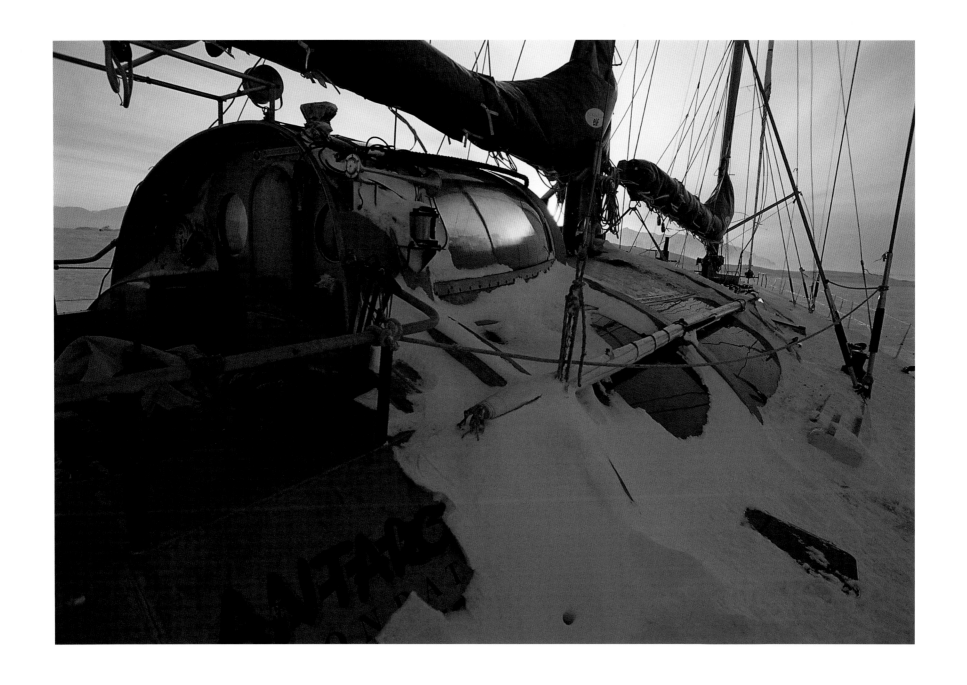

△ Το πλοίο του Jean-Louis Etienne ξεχειμωνιάζει κάτω από τα χιόνια του Spitzberg. Ακινητοποιημένο εδώ και μήνες, υποτάχτηκε στο σκληρό κλίμα της Αρκτικής.

◁ Τον Απρίλιο του 2002, ένα ελικόπτερο εξασφαλίζει τον ανεφοδιασμό της αποστολής «Mission Banquise» του Jean-Louis Etienne στον Βόρειο Πόλο.

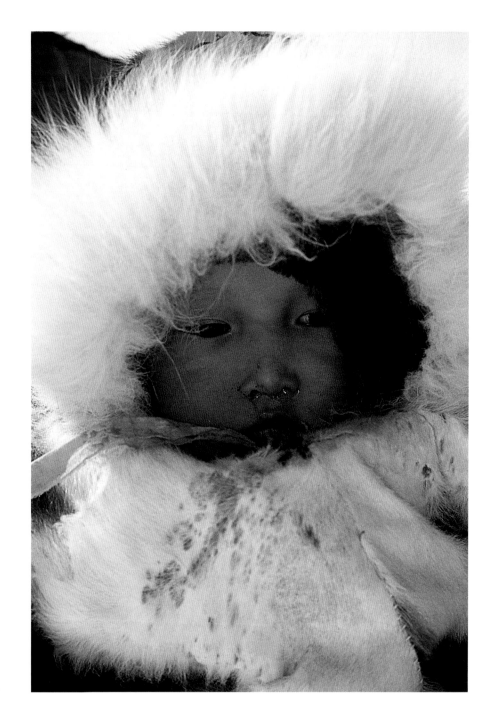

Ένα μωρό από το Tiksi,
στη Yakoutie, έτοιμο για
τον καθημερινό περίπατο.

▷ Στην πολική βάση Krenkel, στο αρχιπέλαγος
François-Joseph, οι επιστήμονες, αντιμέτωποι με τα
στοιχεία της φύσης, προσπαθούν να συλλέξουν τα
μετεωρολογικά δεδομένα.

▷▷ Προάγγελοι της άνοιξης, οι ελαφρές ομίχλες
της Αρκτικής οφείλονται στην εξάτμιση των νερών
που θερμαίνουν οι πρώτες ακτίνες του ήλιου.

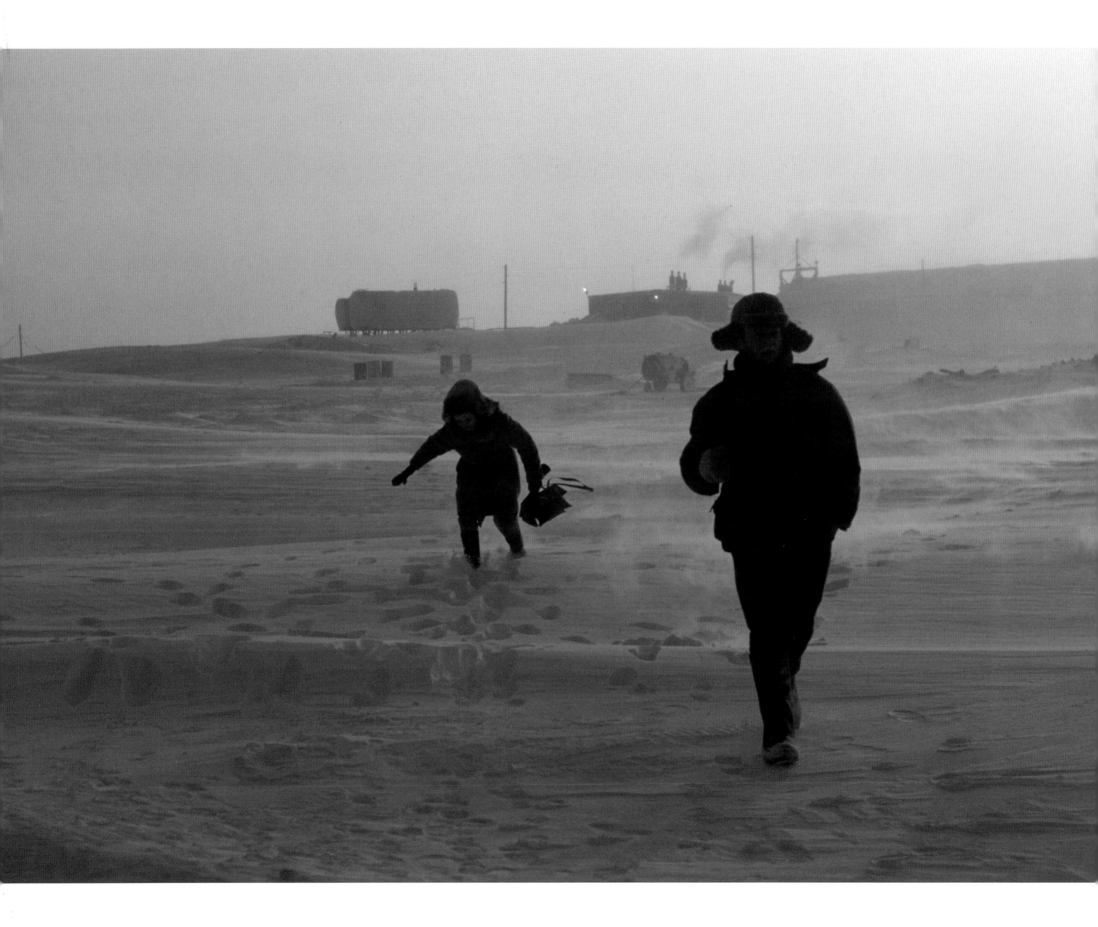

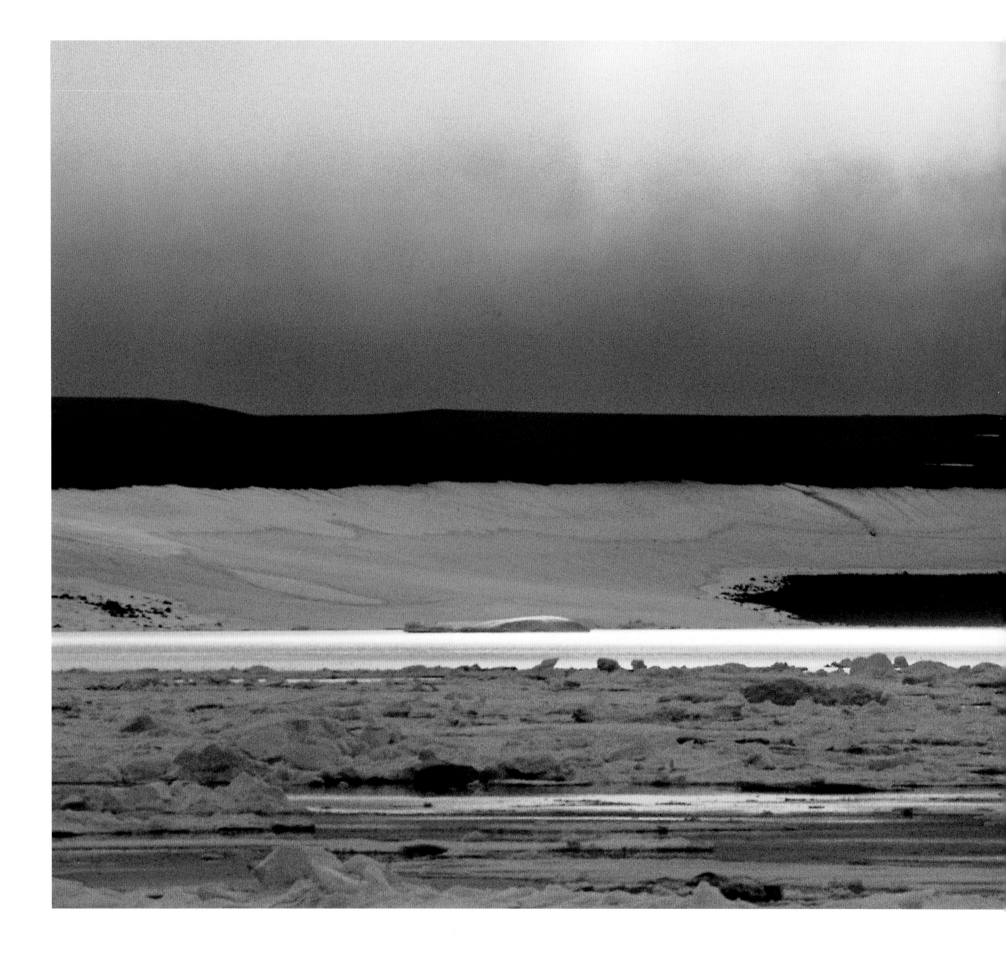

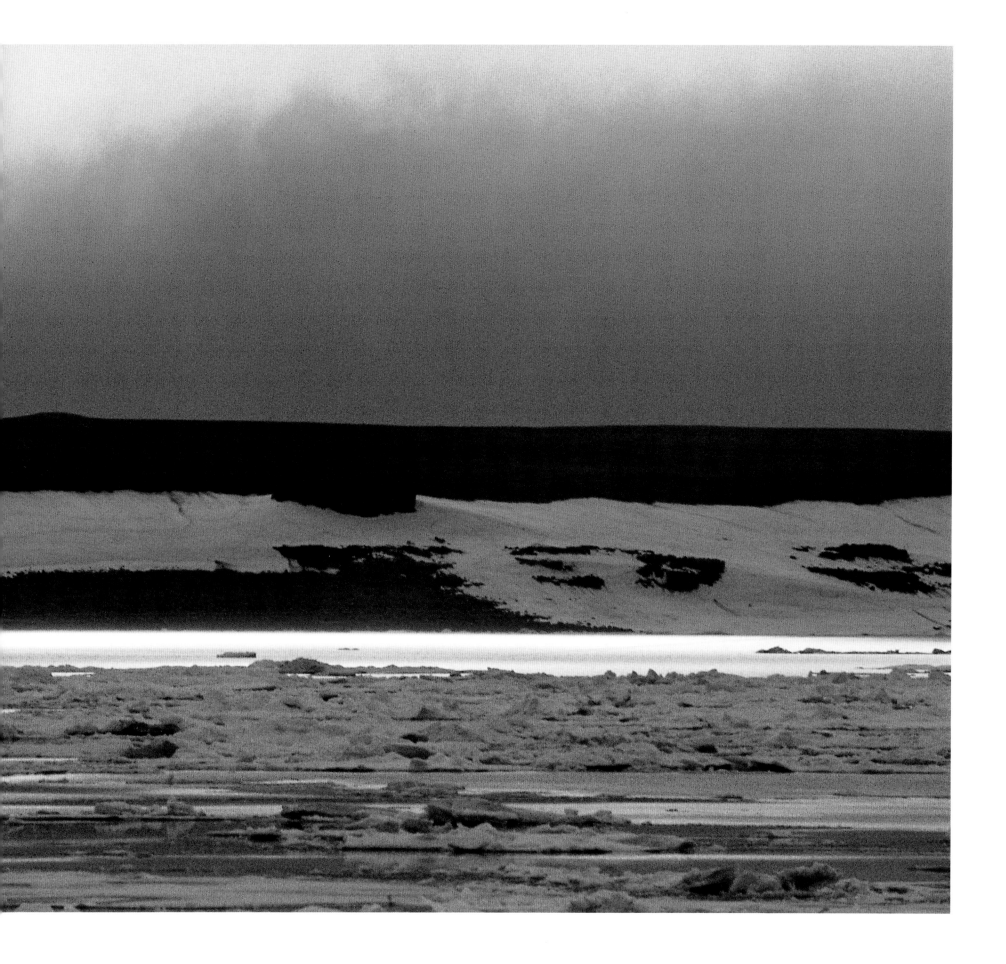

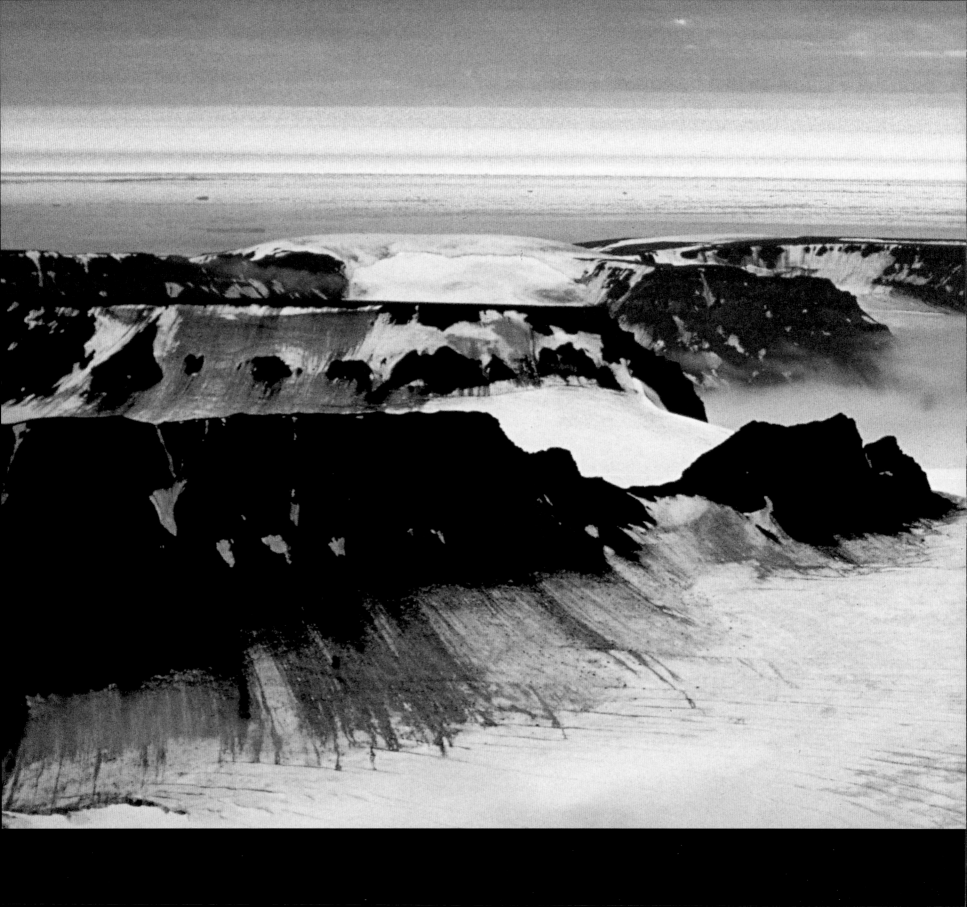

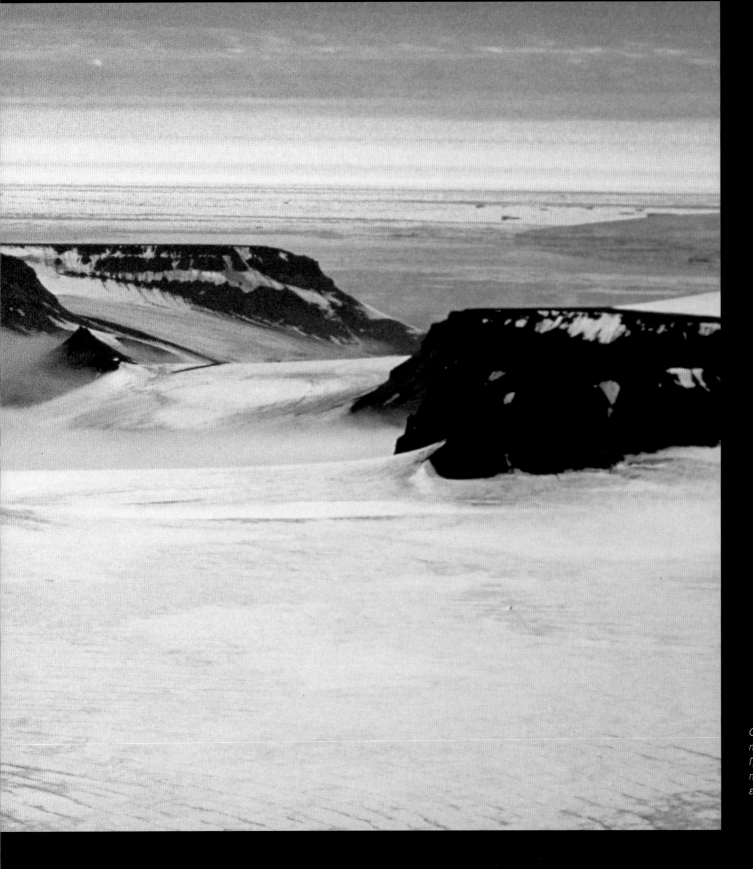

Οι πιο μεγάλοι παγετώνες του βόρειου ημισφαίριου βρίσκονται μέσα στα βουνά της Γροιλανδίας. Λόγω της υπερθέρμανσης του πλανήτη, αρχίζουν να λιώνουν, κάτι που εντείνει την κλιματική ανισορροπία.

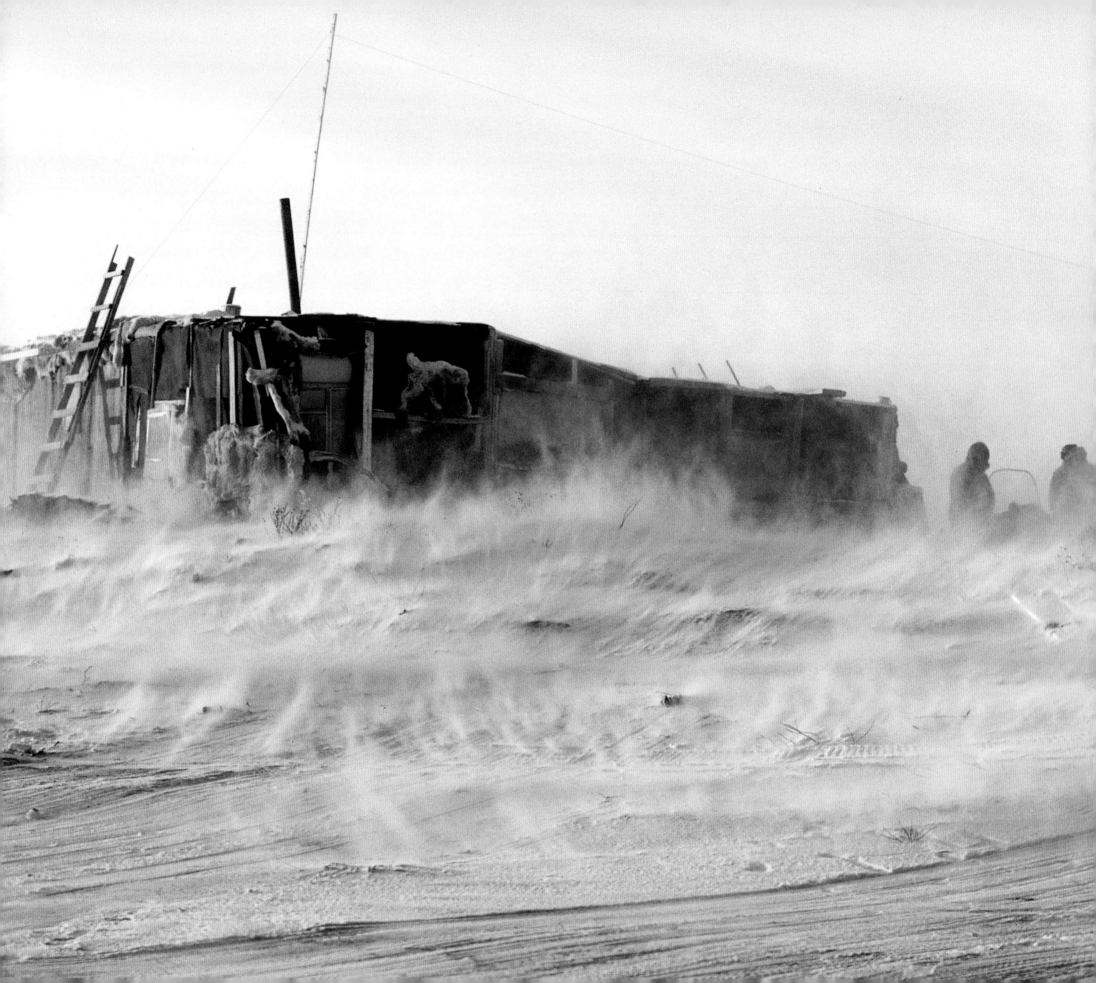

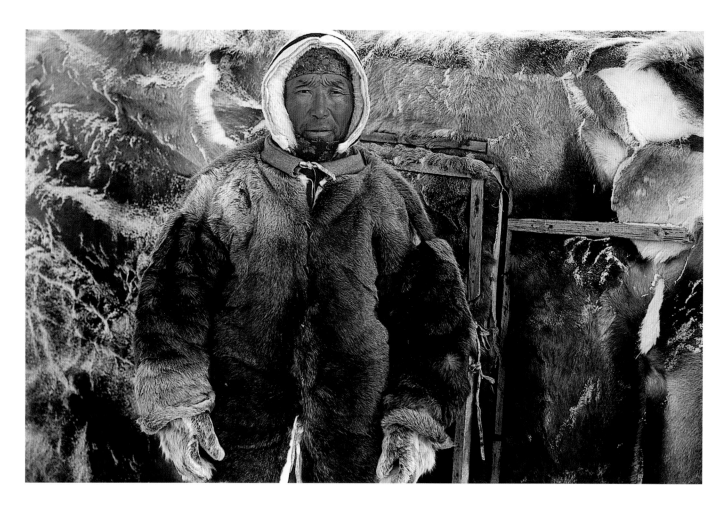

◁ Στο ποτάμι Ρορίgαυ, στα βόρεια της Σιβηρίας, μια καλύβα χρησιμεύει για καταφύγιο των ψαράδων και κυνηγών της τούντρας.

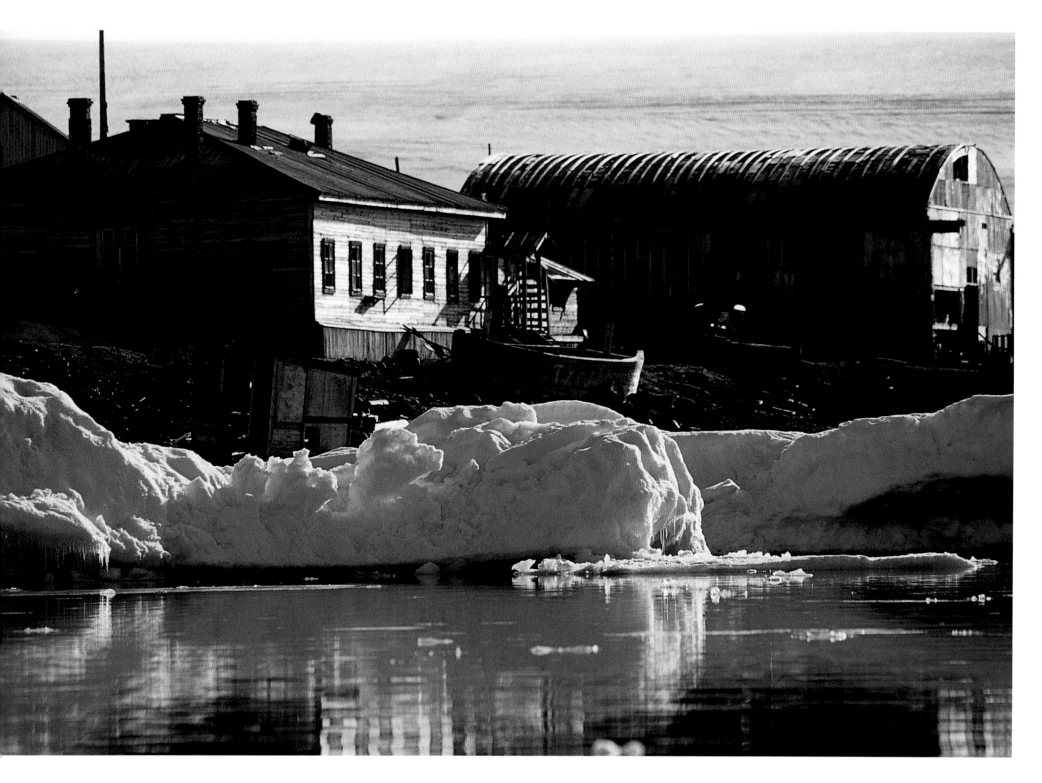

◁◁ Το χρυσαφένιο φως του φθινοπωριάτικου ήλιου
φωτίζει τα βουνά του Spitzberg.

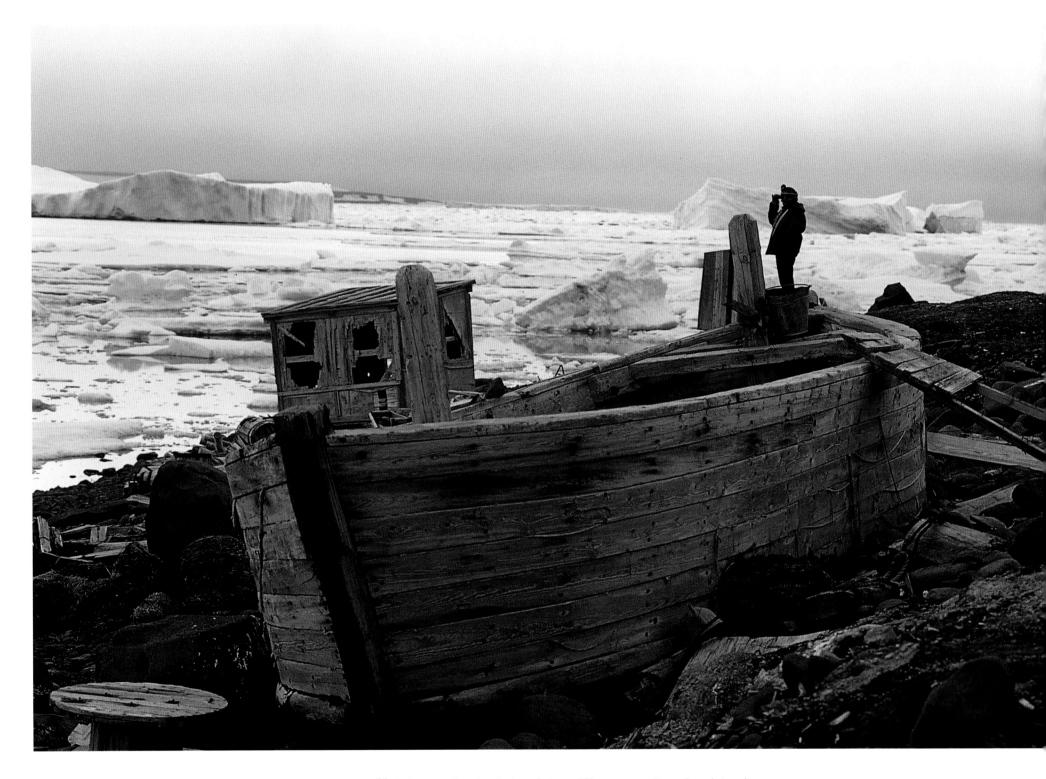

◁△ Τα ίχνη των σοβιετικών πολικών σταθμών στην Tikhaya, στο αρχιπέλαγος François-Joseph,
αποδεικνύουν τη στρατηγική παρουσία επιστημονικών και στρατιωτικών βάσεων.

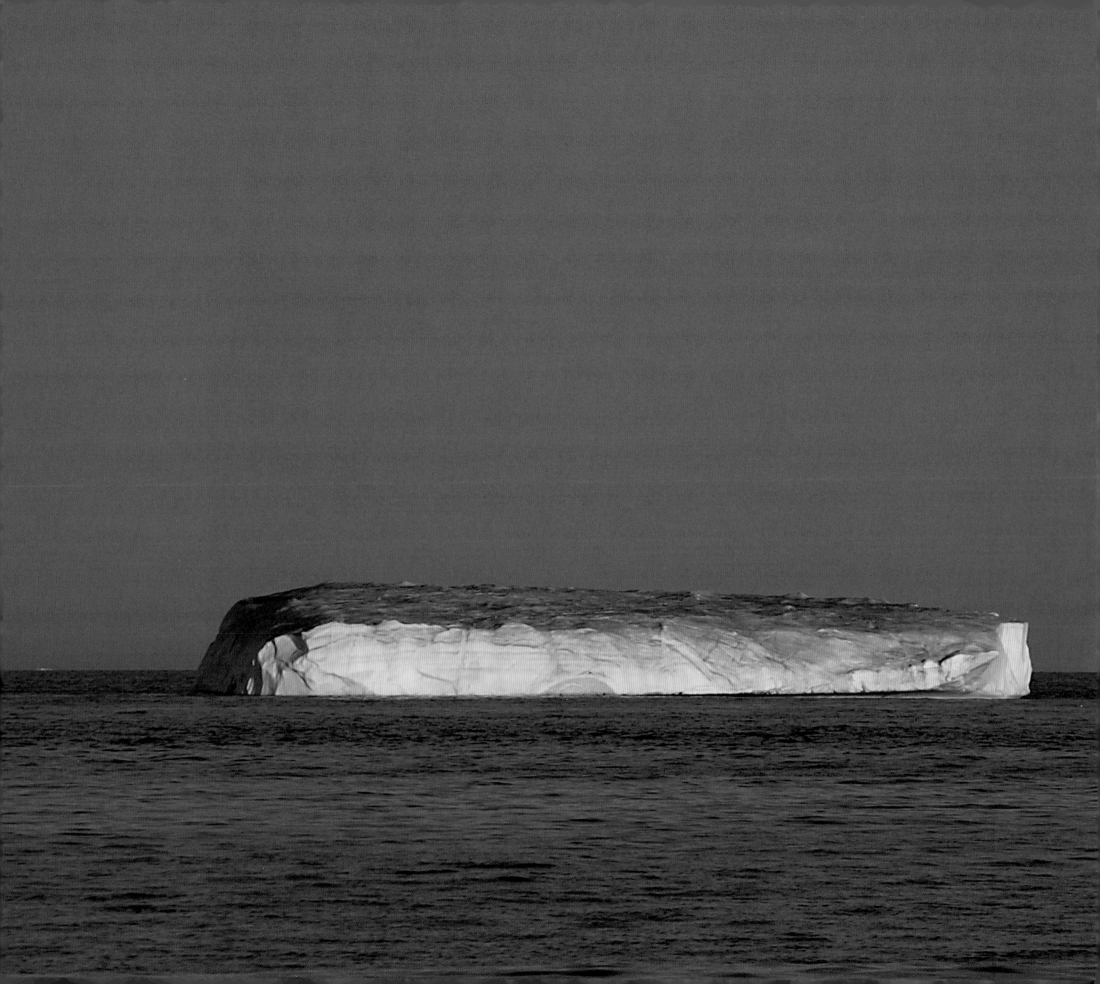

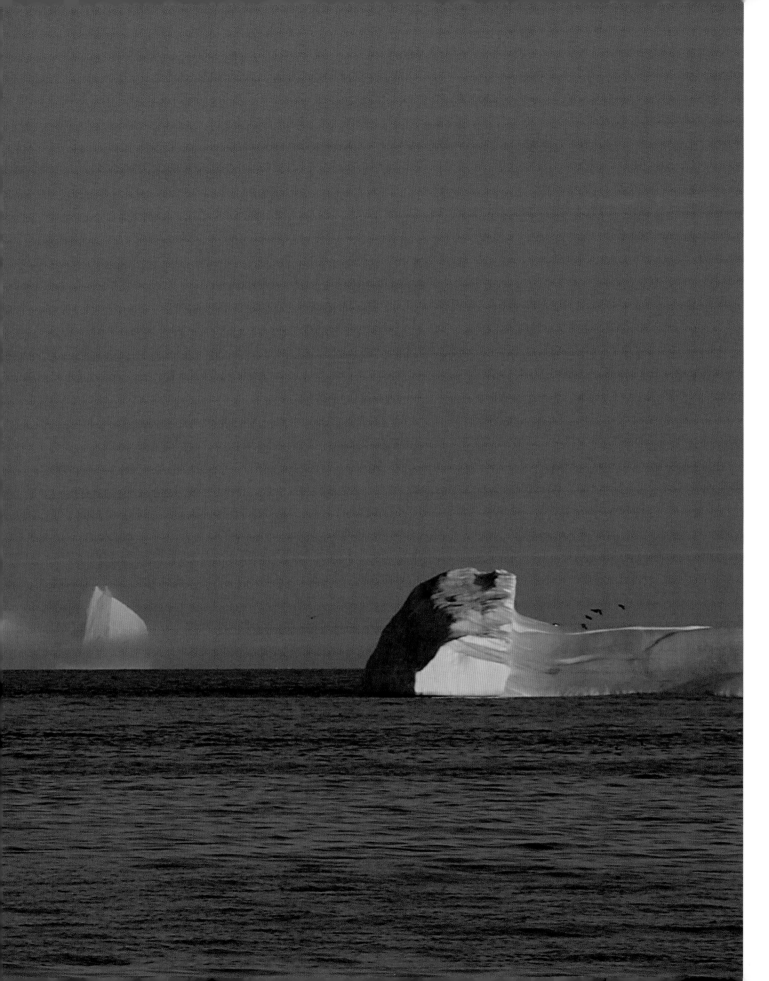

Μεταξύ Καναδά και Γροιλανδίας, το στενό
Davis δέχεται τα χτυπήματα από τα παγόβουνα
που αποκόβονται από τους μεγάλους
παγετώνες στα βορειοδυτικά (όπως το
Humboldt, μήκους πάνω από 100 χιλιόμετρα).

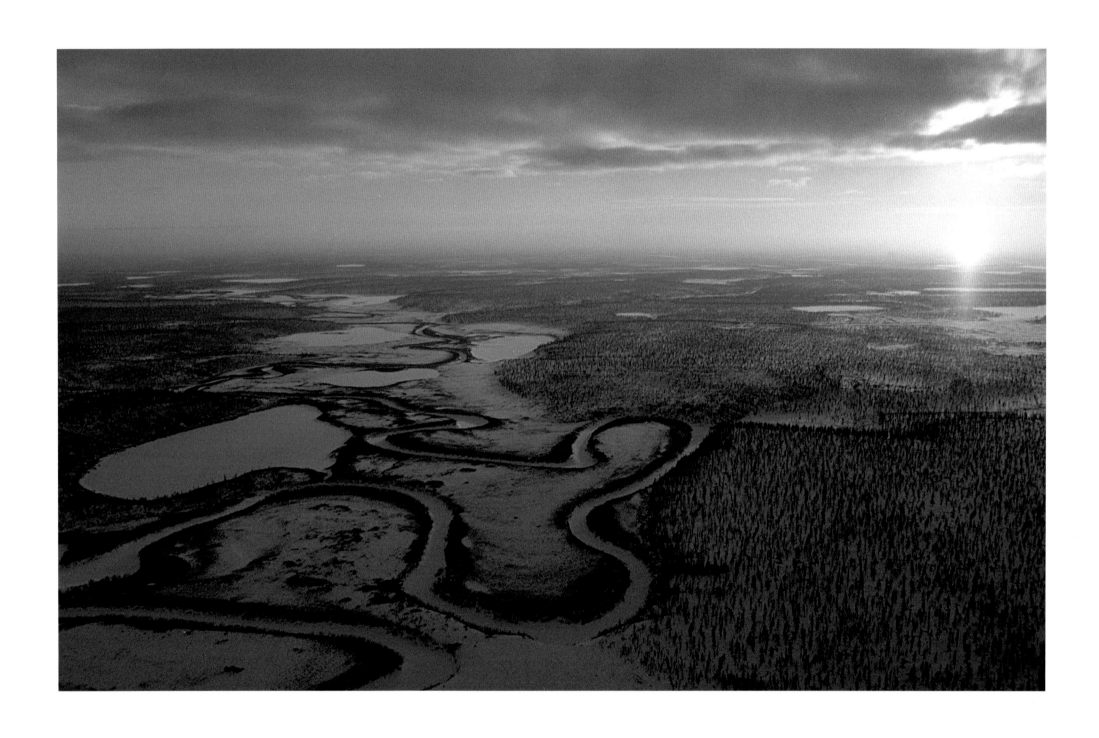

Το αρκτικό φθινόπωρο φτάνει μαζί με τις πρώτες χιονοπτώσεις στη σιβηρική τούντρα που
αυλακώνεται από χιλιάδες ποτάμια που κυλούν ελικοειδώς στα παγωμένα οροπέδια.

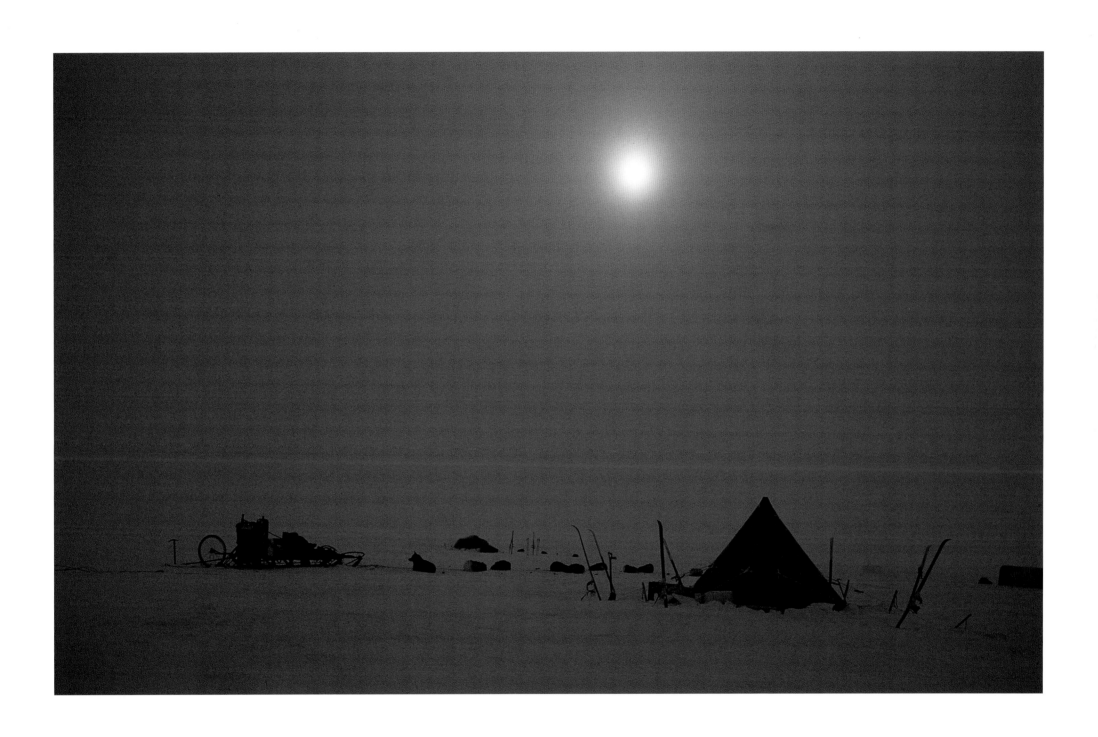

Κατά τη διάρκεια της πορείας της για τον Βόρειο Πόλο, μια αποστολή εγκατέστησε τον καταυλισμό της πάνω στους πάγους.

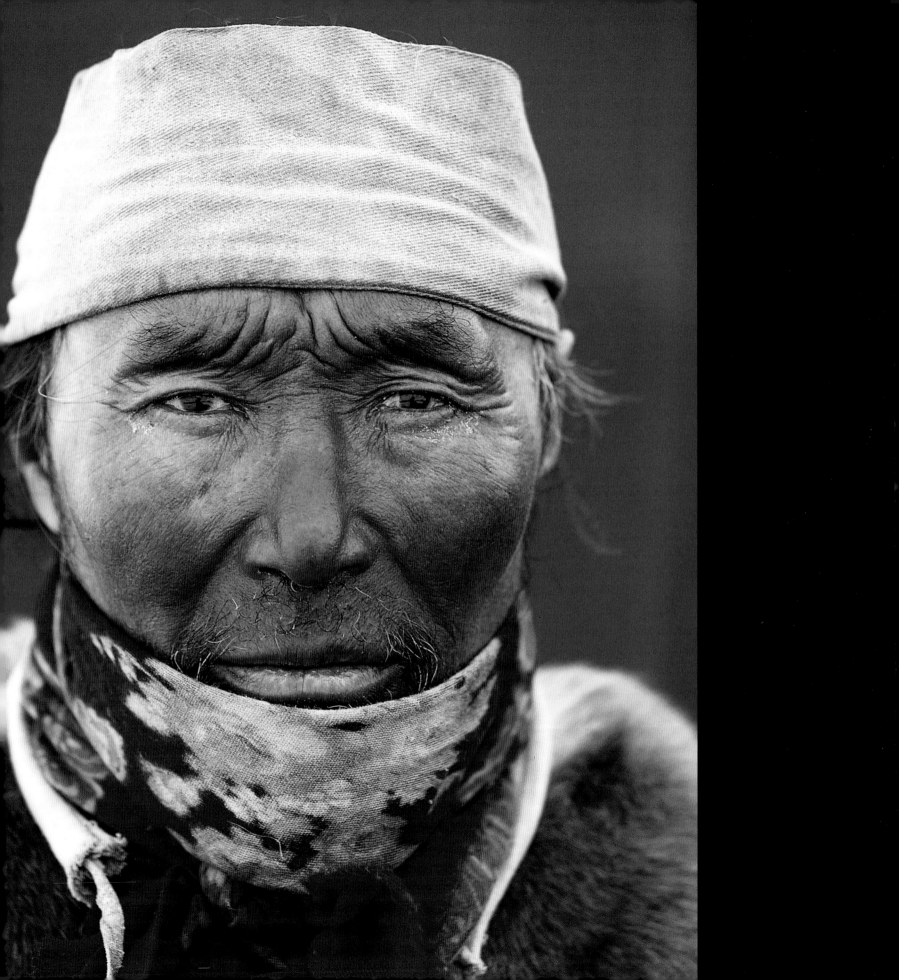

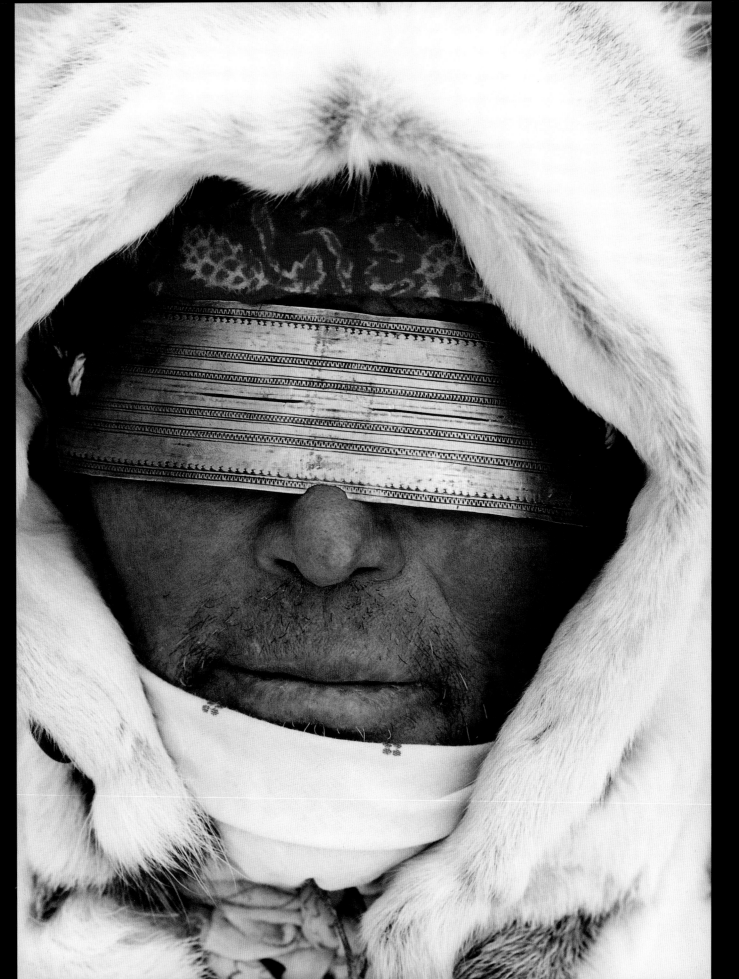

Αυτός ο γέρος
«σοφός» Δολγάνος
είναι εξοπλισμένος
με γυαλιά, για να
προστατευτεί από τα
μόρια πάγου που
αναοπκώνονται λόγω
των δυνατών
βόρειων παγωμένων
ανέμων (blizzard) και
κυρίως για να
αποφύγει την
αντανάκλαση του
ήλιου πάνω στο χιόνι.

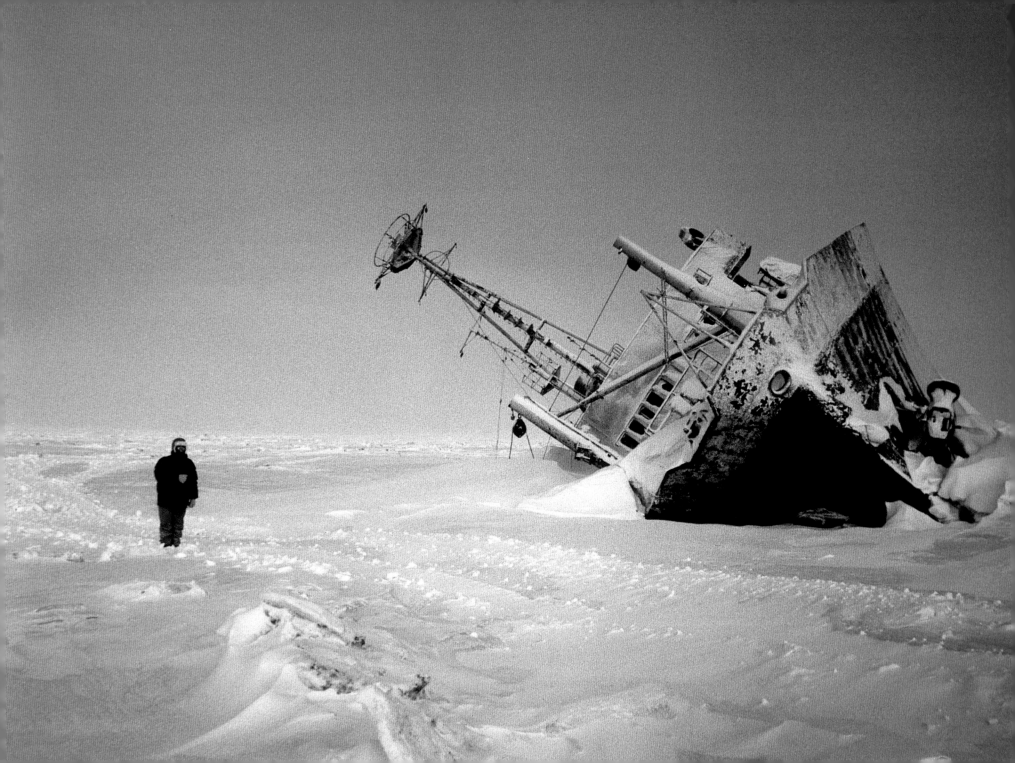

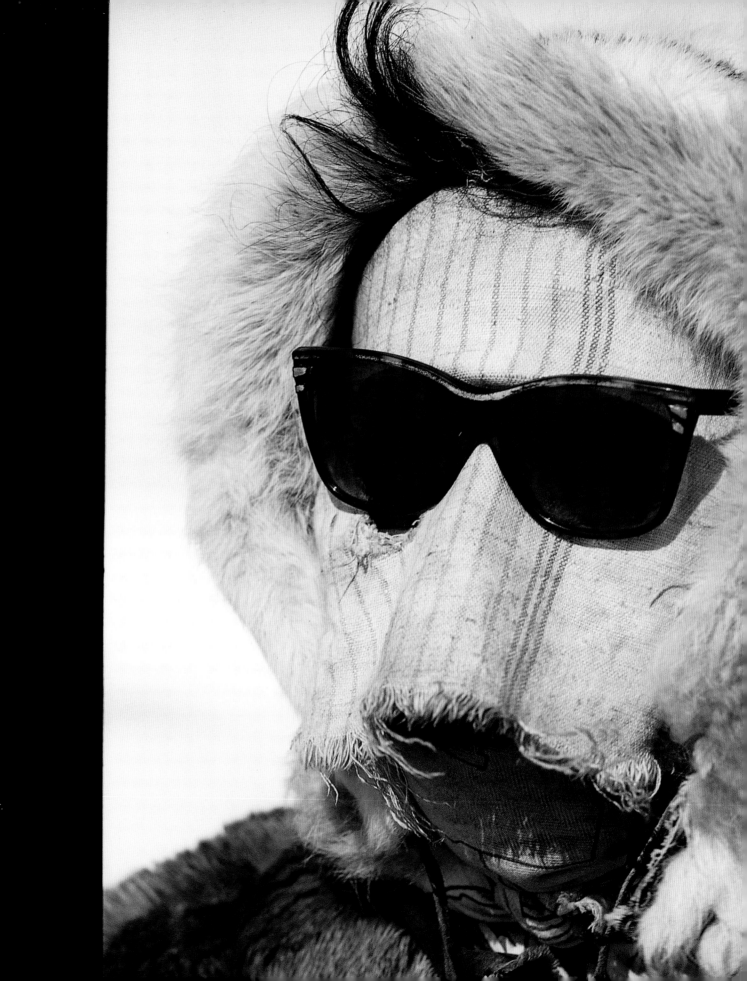

◁ Στο λιμάνι Dickson, στην εκβολή του Ienisseï στη
Σιβηρία, ένα καράβι περιμένει το λιώσιμο των πάγων για
να ταξιδέψει ξανά μέσα στα παγωμένα νερά της Αρκτικής.

▷ Όταν φυσά ο δυνατός βόρειος παγωμένος άνεμος
(blizzard), η μάσκα προστασίας είναι απαραίτητη για να
φυλαχτεί κανείς από τα κρυοπαγήματα.

*Αιχμάλωτο των πάγων, αυτό το καράβι περιμένει πιο γαλήνιους
ουρανούς για να συνεχίσει την πορεία του.*

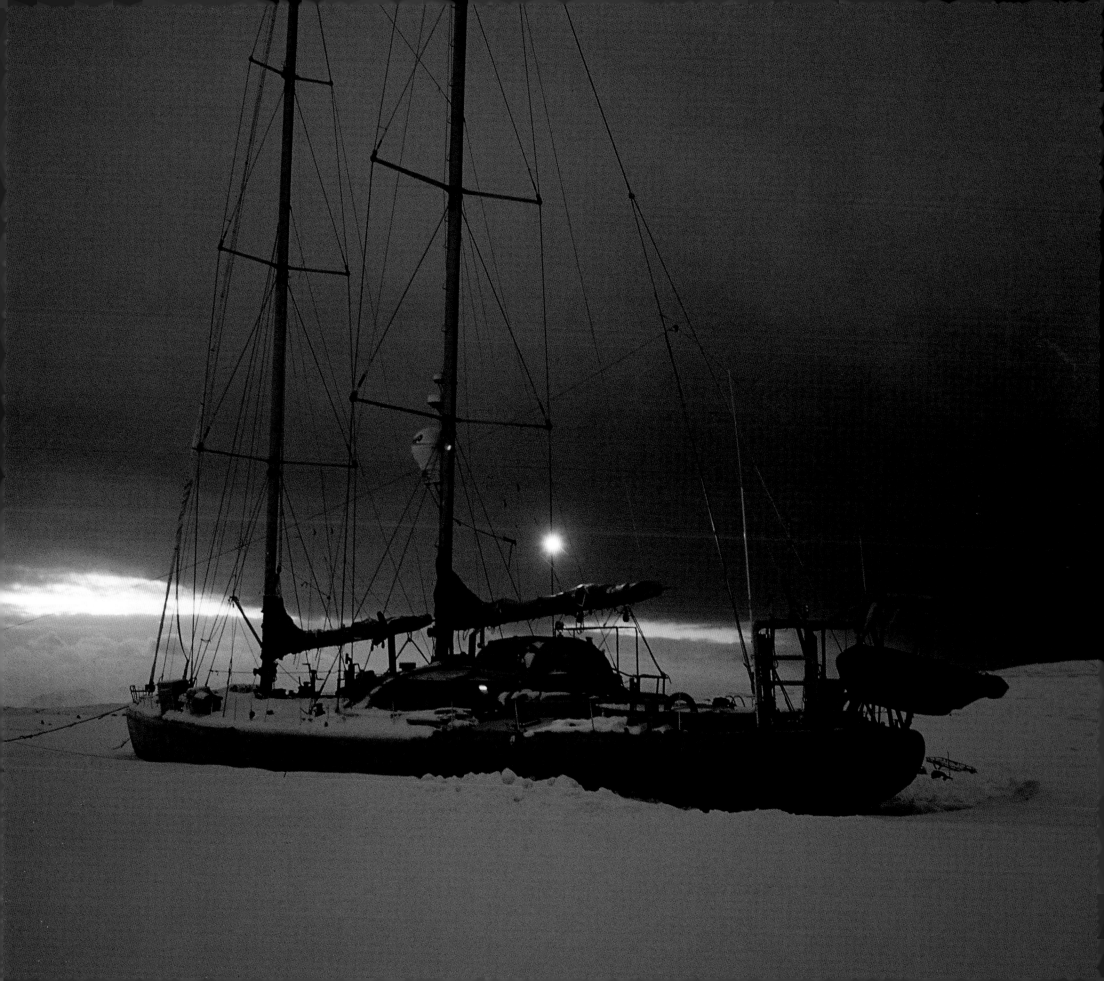

▷ Σ' έναν παγετώνα του Spitzberg, ο δυνατός παγωμένος άνεμος (blizzard) φυσά κατά κύματα και επιβραδύνει κάθε κίνηση στους πάγους.

▽ Με το πρώτο λιώσιμο των πάγων, τα αποδημητικά πουλιά έρχονται να κάνουν φωλιές σ' αυτούς τους τόπους, όπου, στη διάρκεια του καλοκαιριού, υπάρχει άφθονη τροφή.

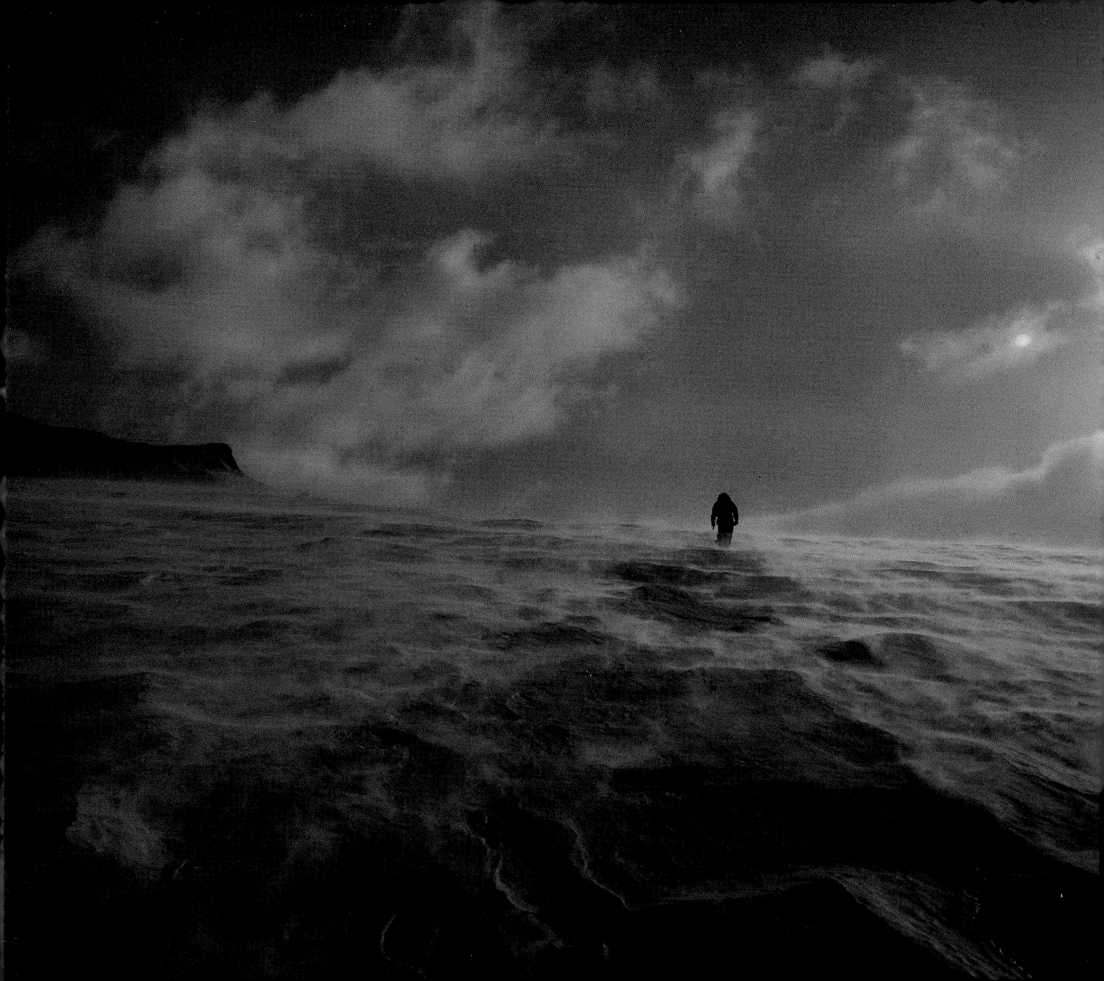

◁△ Μέσα από το φινιστρίνι τού ρωσικού ελικόπτερου MI-8, ο Volodia, ο
Ρώσος γεωλόγος ρίχνει μια τελευταία ματιά στον καταυλισμό που εγκαταλείπει
μετά από μια περίοδο αναζητήσεων και εξερεύνησης της τούντρας.

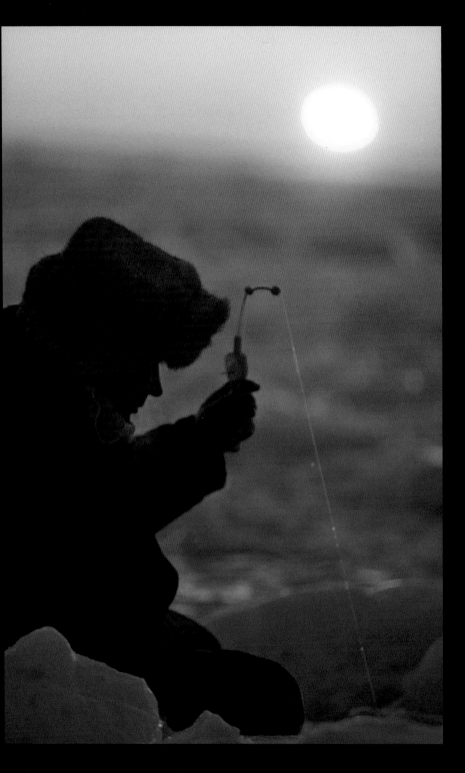

◁ Το ψάρεμα με τρύπα στο πάγο είναι εθνικό σπορ στη Σιβηρία.

▷ Το «Russia» είναι ένα από τα πιο μεγάλα ρωσικά παγοθραυστικά πλοία πυρηνικής προώθησης. Οι τουρμπίνες του αναπτύσσουν 75.000 ίππους και κατορθώνουν να σπάσουν και να λιώσουν τους πάγους του Αρκτικού ωκεανού, με σκοπό να διευκολυνθεί η προσέγγιση του Βόρειου Πόλου.

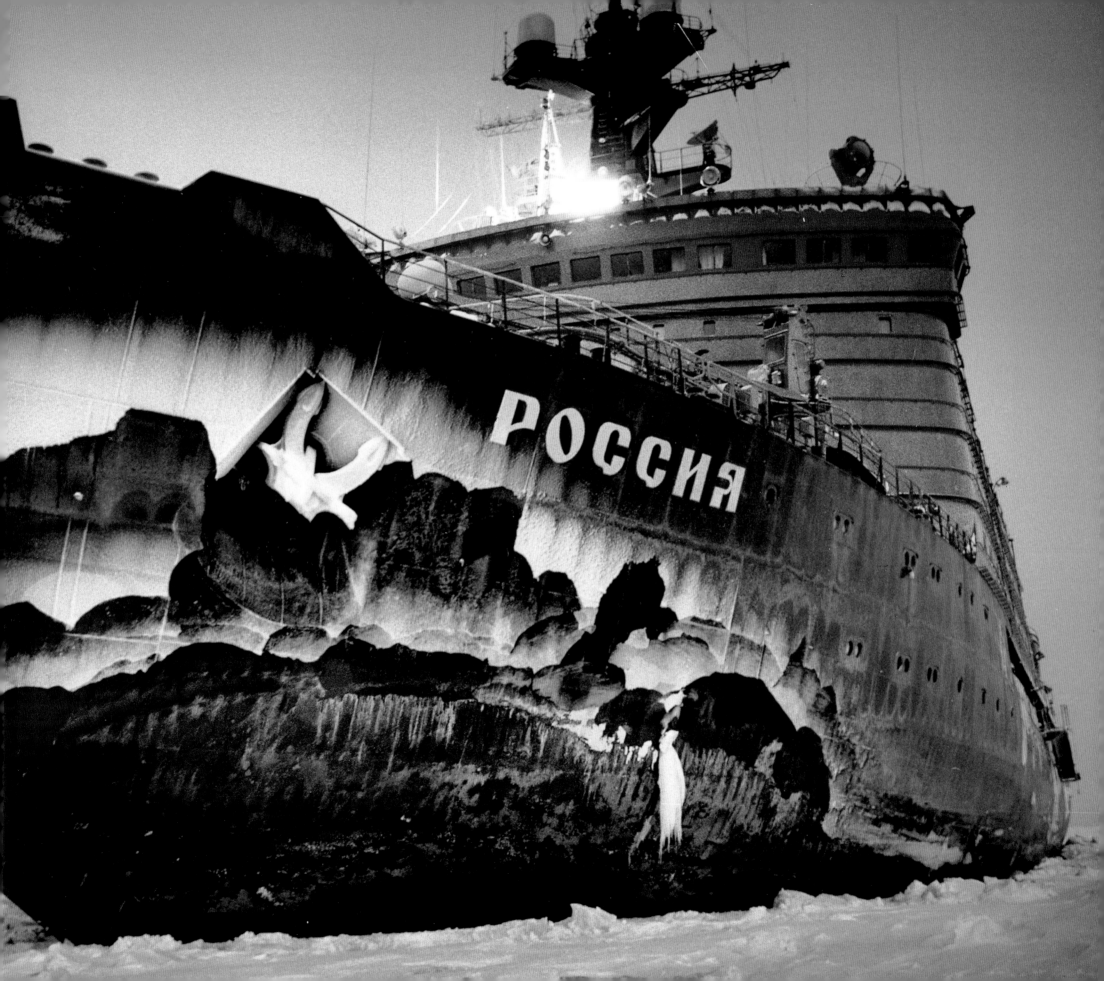

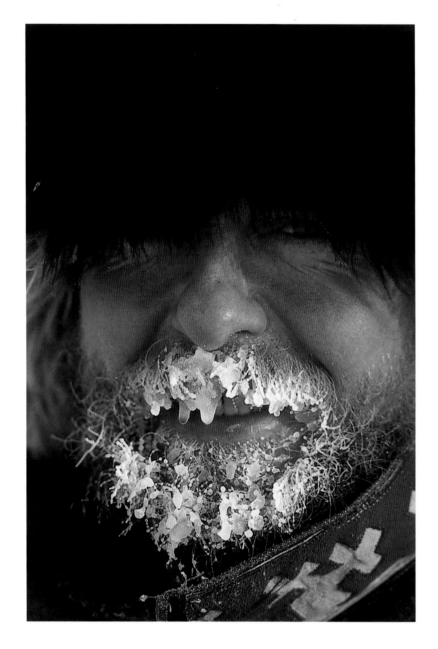

△ Πορτρέτο του Serguei, οδηγού ελκήθρων.

▷ Τον Ιούλιο 2002, στον Βόρειο Πόλο, ο θαλαμίσκος του Δρ. Jean-Louis Étienne μεταφέρεται
με ελικόπτερο στο παγοθραυστικό «Yamal».

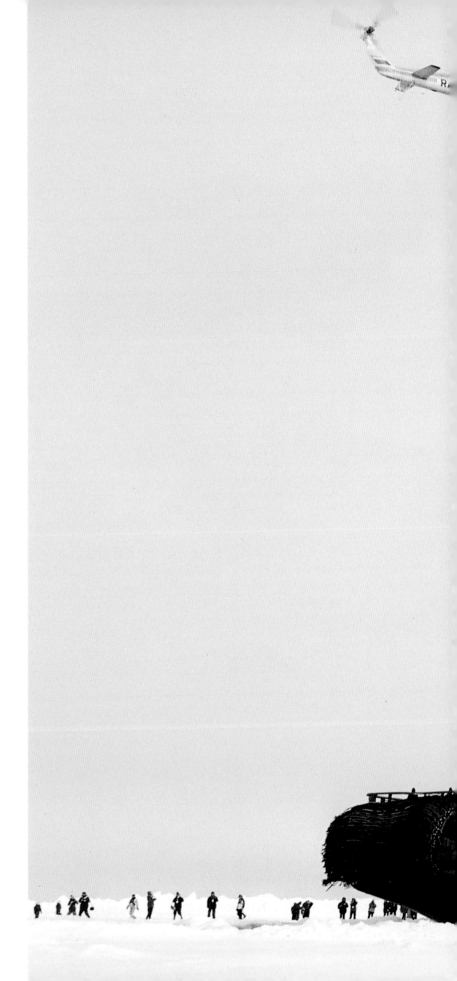

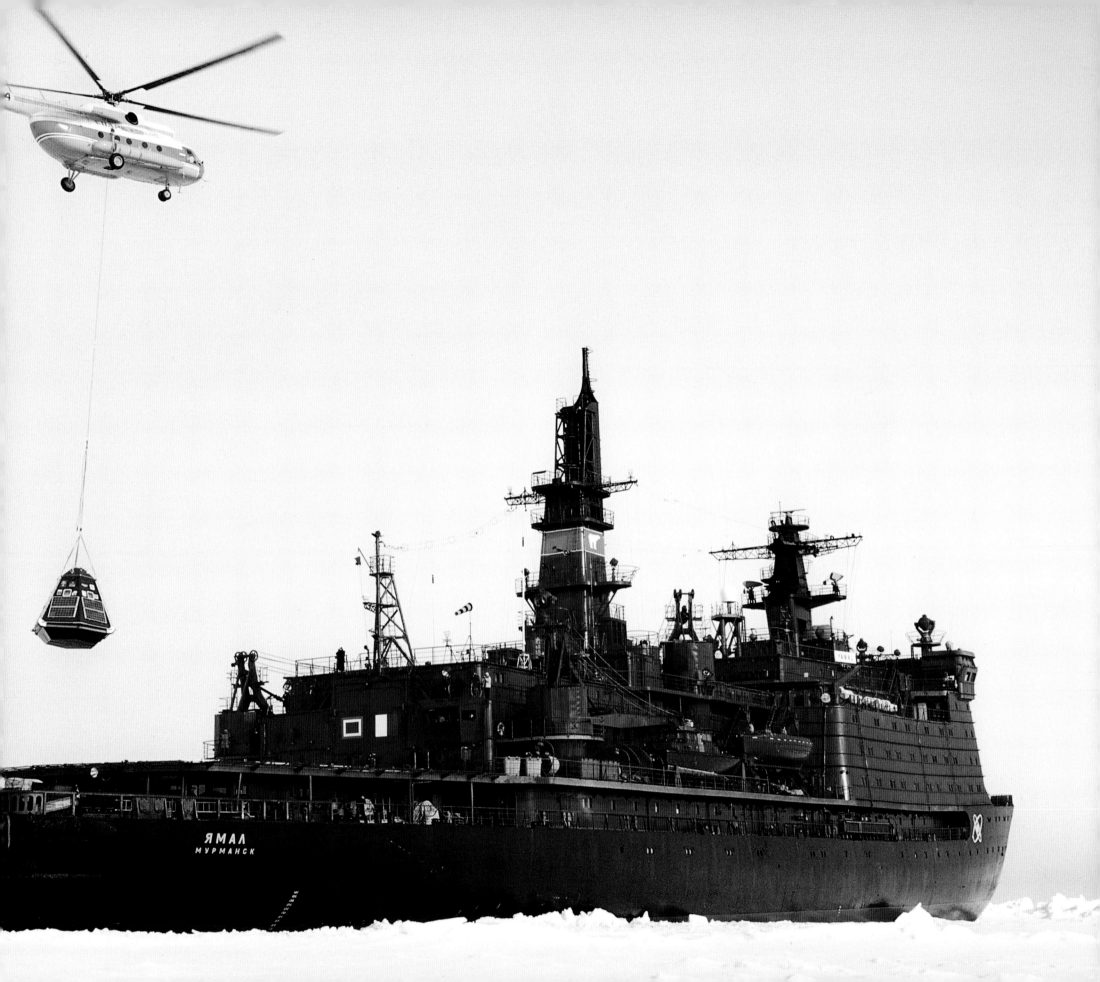

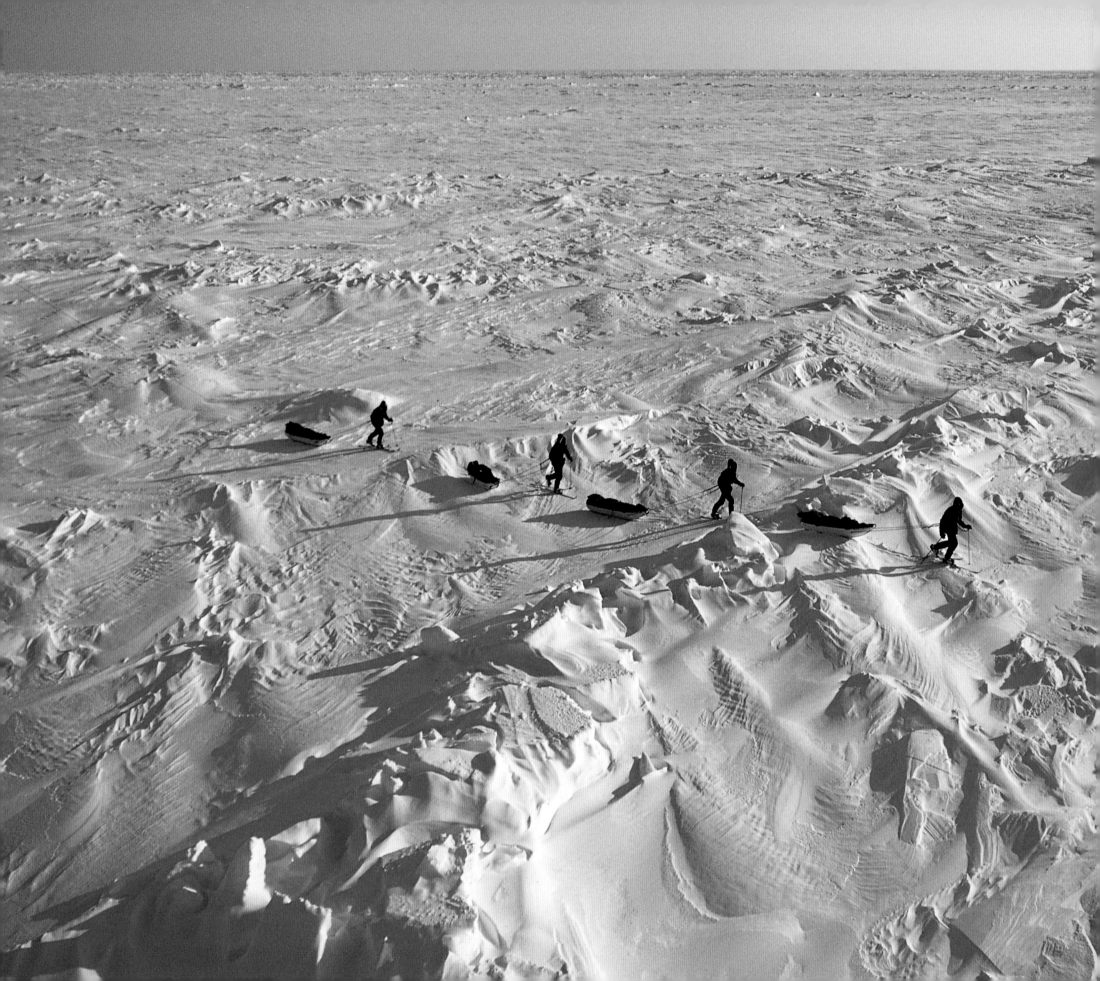

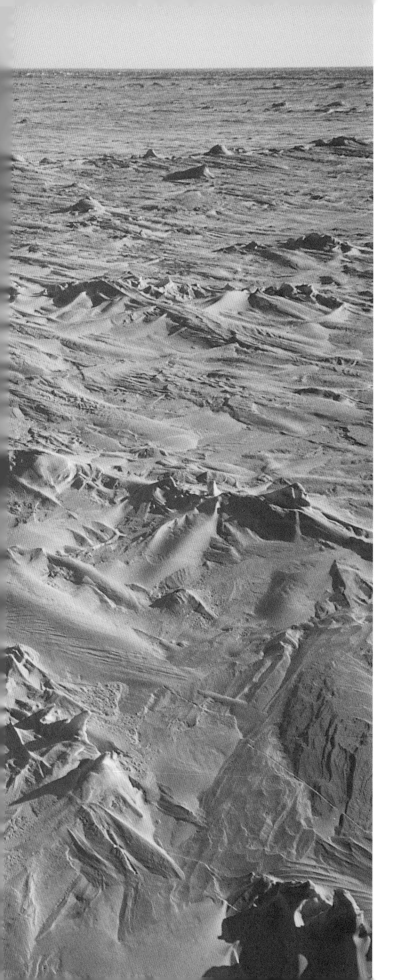

Ο Βόρειος Πόλος πατήθηκε από τη γαλλική αποστολή μετά από πεζοπορία 60 ημερών και πλέον. Όλοι οι μεσημβρινοί συγκλίνουν προς αυτό το μυθικό σημείο, κορυφή του πλανήτη.

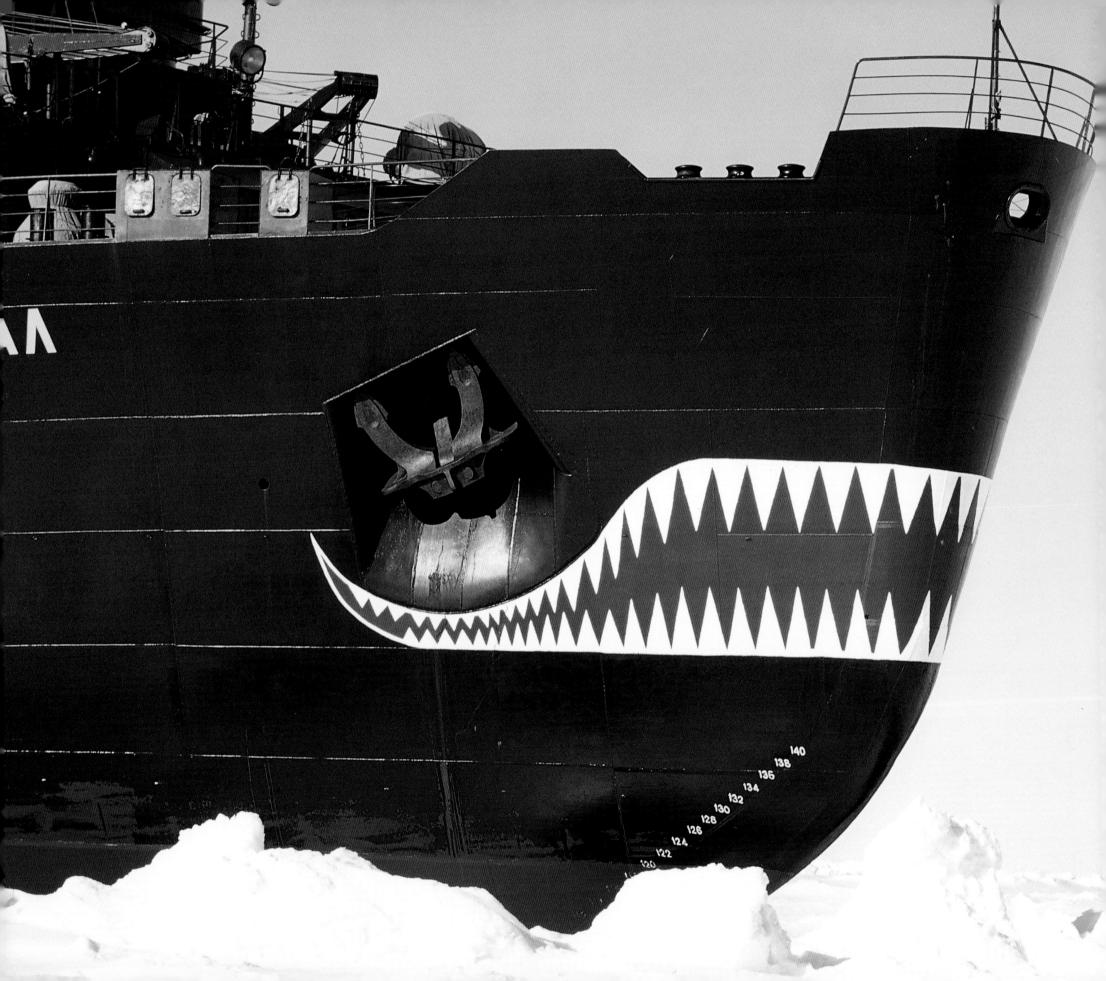

◁ Το ρωσικό παγοθραυστικό «Yamal» βρίσκεται σε ένα στενό του Βόρειου Πόλου. Η δύναμη που αναπτύσσουν οι τουρμπίνες του θα το βοηθήσουν να απελευθερωθεί από τους πάγους.

▽ Στάση ανεφοδιασμού για τα μέλη μιας αποστολής στον δρόμο για τον Πόλο.

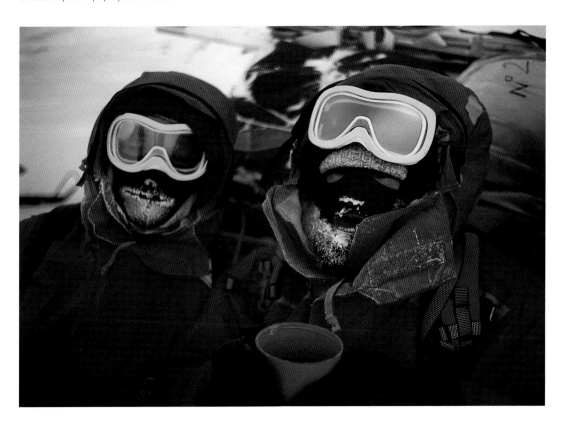

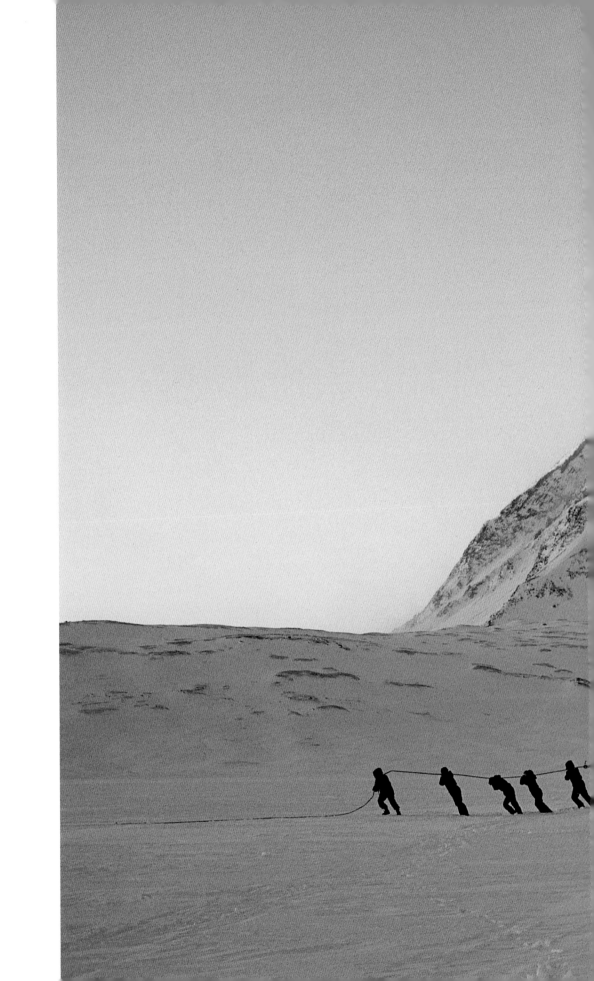

▷ Το πλοίο «Antarctica», αιχμάλωτο των πάγων για μήνες και μήνες μέσα στο φιορντ του Spitzberg. Με τις πρώτες μέρες της άνοιξης, τα μέλη του πληρώματος αρχίζουν τις εργασίες απελευθέρωσης του «αποκοιμισμένου» καραβιού.

▷▷ Στον κόλπο Agarbukta, στα ανατολικά του Spitzberg, μετά από τέσσερις και πλέον μήνες πολικής νύχτας, εμφανίζονται τελικά οι πρώτες ακτίνες του ήλιου.

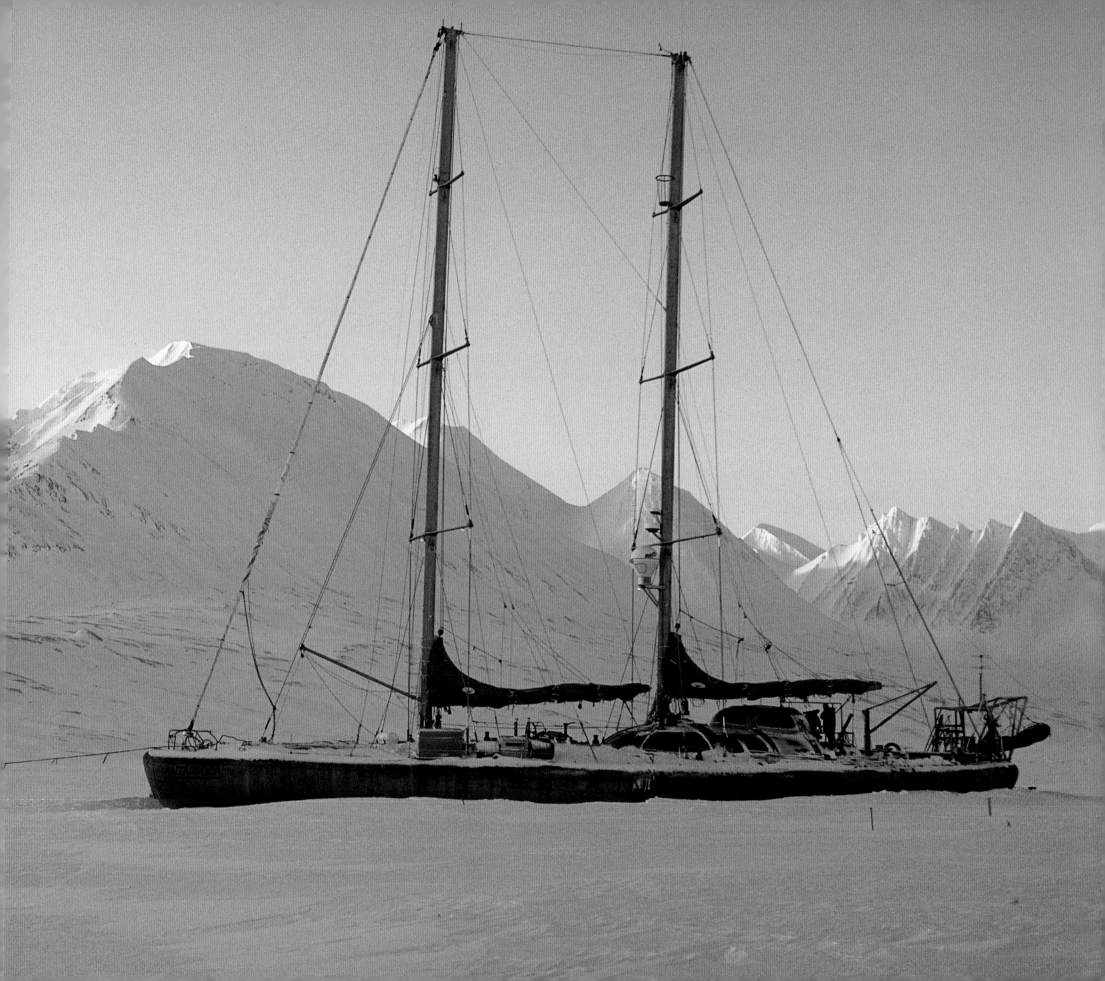

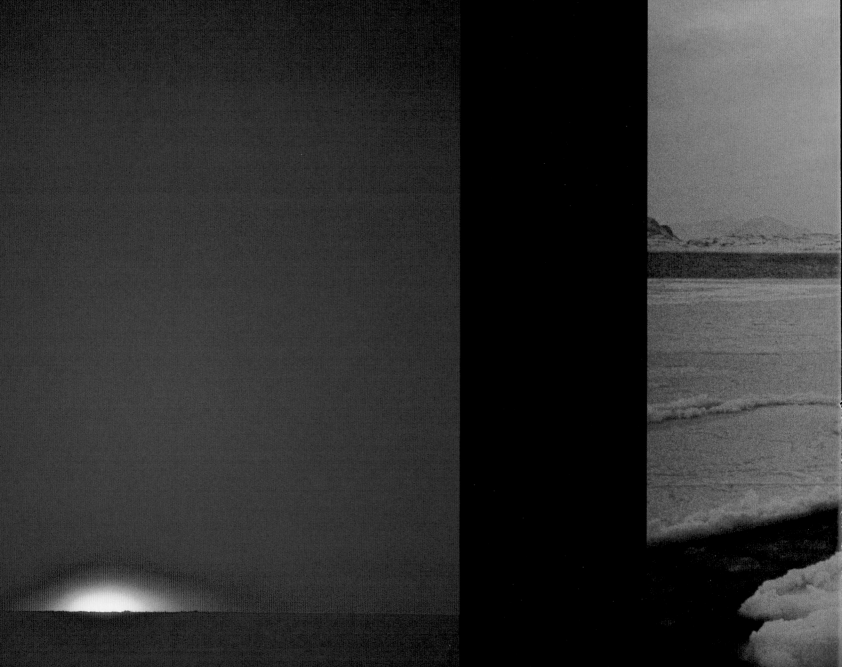

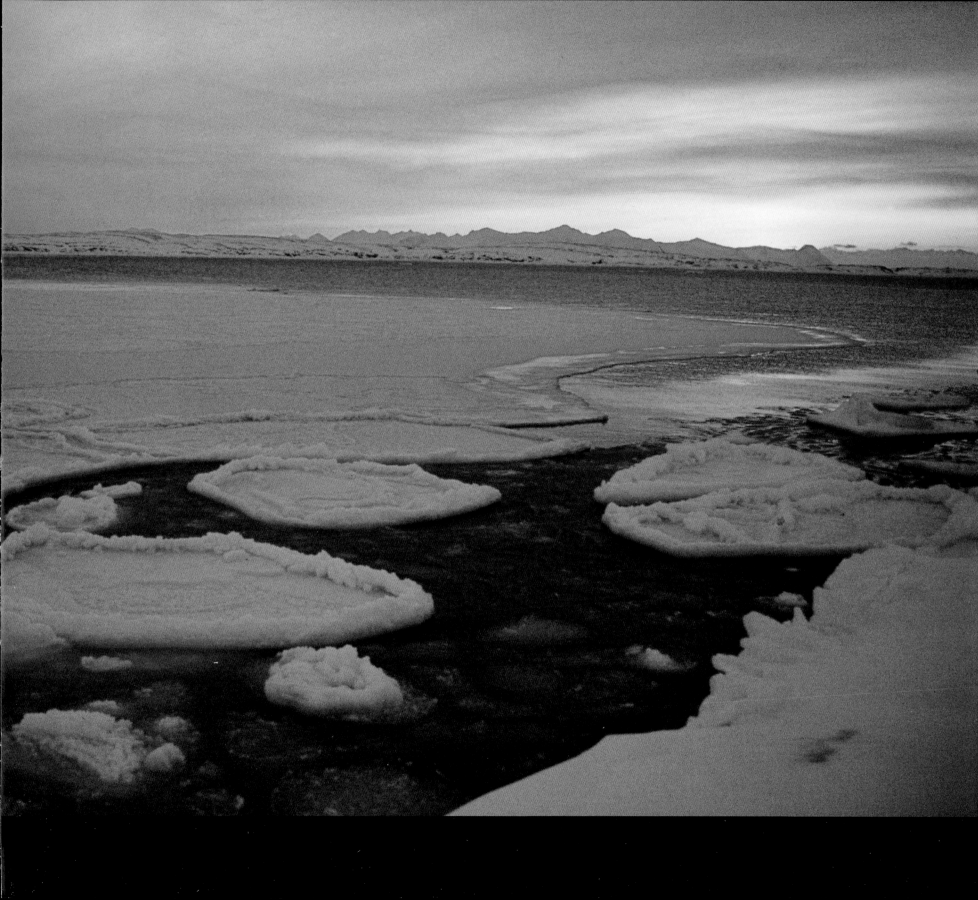

Σε μια πλατεία του Yakoutsk, πρωτεύουσας της Yakoutie, ο ηλικιωμένος άνδρας και το παιδί κάνουν τον καθημερινό τους περίπατο σε θερμοκρασία 30 βαθμών κάτω του μηδενός.